THE MASTER'S HAND VON MEISTERHAND

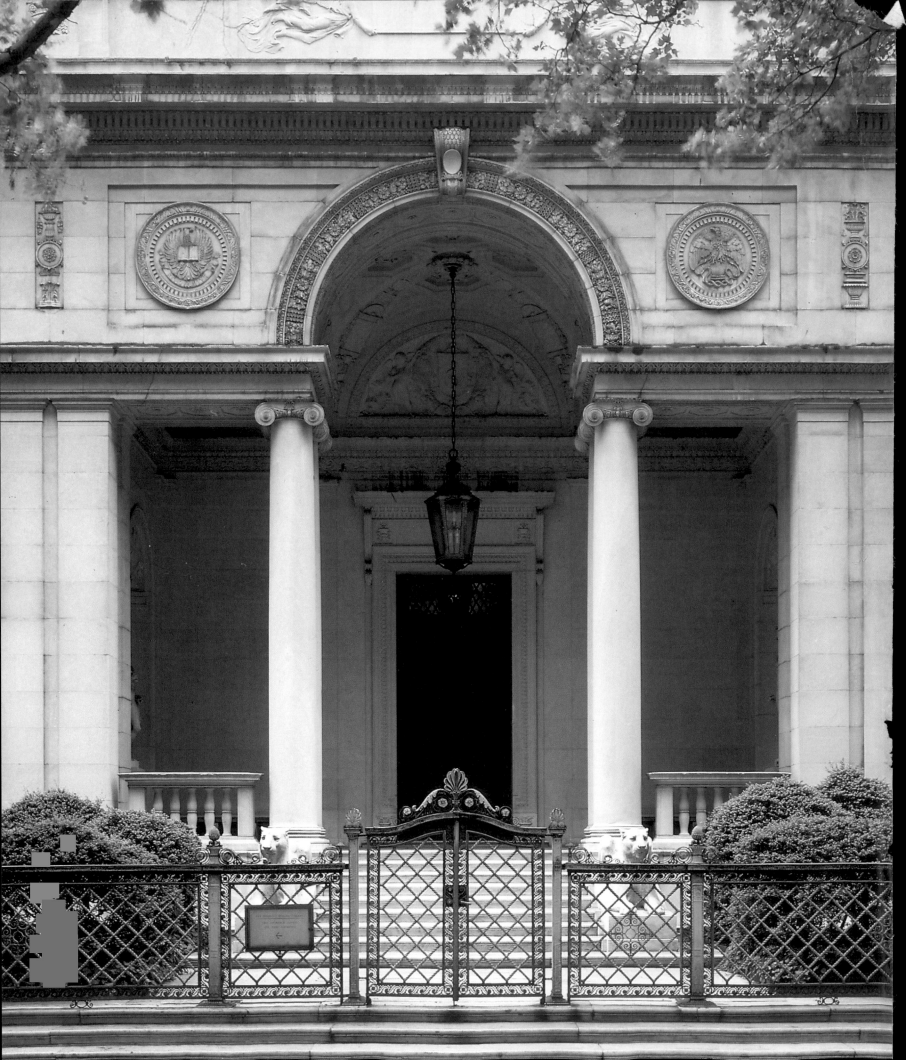

The Master's Hand

Drawings and Manuscripts
from The Pierpont Morgan Library
New York

Von Meisterhand

Zeichnungen, Partituren und Autographen
aus der Pierpont Morgan Library
New York

Cara Dufour Denison
William M. Griswold
Christine Nelson
Robert Parks
J. Rigbie Turner
William M. Voelkle
Roger S. Wieck
Stephanie Wiles

THE PIERPONT MORGAN LIBRARY, NEW YORK
MUSEUM JEAN TINGUELY, BASEL
STÄDELSCHES KUNSTINSTITUT UND STÄDTISCHE GALERIE, FRANKFURT AM MAIN
VERLAG GERD HATJE, STUTTGART

Publication/Publikation

Exhibition dates:
Museum Jean Tinguely, Basel, Switzerland
October 21, 1998 to January 24, 1999
Städelsches Kunstinstitut und Städtische
Galerie, Frankfurt am Main, Germany
February 17 to May 2, 1999

Copublished by The Pierpont Morgan Library
and Verlag Gerd Hatje, Ostfildern-Ruit

Editorial Staff in Europe/Redaktion in Europa:
Matthias Kassel, Paul Sacher Stiftung, Basel
Annja Müller-Alsbach, Museum Jean Tinguely,
Basel
Sabine Sameith, Städelsches Kunstinstitut,
Frankfurt am Main
Jutta Schütt, Städelsches Kunstinstitut,
Frankfurt am Main
Martin Sonnabend, Städelsches Kunstinstitut,
Frankfurt am Main

Translations/Übersetzungen:
Manuela Müller-Windisch
Sabine Sameith (»Drawings/Zeichnungen«)
John Svitek
Martin Windisch

Design of publication/Buchgestaltung:
Gerhard Brunner

Typesetting/Satz:
Fotosatz Weyhing, Stuttgart

Production/Gesamtherstellung:
Dr. Cantz'sche Druckerei, Ostfildern-Ruit

Photography/Photographien: East Room, West
Room, and Library exterior: © 1996 Todd
Eberle; all other photography/alle anderen
Photographien: Schecter M. Lee.
All photography, except/alle Photographien
außer East Room, West Room, and Library
exterior: © 1998 The Pierpont Morgan Library

Published by/Erschienen im
Verlag Gerd Hatje
Senefelderstrasse 12
D-73760 Ostfildern-Ruit
Tel. 00 49/7 11/4 40 50
Fax 00 49/7 11/4 40 52 20
Internet: www.hatje.de

ISBN 3-7757-0754-9 (Verlag)
ISBN 0-87598-126-7 (The Pierpont Morgan
Library)

Printed in Germany

Cover illustration/Umschlagabbildung:
East Room, the Morgan Library (detail),
© 1996 Todd Eberle
Frontispiece: Exterior facade, McKim Mead &
White building, the Morgan Library
Page 33: Enlarged detail of No. 20
Page 137: Enlarged detail of No. 58
Page 249: Enlarged detail of No. 105
Page 289: Enlarged detail of No. 124

Die Deutsche Bibliothek – CIP-Einheitsauf-
nahme

The master's hand : drawings and manuscripts
from the Pierpont Morgan Library New York;
[Museum Jean Tinguely, Basel, Switzerland,
October 21, 1998 to January 24, 1999 ;
Städelsches Kunstinstitut und Städtische
Galerie, Frankfurt am Main, Germany, Feb-
ruary 17 to May 2, 1999] = Von Meisterhand /
Pierpont Morgan Library, New York ... Cara
Dufour Denison ... [Ed. staff: Matthias Kassel
... Transl.: Manuela Müller-Windisch ...]. –
Ostfildern-Ruit : Hatje, 1998
ISBN 3-7757-0754-9 (VHatje)
ISBN 0-87598-126-7 (Pierpont Morgan Library)

Library of Congress Cataloging-in-Publication
Data

The master's hand : drawings and manuscripts
from the Morgan Library,
 New York / Cara Dufour Denison ... [et
al.].
 p. cm.
 An exhibition organized by the Pierpont
Morgan Library in collaboration with the Paul
Sacher Foundation ... [et al.] held at the
Museum Jean Tinguely, Basel, Switzerland, Oct.
21, 1998-Jan. 24, 1999. Städelsches Kunstinstitut
und Städtische Galerie, Frankfurt, Germany,
Feb. 17 – May 2, 1999.
 Includes bibliographical references and
index.
 ISBN 0-87598-126-7 (alk. paper)
 1. Drawing, European--Exhibitions. 2.
Drawing--New York (State)--New York--Exhi-
bitions. 3. Music--Manuscripts--Exhibitions.
4. Manuscripts--New York (State)--New
York--Exhibitions. 5. Pierpont Morgan
Library--Exhibitions. I. Denison, Cara D. II.
Pierpont Morgan Library. III. Paul Sacher
Stiftung (Basel, Switzerland) IV. Museum Jean
Tinguely Basel. V. Städtische Galerie im
Städelschen Kunstinstitut Frankfurt am Main.
NC225.M38 1998
700'.74'7471--dc21 98-36210
 CIP

CONTENTS INHALT

FOREWORD

The seed of this exhibition was planted in November 1994, when Paul Sacher paid his first visit to The Pierpont Morgan Library. Having seen a few of the Library's musical treasures, he asked if we would consider exhibiting a selection of manuscripts from the Paul Sacher Foundation; the Library, in turn, would send some of its own music autographs to the Museum Jean Tinguely in Basel. Shortly after the Basel–New York exchange was arranged, J. P. Morgan & Co. Incorporated suggested adding a German venue, to which the Städelsches Kunstinstitut und Städtische Galerie in Frankfurt graciously agreed. As drawings and illuminated, literary, and historical manuscripts were added, an exhibition that began as a modest display of music manuscripts evolved into *The Master's Hand: Drawings and Manuscripts from the Morgan Library, New York*, the first exhibition in almost thirty years to present an extensive selection from the Library's collections to audiences in Europe. The collections not represented in *The Master's Hand*—printed books and bindings and ancient Near Eastern seals and tablets—are, like all the Library's collections, distinguished not by their size but by their exceptional quality.

For all they have done to ensure the success of the exhibition, I extend my thanks to Dr. Paul Sacher; the Paul Sacher Foundation; J. P. Morgan & Co. Incorporated; Frederick H. S. Allen, Vice President of Corporate Sponsorships at J. P. Morgan & Co. Incorporated; Dr. Margrit Hahnloser and her colleagues at the Tinguely Museum; Dr. Herbert Beck, Director, Dr. Margret Stuffmann, and their colleagues at the Städel; and the staff of the Morgan Library, where J. Rigbie Turner, Mary Flagler Cary Curator of Music Manuscripts and Books, served as curator in charge of *The Master's Hand*.

Charles E. Pierce, Jr.
Director, The Pierpont Morgan Library

VORWORT

Den Grundstein für diese Ausstellung legte Paul Sachers erster Besuch in der Pierpont Morgan Library im November 1994. Nachdem er einige der kostbaren Musikhandschriften der Bibliothek gesehen hatte, fragte er, ob wir bereit wären, eine Auswahl von Manuskripten der Paul Sacher Stiftung in New York auszustellen; im Gegenzug könnte die Pierpont Morgan Library einige ihrer Musikautographen im Museum Jean Tinguely in Basel präsentieren. Kurz nachdem dieser Austausch zwischen Basel und New York vereinbart war, schlug J. P. Morgan & Co. Incorporated vor, einen deutschen Ausstellungsort miteinzubeziehen; Städelsches Kunstinstitut und Städtische Galerie in Frankfurt am Main willigten liebenswürdigerweise ein. Mit der Erweiterung um Zeichnungen, illuminierte, literarische und historische Manuskripte entwickelte sich das, was ursprünglich als kleine Musikhandschriften-Präsentation gedacht war, zu der Ausstellung *Von Meisterhand. Zeichnungen, Partituren und Autographen aus der Pierpont Morgan Library, New York.* Sie zeigt zum ersten Mal seit nahezu dreißig Jahren eine umfassende Auswahl aus den Sammlungen der Pierpont Morgan Library einem europäischen Publikum. Die in *Von Meisterhand* nicht vertretenen Sammlungen – gedruckte Bücher und Einbände, antike Siegel und Schrifttafeln aus dem Nahen Osten – zeichnen sich, wie die Sammlungen der Pierpont Morgan Library überhaupt, nicht durch ihre Größe, sondern durch ihre außergewöhnliche Qualität aus.

Allen, die zum Gelingen dieser Ausstellung beigetragen haben, möchte ich an dieser Stelle herzlich danken: Dr. Paul Sacher, der Paul Sacher Stiftung, J. P. Morgan & Co. Incorporated, Frederick H. S. Allen, Vizepräsident der Corporate Sponsorships von J. P. Morgan & Co. Incorporated, Dr. Margrit Hahnloser und ihren Kollegen am Museum Jean Tinguely, Dr. Herbert Beck, Direktor des Städel, und Dr. Margret Stuffmann, Leiterin der Graphischen Sammlung des Städel, mit ihren Kollegen und den Mitarbeitern der Pierpont Morgan Library, an der J. Rigbie Turner, Mary Flagler Cary Curator of Music Manuscripts and Books, die Ausstellung *Von Meisterhand* verantwortlich betreut hat.

Charles E. Pierce jr.
Direktor der Pierpont Morgan Library

NOTES ON THE EXHIBITION

The inception of this exhibition largely can be traced to the fortunate encounter of two exceptional individuals who, although coming from very different backgrounds, were nevertheless spontaneously able to work together to develop and realize some shared ideas: Paul Sacher, conductor and patron of the arts, and Frederick H. S. Allen, head of corporate sponsorships at J. P. Morgan & Co. Incorporated. Both have long been fascinated by the superb quality and variety of the Morgan Library's collections. Following a visit to the Library by Paul Sacher several years ago, they met in Basel, where they discussed the possibility of organizing the first exhibition of works from the Morgan Library in the German-speaking world. The initial step toward realizing this goal was taken by the Paul Sacher Foundation when it agreed to exhibit at the Morgan Library a representative selection from its outstanding collection of contemporary music manuscripts—its first such undertaking outside Basel. In return the Morgan Library agreed to send an exhibition to Basel, in collaboration with the Museum Jean Tinguely, as well as to Frankfurt, in collaboration with another institution, the Städelsches Kunstinstitut und Städtische Galerie.

The exhibitions in New York and Basel have been sponsored jointly by the Paul Sacher Foundation and J. P. Morgan & Co. Incorporated; that in Frankfurt has been made possible by J. P. Morgan. We are indebted to both the Paul Sacher Foundation and J. P. Morgan for their invaluable support.

This selection of drawings, music manuscripts, autographs, and illuminated manuscripts is intended not only to be a cross section of several Morgan Library collections but also to raise some important questions about the role museums should play in the world today.

Visitors to the exhibition will notice a predominance of music manuscripts and drawings; this clearly reflects the interests of the organizing institutions. In Basel the Paul Sacher Foundation and the Museum Jean Tinguely have become important centers for the cultivation of contemporary music and art. In addition to its important painting gallery, the Städelsches Kunstinstitut in Frankfurt houses a rich collection of drawings by old and modern masters.

Each of these institutions, like the Morgan Library, owes its existence to private initiative. The Paul Sacher Foundation and the Museum Jean Tinguely are of recent European patronage, whereas the Städelsches Kunstinstitut owes its existence to the vision and initiative of an enlightened citizen and banker of the late eighteenth century.

In planning the exhibition we were guided primarily by the extraordinary visual qualities of the objects themselves and by experiences and questions drawn from our own work. We made no effort to develop a unifying idea that justified the unusual juxtaposition of drawings, music manuscripts, texts, and manuscript illuminations, nor did we draw on in-depth knowledge of these diverse subjects.

We see time and again how new technologies—the computer, the CD-ROM, and the Internet—can widen the path to learning and knowledge. But at the same time we sense that our perceptions are being manipulated and influenced in ways that we cannot wholly comprehend. This is of special concern to us as museum curators, for it is nowadays all too easy to miss the delicate form, drown out the soft sound, overlook the individual stroke and subtle line, and thereby lose the small but significant measure of artistic expression. The quest for the sense and meaning of the artwork becomes ever more urgent. But however different the mission, character, and background of the Tinguely and the Städel may be, they are united in this quest.

Museums can only counter this trend by reminding us of the importance of learning to read and decipher artistic objects and by teaching us to reexperience and explore the creative tension between first sketches and the finished draft of a work. This requires sharpened visual and auditory perception, the ability to discern the logical relationships in different forms and, finally, imagination on the part of observers prepared to transcend boundaries by supplementing the process of perception with their own conscious or unconscious experience. This applies equally to drawings, music notations, texts of all kinds, and manuscript illuminations—the last being, in the context of this exhibition, of special significance owing to their unique combination of image, ornament, and text.

The exhibition includes drawings by such famous artists as Rembrandt, Piranesi, Goya, and Blake. But over and above their inherent interest, we hope that this selection will give visitors to the exhibition the opportunity to experience the different aspects of this artistic idiom. A freehand drawing, a design, a sketch of some pictorial detail, the plan of an architectural project—all must be perceived and distinguished as different expressions, different manifestations of the art of drawing. Here we recognize the extent to which drawing can, on the one hand, be the vivid rendering of visual qualities—as well as a mirror of subjective fantasies—and, on the other, the expression of an intellectual outlook of more general significance. Even musical notation, the handwritten score, which is subject to fixed rules, can convey a form of expression comparable to that of a drawing. This can be impressively demonstrated with examples from Bach, Mozart, Beethoven, Schubert, Mahler, or Stravinsky.

While the printed texts of Zola or Maupassant may be more quickly and easily read, anyone who has seen the original manuscripts, with their many corrections, changes, and revisions, will learn far more about the meaning and literary quality of the text.

We chose the title *The Master's Hand* in order to call attention to the written or drawn line in general. In 126 objects, ranging from the rather modest note to splendid manuscript illuminations, the exhibition includes examples of human creativity that span more than a thousand years. Its many aspects are intended to evoke and promote the synchronic perception of the viewer, to arouse curiosity, expand knowledge, fire the imagination, and thus turn into a very special kind of concert for the receptive visitor. It was not without reason that our American colleagues chose *In August Company* as the title of a book about the Morgan Library's collections.

The rather unconventional idea behind this exhibition could not have been realized without the generous help of Charles E. Pierce, Jr., Director of the Morgan Library, and the efforts and understanding of our colleagues at the Library who wrote this catalogue. Our thanks go in particular to J. Rigbie Turner, Mary Flagler Cary Curator of Music Manuscripts and Books, who served as curator in charge of the exhibition; in addition we would like to thank William M. Griswold, Cara Dufour Denison, and Stephanie Wiles in the Department of Drawings and Prints; Robert Parks and Christine Nelson in the Department of Literary and Historical Manuscripts; and William M. Voelkle and Roger S. Wieck in the Department of Medieval and Renaissance Manuscripts. We also received expert and welcome help from our colleagues at the Paul Sacher Foundation, to whom we extend our sincere thanks. And finally we would like to thank all those involved in producing this catalogue: the editorial team, the translators, and Gerhard Brunner, head of production at Dr. Cantz'sche Druckerei.

Margrit Hahnloser
Museum Jean Tinguely, Basel

Margret Stuffmann
Städelsches Kunstinstitut und
Städtische Galerie, Frankfurt am Main

ZUR AUSSTELLUNG

Diese Ausstellung verdankt ihre Entstehung einem glücklichen Zusammentreffen von ungewöhnlichen Menschen, die zwar unterschiedlichen Lebensbereichen angehören, aber dennoch spontan gemeinsame Ideen zu entwickeln und zu realisieren vermögen. Der Dirigent und Förderer der Künste Paul Sacher und der für das kulturelle Engagement der J. P. Morgan Bank verantwortliche Frederick H. S. Allen waren gleichermaßen fasziniert von dem auserlesenen, vielseitigen Reichtum der Pierpont Morgan Library. Angeregt durch einen Besuch Paul Sachers dort vor einigen Jahren, trafen sich nun beide in Basel und besprachen die Möglichkeit, die erste Ausstellung der New Yorker Institution im deutschsprachigen Raum einzurichten. Den ersten Schritt tat Basel, indem die Paul Sacher Stiftung einen Teil ihrer bedeutenden Bestände von zeitgenössischen Musikhandschriften nach New York schickte, was bisher noch nie geschehen war. Im Gegenzug erklärte sich die Pierpont Morgan Library zu einer Ausstellung in Europa bereit, im Museum Jean Tinguely in Basel und im Städelschen Kunstinstitut, Frankfurt am Main, dem Ort der europäischen Banken.

Die Ausstellungen in New York und Basel wurden gemeinschaftlich von der Paul Sacher Stiftung und der J. P. Morgan Bank unterstützt; die Ausstellung in Frankfurt wurde durch J. P. Morgan ermöglicht. Wir sind sowohl der Paul Sacher Stiftung als auch J. P. Morgan für ihre unschätzbare Unterstützung zu großem Dank verpflichtet.

Eine erlesene Auswahl von Handzeichnungen, Partituren, Autographen und Buchmalereien soll zum einen die Pierpont Morgan Library anschaulich repräsentieren, aber auch Fragen stellen, die die Museen hinsichtlich ihrer Aufgabe für die heutige Öffentlichkeit bewegen.

Wenn in dieser Ausstellung Partituren und Handzeichnungen dominieren, erklärt sich dies primär aus dem Interesse beider Veranstalter in Basel und Frankfurt: dem der Paul Sacher Stiftung mit dem Museum Jean Tinguely als Zentrum der Pflege moderner Musik und als Ort zeitgenössischer Kunst sowie dem des Städelschen Kunstinstituts, das neben einer bedeutenden Gemäldegalerie über einen reichen Bestand von Zeichnungen alter und neuerer Meister verfügt.

Der Pierpont Morgan Library in gewisser Beziehung vergleichbar, verdanken beide Institute ihre Entstehung privater Initiative: das Museum Jean Tinguely in Basel dem Beispiel modernen Mäzenatentums in Europa, das Städel in Frankfurt der Einsicht und der Initiative eines aufgeklärten Bürgers und Bankiers im ausgehenden 18. Jahrhundert.

Ohne über das notwendige Detailwissen in den verschiedenen Sparten zu verfügen und ohne ein wissenschaftliches Konzept für die ungewohnte Nachbarschaft von Zeichnungen, Noten, Handschriften und Buchmalereien liefern zu können, ließen wir uns bei der Planung und Auswahl zunächst von der außergewöhnlichen Qualität des Gesehenen leiten, ebenso aber auch von Erfahrungen und Fragestellungen unserer täglichen Arbeit.

Als Zeitgenossen erleben wir immer wieder, wie neue Technologien – Computer, CD-Rom oder Internet –, unsere Möglichkeiten des Lernens und Wissens erweitern. Wir spüren aber auch, wie unsere Wahrnehmung stärker manipuliert und vielleicht verändert wird, als wir es einschätzen können. Als Kuratoren eines Museums sollten wir dieser Tatsache um so mehr Rechnung tragen, als in der gegenwärtigen Situation die kleine Form, der leise Ton, der individuelle Strich, das knappe Zeichen allzu leicht übersehen, übertönt, überspielt werden und das kleine, aber bedeutsame Maß subjektiven Ausdrucks verlorengeht. Die Frage nach dem Sinn und der Bedeutung des Originals stellt sich immer dringlicher. So unterschiedlich Bestimmung und Charakter des Museums Jean Tinguely und des Städel aufgrund ihrer jeweiligen Geschichte sein mögen, gerade diese Problematik ist für beide Institutionen von gleicher Aktualität.

Von seiten des Museums können wir diesem »Trend« nur begegnen, indem wir versuchen, die Lektüre, das Entziffern nicht zu verlernen und die Spannung immer neu zu erfahren und auszuloten, die zwischen der ersten Notiz und dem vollendeten Entwurf oder einem Konzept liegt. Voraussetzung hierzu ist die Genauigkeit der sehenden und hörenden Wahrnehmung, die Fähigkeit eines logischen Nachvollzugs von Formen unterschiedlicher Art und nicht zuletzt die Phantasie eines Betrachters, der bereit ist, Grenzen des Gegebenen zu überschreiten, indem er seine eigene bewußte oder unbewußte Erfahrung in den Prozeß der Wahrnehmung mit einbringt. Dies gilt für die Zeichnung, für die Note, für den geschriebenen Text wie für die alte Buchmalerei gleichermaßen. Im Kontext dieser Ausstellung ist letztere durch die Wechselbeziehung von Bild, Ornament und Text von besonderer Bedeutung.

Es handelt sich bei den Zeichnungen um berühmte Namen – von Rembrandt über Piranesi zu Goya und Blake –, darüber hinaus jedoch ist das Gesagte an der Auswahl der Objekte beispielhaft zu erfahren. Freie Schrift, die Notiz des Details, der Entwurf, das gezeichnete gedankliche Programm oder der Plan einer zu bauenden Architektur sind als unterschiedliche Äußerungen des Zeichnens wahrzunehmen und auseinanderzuhalten. Man erkennt dabei, in welch hohem Maß Zeichnung die Wiedergabe visueller Anschaulichkeit, Spiegel einer subjektiven Phantasie, aber ebenso Symptom einer geistigen Konstellation von übergreifender Bedeutung sein kann. Selbst die Notenschrift, die Partitur, die festen Gesetzen, Schlüsseln und Taktregeln folgt, vermittelt eine der Zeichnung ver-

gleichbare Form des Ausdrucks. Am Beispiel von Bach, Mozart, Beethoven, Schubert oder auch Mahler und Strawinsky ist dies hier eindrücklich nachzuvollziehen.

Die Texte eines Zola oder Maupassant mögen im Druck zwar schneller und leichter zu lesen sein, wer jedoch die vielen Korrekturen, die Mühe des Formulierens und Variierens im originalen Manuskript wahrgenommen und miterlebt hat, wird mehr vom Sinn des Textes, von seiner literarischen Qualität erfahren.

Um die Aufmerksamkeit auf den Schriftduktus im allgemeinen zu lenken, wählten wir für unsere Ausstellung den Titel *Von Meisterhand.* In über hundert Beispielen, von der eher bescheidenen Notiz bis zur prunkvollen Buchmalerei, veranschaulicht und vermittelt sie Fragmente geistigen Lebens aus tausend Jahren. Ihre Vielstimmigkeit fordert und fördert die synchrone Wahrnehmung des Betrachters. Sie will Neugier wecken, Wissen erweitern, Phantasie beflügeln und könnte für den disponierten Betrachter zu einem Konzert besonderer Art werden. Mit gutem Grund haben unsere amerikanischen Kollegen für eine ähnliche Präsentation der Pierpont Morgan Library in ihrem eigenen Land den Titel *In August Company* (In illustrer Gesellschaft) gewählt.

Der unkonventionell anmutende Zuschnitt dieser Ausstellung war nur möglich durch die Großzügigkeit von Charles E. Pierce jr., dem Direktor der Pierpont Morgan Library, und das Verständnis der New Yorker Kollegen, die auch den Katalog geschrieben haben. Wir bedanken uns besonders bei J. Rigbie Turner, dem Leiter der Musikabteilung und Hauptverantwortlichen der Ausstellung. Im Kabinett der Zeichnungen arbeiteten mit uns William M. Griswold, Cara Dufour Denison und Stephanie Wiles, in der Abteilung für Autographe Robert Parks und in der Sammlung der Miniaturen William M. Voelkle und Roger S. Wieck. Auch erhielten wir von den Mitarbeiterinnen und den Mitarbeitern der Paul Sacher Stiftung kompetente und wertvolle Unterstützung. Ihnen allen gilt unser herzlicher Dank.

Dieser schließt alle an der Organisation Beteiligten mit ein, ebenso das Team der Redaktion, die Übersetzer und Gerhard Brunner, den Herstellungsleiter der Dr. Cantz'schen Druckerei.

Margrit Hahnloser
Museum Jean Tinguely, Basel

Margret Stuffmann
Städelsches Kunstinstitut und
Städtische Galerie, Frankfurt am Main

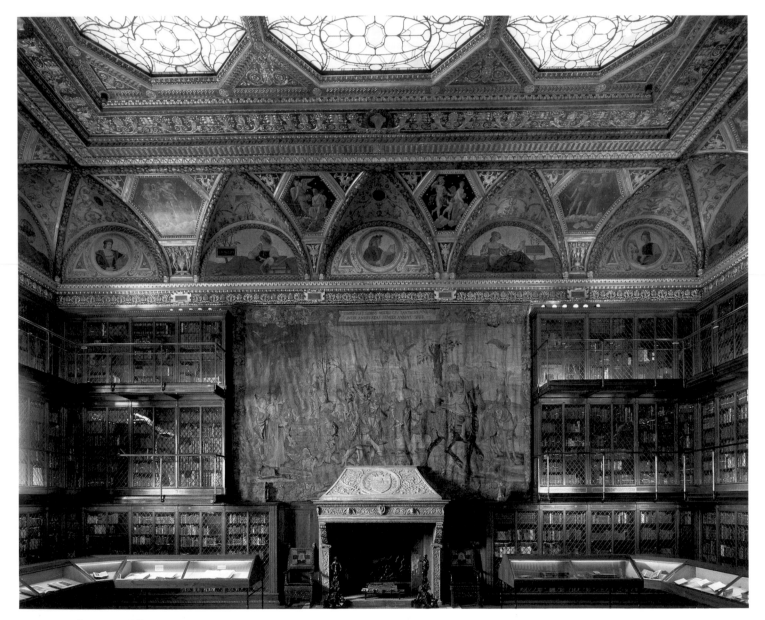

East Room, the Morgan Library

INTRODUCTION

The Morgan Library: A House for Collecting

Now recognized as one of the world's greatest treasuries of seminal artistic, literary, musical, and historical works, The Pierpont Morgan Library began in the 1890s as the private collection of the illustrious American financier for whom it is named. Although the well-educated Morgan was neither a scholar nor a connoisseur in the strictest sense of the word, he acquired, with a keen and intuitive eye, on a vast scale both in quality and scope.

Morgan found inspiration in the European model of a "gentleman's library," acquiring medieval and Renaissance illuminated manuscripts, early and rare printed books, fine bindings, literary and historical autographs, and old master drawings. While the focus was primarily on Western European materials, Morgan had a great interest in the works of important American authors and historical figures.

When Morgan died in 1913, the Library and its contents passed to his son, J. P. Morgan, Jr., known as Jack, who in 1924 established the library as a public institution in memory of "my father's love of rare books and his belief in the educational value of the collection." Since that time, the Morgan Library has operated as an independent research library and museum devoted to the arts and the humanities. While the collections have increased several times over, areas of interest established by Pierpont Morgan have been largely maintained.

When Morgan began to collect, he was already in his fifties and internationally regarded as one of the world's leading bankers and financiers. Born in Hartford, Connecticut, on 17 April 1837, into an old and distinguished New England family, he was raised in an atmosphere of wealth, privilege, and refinement. When he was seventeen, the family moved to London, where his father, Junius Spencer Morgan, became a partner in the American-owned investment house of George Peabody & Co. (later to become J. S. Morgan & Co.). Young Morgan was sent to boarding school in Switzerland, attended the prestigious University of Göttingen in Germany, and spent holidays in England and on the Continent.

He returned to New York in 1857 and began his business career; four years later he became the American agent for his father's firm, securing and protecting overseas investments in the burgeoning railroad, coal, and steel industries. During the turbulent "boom" years following the Civil War, the house of Morgan gained a reputation for stability and integrity, and Pierpont emerged as a powerful and respected businessman in his own right.

Between 1893 and 1895 he reorganized six of the nation's railroads and maintained a controlling interest in all. In 1895 he halted an impending gold crisis by forming a syndicate to exchange bonds for gold. In 1901 he bought out Andrew Carnegie and launched the U.S. Steel Corporation, the largest corporate enterprise the world had known. During the panic of 1907, he raised $25 million in one afternoon to halt a run on the banks. As one biographer noted, Morgan essentially operated as a "one-man Federal Reserve bank."

Pierpont Morgan assiduously shunned publicity and was portrayed by colleagues as brusque, somewhat distant, and often abrupt. With friends and family, however, he was relaxed and convivial, and entertained frequently and lavishly. His first wife, Amelia Sturges, died of tuberculosis four months after their wedding. Three years later, in 1865, he married Frances Louisa Tracy, the daughter of a prominent New York lawyer. They had four children: Louisa, Juliet, Anne, and Jack.

Morgan's lifestyle was suitably grand and comfortable, yet not ostentatious. In 1880 he moved to a large but undistinguished brownstone at Madison Avenue and Thirty-sixth Street. He spent several months of each year abroad and was frequently at his father's London town house at Princes Gate and at Dover House, the family estate at Roehampton. He was equally at home in London, Rome, and New York.

As a rising young businessman, Morgan showed an occasional interest in books and manuscripts and acquired a small group of historical and literary autographs. His father's death in 1890, however, signaled the beginning of his collecting in earnest. It is possible that he put off collecting out of deference to his father, who had acquired some paintings, rare books, and autographs. More important, however, it was only then that Pierpont Morgan had the financial resources to acquire on a truly grand scale. Junius Morgan's estate was valued at roughly $12.4 million, and his son assumed leadership of the family's highly profitable London banking house. That Pierpont Morgan should have used a portion of this wealth to collect was not entirely surprising. America's rapid economic growth during the 1870s and 1880s had been followed by a keen awareness of the need to enrich the cultural and intellectual lives of its citizens. Increasingly it was regarded the patriotic duty of those who could to contribute to the creation of a great republic that could compete culturally with Europe. During this period many of the great U.S. private collections of European old master paintings and sculpture—such as those of Isabella Stewart Gardner, Henry Walters, and Joseph P. Widener—were formed. In March 1880, ten years after its founding, New York's Metropolitan Museum of Art was established in permanent quarters in Central Park. Morgan was elected a trustee of the museum in 1888 and from 1904 until his death served as its president. Under his leadership, the museum began an ambitious acquisition program.

Morgan's rare books, manuscripts, and autographs—his so-called literary collections—were but one aspect of his collecting interests. He also acquired art objects numbering in the thousands, ranging from ancient Egyptian tomb sculpture and Chinese bronzes to Meissen porcelain and paintings by Raphael, Vermeer, and Fragonard. "No price," he was once reported to have said, "is too high for an object of unquestioned beauty and known authenticity."

As he formed his own library, Morgan concentrated primarily on the growth of his autograph collection, which he had begun on a modest scale as a boy. Here as elsewhere he followed a pattern of buying both individual items and entire collections. In the former category were such prizes as the manuscript of Keats's *Endymion* and Dickens's *Christmas Carol.* Major purchases of collections included Sir James Fenn's English historical autographs and Stephen Wakeman's over two hundred and fifty American literary autographs, which contained Hawthorne's notebooks and Thoreau's journals.

Morgan's scholarly nephew Junius encouraged him to collect early printed books and illuminated manuscripts. Notable individual purchases included the splendid Lindau Gospels, Morgan's first major medieval manuscript acquisition, and the very rare Mainz Psalter of 1459. Breadth, however, was achieved through a succession of astute purchases of entire collections—the James Toovey collection of rare books and bindings, the library of books and manuscripts formed by the American collector Theodore Irwin, and, above all, the Richard Bennett collection, acquired in 1902. This group of over seven hundred volumes, including about one hundred illuminated manuscripts and no fewer than thirty-two Caxton imprints, remains the nucleus of the Morgan Library's printed book and illuminated manuscript collections. Morgan became a serious collector of drawings late in life, when he purchased the Charles Fairfax Murray collection. Comprising roughly fifteen hundred works dating from the Renaissance to the eighteenth century, it is generally regarded as the first "classic" collection of old master drawings in the United States. As with the Bennett collection, Fairfax Murray's formed the core of the Library's holdings in this field.

In general Morgan's collecting followed accepted patterns of the day, favoring the older periods and schools of Western Europe. At times, however, he ventured into areas to which few collectors on either side of the Atlantic had gone. In 1911, for example, he purchased most of the group of some sixty Coptic manuscripts that had been discovered the year before in the ruins of a monastic library near the Egyptian village of Hamouli in the Fayum. Another unconventional interest was represented by his impressive collection of ancient Near Eastern cylinder seals, which at his death numbered upwards of twelve hundred items.

Beginning in 1905 Morgan had the able assistance of Belle da Costa Greene as his librarian and general aide-de-camp. Barely twenty when Morgan hired her, Miss Greene had little formal training but soon demonstrated intelligence and enthusiasm, using the same swift and single-minded tactics in making acquisitions as her employer. On a buying trip to London in 1907 she swept up Lord Amherst's Caxtons in private negotiations the night before they were to be sold at auction, thereby increasing Morgan's already outstanding Caxton holdings by seventeen.

The sheer quantity of Morgan's collections began to pose considerable logistical and organizational problems, and by 1900, he began planning a separate structure to the east of his house, along Thirty-sixth Street. He apparently felt that the library he was creating should reflect the importance and value of the objects it would house.

Morgan chose McKim, Mead & White, at the time one of the nation's most prestigious architectural firms and the acknowledged leaders of the American Renaissance movement. Morgan's singling out of Charles F. McKim (1847–1909), whom he knew and respected, as principal architect for the project was logical. His reputation as a scholar-architect along with his serious demeanor appealed to the financier. Morgan's support had helped McKim to establish the American Academy in Rome, where American students could study the great works of the Renaissance and classical antiquity. In Morgan, McKim had a client not only sympathetic to his designs but also willing to pay for the finest craftsmen and materials to realize them. Completed in 1906, the original library ranks among the most successful and fully realized examples of American Renaissance architecture and interior design.

McKim concerned himself with virtually every aspect of the project, including the planning and supervision of the interior decorations. The library would be an expression of the Renaissance philosophy of the unity of the arts, combining architecture, painting, and sculpture into a harmonious whole. And if McKim cast himself in the role of a great Renaissance architect at work on his magnum opus, then Morgan undertook the role of a great Renaissance patron with equal seriousness.

The library was constructed of the finest pinkish white Tennessee marble. McKim's design, essentially a rectangle with a recessed portico, is classically simple. Doric pilasters decorate the facade, and Ionic columns frame the entrance. The arched portico combines two sixteenth-century Italian sources: the garden loggia of the Villa Giulia, designed by Bartolommeo Ammanati, and the entrance of Annibale Lippi's Villa Medici. McKim assembled a distinguished group of craftsmen and sculptors to execute the exterior decoration. In dazzling contrast to the serenity of the exterior, the interior decoration is richly colored and ornamented. Nevertheless, the entire program is harmonious and balanced, conforming to McKim's oft-quoted credo that the interior of a library should "whisper and not shout."

His plan for the interior consisted of three rooms leading off the east, north, and west sides of a domed entrance foyer. The largest of the three, the East Room, was designed for book storage and displays; the West Room was Morgan's private study; and the North Room, the smallest, was the librarian's office.

Of all the rooms, the vaulted entrance foyer, known as the Rotunda, is the most monumental in design and feeling. Pilasters of Skíros marble decorate the walls, and freestanding columns of green-veined cipollino marble flank the doorways leading to the East and West Rooms. The marble floor, with a large red porphyry disc embedded in the center, is modeled after the floor of the Villa Pia in the Vatican gardens. For the painted and stucco decorations, McKim retained the artist H. Siddons Mowbray (1858–1928), who looked to the Renaissance artists Raphael and Pinturicchio as sources for the decoration of the Rotunda and East Room.

The impressive East Room is by far the Library's largest and grandest. The walls, reaching thirty feet, are lined, floor to ceiling, with triple tiers of bookcases of inlaid Circassian walnut. In 1906 Morgan purchased the large Brussels tapestry that hangs over the fireplace. Designed by the sixteenth-century Flemish artist Pieter Coecke van Aelst, it depicts (some would say ironically) the triumph of avarice. The ceiling paintings, with their classical imagery and lofty references to great cultural luminaries of the past, were intended to awe and inspire scholars at work. They also create the illusion that they and the room are indeed part of the distant past.

The West Room, which served as Morgan's private study, is the most sumptuous yet intimate of the Library's rooms. Arranged along the bookshelves are sculpture, porcelain, and other objets d'art from his collections, and the walls are hung with Renaissance paintings. The exquisite antique wooden ceiling was purchased in Florence and reconstructed under McKim's supervision. The room served as a meeting place for leaders and notables from the various worlds in which Morgan moved. Here, surrounded by favorite objects, he received scholars, dealers, and statesmen as well as business colleagues and friends.

The Morgan Library: A Public Institution

When Pierpont Morgan died in Rome on 13 March 1913, his estate was valued at about $128 million, roughly half of which represented his art and book collections. He left virtually everything to his son, Jack, expressing in his will the hope that there would be some disposition of the collections, "which would render them permanently available for the instruction and pleasure of the American people." Precisely how this was to be carried out was left to Jack.

By the time of Pierpont Morgan's death nearly all the paintings, sculpture, and decorative arts that he had kept in England were in a basement storeroom at the Metropolitan Museum, New York. In 1909 the U.S. import duty on art had been abolished (owing largely to Morgan's influence), and England had substantially increased death duties. These two circumstances seem to have been the primary incentive for his decision to transport his vast collections to New York, beginning in February 1912.

Understandably, the Metropolitan, to which he had been so generous during his lifetime, hoped to receive the entire collection. Jack Morgan, however, was obliged to sell a number of the art objects to pay taxes and maintain the liquidity of the estate. But the collections of books, manuscripts, and drawings remained intact. The decision to maintain the library and its collections was no doubt urged by Belle Greene, whose devotion to the library—and powers of persuasion—rivaled those of Pierpont Morgan. It is also true, though, that Jack always had a special regard for the library and appreciated it more than any other of his father's collections.

For a time after Pierpont Morgan's death, the library assumed a secondary role to Jack's more pressing concerns of settling the estate and then arranging financial assistance for the Allies in the early years of World War I. In 1915, however, Belle Greene wrote to the London book dealer Quaritch: "I am glad to tell you that he [has] a strong interest in the library and promised that I may go on collecting books and manuscripts when the war is over." Morgan's subsequent purchases initiated the second great period of growth of the collections. He added 206 illuminated manuscripts to the library, roughly a third as many as had his father. In the area of printed books, he added half as many incunables, including an indulgence printed by Gutenberg, bringing the total to about two thousand. Additions to the collection of old master drawings were modest but included fine drawings by such artists as Reynolds and Ingres.

The most far-reaching consequence of Jack Morgan's stewardship was his decision to establish the library as a public institution. On 15 February 1924, Morgan transferred its ownership to a board of trustees along with a $1.5-million endowment. The indenture of trust provided for the use of the collections for research, the establishment of a gallery of art, and other such activities as the trustees deemed appropriate and desirable. The institution became a public reference library by a special act of the legislature of the State of New York, and Belle Greene was named its first director.

Shortly following the Library's incorporation, Pierpont Morgan's neighboring brownstone was demolished, and on the site a new wing (the Annex) was constructed, doubling the size of the Library. Completed in 1928, the addition consisted of a large entrance foyer, a reading room for scholars, and an exhibition hall. The new structure, designed by Ben-

jamin Wistar Morris, was connected to the original library by a gallery called the Cloister. H. Siddons Mowbray was again commissioned to provide the ceiling paintings for the Annex.

Since Belle Greene's retirement in 1948, there have been three directors of the Morgan Library: Frederick B. Adams, Jr. (1948–69), Charles Ryskamp (1969–87), and Charles E. Pierce, Jr. (1987–present). In the ensuing years, the Library—without losing its decidedly domestic feeling—has expanded both its physical space and public programs. Most dramatically, in 1987, the Library again doubled its size with the acquisition of Jack Morgan's nearby town house. A glass-encased garden court now connects the house with the other buildings. This expansion, completed in 1991, made way for more exhibition space and a wider array of educational activities. Over the years, through purchases and generous gifts, the Library's holdings of rare materials have continued to grow. It now contains a collection of autograph music manuscripts unequaled in the United States and has added important early children's books, Americana, and materials from the twentieth century. Fulfilling the vision of its founders, the Morgan Library has become an internationally recognized center for research as well as a vital museum serving a diverse public.

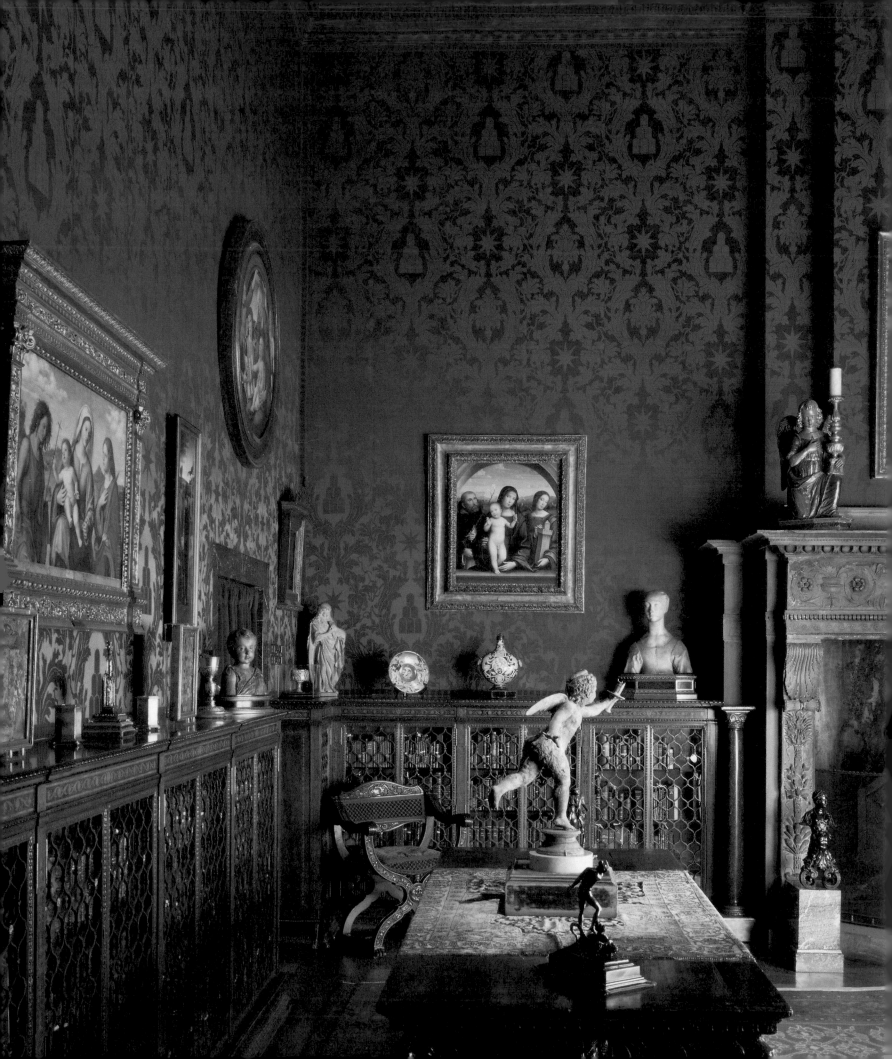

EINLEITUNG

Die Pierpont Morgan Library: Ein Haus der Sammlungen

Heute gilt die Pierpont Morgan Library als eine der größten Schatzkammern bedeutender Werke aus Kunst, Literatur, Musik und Geschichte. Die Bibliothek entstand in den 1890er Jahren als Privatsammlung des berühmten amerikanischen Finanziers, nach dem sie benannt ist. Obgleich der hochgebildete John Pierpont Morgan weder ein Gelehrter noch ein Kunstkenner im engeren Sinn war, nahm er, sowohl was die Qualität als auch das Ausmaß anging, mit scharfem Auge und Intuition Erwerbungen in großem Umfang vor.

Morgan ließ sich von dem europäischen Vorbild der »gentleman's library«, der Sammlerbibliothek, inspirieren; seine Ankäufe umfaßten illuminierte Handschriften aus dem Mittelalter und der Renaissance, frühe und seltene gedruckte Bücher, wertvolle Bucheinbände, literarische und historische Handschriften sowie Zeichnungen der Alten Meister. Zwar lag der Schwerpunkt in erster Linie auf Westeuropa, doch zeigte Morgan auch starkes Interesse an Werken von Autoren und historischen Persönlichkeiten der Vereinigten Staaten.

Als Morgan 1913 starb, ging die Bibliothek mitsamt ihren Beständen an seinen Sohn J. P. Morgan jr., genannt Jack, über, der die Bibliothek 1924 im Gedenken an seines »Vaters Liebe für seltene Bücher und seinen Glauben an den pädagogischen Wert der Sammlung« zu einer öffentlichen Institution machte. Seit dieser Zeit fungiert die Pierpont Morgan Library als unabhängige Forschungsbibliothek und als ein Museum der schönen Künste und der Geistesgeschichte. Während die Sammlungen im Laufe der Zeit stetig gewachsen sind, blieben die durch Pierpont Morgan begründeten Interessengebiete weitgehend erhalten.

Als Morgan mit dem Aufbau der Sammlung begann, war er bereits in den Fünfzigern und international als einer der führenden Bankiers und Finanzexperten anerkannt. Am 17. April 1837 in Hartford, Connecticut, als Sohn einer alten und angesehenen Familie Neuenglands geboren, wuchs er in einer Atmosphäre des Wohlstands, der Privilegien und des erlesenen Geschmackes auf. Als er 17 Jahre alt war, zog die Familie nach London, wo sein Vater, Junius Spencer Morgan, Teilhaber der in amerikanischem Besitz befindlichen Investmentbank von George Peabody & Co. (der späteren J. S. Morgan & Co.) wurde. Der junge Morgan kam auf ein Internat in der Schweiz, besuchte die Göttinger Universität und verbrachte seine Ferien in England und auf dem Kontinent.

1857 kehrte er nach New York zurück und begann seine Karriere als Geschäftsmann. Vier Jahre später war er als Amerikarepräsentant der Firma seines Vaters für die Sicherung

und Betreuung von Überseeinvestitionen in den florierenden Bahn-, Kohle- und Stahl-industrien zuständig. Während der stürmischen Jahre des wirtschaftlichen Aufschwungs nach dem amerikanischen Bürgerkrieg (1861–65) machte sich die Morgan Investmentbank einen Namen in bezug auf Stabilität und Redlichkeit. Morgan stieg zu einem mächtigen und angesehenen selbständigen Geschäftsmann auf. Zwischen 1893 und 1895 sanierte er sechs der nationalen Eisenbahnlinien und sicherte sich die Kontrolle über sie. 1895 verhinderte er eine drohende Goldkrise durch die Bildung eines Syndikats für die Ausgabe fest-verzinslicher Wertpapiere gegen Gold. 1901 zahlte er Andrew Carnegie aus und bildete die U. S. Steel Corporation, damals der Welt größtes Unternehmen. Während des Börsen-sturzes im Jahr 1907 beschaffte er innerhalb eines einzigen Nachmittags 25 Millionen Dollar, um einen Ansturm auf die Banken zu verhindern. Wie ein Biograph bemerkte, war Morgan im Grunde eine »Ein-Mann-Bundesbank«.

Pierpont Morgan scheute beharrlich die Öffentlichkeit und wurde von Mitarbeitern als schroff, distanziert und häufig kurz angebunden beschrieben. Im Kreis seiner Freunde und seiner Familie gab er sich jedoch zwanglos, gesellig und sehr gastfreundlich. Seine erste Frau, Amelia Sturges, starb bereits vier Monate nach ihrer Trauung an Tuberkulose. Drei Jahre später, im Jahr 1865, heiratete er Frances Louisa Tracy, die Tochter eines bekannten New Yorker Anwalts. Sie hatten vier Kinder: Louisa, Juliet, Anne und Jack.

Morgan führte einen vornehmen und kultivierten Lebensstil, fern jeglicher Prunksucht. 1880 bezog er ein großes, schlichtes Haus aus braunem Sandstein an der Madison Avenue und der 36. Straße. Mehrere Monate im Jahr verbrachte er im Ausland und hielt sich regel-mäßig im Londoner Stadthaus seines Vaters am Princes Gate und in Dover House, dem Landsitz der Familie, in Roehampton auf. Er war gleichermaßen in London, Rom und New York zu Hause.

Bereits als junger, aufsteigender Geschäftsmann zeigte Morgan hin und wieder Interesse an Büchern und Manuskripten und erwarb eine kleine Anzahl historischer und literarischer Handschriften. Der Tod seines Vaters im Jahr 1890 gab dann allerdings erst den Anstoß zu seiner ernsthaften Sammeltätigkeit, die er, möglicherweise aus Respekt vor dem Vater, selbst Sammler von Handschriften und seltenen Büchern, zurückgestellt hatte. Entscheidender war jedoch die Tatsache, daß Pierpont Morgan erst jetzt über die finanziellen Mittel ver-fügte, um Ankäufe in großem Stil zu tätigen. Junius Morgans Vermögen wurde auf etwa 12,4 Millionen Dollar geschätzt. Sein Sohn übernahm die Leitung des in Familienbesitz befindlichen und äußerst einträglichen Londoner Bankhauses. Es war keineswegs über-raschend, daß Pierpont Morgan einen Teil dieses Kapitals zum Aufbau einer Sammlung verwendete. Mit Amerikas schnellem wirtschaftlichem Aufschwung in den 1870er und 1880er Jahren verfestigte sich das Bewußtsein, daß auch das kulturelle und intellektuelle

Leben seiner Bürger bereichert werden müsse. Mehr und mehr wurde es als die staatsbürgerliche Pflicht angesehen, je nach individuellen Möglichkeiten am Aufbau einer in kultureller Hinsicht mit Europa konkurrenzfähigen Republik mitzuwirken. Viele der amerikanischen Privatsammlungen europäischer Malerei und Skulptur Alter Meister – wie beispielsweise die von Isabella Stewart Gardner, Henry Walters und Joseph P. Widener – entstanden in dieser Zeit. Zehn Jahre nach seiner Gründung bezog im März 1880 das New Yorker Metropolitan Museum of Art seine Räumlichkeiten im Central Park. Morgan wurde 1888 als »Trustee« in den Aufsichtsrat des Museums gewählt, von 1904 bis zu seinem Tod war er dessen Präsident. Unter seiner Leitung begann das Museum eine ehrgeizige Ankaufspolitik zu betreiben.

Morgans seltene Bücher, Manuskripte und Autographen – seine sogenannten »literarischen« Sammlungen – waren lediglich eine Facette seiner Sammelleidenschaft. Daneben erwarb er Tausende von Kunstobjekten, die von ägyptischen Grabskulpturen und chinesischen Bronzen bis hin zu Meißner Porzellan sowie Gemälden Raffaels, Jan Vermeers und Jean Honoré Fragonards reichten. »Für ein Werk von unzweifelhafter Schönheit und Authentizität ist kein Preis zu hoch«, soll Morgan einmal gesagt haben.

Beim Aufbau seiner eigenen Bibliothek konzentrierte er sich vorrangig auf die Erweiterung der Handschriftensammlung, mit deren Erwerb er in kleinem Rahmen bereits als Junge begonnen hatte. Er kaufte sowohl Einzelwerke als auch ganze Sammlungen an. Zur ersten Kategorie gehörten Handschriften wie John Keats' *Endymion* und Charles Dickens' *Christmas Carol,* zur zweiten Sir James Fenns englische historische Handschriften und über 250 Manuskripte der amerikanischen Literatur – unter anderem Nathaniel Hawthornes Notizbücher und Henry David Thoreaus Tagebücher – aus dem Besitz von Stephen Wakeman.

Morgans gebildeter Neffe Junius ermutigte ihn zum Erwerb früher gedruckter Bücher und illuminierter Handschriften. Erwähnenswert unter den Einzelankäufen sind vor allem das einzigartige Lindauer Evangeliar – Morgans erste bedeutende Erwerbung mittelalterlicher Manuskripte – sowie der seltene Mainzer Psalter von 1459. Vielfalt und Breite wurden allerdings erst durch eine Folge kluger Ankäufe ganzer Sammlungen erreicht. So konnten die James Toovey Collection, spezialisiert auf seltene Bücher und Einbände, die von dem amerikanischen Sammler Theodor Irwin aufgebaute Buch- und Handschriftenbibliothek und darüber hinaus im Jahr 1902 die Richard Bennett Collection erworben werden. Diese Gruppe von über 700 Bänden, zu denen ungefähr 100 illuminierte Handschriften und nicht weniger als 32 Caxton-Drucke gehören, bildet den Kernbestand der Pierpont Morgan Library an gedruckten Büchern und illuminierten Handschriften. Erst mit dem Erwerb der Charles Fairfax Murray Collection wurde Morgan zu einem ernsthaften

Sammler von Zeichnungen. Bestehend aus etwa 1 500 Werken von der Renaissance bis ins 18. Jahrhundert, wird sie allgemein als die erste »klassische« Sammlung europäischer Alter Meister in den Vereinigten Staaten angesehen. Wie die Richard Bennett Collection, so bildete auch die Sammlung von Fairfax Murray das Herzstück der entsprechenden Abteilung der Pierpont Morgan Library.

Generell folgte Morgan im Aufbau seiner Sammlungen einem für seine Zeit typischen Muster, nach dem die älteren Epochen und Schulen der westeuropäischen Kunst bevorzugt wurden. Mitunter wagte er sich allerdings auf Gebiete vor, in die nur wenige Sammler beiderseits des Atlantiks vorgedrungen waren. So erwarb er beispielsweise 1911 den größten Teil einer Gruppe von ungefähr 60 koptischen Handschriften, die im Jahr zuvor in den Ruinen einer Klosterbibliothek nahe des ägyptischen Dorfes von Hamuli in Fayum entdeckt worden waren. Ein anderes ungewöhnliches Interessengebiet wird durch seine eindrucksvolle Sammlung antiker Zylindersiegel aus dem Nahen Osten belegt, die zum Zeitpunkt seines Todes mehr als 1 200 Einzelstücke umfaßte.

Ab 1905 stand ihm Belle da Costa Greene zur Seite, die ihn als Bibliothekarin und in allen anderen Angelegenheiten unterstützte. Als Morgan sie engagierte, war sie kaum zwanzigjährig, und ohne dafür ausgebildet zu sein, bewies Miss Greene rasch ihre Intelligenz und ihren Enthusiasmus auf diesem Gebiet. Bei Erwerbungen verfolgte sie die gleiche geschickte und hartnäckige Taktik wie ihr Arbeitgeber. Während einer Ankaufsreise im Jahre 1907 erwarb sie in London die Caxton-Drucke von Lord Amherst in privaten Verhandlungen in der Nacht, bevor sie auf einer Auktion versteigert werden sollten. Sie vermehrte damit Morgans ohnehin schon hervorragenden Bestand an Caxton-Inkunabeln, Büchern aus der ersten Druckerei Englands, um weitere 17 Exemplare.

Der Umfang der Sammlungen stellte mit der Zeit ein erhebliches logistisches und organisatorisches Problem dar und veranlaßte Morgan um 1900 dazu, mit der Planung eines separaten Gebäudes an der Ostseite des Hauses, entlang der 36. Straße, zu beginnen. Er war der Auffassung, daß das von ihm geschaffene Bibliotheksgebäude in New York der Bedeutung und dem Wert der in ihm versammelten Objekte angemessen sein müsse.

Dafür wählte Morgan McKim, Mead & White, eines der angesehensten amerikanischen Architektenbüros jener Zeit, das eine unbestrittene Führungsrolle in der Bewegung der amerikanischen Neorenaissance innehatte. Daß Morgan Charles F. McKim (1847–1909), den er kannte und schätzte, die Verantwortung für das Bauvorhaben übertrug, war nur folgerichtig. Sein Ruf als »Gelehrter-Architekt« und sein seriöses Auftreten gefielen dem Finanzier. Morgan hatte McKim dabei unterstützt, die amerikanische Akademie in Rom aufzubauen, wo amerikanische Studenten die Meisterwerke der Renaissance und der Antike studieren konnten. Im Gegenzug hatte McKim in Morgan einen Kunden, der nicht

nur seinen Plänen wohlwollend gegenüberstand, sondern auch bereit war, für deren Verwirklichung die erlesensten Künstler, Handwerker und Materialien zu bezahlen. So gehört der 1906 fertiggestellte Bibliotheksbau zu den in Architektur und Innenausstattung gelungensten und vollkommen verwirklichten Werken der amerikanischen Neorenaissance.

McKim nahm sich buchstäblich jedes einzelnen Aspektes des Projektes persönlich an, einschließlich der Planung und Ausführung der Innenausstattung. Die Pierpont Morgan Library sollte Ausdruck des Renaissancegedankens von der Einheit aller Künste sein, Architektur, Malerei und Bildhauerkunst zu einem harmonischen Ganzen verschmelzend. Sah sich McKim in der Rolle eines großen Renaissancearchitekten, der an seinem Opus magnum arbeitete, so erfüllte Morgan die Rolle eines großen Auftraggebers der Renaissance mit der gleichen Ernsthaftigkeit.

Die Bibliothek wurde aus feinstem weißen, leicht rosa schimmernden Tennessee-Marmor errichtet. McKims Entwurf, im wesentlichen ein Rechteck mit einem zurückspringenden Portikus, ist von klassischer Schlichtheit. Dorische Pilaster schmücken die Fassade, und ionische Säulen rahmen den Eingang. Der überwölbte Portikus kombiniert zwei römische Vorbilder aus dem 16. Jahrhundert: die von Bartolomeo Ammanati entworfene Gartenloggia der Villa Giulia und den Eingang von Annibale Lippis Villa Medici. Für die Ausführung des Fassadenschmucks bot McKim hervorragende Kunsthandwerker und Bildhauer auf. In geradezu überwältigendem Kontrast zur Schlichtheit des Äußeren gibt sich die Innenausstattung reich koloriert und verziert. Gleichwohl wirkt das Programm insgesamt harmonisch und ausgewogen, gemäß dem oft zitierten Credo von McKim, daß das Innere einer Bibliothek »flüstern und nicht schreien« solle. Sein Plan für den Innenraum bestand aus drei von der Ost-, Nord- und Westseite der überkuppelten Eingangshalle ausgehenden Räumen. Der größte unter ihnen, der *East Room,* war für die Aufbewahrung von Büchern und für Ausstellungen vorgesehen, während der *West Room* Morgans privater Studienraum und der *North Room,* der kleinste Raum, das Büro des Bibliothekars waren.

Die als *Rotunda* bekannte, überwölbte Eingangshalle ist in Entwurf und Wirkung der großartigste Raum von allen. Pilaster aus Skiros-Marmor zieren die Wände, und freistehende Säulen aus grün geädertem Cipollino-Marmor flankieren die Portale zu *East* und *West Room.* Der Marmorfußboden mit einer im Zentrum eingelassenen, großen roten Porphyrscheibe folgt dem Vorbild des Fußbodens der Villa Pia in den Vatikanischen Gärten. Die Ausführungen des Dekors, Ausmalungen und Stuckarbeiten, vertraute McKim dem Künstler H. Siddons Mowbray (1858–1928) an, der sich in der Ausschmückung der *Rotunda* und des *East Room* an die Renaissancemaler Raffael und Pinturicchio als Vorbilder anlehnte.

Der eindrucksvolle *East Room* ist bei weitem der größte und prächtigste der Bibliothek. Die bis zu zehn Meter hohen Wände sind vom Boden bis zur Decke mit drei übereinander angeordneten Bücherschrankreihen aus kaukasischer Walnuß mit Einlegearbeiten verkleidet. 1906 erwarb Morgan die große Brüsseler Tapisserie, die über dem Kamin hängt. Entworfen im 16. Jahrhundert von dem Flamen Pieter Coecke van Aelst, stellt sie – manche sagen ironisch – den Triumph der Habsucht dar. Die Deckengemälde mit ihren klassischen Szenen und den feierlichen Hinweisen auf große kulturelle Glanztaten sollten den Gelehrten bei ihrer Arbeit Ehrfurcht einflößen und Inspiration sein. Gleichzeitig erzeugen sie beim Betrachter die Illusion, mit dem Raum in diese Vergangenheit einbezogen zu sein.

Der *West Room,* der Morgan als privates Studierzimmer diente, ist der am prächtigsten ausgestattete und doch zugleich der intimste unter den Räumen der Pierpont Morgan Library. Entlang der Bücherregale sind Skulpturen, Porzellan und andere Kunstgegenstände aus seinen Sammlungen angeordnet, an den Wänden hängen Gemälde aus der Renaissance. Die prächtige antike Holzdecke wurde in Florenz erworben und unter McKims Leitung rekonstruiert. Umgeben von seinen Lieblingswerken, empfing Morgan in diesem Raum die führenden Persönlichkeiten der verschiedenen gesellschaftlichen Kreise, in denen er verkehrte, Gelehrte, Kunsthändler und Staatsmänner ebenso wie Geschäftskollegen und Freunde.

Die Pierpont Morgan Library: Eine öffentliche Institution

Als Pierpont Morgan am 13. März 1913 in Rom starb, wurde sein Besitz auf etwa 128 Millionen Dollar geschätzt, wovon seine Kunst- und Büchersammlungen etwa die Hälfte ausmachten. Er hinterließ einen Großteil des Vermögens seinem Sohn Jack. In seinem Testament gab er der Hoffnung Ausdruck, daß man eine geeignete Form finden werde, seine Sammlungen »dauerhaft zur Erziehung und zum Genuß des amerikanischen Volkes zugänglich zu machen«. Wie dies allerdings im einzelnen zu verwirklichen wäre, blieb Jack überlassen.

Zum Zeitpunkt des Todes von Pierpont Morgan befanden sich bereits nahezu alle Gemälde, Skulpturen und Kunstgegenstände, die er in England aufbewahrt hatte, in einem Lagerraum im Untergeschoß des Metropolitan Museum in New York. 1909 war der Einfuhrzoll für Kunstobjekte – maßgeblich unter Morgans Einfluß – abgeschafft worden, während England seine Erbschaftssteuer deutlich erhöht hatte. Diese beiden Umstände scheinen der Hauptanreiz für Morgans Entscheidung gewesen zu sein, seine umfangreichen Sammlungen von Februar 1912 an nach New York zu befördern.

Verständlicherweise hoffte das Metropolitan Museum, dem gegenüber sich Morgan zeitlebens überaus großzügig gezeigt hatte, die gesamte Sammlung zu erhalten. Allerdings sah sich Jack Morgan gezwungen, eine Anzahl von Kunstgegenständen zu verkaufen, um Steuern zu bezahlen und die Liquidität des Nachlasses sicherzustellen. Die Bücher, Handschriften und Zeichnungen blieben davon jedoch unberührt. Zu der Entscheidung, die Bibliothek und ihre Sammlungen zu behalten, hatte zweifellos Belle Greene gedrängt. Ihr Engagement für die Bibliothek und ihre Überzeugungskraft standen Pierpont Morgan in nichts nach. Es trifft allerdings auch zu, daß Jack der Bibliothek stets besondere Beachtung geschenkt hatte und sie höher schätzte als die übrigen Sammlungen seines Vaters.

In den ersten Jahren nach Pierpont Morgans Tod mußte die Bibliothek für Jack hinter zunächst dringenderen Angelegenheiten zurücktreten, wie der Regelung des Nachlasses und die Einrichtung finanzieller Unterstützung für die Alliierten in den Anfangsjahren des Ersten Weltkrieges. 1915 schrieb allerdings Belle Greene an den Londoner Buchhändler Quaritch: »Voller Freude kann ich Ihnen mitteilen, daß er an der Bibliothek ein großes Interesse hat und mir versprach, daß ich nach Ende des Krieges mit dem Erwerb von Büchern und Handschriften fortfahren könne.« Morgans nachfolgende Ankäufe leiteten die zweite große Wachstumsphase in der Geschichte der Sammlungen ein. Er fügte der Bibliothek 206 illuminierte Handschriften hinzu und vergrößerte damit den entsprechenden Bestand seines Vaters um ungefähr ein Drittel. Im Bereich der gedruckten Bücher vergrößerte er die Inkunabelsammlung um die Hälfte auf insgesamt etwa 2000 Exemplare. Darunter war auch ein von Gutenberg gedruckter Ablaß. Bescheidener fiel der Zuwachs an Zeichnungen Alter Meister aus, doch kamen hervorragende Blätter von Künstlern wie Sir Joshua Reynolds und Jean Auguste Dominique Ingres hinzu.

Die weitreichendste Konsequenz in Jack Morgans Verwaltertätigkeit lag in seiner Entscheidung, die Bibliothek zu einer öffentlichen Institution zu machen. Am 15. Februar 1924 übertrug Morgan die Eigentümerschaft zusammen mit einem Stiftungsvermögen von 1,5 Millionen Dollar an ein »Board of Trustees«, einen Treuhänderausschuß. Der Treuhandvertrag sah die Nutzung der Sammlungen zu Forschungszwecken, die Einrichtung einer Kunstgalerie und andere entsprechende Aktivitäten vor, die den Treuhändern angemessen und wünschenswert erschienen. Die Institution wurde kraft eines besonderen Gesetzes seitens des Staates von New York zu einer öffentlichen Präsenzbibliothek, und Belle Greene wurde zur ersten Direktorin ernannt.

Kurz nach der Umwandlung der Bibliothek in eine öffentliche Institution wurde Pierpont Morgans angrenzendes Wohnhaus aus braunem Sandstein abgerissen und an seiner Stelle ein neuer Flügel errichtet, wodurch das Gebäude auf die doppelte Größe anwuchs. Der 1928 fertiggestellte Anbau nach einem Entwurf von Benjamin Wistar Morris bestand

aus einer großen Eingangshalle, einem Lesesaal für Wissenschaftler sowie einer Ausstellungshalle und war mit der ursprünglichen Bibliothek durch eine Galerie verbunden, die *Cloister* (Kreuzgang) genannt wird. Wiederum wurde H. Siddons Mowbray damit betraut, die Deckengemälde für den Anbau auszuführen.

Seitdem Belle Greene 1948 in den Ruhestand trat, haben der Pierpont Morgan Library drei weitere Direktoren vorgestanden: Frederick B. Adams jr. (1948–69), Charles Ryskamp (1969–87) und Charles E. Pierce (seit 1987). In diesen Jahren hat sich die Bibliothek vergrößert – sowohl in räumlicher Hinsicht als auch was den Umfang ihrer öffentlichen Aktivitäten angeht –, ohne dabei ihren intimen Charakter verloren zu haben. Der wichtigste Einschnitt fiel in das Jahr 1987, als die Bibliothek durch den Ankauf von Jack Morgans nahe gelegenem Stadthaus ihre Größe noch einmal verdoppelte. Ein verglaster Hofgarten verbindet nun das Haus mit den übrigen Gebäuden. Das Ergebnis dieser 1991 abgeschlossenen Maßnahme war eine vergrößerte Ausstellungsfläche und ein erweitertes Angebot an pädagogischen Aktivitäten. Durch Neuerwerbungen und großzügige Schenkungen konnten die Bestände der Bibliothek an seltenen Werken im Lauf der Jahre bereichert werden. Sie umfaßt nun eine in den Vereinigten Staaten einzigartige Sammlung von Musikautographen, und bedeutende frühe Kinderbücher, Amerikana und Kunstgegenstände aus dem 20. Jahrhundert sind hinzugekommen. So hat sich die Vision ihrer Gründer erfüllt: Die Pierpont Morgan Library ist zu einem international anerkannten Forschungszentrum und gleichzeitig zu einem lebendigen, einem breiten Publikum dienenden Museum geworden.

DRAWINGS
ZEICHNUNGEN

The forty-six drawings in this exhibition are intended to give some indication of the scope and strengths of the Morgan Library's collection, which concentrates primarily on European art before 1825. Pierpont Morgan's well-known purchase in 1910 of 1,500 drawings from the English artist-collector Charles Fairfax Murray (1849–1919) was the beginning of the Library's collection. Morgan previously had purchased two important collections of Rembrandt etchings and in 1903 had acquired William Blake's twenty-one watercolor illustrations to the *Book of Job* (see Nos. 44–46). But it was with the arrival in the United States of Fairfax Murray's well-chosen, comprehensive collection that Morgan became America's leading collector of European old master drawings.

Fairfax Murray's collection was especially strong in works of the Italian, Dutch, Flemish, and English schools. These remain the nucleus of the Library's collection, and, given the range and quality of Fairfax Murray's collection, it is not surprising that about one third of the drawings being exhibited were chosen from this group. Fairfax Murray had a special affinity for the great seventeenth-century Dutch and Flemish masters and owned important groups of drawings by Rembrandt and his school. Rembrandt's pen-and-ink drawing of his sleeping wife (No. 4) is a compelling record of the artist in his role as observer of the intimate life of women and children. Although less comprehensively represented here, the collection comprises some fine French drawings of the seventeenth and eighteenth centuries, among them a number of sheets by the great expatriate masters Claude Lorrain and Nicolas Poussin. Included in the exhibition is an important compositional study connected with Claude's 1656 painting *Landscape with the Sermon on the Mount* (No. 7).

Extraordinarily strong in sixteenth-century Italian drawings, Fairfax Murray's holdings of seventeenth-century Italian drawings, while less comprehensive, include important sheets by

Guercino and Bernini. The Guercino drawings shown here, four of which were formerly in the Fairfax Murray collection (Nos. 9, 10, 11, and 13), range from careful preparatory studies for paintings to a very free brush drawing of a landscape with a volcano. The eighteenth century is well represented with works by Giovanni Battista Piranesi (Nos. 23–31) as well as Giovanni Battista Tiepolo (Nos. 15–20) and his son Giovanni Domenico (Nos. 32–35). It was the custom of the Tiepolos to mount their drawings systematically into albums, and one of these, formerly owned by the English collector Edward Cheney, was acquired by Fairfax Murray. This passed intact into Morgan's collection, adding more than one hundred Tiepolo drawings, a strength reflected in the present selection. The Fairfax Murray purchase also brought to the United States an exceptional group of eighteenth-century English drawings, with fine examples by Hogarth, Wilson, and, above all, Gainsborough.

Although Pierpont Morgan made a few important purchases before his death in 1913, and his son, J. P. Morgan, Jr., continued to add to the Rembrandt etchings, the Library did not actively collect drawings until the end of World War II, when its first curator of drawings, Felice Stampfle, was appointed and the newly formed Association of Fellows provided the financial support needed to develop the collection. The Fellows were responsible for a number of outstanding acquisitions, including the extraordinary mountain landscape by Jacques de Gheyn II (No. 1), a unique design for a ceiling by Giambattista Tiepolo (No. 16), and Giandomenico Tiepolo's *At the Dressmaker's* (No. 35), part of the sequence in which the artist delightfully satirizes Venetian contemporary life. The extraordinary growth of the collection to its present size of about 10,000 sheets, however, is largely owing to the private collections that have been presented to the Library. Notable among these was the collection of more than 500 architectural and garden drawings formed by Mrs. J. P. Morgan, Jr. This includes the

impressive series of works by Piranesi—seven of which are being exhibited (Nos. 23–29)—that was given to the Library in the 1960s by her sons, Henry S. and Junius P. Morgan.

In 1973 the noted cellist and connoisseur Janos Scholz announced his gift of 1,500 Italian old master drawings. Of the present selection, two Guercino drawings (Nos. 12 and 14) and a sheet of figure studies by Piranesi (No. 30) are from the Scholz collection. The gift of the Scholz collection assured New York's position as the center for the study of Italian drawings in the United States. In 1982 Mrs. Donald M. Oenslager presented to the Library her late husband's extensive collection of over 1,600 theater and stage designs, which included many important, mainly eighteenth-century, Italian drawings. Then in 1996 and 1997, 118 drawings by Giambattista and Giandomenico Tiepolo came to the Library as the gift of Lore Heinemann in memory of her husband, Dr. Rudolf J. Heinemann. This bequest constituted an extremely important addition to the Library's already impressive Tiepolo holdings.

Only in recent years has the Library's collection been extended to the end of the nineteenth century, which is still represented only in outline. A promised gift, the collection of Eugene V. and Clare E. Thaw, includes an especially fine array of nineteenth-century French drawings that will greatly strengthen the Library's holdings in this period, while the Sunny Crawford von Bülow Fund, established in 1978, has enhanced the collection with many splendid drawings—primarily French—including the red chalk river landscape by Watteau (No. 8) in this selection.

The chronological limit of works by English artists also has been extended well into the nineteenth century. The Library has been the recipient of many remarkable English drawings, including works by William Blake, Henry Fuseli (Nos. 40–42), Edward Lear, David Roberts, and the Pre-Raphaelites. Most recently Mr. and Mrs. Thaw presented to the Library a group of important drawings and watercolors by Girtin, Turner, and Constable, significantly strengthening the collection in this area.

The Spanish drawings are of particularly high quality and include sheets by Ribera, Murillo, and Goya, whose vision is brilliantly reflected in four sheets in this exhibition (Nos. 36–39). A number of nineteenth-century German drawings, by such artists as Friedrich, Kersting, and Menzel, have been acquired in recent years, and although the Library has not actively collected American drawings, there is a group of some 260 works by the expatriate artist Benjamin West, a few by his son Raphael Lamar West, and six fine watercolors by John James Audubon for *The Viviparous Quadrupeds of North America,* published between 1845 and 1848. The collection also includes many drawings by the American Renaissance muralist H. Siddons Mowbray, who was responsible for the decoration of the Library's Rotunda and East Room.

Die 46 Zeichnungen dieser Ausstellung sollen einen Eindruck von der Vielfalt und den Stärken der entsprechenden Abteilung der Pierpont Morgan Library vermitteln, die sich vornehmlich auf europäische Kunst vor 1825 konzentriert. Pierpont Morgans wohlbekannter Ankauf von 1500 Zeichnungen aus dem Besitz des englischen Künstlers und Sammlers Charles Fairfax Murray (1849–1919) im Jahr 1910 bildete dazu den Grundstock. Zwar hatte Morgan schon zwei bedeutende Sammlungen von Rembrandt-Radierungen und 1903 William Blakes 21 aquarellierte Illustrationen zum *Buch Hiob* (Kat.-Nrn. 44–46) erworben, aber erst mit dem Eintreffen der erlesenen und umfangreichen Charles Fairfax Murray Collection in den Vereinigten Staaten wurde er zu Amerikas führendem Sammler von Zeichnungen Alter Meister Europas.

Die Sammlung Fairfax Murrays war vor allem reich an Arbeiten der italienischen, holländischen, flämischen und englischen Schulen. Sie bilden nach wie vor den Kern dieser Abteilung der Pierpont Morgan Library, und in Anbetracht ihres Spektrums und ihrer Qualität überrascht es nicht, daß ungefähr ein Drittel der hier ausgestellten Zeichnungen diesem Teil der Sammlung angehört. Fairfax Murray hatte eine besondere Vorliebe für die bedeutenden holländischen und flämischen Meister des 17. Jahrhunderts und besaß wichtige Gruppen von Zeichnungen Rembrandts und dessen Schule. Rembrandts Federzeichnung seiner schlafenden Gemahlin Saskia (Kat.-Nr. 4) ist ein eindrucksvolles Dokument des Künstlers in seiner Rolle als Beobachter des intimen Lebens von Frauen und Kindern. Obgleich hier weniger umfassend vertreten, enthält die Sammlung einige hervorragende französische Zeichnungen aus dem 17. und 18. Jahrhundert, darunter eine Anzahl von Blättern der berühmten in Italien lebenden Maler Claude Lorrain und Nicolas Poussin. In der Ausstellung zu sehen ist eine wichtige Kompositionsstudie, die Claude im Zusammenhang mit seinem 1656 vollendeten Gemälde *Landschaft mit Bergpredigt* (Kat.-Nr. 7) ausführte.

Fairfax Murray besaß eine ungewöhnlich große Anzahl qualitätvoller italienischer Zeichnungen des 16. Jahrhunderts und, wenn auch in geringerem Umfang, des 17. Jahrhunderts, unter denen sich bedeutende Blätter von Guercino und Giovanni Lorenzo Bernini befinden. Von den hier gezeigten Zeichnungen Guercinos stammen vier aus der einstigen Charles Fairfax Murray Collection (Kat.-Nrn. 9–11, 13) und reichen von sorgsam ausgeführten Studien zu Gemälden bis zu der sehr freien Pinselzeichnung einer Landschaft mit Vulkan. Das 18. Jahrhundert ist mit Arbeiten von Giovanni Battista Piranesi (Kat.-Nrn. 23–31) sowie Giovanni Battista Tiepolo (Kat.-Nrn. 15–20) und dessen Sohn Giovanni Domenico (Kat.-Nrn. 32–35) gut vertreten. Es entsprach der Gepflogenheit der Tiepolo, ihre Zeichnungen systematisch in Alben zu kleben. Einen dieser Bände, ursprünglich im Besitz des Engländers Edward Cheney, erwarb Fairfax Murray. Dieses Album gelangte unversehrt in die Pierpont Morgan Library und erweiterte die Sammlung um mehr als 100 Tiepolo-Zeichnungen, eine Stärke, die sich in der vorliegenden Auswahl widerspiegelt. Der Erwerb der Charles Fairfax Murray Collection brachte ferner eine außergewöhnliche Gruppe englischer Zeichnungen des 18. Jahrhunderts in die Vereinigten Staaten mit schönen Blättern von William Hogarth, Richard Wilson und insbesondere von Thomas Gainsborough.

Pierpont Morgan hatte vor seinem Tod im Jahr 1913 noch einige bedeutende Ankäufe getätigt, und sein Sohn J. P. Morgan jr. hatte den Bestand der Rembrandt-Radierungen fortwährend erweitert. Dennoch begann die Library erst am Ende des Zweiten Weltkrieges systematisch Zeichnungen zu sammeln, als Felice Stampfle zur ersten Zeichnungskuratorin ernannt wurde und die neu gegründete *Association of Fellows* die notwendigen finanziellen Mittel für die Erweiterung der Sammlung bereitstellte. Dieser Förderkreis war verantwortlich für eine Anzahl von hervorragenden Erwerbungen, darunter die außergewöhnliche *Berglandschaft* Jacques de Gheyns II (Kat.-

Nr. 1), der einzigartige Entwurf eines Decken-gemäldes von Giovanni Battista Tiepolo (Kat.-Nr. 16) und Giovanni Domenico Tiepolos Zeichnung *Bei der Schneiderin* (Kat.-Nr. 35), die zu einer Folge von wunderbaren, satirischen Schilderungen des zeitgenössischen venezianischen Lebens gehört. Daß die Sammlung bis zu ihrem gegenwärtigen Umfang von 10 000 Blatt anwachsen konnte, verdankt sie Privatsammlungen, die der Pierpont Morgan Library geschenkt wurden. Hervorzuheben ist die von Mrs. J. P. Morgan jr. zusammengetragene Sammlung von mehr als 500 Architektur- und Gartenzeichnungen. Sie enthält auch die eindrucksvolle Serie von Werken Piranesis – sieben von ihnen werden hier gezeigt (Kat.-Nrn. 23–29) –, die ihre Söhne Henry S. und Junius P. Morgan in den sechziger Jahren der Library übergaben.

1973 gab der berühmte Cellist und Kunstkenner Janos Scholz seine Schenkung von 1500 Zeichnungen italienischer Alter Meister bekannt; in unserer Auswahl finden sich daraus zwei Zeichnungen von Guercino (Kat.-Nrn. 12, 14) und ein Blatt mit Figurenstudien von Piranesi (Kat.-Nr. 30). Diese Schenkung sicherte New Yorks Position als Forschungszentrum für italienische Zeichnungen in den Vereinigten Staaten. 1982 übergab Mrs. Donald M. Oenslager der Library die umfangreiche Sammlung ihres verstorbenen Mannes von über 1600 Theater- und Bühnenentwürfen, die viele bedeutende italienische Zeichnungen, vor allem des 18. Jahrhunderts, enthielt. 1996 und 1997 gingen 118 Zeichnungen von Giovanni Battista und Giovanni Domenico Tiepolo als Geschenk von Lore Heinemann im Gedenken an ihren Mann Dr. Rudolf J. Heinemann in den Besitz der Library über; dieser Nachlaß bildete eine wichtige Ergänzung zum bereits eindrucksvollen Bestand an Zeichnungen der Tiepolo.

Erst in den letzten Jahren wurde die Sammlung der Pierpont Morgan Library bis auf das Ende des 19. Jahrhunderts ausgedehnt; doch ist dieser Zeitraum nach wie vor nur in Ansätzen vertreten. Die in Aussicht gestellte Schenkung der Sammlung von Eugene V. und Clare E. Thaw enthält eine besonders hochwertige Gruppe französischer Zeichnungen des 19. Jahrhunderts, die den entsprechenden Bestand der Library auf hervorragende Weise verstärken wird. Der 1978 gegründete Sunny Crawford von Bülow Fund bereicherte die Sammlung durch viele erstklassige – vorrangig französische – Zeichnungen, darunter die *Flußlandschaft* in Rötel von Jean Antoine Watteau (Kat.-Nr. 8).

Auch in bezug auf die Arbeiten englischer Künstler wurde die bisherige zeitliche Begrenzung bis an das Ende des 19. Jahrhunderts ausgedehnt. Die Pierpont Morgan Library hat diesbezüglich viele bemerkenswerte Zeichnungen erhalten, darunter Werke von William Blake (Kat.-Nrn. 43–46), Johann Heinrich Füssli (Kat.-Nrn. 40–42), Edward Lear, David Roberts und der Präraffaeliten. Erst kürzlich schenkten Mr. und Mrs. Thaw der Library eine Gruppe bedeutender Zeichnungen und Aquarelle von Thomas Girtin, William Turner und John Constable, wodurch dieses Gebiet bedeutsam gestärkt wurde.

Von besonders hoher Qualität sind die Zeichnungen spanischer Künstler wie die von José de Ribera, Bartolomé Esteban Murillo und Francisco Goya, dessen Sichtweise sich meisterhaft in vier Blättern der Ausstellung widerspiegelt (Kat.-Nrn. 36–39). Deutsche Zeichnungen des 19. Jahrhunderts von Caspar David Friedrich, Georg Friedrich Kersting und Adolph von Menzel wurden in den vergangenen Jahren angekauft, und obwohl die Library nicht gezielt amerikanische Zeichnungen gesammelt hat, verfügt sie über ungefähr 260 Blätter des hauptsächlich in England tätigen Benjamin West, einige von seinem Sohn Raphael Lamar West und über sechs schöne Aquarelle von John James Audubon für die *Viviparous Quadrupeds of North America*, veröffentlicht zwischen 1845 und 1848. Außerdem besitzt die Sammlung viele Zeichnungen des amerikanischen Neorenaissancemalers H. Siddons Mowbray, der die Deckengemälde der *Rotunda* und des *East Room* der Bibliothek ausführte.

JACQUES DE GHEYN II
(Antwerp 1565–1629 The Hague)

MOUNTAIN LANDSCAPE

Pen and brown ink, over very faint indications in black chalk; vertical fold through center
292 x 389 mm
Watermark: none

Inscribed in pen and brown ink at lower right, trimmed to illegibility

Gift of the Fellows; Acc. no. 1967.12

BERGLANDSCHAFT

Feder in Braun über Spuren von schwarzer Kreide, vertikale Knickfalte in der Mitte
292 x 389 mm
Kein Wasserzeichen

Bezeichnet unten rechts mit Feder in Braun: durch Beschneiden unleserlich

Geschenk der Association of Fellows; Inv.-Nr. 1967.12

This sweeping view over a rugged mountainous terrain recalls Pieter Brueghel and the "cosmic landscapes" of Joachim Patenir. Its attribution has been questioned because of the existence of a remarkably close version inscribed *de Gheÿn* in an old hand, in the Nationalmuseum, Stockholm. None other than the late J. Q. van Regteren Altena, who studied De Gheyn throughout his lifetime, concluded that the Morgan drawing must be a copy by the artist from the version now in Stockholm. While the somewhat archaizing calligraphy in this drawing differs from the artist's more typical vigorous, swinging line, it may be recalled that the artist was capable of wide variety in his pen style and was often attracted to earlier models. It is doubtful that this is a real landscape. Moreover De Gheyn never traveled outside the Lowlands, so his acquaintance with mountain scenery must have derived from the works of others, such as Brueghel and Hendrick Goltzius. His signed and dated engraving after *Castle with a Round Tower,* now in Berlin, presumably signed by Brueghel and dated 1561, shows his familiarity with such works.

Provenance
Mrs. Murray Baillie, Ilston Grange, near Leicester; James Murray Usher; sale (Alexandrine de Rothschild and others, including James Murray Usher), Sotheby's, 6 July 1967, lot 6, repr.; acquired from R. M. Light & Co., Inc., Boston.

Selected bibliography and exhibitions
Stampfle 1991, no. 62, repr. (includes previous bibliography and exhibitions).

Dieser weite Blick über eine zerklüftete Berglandschaft erinnert an Pieter Brueghel und die »Weltlandschaften« des Joachim Patinir. Die Zuschreibung wurde angezweifelt, da sich im Stockholmer Nationalmuseum eine diesem Blatt außergewöhnlich nahestehende Fassung befindet, welche die alte Bezeichnung *de Gheÿn* trägt. Kein anderer als der verstorbene J. Q. van Regteren Altena, der sich mit de Gheyn zeitlebens beschäftigte, gelangte zu der Erkenntnis, daß die Zeichnung der Pierpont Morgan Library eine vom Künstler ausgeführte Kopie der Stockholmer Fassung sein müsse. Obwohl der ein wenig archaisch anmutende Duktus sich von de Gheyns typischen kraftvollen und schwingenden Linien unterscheidet, darf daran erinnert werden, daß der Künstler in seinen Federzeichnungen zu großer Vielseitigkeit fähig war und sich häufiger von älteren Vorlagen anregen ließ. Es ist zweifelhaft, ob es sich um eine Wiedergabe nach der Natur handelt. Zudem hat de Gheyn die Niederlande nicht verlassen, so daß seine Kenntnis von Berglandschaften aus Werken anderer Künstler herrühren muß, etwa Brueghels und Hendrick Goltzius'. Sein signierter und datierter Kupferstich nach der heute in Berlin aufbewahrten Zeichnung *Burg mit rundem Turm,* die vermutlich von Brueghel signiert und 1561 datiert wurde, zeigt de Gheyns Vertrautheit mit solchen Arbeiten.

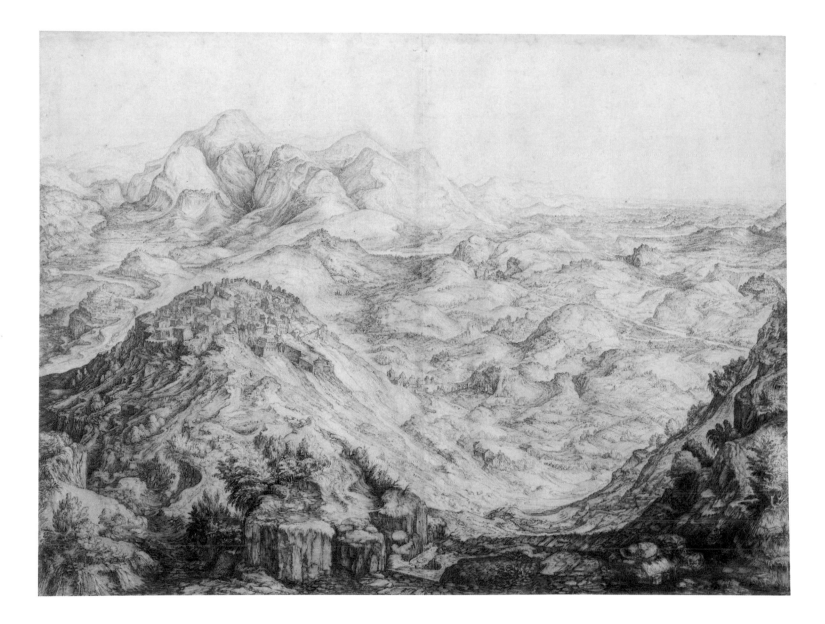

PETER PAUL RUBENS

(Siegen, Germany, 1577–1640 Antwerp)

2

ANGEL BLOWING A TRUMPET, FACING RIGHT

Black chalk, heightened with white bodycolor, some lines partially accented in pen and black ink; squared for enlargement in black chalk
245 x 285 mm
Watermark: illegible fragment, possibly Heawood 2888–98

Inscribed in graphite on that part of mount underneath drawing, *fr a little shop / at Hastings / in 1875* (visible with fiber-optic light)

Purchased by Pierpont Morgan, 1910; Acc. no. I, 233

TROMPETE BLASENDER ENGEL, NACH RECHTS

Schwarze Kreide, weiß gehöht, einige Linien zum Teil mit Feder in Schwarz nachgezogen, Quadrierung (zur Vergrößerung) in schwarzer Kreide
245 x 285 mm
Wasserzeichen: unleserliches Fragment, möglicherweise Heawood 2888–98

Bezeichnet in Bleistift auf der Montierung unterhalb der Zeichnung: *fr a little shop / at Hastings / in 1875* (lesbar unter Glasfaserlicht)

Erworben 1910 von Pierpont Morgan; Inv.-Nr. I, 233

Rubens's most important commission in Antwerp was his work for the then new Jesuit church of St. Charles Borromeo, built by the Jesuit architect Pieter Huyssens and dedicated on 12 September 1621. While Rubens executed the two large paintings for the high altar, now in the Kunsthistorisches Museum, Vienna, and the extensive cycle of thirty-nine ceiling paintings for the aisles and galleries, he prepared designs for the decorative elements of the facade. Of the few surviving preparatory designs for the facade decorations that survive, this drawing and another sheet in the Morgan collection, *Angel Blowing a Trumpet, Facing Left* (Acc. no. 1957.1), along with the *Cartouche Supported by Cherubs* in the British Museum are the most impressive. As Burchard was the first to point out, the Morgan angels served as models for the relief sculpture in the spandrels of the central portal of the church, above which is the relief of the great cartouche with the monogram of Christ based on the British Museum design. Both drawings, like the London sheet, are squared for enlargement, presumably for the execution of large-scale cartoons to guide the sculptor. The Morgan sheets were separated for more than two hundred years until 1957, when the angel of the right spandrel was united with its companion of the left. As far as is known, they were last together in the collection of Jonathan Richardson, Sr., the English painter and collector. They are usually dated 1617–20.

Provenance
Jonathan Richardson, Sr. (Lugt 2184); Charles Fairfax Murray; Pierpont Morgan (no mark; see Lugt 1509).

Selected bibliography and exhibitions
Stampfle 1991, no. 308, repr. (includes previous bibliography and exhibitions).

Rubens' bedeutendste Auftragsarbeit in Antwerpen war die Gestaltung der neuen Jesuitenkirche St. Karl Borromäus, die von dem Jesuitenpater und Architekten Pieter Huyssens erbaut und am 12. September 1621 eingeweiht wurde. Rubens führte nicht nur die beiden großen Gemälde für den Hochaltar, heute im Kunsthistorischen Museum in Wien, und einen umfangreichen Zyklus von 39 Deckengemälden für die Seitenschiffe und die Emporen aus, sondern fertigte auch Entwürfe für den plastischen Schmuck der Fassade an. Unter den wenigen erhaltenen Vorstudien zur Fassadendekoration gehören diese und eine weitere Zeichnung aus der Pierpont Morgan Library, *Trompete blasender Engel, nach links* (Inv.-Nr. 1957.1), neben der *Kartusche gehalten von Putten* aus dem British Museum in London, zu den eindrucksvollsten. Wie Ludwig Burchard als erster ausführte, dienten die Engel der Pierpont Morgan Library als Vorlage für die Reliefs der Bogenzwickel am Hauptportal. Über diesem befindet sich das Relief der großen Kartusche mit dem Monogramm Christi, das auf den Entwurf im British Museum zurückgeht. Beide Zeichnungen, wie auch das Londoner Blatt, sind quadriert, vermutlich um großformatige Kartons als Vorlage für den Bildhauer anzulegen. Mehr als zwei Jahrhunderte lang waren die Blätter der Pierpont Morgan Library voneinander getrennt, bis 1957 der Engel des rechten Bogenzwickels mit seinem Pendant zusammengeführt wurde. Soweit bekannt, waren sie zuletzt in der Sammlung des englischen Malers und Sammlers Jonathan Richardson d. Ä. vereint. Sie werden für gewöhnlich auf 1617 bis 1620 datiert.

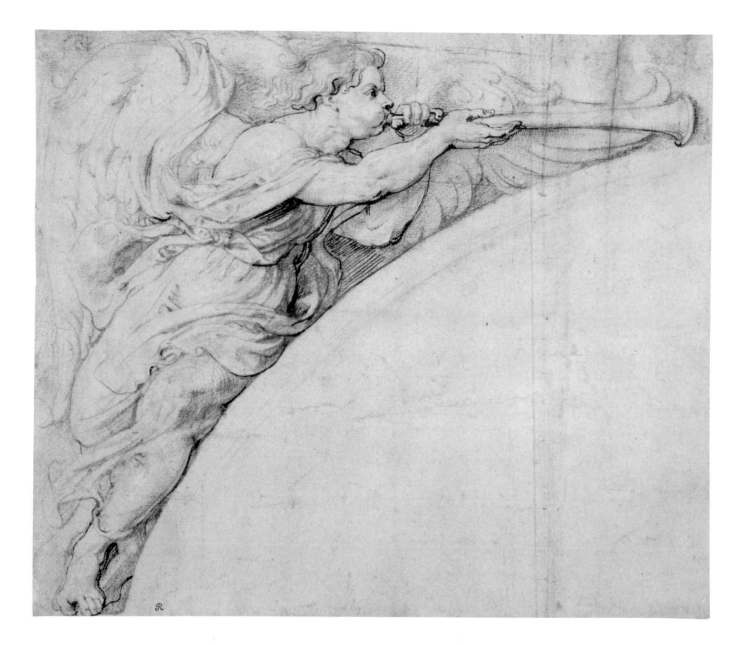

ANTHONY VAN DYCK
(Antwerp 1599–1641 London)

3

DIANA AND ENDYMION

Pen and point of brush, brown ink and brown wash, heightened with white bodycolor, on blue-gray paper
190 x 228 mm
Watermark: none

Inscribed in graphite on old mount, now removed, in Jacob de Vos Jbzn's hand, *K Dec. 65* (1865 was the date of the art historical conferences of Arti et Amicitiae at Amsterdam where the collector showed his drawings); in red ink, */ r(?).t.e.*

Purchased by Pierpont Morgan; Acc. no. I, 240

DIANA UND ENDYMION

Feder und Pinsel in Braun, braune Lavierung, weiß gehöht auf blau-grauem Papier
190 x 228 mm
Kein Wasserzeichen

Bezeichnet auf der alten, heute entfernten Montierung mit Bleistift in der Schrift des Vorbesitzers Jacob de Vos Jacobszoon: *K Dec. 65* (1865 zeigte der Sammler seine Zeichnungen auf den kunsthistorischen Versammlungen Arti et Amicitiae in Amsterdam); mit Feder in Rot: */ r (?).t.e.*

Erworben von Pierpont Morgan; Inv.-Nr. I, 240

On this sheet of blue paper—used to suggest a night setting—Van Dyck rapidly sketched two designs for a composition of Diana and Endymion, one above the other. The artist first lightly sketched the lower group with his pen, showing the moon goddess kissing the cheek of the sleeping shepherd whose beauty had drawn her to earth. He then tried a variant pose above, in which Diana, clearly identified by the crescent diadem, only watches the youth as he sleeps, his body more relaxed in a reclining position and his legs crossed. Alternate positions for Diana's left arm were considered, but in the end the artist returned to the first sketch and carried it further with rapid applications of wash. The white highlighting in the upper sketch is perhaps suggestive of moonlight, and the cupid with the smoking torch is a further indication of the night setting. The drawing seems to date to the late 1620s, when the artist was working on a similar composition, the painting of *Rinaldo and Armida* for Charles I, now in the Baltimore Museum of Art. No related picture is known; the very different treatment of the theme in Madrid is thought to be a much earlier work than this drawing.

Provenance
William Young Ottley (no mark; see Lugt 2662–65); possibly his sale, London, T. Philipe, 11–14 April 1804, one of four in lot 430 ("Van Dyck. Four—Narcissus…, Studies of Heads … and two sheets of pen sketches, one on both sides"); Samuel Woodburn (no mark; see Lugt 2584); Lawrence-Woodburn sale, Christie's, 12–14 June 1860, lot 1211 ("Dyck [A. van]—Venus supporting the dead body of Adonis—pen and bistre wash"; to Seymour for £1.4.0); presumably H. Danby Seymour (no mark; see Lugt 176); not in his sale, Sotheby's, 20 May 1875; Jacob de Vos Jbzn (Lugt 1450); his sale, Amsterdam, Roos, Muller…, 22–24 May 1883, lot 145 ("Couple amoureux. Croquis à la plume sur papier bleu–Hauteur 19 largeur 22.5 cent. Collection Sir Thomas Lawrence"; to Thibaudeau for Fl. 510); Sir Francis Seymour Haden (Lugt 1227); his sale, Sotheby's, 15–19 June 1891, lot 546 ("Venus and Adonis, pen and bistre"; to Fairfax Murray for £4.4.0); Charles Fairfax Murray; Pierpont Morgan (no mark; see Lugt 1509).

Selected bibliography and exhibitions
Stampfle 1991, no. 269, repr. (includes previous bibliography and exhibitions); New York and Fort Worth 1991, no. 51, repr. in color.

Auf diesem Blatt, dessen blauer Papierton eine nächtliche Stimmung andeuten soll, skizzierte van Dyck mit rasch ausgeführten Strichen zwei übereinanderliegende Entwürfe für eine Komposition mit Diana und Endymion. Zunächst legte der Künstler mit leichtem Federstrich die untere Gruppe an; sie zeigt die Mondgöttin, die Wange des schlafenden Hirten küssend, dessen Schönheit sie auf die Erde gelockt hatte. Darüber erprobte van Dyck dann eine Darstellungsvariante, in welcher die mit ihrem sichelförmigen Diadem eindeutig gekennzeichnete Diana den schlafenden jungen Mann lediglich anblickt, der nun mit gekreuzten Beinen entspannter daliegt. Alternative Haltungen von Dianas linkem Arm wurden erwogen, aber schließlich kehrte der Künstler zum ersten Entwurf zurück und entwickelte ihn durch eine zügige Lavierung weiter. Die Weißhöhung in der oberen Skizze soll wahrscheinlich Mondlicht andeuten, und auch Amor mit der brennenden Fackel ist ein weiterer Hinweis auf den nächtlichen Schauplatz. Die Zeichnung scheint aus den späten 1620er Jahren zu datieren, als der Künstler an einer ähnlichen Komposition, dem Gemälde *Rinaldo und Armida* (heute im Baltimore Museum of Art), für Karl I. von England gearbeitet hat. Ein mit dem vorliegenden Blatt in Verbindung stehendes Gemälde ist nicht bekannt; die sich von der Zeichnung stark unterscheidende Behandlung des Themas in Madrid wird erheblich früher datiert.

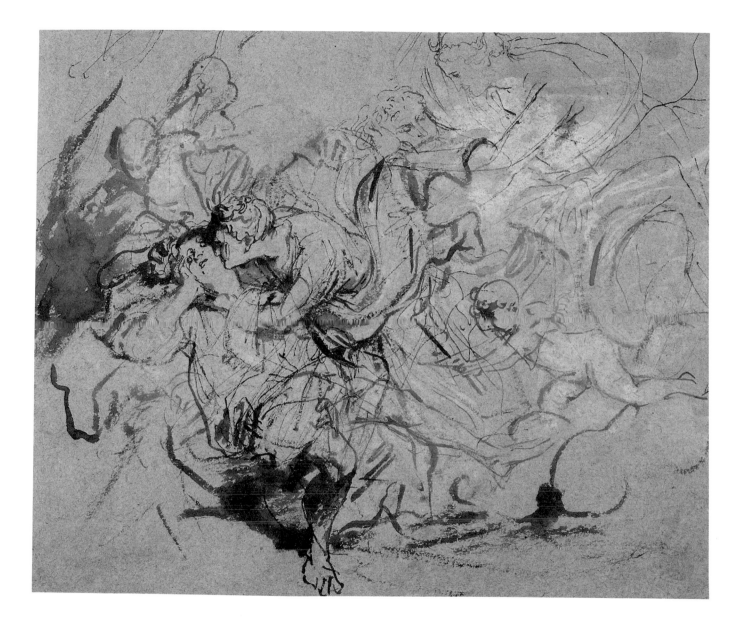

REMBRANDT HARMENSZ. VAN RIJN

(Leiden 1606–1669 Amsterdam)

4

Two Studies of Saskia Asleep

Pen and brown ink, brown wash
130 x 171 mm
Watermark: fragment with letters *WR*
(cf. Briquet 721 1–12)

Inscribed in pen and brown ink, at lower left, by Jan van Rijmsdijk, *Rijmsdyck's M.;* on verso of mount, at upper center, possibly also by Rijmsdijk, *BXI / BXI B / Rijmsdijk*

Purchased by Pierpont Morgan, 1910; Acc. no. I, 180

Zwei Studien der schlafenden Saskia

Feder in Braun, braune Lavierung
130 x 171 mm
Wasserzeichen: Fragment mit den Buchstaben *WR* (vgl. Briquet 721 1–12)

Unten links mit Feder in Braun bezeichnet von Jan van Rijmsdijk: *Rijmsdyck's M.;* verso oben Mitte auf der Montierung, möglicherweise auch von Rijmsdijk: *BXI / BXI B / Rijmsdijk*

Erworben 1910 von Pierpont Morgan; Inv.-Nr. I, 180

In this sheet, Rembrandt's interest is concentrated on the physical likeness of his wife, Saskia, who is recognizable in the upper sketch, which apparently was made first. The lower sketch was added as the sleeper, now sunk more deeply into her pillows, shifted her hand and opened her mouth.

This drawing is one of a sizable group of studies representing Saskia in bed, done probably between 1635 and 1641. It seems to be among the earlier studies of the group and is best dated about 1635–37, since Saskia shows little sign of the ravages of the ill health that prematurely aged her. It is perhaps closest stylistically to the drawing in Groningen, where Saskia is seen sitting up in bed.

Provenance
Jan van Rijmsdijk (Lugt 2167); Tighe (according to Fairfax Murray); Charles Fairfax Murray; Pierpont Morgan (no mark; see Lugt 1509).

Selected bibliography and exhibitions
Paris and elsewhere 1979–80, no. 69, repr. (includes previous bibliography and exhibitions).

In diesem Blatt konzentrierte sich Rembrandts Interesse auf die physische Erscheinung seiner Frau Saskia, die in der oberen Skizze, welche allem Anschein nach zuerst ausgeführt wurde, zu erkennen ist. Die untere Skizze wurde hinzugefügt, nachdem die Schlafende, nunmehr tiefer in ihre Kissen versunken, die Handhaltung verändert und ihren Mund geöffnet hatte.

Die Zeichnung gehört zu einer größeren Gruppe von Studien, die Saskia im Bett zeigen und vermutlich zwischen 1635 und 1641 entstanden sind. Dabei scheint sie den früheren Blättern der Folge anzugehören und ist am ehesten in die Jahre 1635 bis 1637 zu datieren, da Saskia kaum Anzeichen des schlechten Gesundheitszustandes erkennen läßt, der sie vorzeitig altern ließ. Stilistisch steht das Blatt der Zeichnung in Groningen am nächsten, in der Saskia aufrecht im Bett sitzend dargestellt ist.

4

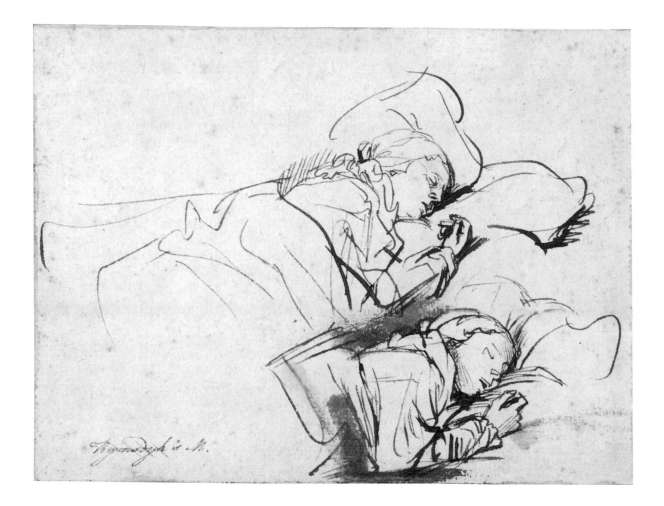

REMBRANDT HARMENSZ. VAN RIJN

(Leiden 1606–1669 Amsterdam)

5

ACTOR IN THE ROLE OF BADELOCH

Pen and brown ink, brown wash, corrected with lead white; additions in pen and gray ink
228 x 140 mm
Watermark: none visible through lining

Inscribed in pen and brown ink, at lower right, by Jan van Rijmsdijk, *Rijmsdijk's Museum;* on verso of mount at upper center, possibly also by Rijmsdijk, *BXI / Rijmsdijk;* at lower right, in graphite, *LSD / 3.3.0.*

Purchased by Pierpont Morgan, 1910; Acc. no. I, 177

SCHAUSPIELER IN DER ROLLE DER BADELOCH

Feder in Braun, braune Lavierung, Überarbeitungen in Bleiweiß, Ergänzungen mit Feder in Grau
228 x 140 mm
Wasserzeichen: nicht erkennbar aufgrund der Montierung

Bezeichnet unten rechts mit Feder in Braun von Jan van Rijmsdijk: *Rijmsdijk's Museum;* verso oben Mitte auf der Montierung, eventuell auch von Rijmsdijk: *BXI / Rijmsdijk;* unten rechts in Bleistift: *LSD / 3.3.0.*

Erworben 1910 von Pierpont Morgan; Inv.-Nr. I, 177

Badeloch, the wife of Gijsbrecht, was a character in Joost van den Vondel's best-known play, *Gijsbrecht van Aemstel,* which had its premiere on 3 January 1638. Its principal theme evoked the rebirth and hegemony of Amsterdam after its brutal destruction. A sizable group of Rembrandt's drawings represents characters from Dutch classical tragedy and includes at least six others said to be of Badeloch in the print rooms of Berlin, Dresden, Leipzig, and Rotterdam as well as in the Gathorne-Hardy collection at Newbury. While the figure of Badeloch appears to be a woman, all female roles were portrayed by male actors on the Amsterdam stage prior to 1655. The rich brocade of Badeloch's gown, handled masterfully by the artist, is comparable to that of the bishop in *Gijsbrecht van Aemstel and His Men Kneeling Before Bishop Gozewijn,* in the Herzog Anton Ulrich Museum, Brunswick. Both drawings bring to mind the similar treatment of the rich materials in the gown of the young woman in Rembrandt's etching *The Spanish Gypsy* (B. 120), which, Gersaint stated, was intended to illustrate a Dutch tragedy that was still being performed in Amsterdam during the eighteenth century.

Provenance
Jan van Rijmsdijk (Lugt 2167); Tighe (according to Fairfax Murray); Charles Fairfax Murray; Pierpont Morgan (no mark; see Lugt 1509).

Selected bibliography and exhibitions
Paris and elsewhere 1979–80, no. 70, repr. (includes previous bibliography and exhibitions).

Badeloch, die Frau des Gijsbrecht, ist eine Figur in Joost van den Vondels bekanntestem Drama *Gijsbrecht van Aemstel,* das am 3. Januar 1638 uraufgeführt wurde. Es handelt vom Wiederaufbau und der Hegemonie der Stadt Amsterdam nach ihrer gewaltsamen Zerstörung. Eine größere Gruppe von Zeichnungen Rembrandts zeigt Figuren aus klassischen holländischen Tragödien. Darunter befinden sich mindestens sechs Blätter, die Badeloch darstellen sollen. Sie werden in den Kabinetten der Museen von Berlin, Dresden, Leipzig und Rotterdam sowie der Gathorne-Hardy Collection in Newbury aufbewahrt. Obwohl alle Frauenrollen auf den Amsterdamer Bühnen vor 1655 von Männern gespielt wurden, scheint hier die Gestalt der Badeloch eine Frau zu sein. Das kostbare Brokatgewand, vom Künstler meisterhaft wiedergegeben, ist vergleichbar mit dem des Bischofs in dem *Gijsbrecht van Aemstel und seine Männer knien vor dem Bischof Gozewijn* betitelten Blatt aus dem Braunschweiger Herzog Anton Ulrich-Museum. Beide Zeichnungen erinnern in der Behandlung des edlen Gewandstoffes an die junge Frau in Rembrandts Radierung *Die spanische Zigeunerin* (B. 120), die, wie Gersaint mitteilte, eine holländische Tragödie illustrieren sollte, welche in Amsterdam noch im 18. Jahrhundert aufgeführt wurde.

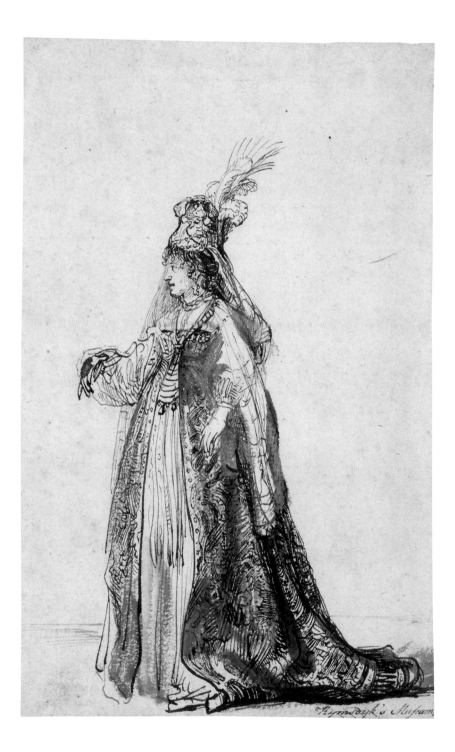

REMBRANDT HARMENSZ. VAN RIJN

(Leiden 1606–1669 Amsterdam)

THREE STUDIES FOR A DESCENT FROM THE CROSS

Mark 15:42–46
Quill and reed pen, and brown ink
190 x 205 mm
Watermark: none

The Thaw Collection, promised gift to
The Pierpont Morgan Library

DREI STUDIEN FÜR EINE KREUZABNAHME

Markus 15, 42–46
Kiel- und Rohrfeder in Braun
190 x 205 mm
Kein Wasserzeichen

Sammlung Thaw, in Aussicht gestellte
Schenkung an die Pierpont Morgan
Library

This remarkably expressive sheet was most likely executed during the first half of the 1650s, a time when Rembrandt, in his drawings and etchings, was particularly preoccupied with the Life and Passion of Christ. It appears that the artist drew the study on the right first; he then revised the original position of Christ's left forearm and back, pressing heavily on the broad nibs of his reed pen to produce the bold outlines. In the smaller sketch at the upper left he incorporated the new position of the forearm and clarified that of the shoulder, at the same time altering the relationship of the two heads so that Christ's head would no longer overlap the other. Finally, at the lower left, he studied this new juxtaposition on a larger scale. Scholars have associated this sheet with the etching of 1654 (B. 83) as well as with the painting in the National Gallery, Washington, D.C. While it cannot be said that the present drawing is directly connected with either work, it would seem to relate to the painting more closely than it does to the etching.

Provenance
George Guy, fourth earl of Warwick (according to Benesch; no mark; see Lugt 2600); Thomas Halstead; Dr. A. Hamilton Rice, New York; Mr. and Mrs. Louis H. Silver, Chicago; Knoedler, New York; Robert Lehman, New York; Norton Simon Foundation, Los Angeles; R. M. Light & Co., Inc., Boston.

Selected bibliography and exhibitions
Paris and elsewhere 1979–80, no. 72, repr. (includes previous bibliography and exhibitions); Thaw III, no. 19, repr.; Thaw, Royal Academy, no. 15, repr.

Dieses bemerkenswert ausdrucksvolle Blatt wurde höchstwahrscheinlich in der ersten Hälfte der 1650er Jahre angefertigt, einer Zeit, in der Rembrandt sich in seinen Zeichnungen und Radierungen besonders mit der Lebens- und Leidensgeschichte Christi beschäftigte. Offenbar zeichnete der Künstler zuerst die rechte Studie; dann überarbeitete er die ursprüngliche Haltung des linken Unterarmes und die Ausführung des Rückens Christi, wobei er die breite Spitze seiner Rohrfeder stark andrückte, um kräftige Konturen zu erzielen. In der kleineren Skizze oben links behielt er die neue Position des Unterarmes bei und klärte die der Schulter, gleichzeitig veränderte er das Verhältnis der beiden Köpfe zueinander, so daß der Kopf des Leichnams Christi nicht länger den der anderen Figur überschneidet. Schließlich erprobte er unten links diese neue Gegenüberstellung in einem etwas größeren Format. Die Forschung hat dieses Blatt mit der Radierung von 1654 (B. 83) und dem Gemälde in der National Gallery of Art in Washington in Verbindung gebracht. Obschon kein direkter Zusammenhang zwischen der vorliegenden Zeichnung und den beiden anderen Werken besteht, scheint sie näher dem Gemälde als der Radierung.

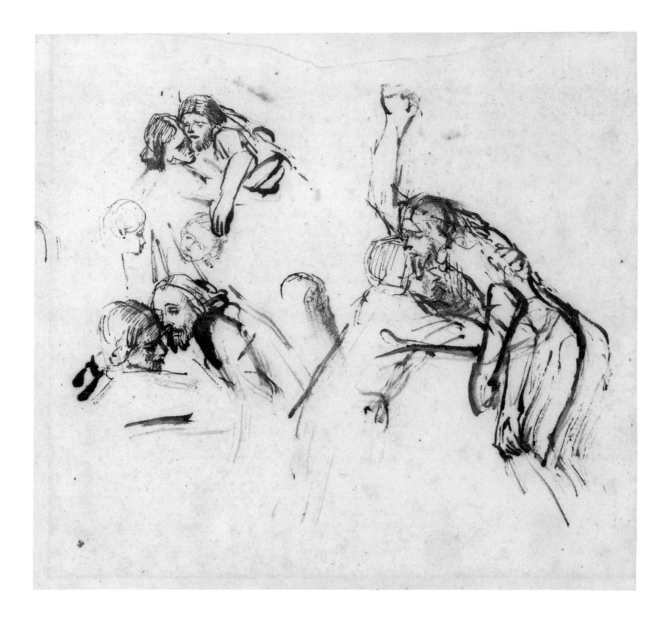

CLAUDE GELLEE, CALLED CLAUDE LORRAIN

(Chamagne 1600–1683 Rome)

7

THE SERMON ON THE MOUNT

Matthew 5–7
Pen and brown ink, brown wash;
divided into quadrants in black chalk
243 x 371 mm
Watermark: none

Purchased by Pierpont Morgan, 1910;
Acc. no. I, 27z

DIE BERGPREDIGT

Matthäus, Kap. 5–7
Feder in Braun, braune Lavierung,
quadriert in schwarzer Kreide
243 x 371 mm
Kein Wasserzeichen

Erworben 1910 von Pierpont Morgan;
Inv.-Nr. I, 272

This drawing is the most detailed of several surviving compositional studies for the exceptionally large picture that Claude painted in 1656 for François Bosquet (1605–1676), bishop of Montpellier. Two of the other studies are in the Teyler Museum, Haarlem (Roethlisberger 765–66), while a third is in the British Museum (Roethlisberger 769, Oo. 7-232). Although the Morgan drawing is squared for transfer, the artist significantly simplified the composition before putting it down on canvas. Some of these changes are evident in the British Museum drawing, the latest known in the series, indicating that the present sheet is most likely the third in the sequence of four preparatory drawings. The painting, which was formerly in the collection of the duke of Westminster, entered the Frick Collection, New York, in 1960.

Provenance
Sir Joshua Reynolds (Lugt 2364); Dr. Henry Wellesley (Lugt 1384); Sir William Richard Drake; his sale, London, Christie's, 24–25 May 1892, lot 403 ("Claude. The Sermon on the Mount: our Saviour surrounded by the multitude seated on the mount, under a cluster of trees; on the left a view of the sea, with shipping, etc.; figures of animals in the foreground—in pen and sepia. From the Collections of Sir J. Reynolds and Dr. Wellesley"); Charles Fairfax Murray; Pierpont Morgan; no mark, see Lugt 1509.

Selected bibliography and exhibitions
Fairfax Murray 1905–12, vol. 1, no. 272, repr.; Washington, and Paris 1982–83, no. 550, repr. (includes full bibliography and exhibitions).

Von mehreren überlieferten Kompositionsstudien für ein außergewöhnlich großes Gemälde, das Claude Lorrain 1656 für den Bischof François Bosquet (1605–76) von Montpellier ausgeführt hat, ist diese Zeichnung die detaillierteste. Zwei der anderen Studien befinden sich im Teyler Museum in Haarlem (Roethlisberger 765–66), eine dritte im British Museum in London (Roethlisberger 769, Oo. 7-232). Obwohl unsere Zeichnung quadriert ist, hat der Künstler die Komposition vor der Übertragung auf die Leinwand erheblich vereinfacht. Einige dieser Veränderungen zeigt auch die Londoner Zeichnung, die letzte bekannte aus der Folge; sie läßt darauf schließen, daß es sich bei dem vorliegenden Blatt mit großer Wahrscheinlichkeit um die dritte der insgesamt vier Studien handelt. Das vollendete Gemälde befand sich früher im Besitz des Herzogs von Westminster und gelangte 1960 in die Frick Collection nach New York.

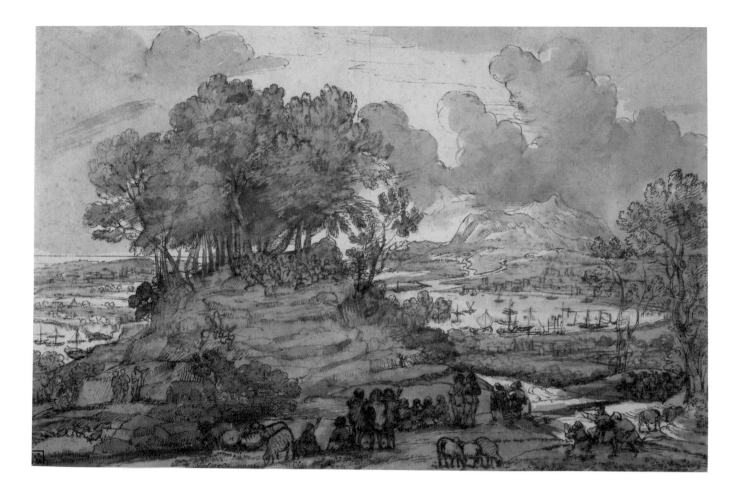

JEAN ANTOINE WATTEAU
(Valenciennes 1684–1721 Nogent-sur-Marne)

8

RIVER LANDSCAPE WITH
A FORTIFIED TOWN AND
DISTANT MOUNTAINS

Red chalk
330 x 465 mm
Watermark: coat of arms with serpent
(close to Heawood 688)

Purchased on the Sunny Crawford von
Bülow Fund 1978; Acc. no. 1995.1

FLUSSLANDSCHAFT MIT EINER
BEFESTIGTEN STADT UND
BERGEN IN DER FERNE

Rötel
330 x 465 mm
Wasserzeichen: Wappen mit Schlange
(ähnlich Heawood 688)

Erworben 1978 mit Mitteln des Sunny
Crawford von Bülow Fund;
Inv.-Nr. 1995.1

This drawing—the largest known by the artist—may be one of a hundred copies Watteau made after Venetian drawings by Titian and Campagnola acquired in 1715 by Pierre Crozat, the great collector and patron of the artist. The work that Watteau copied in this drawing—most likely a Campagnola—is not known. The artist's red chalk lends a softer and more atmospheric character to the essentially dry pen rendering of Campagnola's landscapes. Watteau's *River Landscape,* with its view of a curving waterway, distant mountains, high vantage point, and even a few of the buildings and bridges seen here, resembles the Campagnola print *Landscape with Wandering Family.*[1]

Watteau liked this mountainous background and adapted it freely in *Le Pèlerinage à l'isle de Cithère,* in which the mountains are similar but have been repositioned directly behind the river or lake that appears in the painting. The shoreline, along with the high viewpoint of the figures in the foreground, is similar in both compositions. Watteau also used the mountain motif for *Fête d'Amour,* a painting in Dresden. In this work, the position, if not quite the pose, of the seated warrior is repeated above the landscape.

Provenance
Camille Groult; J. Groult; P. Bordeaux-Groult; Didier Aaron, New York; sale, Lille, 13 March 1994, lot 27, repr. (in color); Galerie Schmit, Paris.

Selected bibliography and exhibitions
New York 1995–96, no. 1, repr. in color (includes previous bibliography and exhibitions).

1. Dreyer [1971], no. 33, repr.

Diese größte bekannte Zeichnung des Künstlers könnte eine der 100 Kopien sein, die Watteau nach venezianischen Zeichnungen von Tizian und Campagnola anfertigte, welche der bedeutende Sammler und Mäzen Pierre Crozat 1715 erworben hatte. Welches Werk – am ehesten wohl eines von Campagnola – Watteau als Vorlage dieser Zeichnung diente, ist nicht bekannt. Der vom Künstler verwendete Rötel erzeugt im Vergleich zu den eher trockenen Federstrukturen der Landschaftszeichnungen Campagnolas einen weicheren und atmosphärischeren Charakter. In bezug auf den Blick über einen sich windenden Wasserlauf, die fernen Berge, den hohen Blickpunkt und auch hinsichtlich der dargestellten Gebäude und Brücken gleicht Watteaus *Flußlandschaft* Campagnolas druckgraphischer Arbeit *Landschaft mit wandernder Familie.*[1]

Watteau schätzte diesen bergigen Hintergrund und übernahm ihn in freier Umsetzung für das Gemälde *Le Pèlerinage à l'isle de Cithère,* in dem die Berge ähnlich dargestellt, aber unmittelbar hinter dem Fluß oder See angeordnet sind. Der Uferverlauf sowie der hohe Standort der Figuren im Vordergrund sind in beiden Kompositionen vergleichbar. Watteau verwendete das Bergmotiv auch in dem Dresdner Gemälde *Fête d'Amour.* In diesem Werk wird der Standort, wenn auch nicht die ganze Pose des über der Landschaft sitzenden Kriegers wiederholt.

1. Dreyer [1971], Nr. 33, Abb.

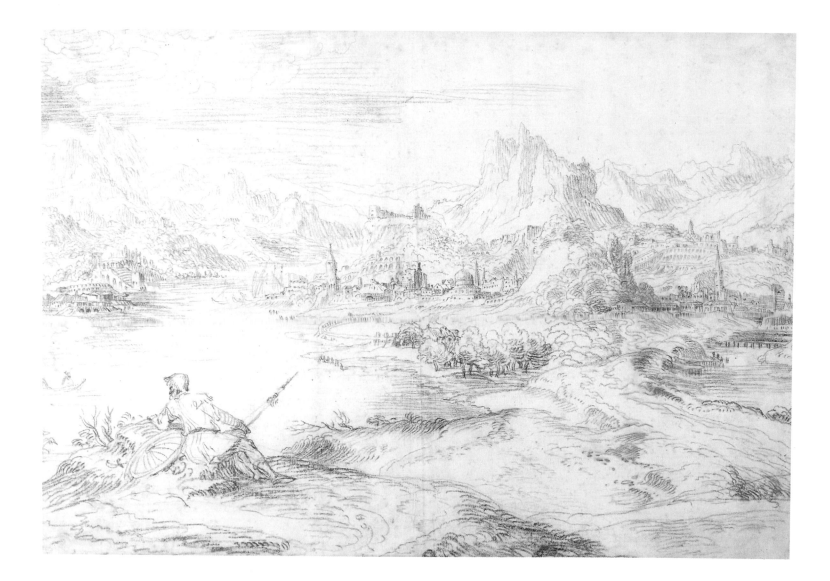

GIOVANNI FRANCESCO BARBIERI, CALLED IL GUERCINO

(Cento 1591–1666 Bologna)

SATIRE ON GAMBLING

Pen and brown ink, brown wash; lined
256 x 393 mm
Watermark: none visible through lining

Inscribed by the artist in pen and brown ink at upper left, *Sicut mat.;* at lower left, *DAI DAI / AL' MAT. / LE' AMATIÌ P CHÈ LA' / MANGIA DEL CERVEL / D' GAT' AL LOV* ("Surely mad," and "Give, give to the madman. He went mad because he eats cats' brains with eggs.")

Purchased by Pierpont Morgan, 1910; Acc. no. I, 101

SATIRE AUF DAS GLÜCKSSPIEL

Feder in Braun, braun laviert; aufgezogen
256 x 393 mm
Wasserzeichen: nicht erkennbar aufgrund der Montierung

Bezeichnet oben links vom Künstler mit Feder in Braun: *Sicut mat.;* unten links: *DAI DAI / AL' MAT. / LE' AMATIÌ P CHÈ LA' / MANGIA DEL CERVEL / D'GAT' AL LOV* (»bestimmt verrückt«, und »Gib, gib es dem Verrückten. Er wurde verrückt, weil er Katzenhirne mit Eiern aß.«)

Erworben 1910 von Pierpont Morgan; Inv.-Nr. I, 101

The subject of this spirited drawing has yet to be satisfactorily explained. The strabismic figure wearing a feathered hat adorned with tarot cards might be the artist himself—whose nickname, Guercino, means "cross-eyed"—while the various inscriptions may, as Felice Stampfle and Jacob Bean have suggested, refer to either a proverb or local folklore. The present title, supplied by Charles Fairfax Murray, was no doubt inspired not only by the fantastic head-dress of the central figure but also by the fact that he is shown being robbed of his shirt, shoes, hose, and other belongings. The owl pursued by day birds at the upper left presumably alludes to the same moralizing theme.

This drawing belongs to a small group of similar genre scenes and capricci, of which the most closely related may be a comparably inscribed *Street Scene with a Vendor* in the Royal Library, Windsor Castle (Inv. no. 2474).[1] On the basis of style, both works would appear to have been executed a few years prior to Guercino's departure from Cento for Rome in 1621.

Provenance
Sir Joshua Reynolds (Lugt 2364); Lord Palmerston (according to Fairfax Murray); Charles Fairfax Murray; Pierpont Morgan.

Selected bibliography and exhibitions
Fairfax Murray 1905–12, vol. 1, no. 101, repr.; Parker 1956, p. 448, under no. 870; New York 1967, no. 38, repr.; Bologna 1968, no. 242, repr.; Roli 1972, no. 23, repr.; John Varriano in South Hadley 1974, no. 26; Ottawa 1982, no. 52, repr.; Cambridge and elsewhere 1991, no. 82, repr.

1. Cambridge and elsewhere 1991, p. 188, under no. 82; London 1991, no. 187, repr.

Bisher ist es nicht gelungen, das Thema dieser temperamentvollen Zeichnung zufriedenstellend zu erklären. Die schielende Figur, die einen mit Tarotkarten geschmückten Federhut trägt, könnte den Künstler selbst darstellen – zumal dessen Spitzname »Guercino« soviel wie »Schielender« bedeutet –, wohingegen die Beschriftungen, wie Felice Stampfle und Jacob Bean vermutet haben, sich entweder auf ein Sprichwort beziehen oder im Zusammenhang mit lokalem Brauchtum gesehen werden müssen. Der gegenwärtige Titel stammt von Charles Fairfax Murray und wurde zweifellos nicht nur von dem skurrilen Kopfschmuck der Hauptfigur angeregt, sondern ebenso von der Tatsache, daß die Figur ihres Hemdes, der Schuhe, Strümpfe und anderer persönlicher Dinge beraubt wird. Die am oberen linken Bildrand von Vögeln verfolgte Eule spielt vermutlich auf das gleiche moralisierende Thema an.

Die Zeichnung gehört zu einer kleinen Gruppe vergleichbarer Genreszenen und Capriccios, unter denen die ähnlich beschriftete *Straßenszene mit einem Verkäufer* in der Royal Library von Windsor Castle (Inv.-Nr. 2474) dieser am nächsten verwandt zu sein scheint.[1] Der zeichnerische Stil beider Blätter spricht für eine Entstehungszeit vor Guercinos Abreise von Cento nach Rom im Jahr 1621.

1. Cambridge u. a. 1991, S. 188, unter Nr. 82; London 1991, Nr. 187, Abb.

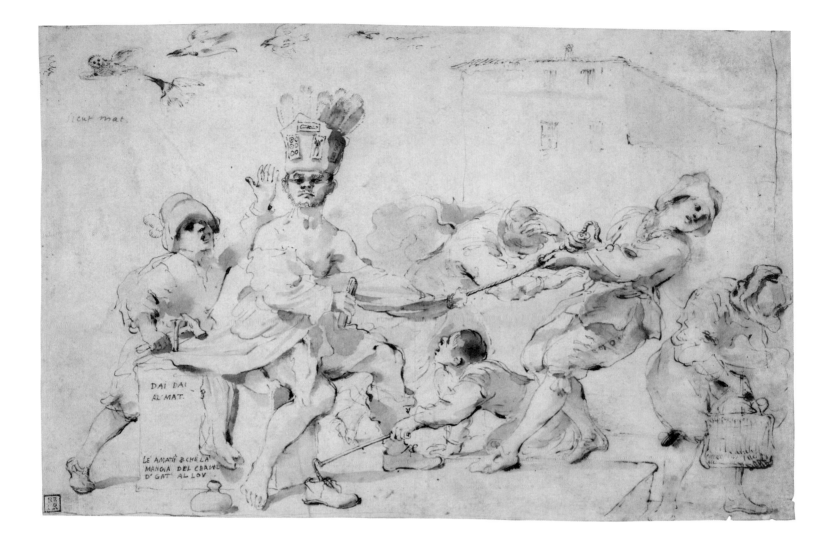

GIOVANNI FRANCESCO BARBIERI, CALLED IL GUERCINO

(Cento 1591 – 1666 Bologna)

THE MARTYRDOM OF
SS. JOHN AND PAUL

Pen and brown ink, brown wash
Verso: *The Martyrdom of SS. John and Paul*
250 x 300 mm
Watermark: none

Purchased by Pierpont Morgan, 1910;
Acc. no. I, 101h

DIE MARTYRIEN DER HEILIGEN
JOHANNES UND PAULUS

Feder in Braun, braun laviert
Verso: *Martyrien der heiligen Johannes und Paulus*
250 x 300 mm
Kein Wasserzeichen

Erworben 1910 von Pierpont Morgan;
Inv.-Nr. I, 101h

Both recto and verso of this sheet contain studies for Guercino's painting *The Martyrdom of SS. John and Paul, with the Virgin and Child Above*, now in the Musée des Augustins, Toulouse. The painting is one of two that Guercino executed about 1632 for the side walls of the Giroldi Chapel in the cathedral at Reggio Emilia.[1] A remarkable series of preparatory drawings survives for *The Martyrdom of SS. John and Paul* as well as for *The Visitation* (now in the Musée des Beaux-Arts, Rouen) that Guercino painted for the opposite wall, providing unusually rich documentation of the artist's creative process.

In the Library's drawing and in other studies for the same picture in the Rijksmuseum, Amsterdam (Inv. no. 64:38), the Courtauld Institute Galleries, London (Inv. no. 1341), and the collection of Sir Denis Mahon (on loan to the Ashmolean Museum, Oxford), Guercino experimented with the poses of the executioner and two apostles, altering the relationships of the figures and reversing elements of the composition in order to achieve a harmonious and clearly legible design. It is typical of Guercino's later work that the painting should be less dramatic in conception than the numerous sketches that preceded it. In the picture, the swordsman is seen from the back; the kneeling saint is at the lower left; and the decapitated corpse is on the right.

Provenance
Sir Charles Greville (Lugt 549); earls of Warwick (Lugt 2600); unidentified collector's mark in pen and black ink at lower right, J (probably Lugt 1404); Charles Fairfax Murray; Pierpont Morgan.

Selected bibliography and exhibitions
New York 1967, no. 40, repr. (recto and verso); Bologna 1968, no. 128, repr. (recto and verso); John Varriano in South Hadley 1974, no. 12; Reggio Emilia 1982, pl. 50 (recto); Cambridge and elsewhere 1991, no. 24, repr. (recto and verso); London 1991, p. 115, under no. 87.

1. Salerno 1988, no. 139, repr. Guercino contracted to paint both pictures in 1627 but did not receive payment until 1632. It is unlikely that the preparatory drawings were made earlier than about 1630.

Sowohl die Vorder- als auch die Rückseite des Blattes zeigen Studien für Guercinos Gemälde *Die Martyrien der heiligen Johannes und Paulus, über ihnen die Muttergottes mit dem Kind*, das sich heute im Musée des Augustins von Toulouse befindet. Es ist eines von zwei Gemälden, die Guercino um 1632 für die Seitenwände der Giroldi-Kapelle im Dom von Reggio Emilia ausführte.[1] Ebenso wie für das Gemälde mit den Martyrien der Apostel ist für die *Heimsuchung* (heute im Musée des Beaux-Arts in Rouen), die Guercino für die gegenüberliegende Wand malte, eine bemerkenswerte Serie von Entwurfszeichnungen überliefert, die einen ungewöhnlich tiefen Einblick in den schöpferischen Prozeß des Künstlers gewähren.

In der Zeichnung der Pierpont Morgan Library und auch in weiteren Studien im Amsterdamer Rijksmuseum (Inv.-Nr. 64:38), in den Londoner Courtauld Institute Galleries (Inv.-Nr. 1341) und der Sammlung von Sir Denis Mahon (als Leihgabe im Ashmolean Museum in Oxford) experimentierte Guercino mit den Haltungen des Scharfrichters und der beiden Apostel. Er veränderte das Verhältnis der Figuren zueinander und vertauschte kompositorische Elemente, um ein harmonisches und klar lesbares *disegno* zu erhalten. Typisch für Guercinos Spätwerk, ist das Gemälde weniger dramatisch angelegt als die zahlreichen, vorangegangenen Entwürfe. So ist der Henker im Gemälde von hinten zu sehen; der kniende Heilige befindet sich links unten und der enthauptete Körper auf der rechten Seite.

1. Salerno 1988, Nr. 139, Abb. Guercino verpflichtete sich 1627 vertraglich zur Ausführung der beiden Bilder, erhielt aber erst 1632 eine Bezahlung. Es ist unwahrscheinlich, daß die vorbereitenden Zeichnungen früher als etwa 1630 entstanden sind.

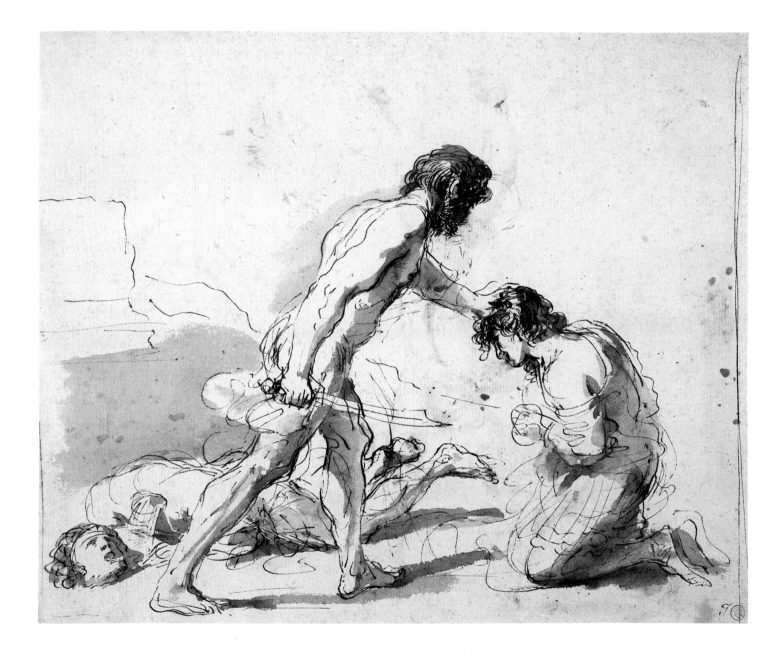

GIOVANNI FRANCESCO BARBIERI, CALLED IL GUERCINO

(Cento 1591–1666 Bologna)

VIRGIN OF THE ROSARY WITH SS. CATHERINE AND DOMINIC

Pen and brown ink, brown wash
358 x 268 mm
Watermark: six fleurs-de-lis in a shield, surmounted by a crown

Purchased by Pierpont Morgan, 1910; Acc. no. IV, 167

ROSENKRANZMADONNA MIT DEN HEILIGEN KATHARINA UND DOMINIKUS

Feder in Braun, braun laviert
358 x 268 mm
Wasserzeichen: Wappenschild mit sechs Lilien, darüber eine Krone

Erworben 1910 von Pierpont Morgan; Inv.-Nr. IV, 167

This is a compositional study for an altarpiece of the same popular devotional subject that Guercino painted in 1637 for the church of San Domenico, Turin. Another preparatory drawing for the picture, in red chalk instead of pen and wash, is in the British Museum, London (Inv. no. 1910-2-12-8),[1] while a copy by Francesco Bartolozzi in the Albertina, Vienna (Inv. no. 1377), and an etching by Adam Bartsch record two other, presumably lost, studies for the painting, as Nicholas Turner and Carol Plazzotta were the first to observe.[2]

The painting is more symmetrical in composition than are any of the preparatory drawings. While the pose of Saint Catherine in the altarpiece is similar to that in the Library's study, the figure of Saint Dominic is shown kneeling at the lower left, rather than standing behind the female saint, and the angel holding a salver in the present sheet has been suppressed.

Provenance
Michael Rysbrack (engraved 1763 by W. W. Ryland when in Rysbrack's collection); Sir Thomas Lawrence (Lugt 2445); Charles Fairfax Murray; Pierpont Morgan.

Selected bibliography and exhibitions
Rogers 1778, pp. 108–11, repr. in facsimile; Fairfax Murray 1905–12, vol. 4, no. 167, repr.; New York 1967, no. 42, repr.; Bologna 1968, p. 136, under no. 141; Cambridge and elsewhere 1991, p. 219, no. 127 of selective checklist of Guercino drawings in North American collections; London 1991, p. 138, under no. 113; Bologna 1991, no. 99, repr.

1. London 1991, no. 113, repr.
2. Ibid., pp. 138–40, under no. 113.

Die Kompositionsstudie für ein Altarbild greift dasselbe verbreitete religiöse Thema auf, das Guercino 1637 für die Kirche San Dominico in Turin gemalt hat. Eine weitere Vorzeichnung des Gemäldes, in Rötel anstatt mit Feder und Lavierung ausgeführt, befindet sich im British Museum in London (Inv.-Nr. 1910-2-12-8),[1] während mit der Kopie von Francesco Bartolozzi in der Wiener Albertina (Inv.-Nr. 1377) und einer Radierung von Adam Bartsch zwei weitere, vermutlich verlorengegangene Studien für das Gemälde dokumentiert sind, was erstmals von Nicholas Turner und Carol Plazzotta festgestellt wurde.[2]

Das Gemälde ist im Aufbau symmetrischer als alle Entwurfszeichnungen. Während sich die Körperhaltungen der heiligen Katharina im Altarbild und in der Studie der Pierpont Morgan Library gleichen, steht die Figur des heiligen Dominikus dort nicht mehr hinter der Heiligen, sondern kniet unten links, und der Engel, der im vorliegenden Blatt noch ein Tablett trägt, entfällt ganz.

1. London 1991, Nr. 113, Abb.
2. Ebenda, S. 138–40, unter Nr. 113.

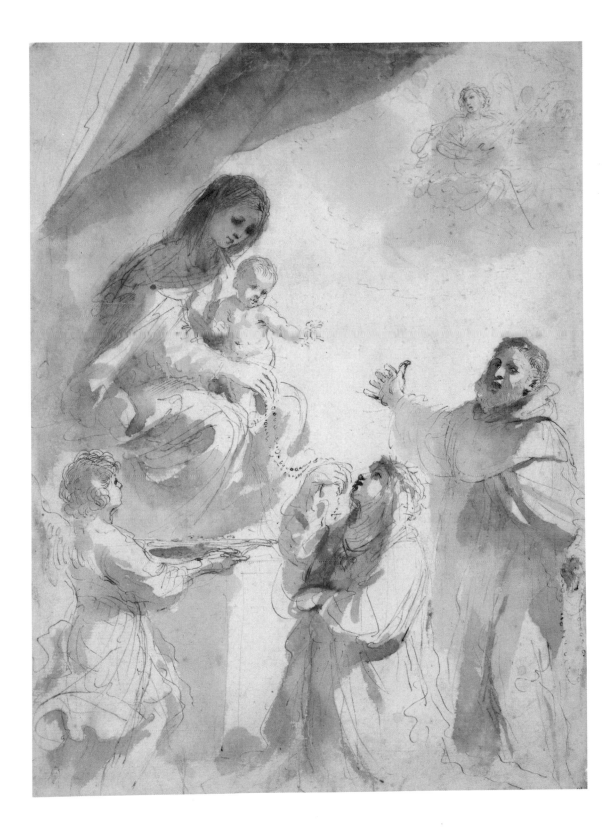

GIOVANNI FRANCESCO BARBIERI, CALLED IL GUERCINO

(Cento 1591 – 1666 Bologna)

LANDSCAPE WITH A VOLCANO

Brush and brown wash on blue paper; lined
258 x 372 mm
Watermark: illegible

Janos Scholz Collection;
Acc. no. 1975.36

LANDSCHAFT MIT VULKAN

Pinsel in Braun auf blauem Papier; aufgezogen
258 x 372 mm
Wasserzeichen: unleserlich

Sammlung Janos Scholz;
Inv.-Nr. 1975.36

Provenance
Benedetto and Cesare Gennari (?); Lord Northwick; William Bateson (Lugt Supp. 2604a); acquired by Janos Scholz in 1956.

Selected bibliography and exhibitions
New York 1967, no. 50, repr.; Santa Barbara and elsewhere 1974, no. 57, repr. (with previous bibliography and exhibitions); University Park 1975, no. 19, fig. 20; Scholz 1976, no. 87, repr.; Los Angeles 1976–77, no. 96, repr.; Morgan Library 1978, pp. 247–49; Cambridge and elsewhere 1991, no. 74, repr.; Griswold 1991, p. 644; London 1991–92, p. 204, under no. 182.

This remarkable sheet is anomalous among Guercino's extant landscapes, almost all of which are in pen and brown ink, with little or no wash, on white paper. That this sheet was executed entirely with the brush on blue paper has led some scholars, including the present writer, to question Guercino's authorship.[1] The overall composition as well as the treatment of the trees and the diminutive figures in the right foreground are nonetheless consistent with Guercino's landscapes, while the old mount, which suggests the drawing was formerly in the collection of the artist's heirs, Benedetto and Cesare Gennari, further attests to the authenticity of the sheet.[2] Moreover, there exists a small number of landscape drawings plausibly attributed to Guercino that are executed primarily in brush and wash, with relatively little penwork.[3]

Like other landscapes by Guercino, this drawing would appear to be the product of the artist's imagination. The volcano does not seem to be Mount Vesuvius—the only active volcano in seventeenth-century Italy—which Guercino almost certainly never visited. The composition was therefore in all likelihood inspired by the work of another artist, whose direct observation of nature Guercino reinterpreted with characteristic virtuosity.

1. Griswold 1991, p. 644.
2. The patterned border of the mount is similar in design to those on drawings indisputably from the Gennari collection, although it is in pen and red—instead of the more usual black—ink.
3. Examples include a sketch of *Shepherds Peering into a Chasm*, formerly in the collection of John Nicholas Brown and now the property of the National Gallery of Art, Washington (Inv. no. 1986.59.1; see Cambridge and elsewhere 1991, no. 73, repr.), and a *Landscape with a Tree Rising in the Center Foreground* in the Royal Library, Windsor Castle (Inv. no. 2765; see London 1991, no. 182, repr.).

Unter den überlieferten Landschaftszeichnungen Guercinos, die fast alle mit Feder in Braun, mit wenig oder ganz ohne Lavierung auf weißem Papier angelegt sind, nimmt dieses außergewöhnliche Blatt eine Sonderstellung ein. Die Tatsache, daß diese Zeichnung ausschließlich mit dem Pinsel auf blauem Papier ausgeführt wurde, veranlaßte die Forschung wie auch den Verfasser dieses Katalogs, die Autorschaft Guercinos anzuzweifeln.[1] Trotzdem stimmt die Gesamtkomposition wie auch die Behandlung der Bäume und der kleinen Figuren des Vordergrundes mit Guercinos Landschaften überein; darüber hinaus bezeugt die alte Montierung, die darauf hindeutet, daß sich die Zeichnung früher in der Sammlung der Erben des Künstlers, Benedetto und Cesare Gennari, befunden hat, die Authentizität des Blattes.[2] Zudem existiert eine kleine Anzahl von Landschaftszeichnungen, die trotz der vorwiegenden Ausführung mit Pinsel und Lavierung sowie dem verhältnismäßig geringen Anteil in Feder Guercino zugeschrieben werden.[3]

Wie andere Landschaften des Künstlers, so dürfte auch diese Zeichnung aus der Imagination entstanden sein. Bei dem Vulkan scheint es sich auch nicht um den Vesuv zu handeln – dem einzigen aktiven Vulkan im 17. Jahrhundert in Italien –, den Guercino mit Sicherheit nie aufgesucht hat. Es ist daher wahrscheinlicher, daß die Komposition von einem Werk eines anderen Künstlers angeregt wurde, dessen unmittelbare Naturbeobachtung Guercino mit der ihm eigenen Virtuosität neu interpretiert hat.

1. Griswold 1991, S. 644.
2. Die Gestaltung der Rahmung auf dem Untersatzblatt gleicht der bei anderen Zeichnungen, die zweifelsfrei aus der Sammlung Gennari stammen, wenn sie auch mit Feder und roter – anstatt der üblichen schwarzen – Tinte ausgeführt ist.
3. Dazu zählt zum Beispiel eine Skizze mit Schäfern, welche in einen Abgrund blicken, früher in der Sammlung von John Nicholas Brown und nun im Besitz der National Gallery of Art in Washington (Inv.-Nr. 1986.59.1; siehe Cambridge u. a. 1991, Nr. 73, Abb.), und eine Landschaft mit einem Baum, der sich in der Mitte des Vordergrundes erhebt, in der Royal Library, Windsor Castle (Inv.-Nr. 2765; siehe London 1991, Nr. 182, Abb.).

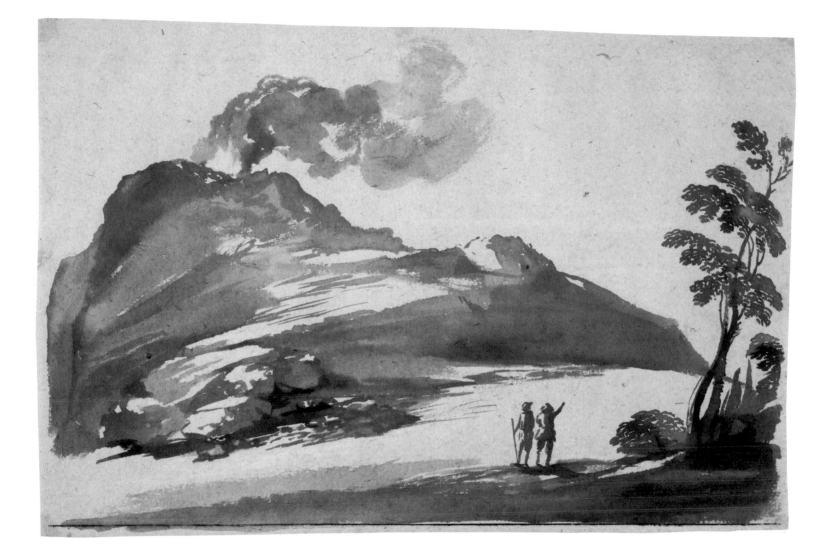

GIOVANNI FRANCESCO BARBIERI, CALLED IL GUERCINO

(Cento 1591–1666 Bologna)

RIVER LANDSCAPE WITH
SWIMMERS

Pen and brown ink
262 x 428 mm
Watermark: none

Purchased by Pierpont Morgan, 1910
Acc. no. IV, 168

FLUSSLANDSCHAFT MIT
SCHWIMMERN

Feder in Braun
262 x 428 mm
Kein Wasserzeichen

Erworben 1910 von Pierpont Morgan;
Inv.-Nr. IV, 168

Like his older Bolognese contemporaries Annibale Carracci (1560–1609) and Domenichino (1581–1641), Guercino was an enormously prolific landscape draughtsman, whose innumerable drawings inspired by the countryside near Cento were imitated not only by his immediate followers but also by later copyists and forgers. None of Guercino's landscape sketches is directly related to a known painting. Instead, they presumably were made for pleasure and are therefore usually impossible to assign to a particular period in the artist's career. Nevertheless, this splendid example—one of three that Pierpont Morgan purchased from Charles Fairfax Murray in 1910—is comparable in handling to several landscape drawings that Sir Denis Mahon believes may have been executed during the late 1620s because of their stylistic affinity with a sheet in the Uffizi, Florence, that bears the date 1626.[1]

During the eighteenth century, this drawing was engraved in reverse by the comte de Caylus (Anne-Claude-Philippe de Tubières, 1692–1765).

Provenance
François Renaud (Lugt Supp. 1042); Moriz von Fries (Lugt 2903); A. C. Poggi (Lugt 617); Sir Charles Greville (Lugt 549); earls of Warwick (Lugt 260); Charles Fairfax Murray; Pierpont Morgan.

Selected bibliography and exhibitions
Fairfax Murray 1905–12, vol. 4, no. 168, repr.; New York 1967–68, no. 51, repr.; Bologna 1968, no. 212, repr.; Roli 1972, no. 61, repr.; Bagni 1984, p. 187, under n. 2, p. 193, fig. 155; Bagni 1985, no. 24; Cambridge and elsewhere 1991, p. 219, no. 128 of selected checklist of Guercino drawings in North American collections.

1. For comparable drawings and a discussion of this problem, see Bologna 1991, p. 268, under no. 169, and p. 274, under no. 173.

Wie seine älteren Bologneser Zeitgenossen Annibale Carracci (1560–1609) und Domenichino (1581–1641) war Guercino ein äußerst produktiver Landschaftszeichner, dessen unzählige, von der Gegend um Cento angeregte Blätter nicht nur von seinen unmittelbaren Nachfolgern nachgeahmt wurden, sondern auch von späteren Kopisten und Fälschern. Keine der Landschaftsskizzen Guercinos steht in direkter Beziehung zu einem bekannten Gemälde. Vielmehr sind sie als freie Zeichnungen entstanden und lassen sich daher im allgemeinen keiner bestimmten Schaffensperiode seiner künstlerischen Laufbahn zuordnen. Dennoch ist dieses herausragende Beispiel – eines von drei Blättern, die Pierpont Morgan von Charles Fairfax Murray 1910 erworben hat – in seiner Ausführung vergleichbar mit mehreren Landschaftszeichnungen, die Sir Denis Mahon zufolge in den späten 1620er Jahren ausgeführt worden sind. Sie weisen eine stilistische Nähe zu einem Blatt in den Uffizien auf, welches das Datum 1626 trägt.[1]

Im 18. Jahrhundert wurde die Zeichnung vom Comte de Caylus (Anne-Claude-Philippe de Tubières, 1692–1765) seitenverkehrt radiert.

1. Zu Vergleichsbeispielen und der Diskussion dieses Problems siehe Bologna 1991, S. 268, unter Nr. 169, und S. 274, unter Nr. 173.

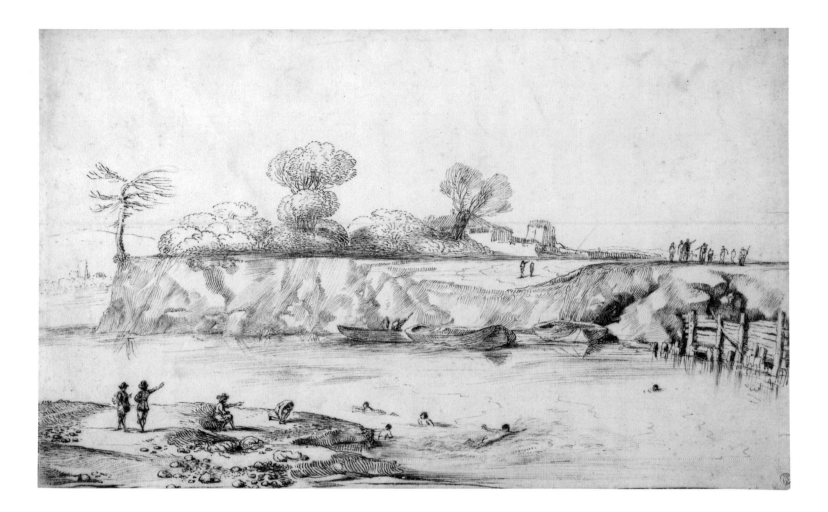

GIOVANNI FRANCESCO BARBIERI, CALLED IL GUERCINO

(Cento 1591–1666 Bologna)

THE BIRDCATCHER

Pen and brown ink
248 x 128 mm
Watermark: none visible through lining

Inscribed in pen and brown ink at lower right corner, *10*

Janos Scholz Collection;
Acc. no. 1979.8

DER VOGELFÄNGER

Feder in Braun
248 x 128 mm
Wasserzeichen: nicht erkennbar aufgrund der Montierung

Bezeichnet mit Feder in Braun in der unteren rechten Ecke: *10*

Sammlung Janos Scholz;
Inv.-Nr. 1979.8

During his long and immensely productive career Guercino produced numerous drawings of everyday life as well as hundreds of caricatures. Many such works, including this sketch of a birdcatcher, combine elements of both genres, distorting physiognomy and costume to humorous effect. As David Stone has pointed out in connection with a stylistically unrelated sheet depicting a grain merchant, now in the National Gallery of Art, Washington, D.C. (Inv. no. 1974.102.1), Guercino's studies of merchants and tradesmen belong to the same tradition as Annibale Carracci's series of drawings of comparable subjects, the *Arti di Bologna*.[1]

Like his landscapes, Guercino's caricatures were made for pleasure, rather than as studies for paintings; they are therefore undocumented and, with few exceptions, exceedingly difficult to date. The meticulous style of this drawing nevertheless indicates it might have been executed during the 1630s or 1640s.

Provenance
Acquired by Janos Scholz in 1965.

Selected bibliography and exhibitions
John Varriano in South Hadley 1974, no. 31, repr.; Morgan Library 1981, p. 175; Cambridge and elsewhere 1991, p. 220, no. 142, of selected checklist of Guercino drawings in North American collections, pl. Q.

1. Cambridge and elsewhere 1991, p. 180, under no. 78; for the *Arti di Bologna*, see Marabottini 1966.

Während seiner langen und enorm produktiven Laufbahn fertigte Guercino neben zahllosen Zeichnungen mit Alltagsszenen Hunderte von Karikaturen an. Viele solcher Werke, darunter dieses Blatt eines Vogelfängers, kombinieren Elemente beider Gattungen, indem sie die Gesichter und Kleidung verzerrt wiedergeben, um eine komische Wirkung zu erzielen. David Stone hat anhand eines stilistisch nicht verwandten Blattes mit der Darstellung eines Getreidehändlers aus der National Gallery of Art in Washington (Inv.-Nr. 1974.102.1) gezeigt, daß Guercinos Studien von Händlern und Handwerkern derselben Tradition angehören wie Annibale Carraccis Zeichnungsserie mit einer vergleichbaren Thematik, den *Arti di Bologna*.[1]

Genauso wie seine Landschaften sind Guercinos Karikaturen als freie Zeichnungen angefertigt worden und nicht als Studien für Gemälde; es fehlen ihnen daher dokumentarische Bezüge, und abgesehen von wenigen Ausnahmen sind sie äußerst schwer zu datieren. Der präzise zeichnerische Stil spricht jedoch dafür, daß dieses Blatt in den 1630er oder 1640er Jahren ausgeführt worden sein könnte.

1. Cambridge u. a. 1991, S. 180, unter Nr. 78; zu den *Arti di Bologna* siehe Marabottini 1966.

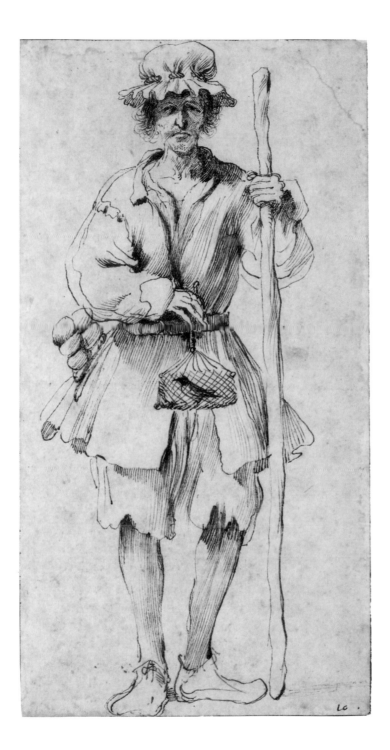

GIOVANNI BATTISTA TIEPOLO

(Venice 1696 – 1770 Madrid)

15

SAINT DOMINIC WITH ARMS
OUTSTRETCHED

Pen and brown ink, brown wash, over
black chalk
205 x 185 mm; upper corners
diagonally cropped
Watermark: none

Purchased by Pierpont Morgan;
Acc. no. IV, 116d

DER HEILIGE DOMINIKUS MIT
AUSGESTRECKTEN ARMEN

Feder in Braun, braune Lavierung über
schwarzer Kreide
205 x 185 mm, obere Ecken diagonal
beschnitten
Kein Wasserzeichen

Erworben von Pierpont Morgan;
Inv.-Nr. IV, 116d

The Morgan Library is extraordinarily rich in drawings by Giovanni Battista Tiepolo. More than a hundred of the Library's Tiepolos come from one of nine albums of the artist's drawings that were formerly in the collection of Edward Cheney and were sold as a single lot at Sotheby's in London in 1885. The albums were purchased by the London dealers E. Parsons and Sons, from whom Charles Fairfax Murray evidently acquired the volume eventually purchased by Pierpont Morgan. As Peter Dreyer has observed, the Library's album originally bore the title *SOFITI* (Ceilings) and consisted almost entirely of pen-and-wash drawings of individual figures or figural groups seen from below.[1] Presumably it was Tiepolo himself who organized his drawings in this fashion, in all likelihood just prior to his 1762 departure from Venice for Madrid.

This sheet is one of three studies from the album that depict the apotheosis of Saint Dominic[2]; a fourth drawing of the same subject is in the Kupferstichkabinett, Berlin (Inv. no. KdZ 72510).[3] All four seem to have been executed in connection with *The Glory of Saint Dominic*, which Tiepolo frescoed in 1737–39 on the ceiling of the church of Santa Maria del Rosario (better known as the Gesuati) in Venice.[4]

Provenance
Count Bernardino Algarotti Corniani; Edward Cheney; sale, Sotheby's, London, 29 April 1885, part of no. 1024; Charles Fairfax Murray; purchased by Pierpont Morgan in 1910.

Selected bibliography and exhibitions
New York 1971, no. 66, repr.; Cambridge and New York 1996–97, no. 36, repr.

1. See Cambridge and New York 1996–97, pp. 317–30.
2. For the other two drawings (Inv. nos. IV, 99, and IV, 100), see Cambridge and New York 1996–97, nos. 36 and 37, repr.
3. Reproduced in Cambridge and New York 1996–97, p. 116, fig. 1.
4. The fresco is reproduced in Cambridge and New York 1996–97, p. 118, fig. 1.

Die Pierpont Morgan Library ist außergewöhnlich reich an Zeichnungen von Giovanni Battista Tiepolo. Mehr als 100 Blätter des Künstlers stammen aus einem der neun Künstleralben, die sich früher in der Sammlung Edward Cheneys befanden und 1885 bei Sotheby's in London als ein Posten versteigert wurden. Erstanden haben diese Alben die Londoner Kunsthändler E. Parsons and Sons, von denen Charles Fairfax Murray offensichtlich jenen Band erwarb, den Pierpont Morgan schließlich ankaufte. Wie Peter Dreyer festgestellt hat, trug das Album ursprünglich den Titel *SOFITI* (Decken) und enthielt fast ausschließlich lavierte Federzeichnungen von Einzelfiguren oder Figurengruppen in Untersicht.[1] Vermutlich war es Tiepolo selbst, der die Zeichnungen auf diese Weise ordnete, aller Wahrscheinlichkeit nach kurz vor seiner Abreise von Venedig nach Madrid im Jahr 1762.

Dieses Blatt ist eines von drei Studien des Albums, die die Apotheose des heiligen Dominikus schildern;[2] eine vierte Zeichnung desselben Themas befindet sich im Kupferstichkabinett in Berlin (KdZ 72510).[3] Alle vier scheinen im Zusammenhang mit seinem 1737 bis 1739 ausgeführten Deckenfresko *Die Aufnahme des heiligen Dominikus in den Himmel* in der Kirche Santa Maria del Rosario (bekannter als Chiesa dei Gesuati) in Venedig entstanden zu sein.[4]

1. Siehe Cambridge und New York 1996–97, S. 317–30.
2. Zu den anderen zwei Zeichnungen (Inv.-Nrn. IV, 99 und IV, 100) siehe Cambridge und New York 1996–97, Nrn. 36, 37, Abb.
3. Abgebildet in Cambridge und New York 1996–97, S. 116, Abb. 1.
4. Das Fresko ist abgebildet in Cambridge und New York 1996–97, S. 118, Abb. 1.

GIOVANNI BATTISTA TIEPOLO

(Venice 1696–1770 Madrid)

DESIGN FOR A CEILING: THE
TRIUMPH OF HERCULES

Pen and brown ink, brown wash, over
black chalk, with some corrections in
white gouache
459 x 606 mm
Watermark: none

Inscribed on verso in pen and brown
ink, *660–661*; in pencil, *Tiepolo G. B.*

Purchased as the Gift of the Fellows;
Acc. no. 1968.8

ENTWURF FÜR EIN DECKEN-
GEMÄLDE: DER TRIUMPH DES
HERKULES

Feder in Braun und braune Lavierung
über schwarzer Kreide, einige Korrek-
turen in weißer Gouache
459 x 606 mm
Kein Wasserzeichen

Verso mit Feder in Braun bezeichnet:
660-661; in Bleistift: *Tiepolo G. B.*

Erworben als Geschenk der Associa-
tion of Fellows; Inv.-Nr. 1968.8

This drawing is Tiepolo's only known design
for a ceiling that also represents the accom-
panying illusionistic architectural setting,
or *quadratura.* Such *quadratura* ordinarily
would have been designed and executed by a
specialist, and this drawing is thus problematic
in terms of attribution as well as function.
Nevertheless, Bernard Aikema has argued
strongly in favor of Tiepolo's authorship of
both the figures and the architectural surround
and has suggested that the sheet was drawn as
a *modello* to be submitted to the patron.[1] The
fresco itself seems never to have been executed,
but the style of the drawing points to a date in
the 1730s. Another sheet by Tiepolo, in the
Museo Horne, Florence (Inv. no. 6351), de-
picts almost the same figural composition but
without the elaborate architectural frame-
work.[2]

Provenance
Guggenheim, Venice; sale, Hugo Helbing, Munich,
30 September–4 October 1913, no. 1152, repr.; Adrien
Fauchier-Magnan; sale, Sotheby's, London, 4 December
1935, no. 55 (withdrawn); sale, Palais Galliéra, Paris,
16 June 1966, no. 7, repr.; Giancarlo Baroni, Florence;
Ettore Viancini, Venice.

Selected bibliography and exhibitions
New York 1971, p. 43, under no. 64, no. 69, repr.;
Morgan Library 1973, p. 122; Pignatti 1974, pl. XVIII;
Birmingham and Springfield 1978, p. 10, repr., no. 78;
New York 1981, no. 92, repr.; Cambridge and New
York 1996–97, no. 35, repr.

1. In Cambridge and New York 1996–97, p. 114.
2. Reproduced in Cambridge and New York 1996–97,
p. 115, fig. 1.

Diese Zeichnung ist der einzige bekannte
Entwurf Tiepolos für ein Deckengemälde, in
dem auch die rahmenden illusionistischen
Architekturelemente, die *quadratura,* darge-
stellt sind. Eine solche *quadratura* wird
gewöhnlich von einem Spezialisten entworfen
und ausgeführt, deshalb ergeben sich bei dieser
Zeichnung Probleme bezüglich ihrer Funktion
und der Zuschreibung. Trotzdem plädierte
Bernard Aikema sowohl bei den Figuren als
auch beim architektonischen Rahmen ent-
schieden für die Autorschaft Tiepolos; er nahm
an, daß das Blatt als ein *modello* zur Vorlage
beim Auftraggeber angefertigt wurde.[1] Das
eigentliche Fresko scheint niemals ausgeführt
worden zu sein, doch deutet der zeichnerische
Stil auf eine Entstehung in den 1730er Jahren
hin. Ein weiteres Blatt Tiepolos im Museo
Horne in Florenz (Inv.-Nr. 6351) weist bei-
nahe die gleiche figurale Komposition auf,
allerdings ohne das reiche architektonische
Rahmenwerk.[2]

1. In Cambridge und New York 1996–97, S. 114.
2. Abgebildet in Cambridge und New York 1996–97,
S. 115, Abb. 1.

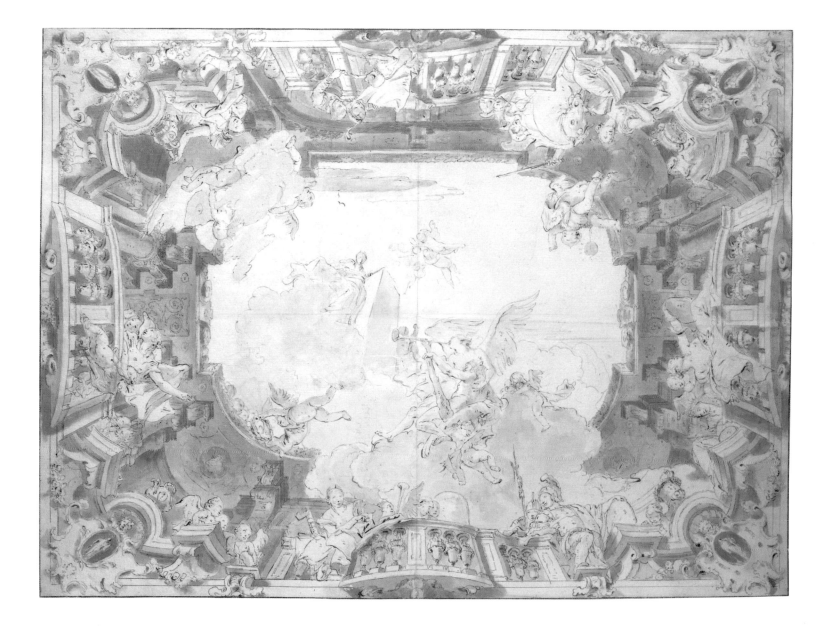

GIOVANNI BATTISTA TIEPOLO

(Venice 1696–1770 Madrid)

17

The Virgin and Child with
Saint Francis of Paola, an
Unidentified Saint, and
Saint Francis of Assisi

Pen and brown ink, brown wash, over
black chalk
352 x 257 mm
Watermark: none

Inscribed in black chalk at lower right,
Gio Batta Tiepolo Venez (?)

Janos Scholz Collection;
Acc. no. 1974.28

Madonna mit Kind, dem
heiligen Franziskus von
Paula, einem nicht iden-
tifizierten Heiligen und
dem heiligen Franziskus
von Assisi

Feder in Braun und braune Lavierung
über schwarzer Kreide
352 x 257 mm
Kein Wasserzeichen

Bezeichnet unten rechts in schwarzer
Kreide: *Gio Batta Tiepolo Venez* (?)

Sammlung Janos Scholz;
Inv.-Nr. 1974.28

As early as 1732, Tiepolo's first biographer, Vincenzo da Canal, wrote that the artist's drawings were "so highly esteemed that books of them were sent to the most distant countries."[1] It is entirely possible that such finished drawings as this one were made for sale to connoisseurs, rather than in connection with paintings or frescoes; at any rate, this drawing cannot be connected with a known picture. Nevertheless, it is closely related to several drawings of the Virgin and Child with saints in the Museo Civico, Trieste[2]; the Fogg Art Museum, Harvard University, Cambridge, Massachusetts (Inv. no. 1965.417)[3]; The Metropolitan Museum of Art, New York (Robert Lehman Collection, Inv. no. 1975.1.440)[4]; and elsewhere, which Bernard Aikema has recently characterized as "attempts at a new typology" of this type of composition.[5] On the basis of style, all these sheets can be dated to the mid-1730s.

Provenance
Prince Alexis Orloff (according to Janos Scholz; not in sale); Janos Scholz.

Selected bibliography and exhibitions
New York 1971, no. 71, repr. (with previous bibliography and exhibitions); Morgan Library 1976, p. 183; Scholz 1976, no. 135, repr.; Cambridge and New York 1996–97, no. 27, repr.

1. Quoted from Vincenzo da Canal, *Vita di Gregorio Lazzarini* (Venice, 1809), p. xxxii, in Cambridge and New York 1996–97, p. 13.
2. Vigni 1972, p. 62, no. 59.
3. Cambridge and New York 1996–97, no. 26, repr.
4. New York 1971, no. 70, repr.
5. Cambridge and New York 1996–97, p. 76, under no. 26.

Schon 1732 schrieb Tiepolos erster Biograph Vincenzo da Canal, daß die Zeichnungen des Künstlers »eine so hohe Wertschätzung erfahren, daß sie zu Büchern gebunden in die entferntesten Länder geschickt wurden«.[1] Es ist sehr gut möglich, daß ausgearbeitete Zeichnungen wie die vorliegende eher für den Verkauf an Kunstkenner als im Kontext eines Gemäldes oder Freskos angefertigt wurden; auf jeden Fall kann diese Zeichnung nicht mit einem bekannten Bild in Verbindung gebracht werden. Sie ist dennoch eng verwandt mit verschiedenen Zeichnungen: der Madonna mit Kind und Heiligen des Museo Civico, Triest,[2] des Fogg Art Museum, Harvard University, Cambridge, Massachusetts (Inv.-Nr. 1965.417),[3] des Metropolitan Museum of Art, New York (Robert Lehman Collection, Inv.-Nr. 1975.1.440),[4] und anderen, die Bernard Aikema jüngst als »Versuche einer neuen Typologie« dieser Art von Komposition beschrieben hat.[5] Dem Stil nach datieren alle diese Blätter aus der Mitte der 1730er Jahre.

1. Zitiert nach Vincenzo da Canal, *Vita di Gregorio Lazzarini* (Venedig 1809), S. xxxii, in Cambridge und New York 1996–97, S. 13.
2. Vigni 1972, S. 62, Nr. 59.
3. Cambridge und New York 1996–97, Nr. 26, Abb.
4. New York 1971, Nr. 70, Abb.
5. Cambridge und New York 1996–97, S. 76, unter Nr. 26.

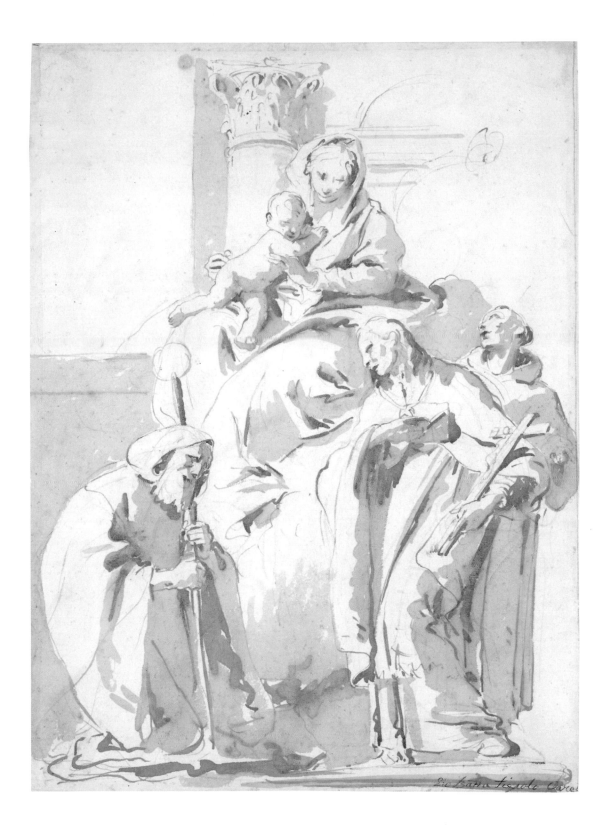

GIOVANNI BATTISTA TIEPOLO
(Venice 1696–1770 Madrid)

18

Two Zephyrs with a Horse
of Apollo

Pen and brown ink, brown wash, over
black chalk
245 x 389 mm
Watermark: none

Purchased by Pierpont Morgan;
Acc. no. IV, 120

Zwei Zephyre mit einem
Pferd Apollos

Feder in Braun, braune Lavierung über
schwarzer Kreide
245 x 389 mm
Kein Wasserzeichen

Erworben von Pierpont Morgan;
Inv.-Nr. IV, 120

In 1740 Antonio Giorgio Clerici commissioned Tiepolo to fresco the ceiling of the long gallery of his palace in Milan. An extraordinary series of preparatory drawings, many of them preserved in the Morgan Library, The Metropolitan Museum of Art, New York, and the Museo Horne, Florence, has been connected with either the fresco, which represents Apollo, the gods of Olympus, the Four Continents, and the Seasons, or the related oil sketch on canvas, now in the Kimbell Art Museum, Fort Worth.[1] This important group of drawings—all of which are in pen and ink with brown or golden brown wash over extremely free preliminary indications in black chalk—is among Tiepolo's supreme achievements as a draughtsman.

This sketch, which represents two winged female figures with one of the horses of Apollo, corresponds closely to a passage at the lower center of the oil sketch.

Provenance
Count Bernardino Algarotti Corniani; Edward Cheney; sale, Sotheby's, London, 29 April 1885, part of no. 1024; E. Parsons and Sons, London; Charles Fairfax Murray; purchased by Pierpont Morgan in 1910.

Selected bibliography and exhibitions
Fairfax Murray 1905–12, vol. 4, no. 120; Cambridge 1970, no. 19, repr.; New York 1971, no. 79, repr.; Cambridge and New York 1996–97, no. 42, repr.

1. See Cambridge and New York 1996–97, no. 38, repr., colorplate 2 (the image is reversed).

Antonio Giorgio Clerici beauftragte Tiepolo 1740 mit der Ausführung eines Deckenfreskos in der langgestreckten Galerie seines Stadtpalastes in Mailand. Eine außergewöhnliche Serie von Vorstudien – viele von ihnen befinden sich in der Pierpont Morgan Library, im Metropolitan Museum in New York und dem Museo Horne in Florenz – wurden entweder mit dem Fresko, das Apollo, die Götter des Olymp, die vier Kontinente und die Jahreszeiten darstellt, oder aber mit der entsprechenden auf Leinwand gemalten Ölskizze, heute im Kimbell Art Museum in Fort Worth, in Zusammenhang gebracht.[1] Diese bedeutende Gruppe von Zeichnungen, die alle mit Feder, brauner oder goldbrauner Lavierung über einer äußerst freien Vorzeichnung in schwarzer Kreide ausgeführt wurden, zählt zu den Höhepunkten der Zeichenkunst Tiepolos.

Der vorliegende Entwurf, der zwei geflügelte weibliche Figuren mit einem der Pferde Apollos zeigt, entspricht genau einer Passage im unteren Mittelteil der Ölskizze.

1. Siehe Cambridge und New York 1996–97, Nr. 38, Abb. Farbtafel 2 (das Bild ist seitenverkehrt).

72

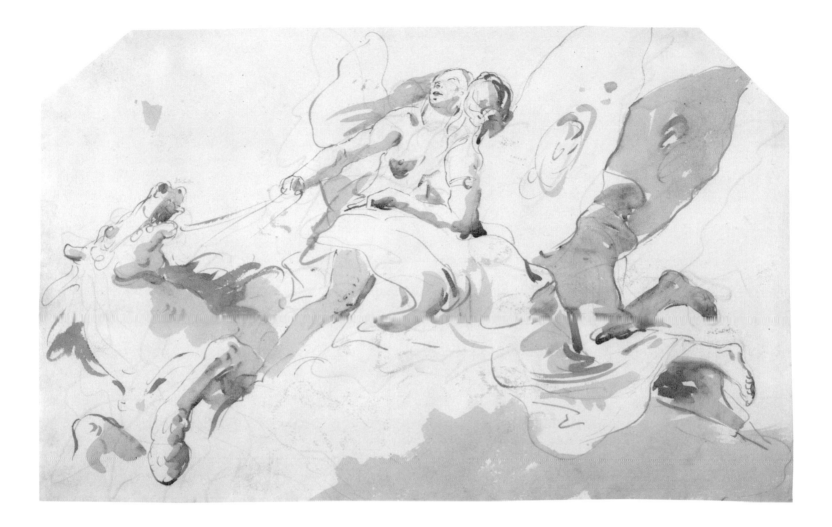

GIOVANNI BATTISTA TIEPOLO
(Venice 1696–1770 Madrid)

19

TIME AND CUPID

Pen and brown ink, brown wash, over
black chalk
270 x 315 mm
Watermark: none

Purchased by Pierpont Morgan;
Acc. no. IV, 125

KRONOS UND AMOR

Feder in Braun, braune Lavierung über
schwarzer Kreide
270 x 315 mm
Kein Wasserzeichen

Erworben von Pierpont Morgan;
Inv.-Nr. IV, 125

The shape of the Palazzo Clerici ceiling differs considerably from that of the related oil sketch in Fort Worth (see No. 18). Whether or not this is because Antonio Giorgio Clerici changed his mind about which room in the palace the artist was to paint—as Bernard Aikema has recently suggested[1]—the long, narrow proportions of the gallery evidently required Tiepolo to rethink the design of the ceiling. It was presumably at this time that the artist executed further preparatory drawings, in which he developed motifs that appear in the fresco but not in the oil sketch.

This luminous study was utilized with very few changes for the figures of Time and Cupid, who appear seated upon clouds and to the right of Venus on the south side of the fresco. Additional studies for the figure of Time, all formerly in the collection of the marquis de Biron and not as close to the finished work, are in The Metropolitan Museum of Art, New York (Inv. nos. 37.165.7, 37.165.9, and 37.165.12).[2]

Provenance
Count Bernardino Algarotti Corniani; Edward Cheney; sale, Sotheby's, London, 29 April 1885, part of no. 1024; E. Parsons and Sons, London; Charles Fairfax Murray; purchased by Pierpont Morgan in 1910.

Selected bibliography and exhibitions
Fairfax Murray 1905–12, vol. 4, no. 125; Benesch 1947, no. 30, repr.; New York 1971, no. 91, repr.; New York 1981, no. 91, repr.; Barcham 1992, p. 31, fig. 23; Cambridge and New York 1996–97, no. 44, repr.

1. In Cambridge and New York 1996–97, p. 121, under no. 38.
2. Reproduced in Bean and Griswold 1990, nos. 205, 204, and 206, respectively.

Die Form der Decke des Palazzo Clerici unterscheidet sich deutlich von der korrespondierenden Ölskizze in Fort Worth (vgl. Kat.-Nr. 18). Es mag sein, daß Antonio Giorgio Clerici seine Meinung darüber änderte, welchen Raum des Stadtpalastes der Künstler ausmalen sollte, wie Bernard Aikema kürzlich vorschlug,[1] jedenfalls nötigten die langgestreckten, engen Proportionen der Galerie Tiepolo zu einer Überarbeitung des Deckenentwurfs. Wohl zu diesem Zeitpunkt führte der Künstler weitere Vorzeichnungen aus, in denen er Motive entwickelte, die zwar im Fresko, nicht aber in der Ölskizze erscheinen.

Bis auf wenige Veränderungen wurde diese brillante Studie auf der Südseite des Freskos für die Figuren von Kronos und Amor verwendet, die auf Wolken und zur Rechten der Venus sitzen. Weitere Studien zur Gestalt des Kronos, die früher alle der Sammlung des Marquis de Biron angehörten und deren Nähe zum vollendeten Werk nicht so groß ist, befinden sich heute im Metropolitan Museum in New York (Inv.-Nrn. 37.165.7, 37.165.9, 37.165.12).[2]

1. In Cambridge und New York 1996–97, S. 121, unter Nr. 38.
2. Abgebildet in Bean und Griswold 1990, Nrn. 205, 204 beziehungsweise 206.

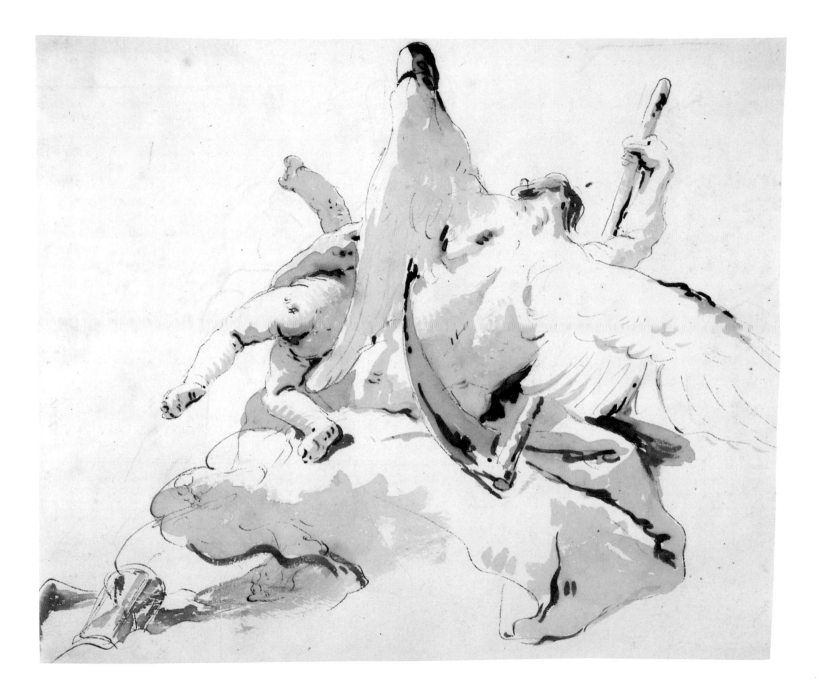

GIOVANNI BATTISTA TIEPOLO

(Venice 1696–1770 Madrid)

NOBILITY AND VIRTUE

Pen and black ink, gray wash, over
black chalk
250 x 250 mm
Watermark: none

Purchased by Pierpont Morgan;
Acc. no. IV, 108

ALLEGORIE DER EHREN-
HAFTIGKEIT UND TUGEND

Feder in Schwarz, graue Lavierung
über schwarzer Kreide
250 x 250 mm
Kein Wasserzeichen

Erworben von Pierpont Morgan;
Inv.-Nr. IV, 108

During the 1740s Tiepolo treated the subject of Nobility and Virtue in a series of canvases and frescoes for villas and palaces in and around Venice. The figures appear together in ceiling paintings or frescoes in the Palazzo Scotti Gallarati, Milan; the Palazzo Caiselli, Udine (now in the Museo Civico); the Villa Cordellina, Montecchio Maggiore; the Palazzo Barbarigo, Venice (now in the Ca' Rezzonico); and the Palazzo Manin, Venice (now in the Norton Simon Museum, Pasadena). In these works Nobility is personified as a woman holding a statuette of Minerva and Virtue as a winged woman who carries a lance and has the disk of the sun on her breast.

This drawing is one of four stylistically identical studies of Nobility and Virtue that were acquired by Pierpont Morgan with the collection of Charles Fairfax Murray in 1910.[1] While Tiepolo took certain liberties with the figures' attributes, all four sheets are unquestionably related to his various painted versions of the theme. Although none of the Library's drawings corresponds exactly to any of Tiepolo's paintings or frescoes, Bernard Aikema has convincingly argued that they may have been drawn in 1743 and utilized in connection with more than one of these projects.[2]

Provenance
Count Bernardino Algarotti Corniani; Edward Cheney; sale, Sotheby's, London, 29 April 1885, presumably part of no. 1024; E. Parsons and Sons, London; Charles Fairfax Murray; purchased by Pierpont Morgan in 1910.

Selected bibliography and exhibitions
Fairfax Murray 1905–12, vol. 4, no. 108, repr.; New York 1971, no. 105, repr.; Cambridge and New York 1996–97, no. 52, repr.

1. Inv. nos. IV, 106; IV, 107; IV, 108; and IV, 133a.
2. Cambridge and New York 1996–97, p. 144, under no. 50.

In den 1740er Jahren behandelte Tiepolo das Thema der Ehrenhaftigkeit und Tugend in einer Serie von Gemälden und Fresken für Villen und Paläste in und um Venedig. Die Figuren erscheinen gemeinsam auf Deckenmalereien oder -fresken des Palazzo Scotti Gallarati in Mailand und des Palazzo Caiselli in Udine (heute im Museo Civico), der Villa Cordellina in Montecchio Maggiore, dem Palazzo Barbarigo (heute in der Ca' Rezzonico) und dem Palazzo Manin in Venedig (heute im Norton Simon Museum, Pasadena). In diesen Werken wird die Allegorie der Ehrenhaftigkeit von einer Frau verkörpert, die eine Minerva-Statuette hält; die Tugend tritt als geflügelte weibliche Gestalt auf, die eine Lanze mit sich führt und auf der Brust eine Sonnenscheibe trägt.

Unsere Zeichnung ist eine von vier stilistisch identischen Studien zur Ehrenhaftigkeit und Tugend, die Pierpont Morgan 1910 mit der Charles Fairfax Murray Collection erwarb.[1] Obwohl Tiepolo sich gewisse Freiheiten bei den Attributen der Figuren erlaubte, stehen alle vier Zeichnungen zweifelsohne in Beziehung zu den verschiedenen gemalten Fassungen des Themas. Wenn auch keine Zeichnung der Pierpont Morgan Library genau mit einem von Tiepolos Gemälden oder Fresken übereinstimmt, hat Bernard Aikema überzeugend dargelegt, daß sie offenbar 1743 angefertigt wurden und in Verbindung mit mehr als einem dieser Projekte Verwendung fanden.[2]

1. Inv.-Nrn. IV, 106; IV, 107; IV, 108 und IV, 133a.
2. Cambridge und New York 1996–97, S. 144, unter Nr. 50.

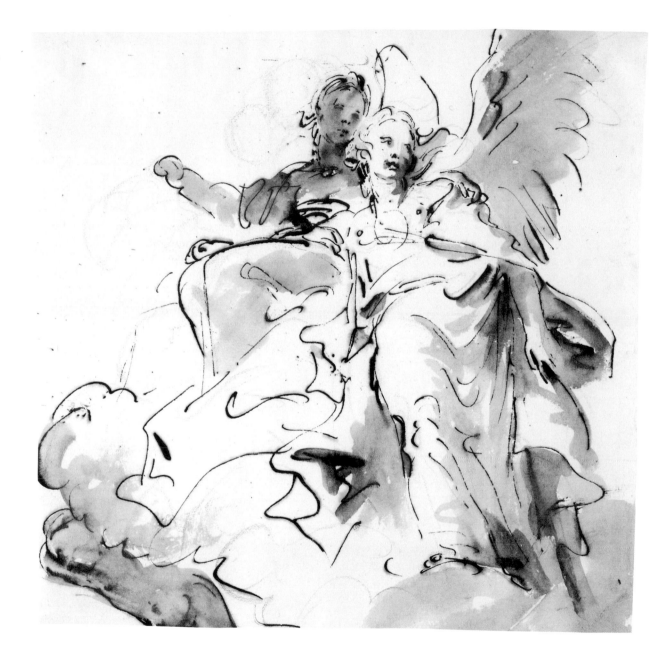

FRANCESCO GUARDI

(Venice 1712–1793 Venice)

21

The Bucintoro on the Way to the Lido on Ascension Day

Pen and brown ink, brown wash, over traces of black chalk
426 x 702 mm
Watermark: the letters *FV* surmounted by three stars

Inscribed in pen and brown ink at lower left, *S. Nicolo de Lido D.° 1 S. Servolo D.° 3 malamoco D.° 5 / S. Lasero D.° 2 Chioza D.° 4 e*

Purchase; Acc. no. 1978.15

Der Bucintoro auf dem Weg zum Lido am Himmelfahrtstag

Feder in Braun, braune Lavierung über Spuren von schwarzer Kreide
426 x 702 mm
Wasserzeichen: Buchstaben *FV*, darüber drei Sterne

Bezeichnet unten links mit Feder in Braun: *S. Nicolo de Lido D.° 1 S. Servolo D.° 3 malamoco D.° 5 / S. Lasero D.° 2 Chioza D.° 4 e*

Ankauf; Inv.-Nr. 1978.15

Until 1789 the symbolic marriage of Venice to the Adriatic was celebrated every year on the Feast of the Ascension, upon which the doge journeyed to the Lido in the state barge, the Bucintoro, to toss a consecrated ring into the sea. The spectacle was depicted by Guardi in a number of paintings and sketches, including this sheet and another large pen-and-wash drawing, also in the Morgan Library (Acc. no. 1947.2), which is a study for a painting of the early 1780s that was formerly in the collection of Alessandro Brass, Venice.[1] Both drawings represent the Bucintoro accompanied by a state galley and numerous gondolas, with the church of San Niccolò di Lido in the distance. However, the present drawing may have been conceived not as a study for a painting but either as an independent work of art or—as the topographical key at the lower left would suggest—in connection with an unexecuted engraving.[2] The composition of the drawing repeats that of a painting formerly in the collection of Mario Crespi, Milan.[3]

Provenance
Mrs. Herbert N. Straus.

Selected bibliography and exhibitions
Byam Shaw 1954, p. 165, no. 8, fig. 6; New York 1971, no. 196, repr.; Morassi 1975, no. 285, fig. 285; Morgan Library 1981, pp. 196–97.

1. See Morassi 1975, no. 283, fig. 287 (the drawing); Morassi 1973, no. 289, fig. 318 (the painting).
2. Byam Shaw 1954, p. 165.
3. See Morassi 1973, no. 283, fig. 313.

Bis 1789 wurde an Christi Himmelfahrt alljährlich die symbolische Hochzeit Venedigs mit dem Adriatischen Meer feierlich begangen; dabei fuhr der Doge in seiner Staatsbarke, dem *Bucintoro*, zum Lido und warf dort einen geweihten Ring ins Meer. Dieses Schauspiel hielt Guardi in zahlreichen Gemälden und Skizzen fest, darunter in diesem Blatt und einer weiteren lavierten Federzeichnung, die sich ebenfalls in der Pierpont Morgan Library (Inv.-Nr. 1947.2) befindet. Letztere ist eine Studie für ein Gemälde aus den frühen 1780er Jahren, das früher der Sammlung von Alessandro Brass in Venedig angehört hat.[1] Beide Zeichnungen zeigen den von einer Staatsgaleere und zahlreichen Gondeln begleiteten *Bucintoro* mit der Kirche San Niccolò di Lido in der Ferne. Jedoch ist die vorliegende Zeichnung wohl nicht als Vorstudie für ein Gemälde konzipiert, sondern entweder als autonomes Kunstwerk oder – wie es die topographische Erläuterung am unteren linken Rand nahelegt – im Hinblick auf eine nicht ausgeführte Radierung.[2] Die Komposition der Zeichnung wiederholt die eines Gemäldes, das sich früher in der Sammlung von Mario Crespi in Mailand befunden hat.[3]

1. Siehe Morassi 1975, Nr. 283, Abb. 287 (die Zeichnung); Morassi 1973, Nr. 289, Abb. 318 (das Gemälde).
2. Byam Shaw 1954, S. 165.
3. Siehe Morassi 1973, Nr. 283, Abb. 313.

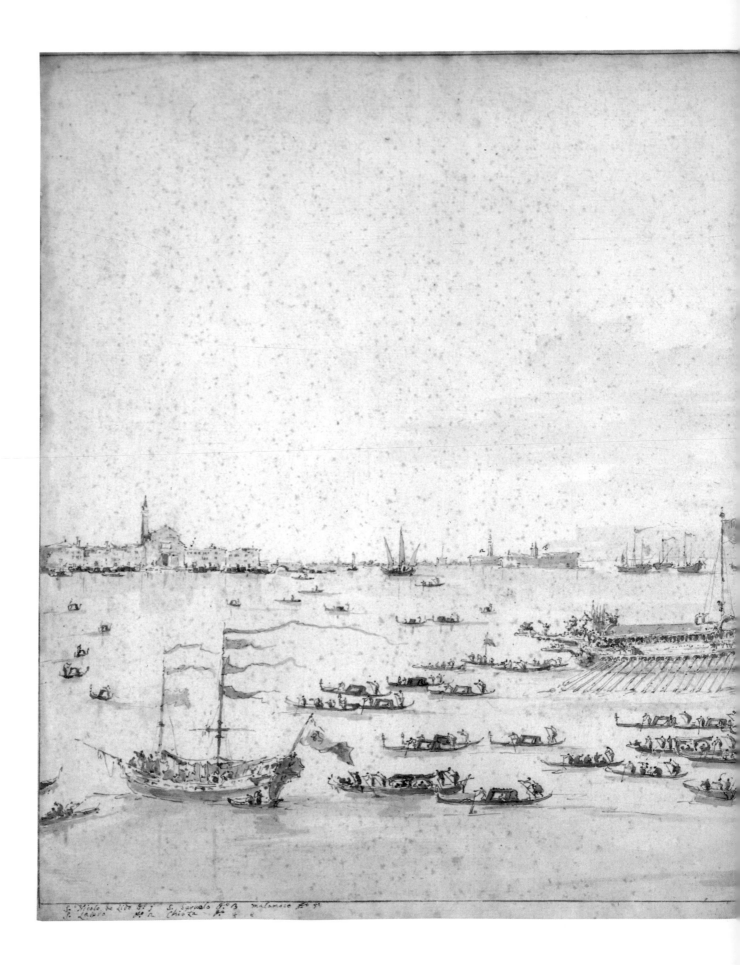

S.ta Nicolo de Lido &.c j S. Spirito q.o 13 malamoco fe: 5:
S. Lazaro do h. Chiozza fi: 4 c

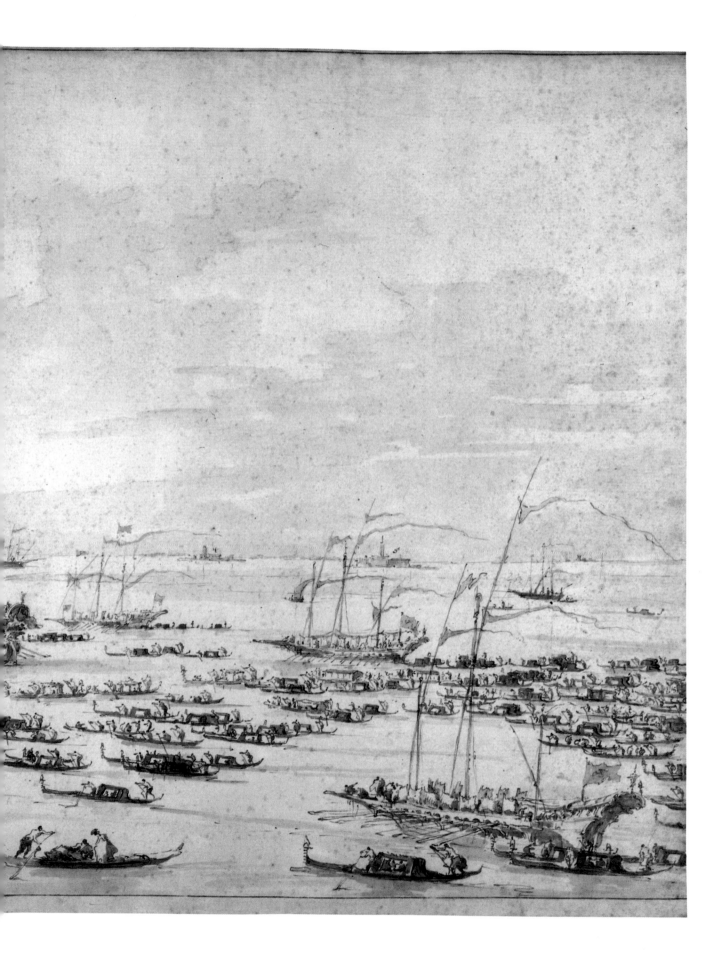

FRANCESCO GUARDI
(Venice 1712–1793 Venice)

BALLAD SINGER ON THE
PIAZZETTA

Pen and dark brown ink, over traces of
black chalk, on gray-brown paper;
lined
212 x 385 mm
Watermark: none visible through
lining

Inscribed in pen and brown ink at
lower left, *Parte della Piazzetta e
punta di S. Giorgio Maggiore*

Purchased by Pierpont Morgan;
Acc. no. I, 78c

BALLADENSÄNGER AUF DER
PIAZZETTA

Feder in Dunkelbraun über Spuren
von schwarzer Kreide auf
graubraunem Papier; aufgezogen
212 x 385 mm
Wasserzeichen: nicht erkennbar auf-
grund der Montierung

Bezeichnet unten links mit Feder in
Braun: *Parte della Piazzetta e punta di
S. Giorgio Maggiore*

Erworben von Pierpont Morgan;
Inv.-Nr. I, 78c

This drawing, executed with dazzling virtuos-
ity in pen and ink without the usual addition
of wash, represents a crowd gathered before a
ballad singer who has set up his standard in
front of Jacopo Sansovino's Libreria, opposite
the Palazzo Ducale, Venice. A corner of the
lower part of the Campanile is visible on the
right. Guardi depicted similar views with dif-
ferent staffage in other drawings,[1] while a
painting of a ballad singer on the Piazzetta is in
the Ca' d'Oro, Venice.[2]

Provenance
Charles Fairfax Murray; purchased by Pierpont
Morgan in 1910.

Selected bibliography and exhibitions
Benesch 1947, no. 57, repr.; Houston 1958, no. 38,
repr.; Venice 1965, no. 45, repr.; New York 1971,
no. 191, repr.; Morassi 1975, no. 341, Fig. 339.

1. For example, Paris, Musée du Louvre, Département
des Arts Graphiques, Inv. no. R. F. 629; see Morassi
1975, no. 340, fig. 338.
2. See Morassi 1973, no. 371, fig. 399.

Diese Zeichnung, in bewundernswerter Vir-
tuosität mit Feder ohne die übliche Lavierung
ausgeführt, zeigt eine Menschenansammlung
um einen Balladensänger, der seine Standarte
vor der Libreria Jacopo Sansovinos in Venedig,
gegenüber dem Palazzo Ducale, aufgestellt hat.
Rechts ist eine Ecke des unteren Teils des
Campaniles zu erkennen. Guardi stellte ver-
gleichbare Ansichten mit ähnlicher Staffage in
anderen Zeichnungen dar;[1] ein Gemälde mit
einem Balladensänger auf der Piazzetta befin-
det sich in der Ca' d'Oro in Venedig.[2]

1. Zum Beispiel Paris, Musée du Louvre, Départe-
ment des Arts Graphiques, Inv.-Nr. R. F. 629; siehe
Morassi 1975, Nr. 340, Abb. 338.
2. Siehe Morassi 1973, Nr. 371, Abb. 399.

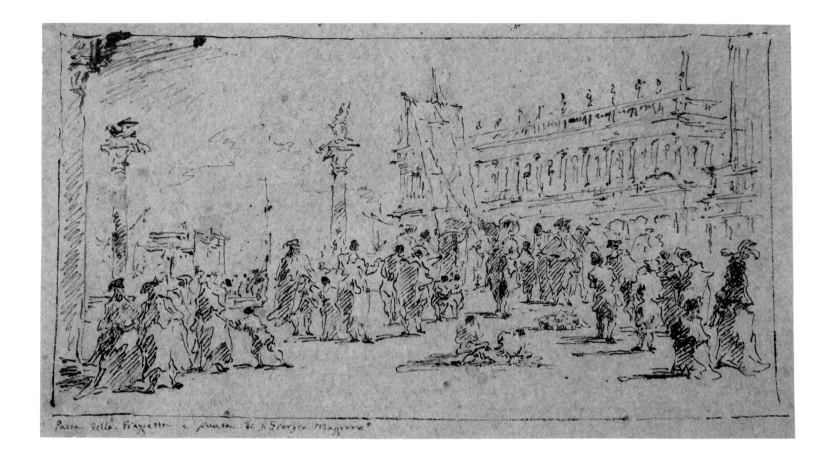

Parte della Piazzetta e punta di S. Giorgio Maggiore

GIOVANNI BATTISTA PIRANESI
(Mogliano Veneto 1720–1778 Rome)

DESIGN FOR A TITLE PAGE

Pen and brown ink, brown wash, over
black chalk; smudges of red chalk
Verso: Study of standing male nude in
black chalk
395 x 519 mm
Watermark: fleur-de-lis in circle with
letters $C^A C$ above and letter F below

Bequest of the late Junius S. Morgan
and gift of Henry S. Morgan;
Acc. no. 1966.11:7

ENTWURF FÜR EIN TITELBLATT

Feder in Braun, braune Lavierung über
schwarzer Kreide; Flecken von Rötel
Verso: Studie zu einem stehenden,
männlichen Akt in schwarzer Kreide
395 x 519 mm
Wasserzeichen: Lilien in einem Kreis,
darüber die Buchstaben $C^A C$ und
darunter F

Nachlaß des verstorbenen Junius S.
Morgan und Geschenk von Henry S.
Morgan; Inv.-Nr. 1966.11:7

Following his return to Venice from Rome in
1744, Piranesi came under the influence of
such artists as Canaletto, Marco Ricci, and
most importantly, Giambattista Tiepolo. The
combined influence of Venice and Rome are
evident not only in individual motifs but in the
handling and technique of this sheet as well.
The drawing probably was executed sometime
after 1744, placing it close to when Piranesi be-
gan producing elaborate title pages and fron-
tispieces for his series of etchings. While the
large size, elaborate composition, and style re-
lates it to the artist's etchings, there is only a
very loose relationship between this sheet and
his four etchings, the *Grotteschi,* particularly
The Monumental Tablet. The drawing pre-
sumably was not made in Venice since, as An-
drew Robison has pointed out, it is executed
on what appears to be central Italian paper.[1]

The black chalk nude on the verso is a
large-scale counterpart of the *ignudi* found on
another drawing in the Library's collection,
the *Gondola* (Acc. no. 1966.11:10). Since the
top of the head, hands, and feet of the nude are
missing, it is possible that the sheet was cut
down at some point. This seems to be con-
firmed by certain details of the recto, particu-
larly the wing that has been cut off at the left
and the crown at the top of the sheet.

Provenance
Mrs. J. P. Morgan, New York; her sons, Junius S.
Morgan and Henry S. Morgan, New York.

Selected bibliography and exhibitions
Robison 1977, pp. 387, 400, n. 5; Stampfle 1978, no. 7,
repr.; Washington 1978, p. 31, no. 1; Robison 1986,
p. 27, fig. 29; Montreal 1993–94, no. 18 (includes full
bibliography and exhibitions).

1. Robison 1986, p. 27.

Nach seiner Rückkehr aus Rom nach Venedig
im Jahr 1744 beeinflußten Piranesi Künstler
wie Canaletto, Marco Ricci und insbesondere
Giambattista Tiepolo. Der vereinte Einfluß
von Venedig und Rom wird in dieser Zeich-
nung nicht nur an Einzelmotiven, sondern
auch an der technischen Ausführung sichtbar.
Vermutlich wurde sie nach 1744 geschaffen,
um die Zeit, als Piranesi begann, kunstvolle
Titelblätter und Frontispize für seine Radier-
folgen zu entwerfen. Obwohl sie in bezug auf
ihr großes Format, die Ausarbeitung der Kom-
position und den zeichnerischen Stil den
Radierungen des Künstlers nahesteht, existiert
nur eine schwache Verbindung zwischen die-
sem Blatt und den vier Radierungen Piranesis,
den *Grotteschi,* insbesondere zu dem Blatt *Die
Grabplatte.* Wie Andrew Robison nachweisen
konnte, ist diese Zeichnung nicht in Venedig
entstanden, denn das Papier scheint aus Mittel-
italien zu stammen.[1]

Bei dem rückseitigen Akt in schwarzer
Kreide handelt es sich um ein großformatiges
Gegenstück zu einem der *ignudi,* die sich auf
einer anderen Zeichnung der Sammlung der
Pierpont Morgan Library befinden: der *Gon-
del* (Inv.-Nr. 1966.11:10). Da der obere Teil des
Kopfes, die Hände und die Füße des Aktes
fehlen, ist es möglich, daß das Blatt irgend-
wann beschnitten wurde. Diese Vermutung
scheinen auch gewisse Details der Vorderseite
zu bestätigen, insbesondere der abgeschnittene
Flügel auf der linken Seite und die Krone am
oberen Rand.

1. Robison 1986, S. 27.

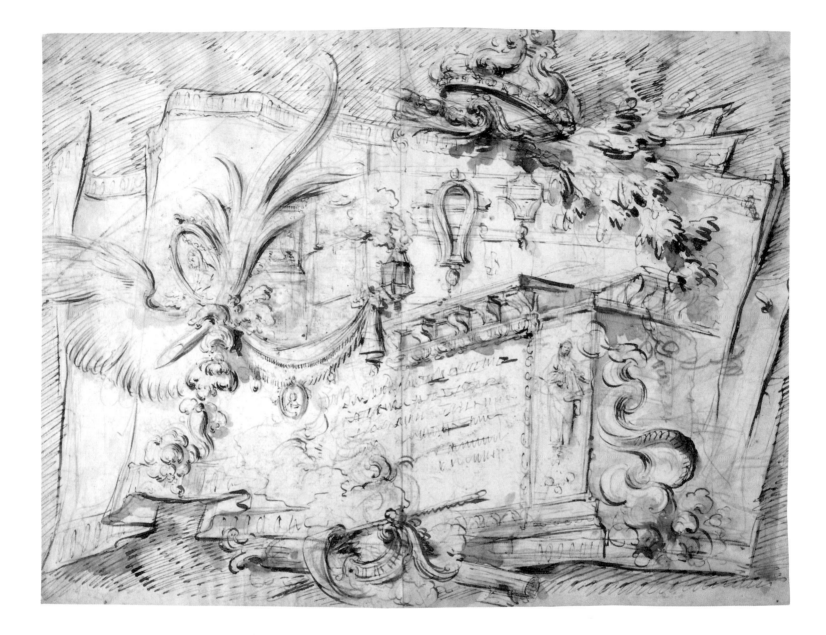

GIOVANNI BATTISTA PIRANESI
(Mogliano Veneto 1720–1778 Rome)

CAPRICCIO

Pen and brown ink, brown wash, over
black chalk
367 x 511 mm
Watermark: bow and arrow (Robison
1986, watermark 50)

Inscribed at lower left, *tronco / grande /
per terra / ò sia terreno;* at lower center,
two illegible words

Bequest of the late Junius S. Morgan
and gift of Henry S. Morgan;
Acc. no. 1966.11:9

CAPRICCIO

Feder in Braun, braune Lavierung über
schwarzer Kreide
367 x 511 mm
Wasserzeichen: Pfeil und Bogen
(Robison 1986, Wasserzeichen 50)

Bezeichnet unten links: *tronco / grande /
per terra / ò sia terreno;* unten Mitte:
zwei unleserliche Wörter

Nachlaß Junius S. Morgan und
Geschenk von Henry S. Morgan;
Inv.-Nr. 1966.11:9

Giambattista Tiepolo's *Vari capricci, Scherzi,*
and his ten *Capricci,* the prints published by
Zanetti in 1743 and again in 1749, were an important source of inspiration for Piranesi's
four impressive fantasies, the etched *Grotteschi,* which date from 1747 to 1749. Like No.
23, this drawing is related in mood and even
space to the *Grotteschi.* It is not directly connected with any one print, but it is important
to point out that the size of the drawing is almost identical with those prints. Individual
motifs—water pouring from a vase, the fallen
columns, and the crouching animal-like forms—
appear in somewhat different form in the etching *The Skeletons.* The lower part of the
present drawing has been cut off, possibly
eliminating the bones that appear in the foreground of the etching. The way in which Piranesi has carefully worked out the light and
shade in the background is also close to the
etching. In the drawing, light areas are contrasted with areas of rapidly applied wash and
loosely scribbled pen hatching similar to the
graphic vocabulary of the etching.

Andrew Robison has pointed out that although the foreground details are reminiscent
of the *Grotteschi,* the background buildings
and surrounding arcade can be related to Piranesi's more strictly architectural fantasies, the
earlier *Tempio antico,* for instance, in the *Prima parte,* and his later *Ponte Magnifico.* Indeed, the watermark on this drawing is the
same as that of No. 23, dating from about 1747
to 1749.

Provenance
Mrs. J. P. Morgan, New York; her sons, Junius S.
Morgan and Henry S. Morgan, New York.

Selected bibliography and exhibitions
Robison 1977, pp. 387, 400, no. 5; Stampfle 1978,
no. 9, repr.; Washington 1978, p. 38, no. 15; Robison
1986, p. 30, fig. 33, under no. 21; Montreal 1993–94,
no. 20 (includes full bibliography and exhibitions).

Giambattista Tiepolos Druckgraphiken *Vari
Capricci, Scherzi di fantasia* und die zehn
Capricci, von Zanetti erstmals 1743 und nochmals 1749 publiziert, waren eine wichtige
Inspirationsquelle für die eindrucksvollen vier
»Phantasien« Piranesis, die radierten *Grotteschi*
aus den Jahren 1747 bis 1749. Wie Kat.-Nr. 23
ist auch diese Zeichnung in bezug auf Stimmung und räumliche Gestaltung verwandt mit
den *Grotteschi.* Es besteht zwar kein direkter
Zusammenhang mit einer der Druckgraphiken, aber es ist wichtig darauf hinzuweisen,
daß die Maße dieser Zeichnung mit denen der
Graphiken nahezu identisch sind. Einzelne
Motive wie das aus einer Vase herunterfließende Wasser, die umgestürzten Säulen und
die kauernden, tierartigen Gestalten erscheinen in wenig abgewandelter Form in der
Radierung *Die Skelette.* Der untere Teil der
vorliegenden Zeichnung ist beschnitten, möglicherweise um die im Vordergrund der Radierung liegenden Gebeine zu eliminieren. Auch
Piranesis sorgfältige Ausarbeitung von Licht
und Schatten im Hintergrund entspricht derjenigen der Radierung. In der Zeichnung
kontrastieren leuchtende Flächen mit solchen
von rasch aufgetragener Lavierung und locker
hingeworfener Federschraffur, vergleichbar mit
dem graphischen Vokabular der Radierung.

Andrew Robison hat hervorgehoben, daß,
obgleich die Details des Vordergrundes an diejenigen der *Grotteschi* erinnern, die Gebäude
im Hintergrund und die umlaufende Arkade
mit Piranesis stärker architektonisch ausgerichteten »Phantasien« in Beziehung gesetzt
werden können, zum Beispiel mit dem früheren *Tempio antico* aus der *Prima Parte* und
dem späteren *Ponte Magnifico.* Tatsächlich ist
das Wasserzeichen dieser Zeichnung identisch
mit dem der Kat.-Nr. 23 und ist um die Jahre
1747 bis 1749 zu datieren.

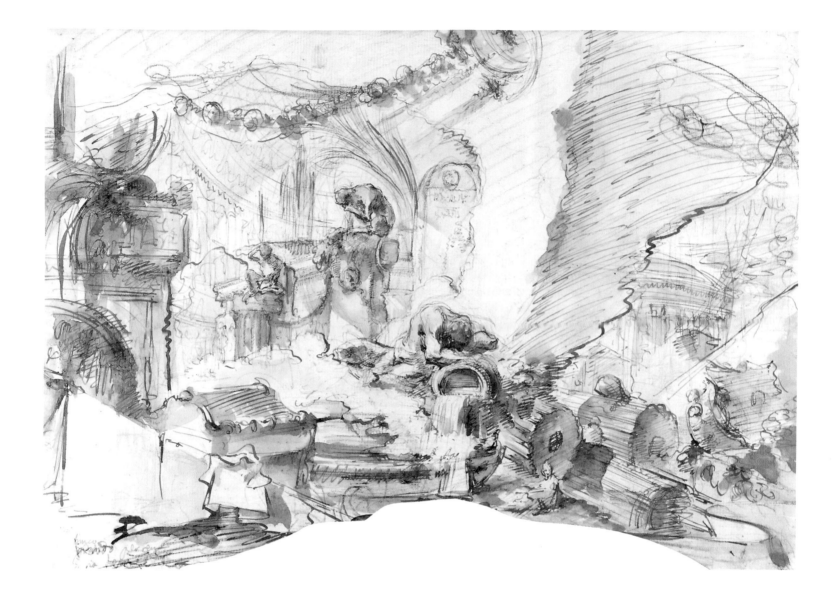

GIOVANNI BATTISTA PIRANESI

(Mogliano Veneto 1720–1778 Rome)

25

SHEET OF SKETCHES AFTER FISCHER VON ERLACH

Pen and brown ink
Verso: Rough copy of the right side of the garden and buildings of Schönbrunn and a section of Trajan's column
418 x 283 mm
Watermark: fragment of a fleur-de-lis in double circle

Extensively inscribed with descriptions of monuments, vases, temples, etc., taken from Fischer von Erlach's *Entwurff einer historischen Architectur*[1]

Bequest of the late Junius S. Morgan and gift of Henry S. Morgan; Acc. no. 1966.11:17

SKIZZENBLATT NACH FISCHER VON ERLACH

Feder in Braun
Verso: flüchtige Kopie der rechten Seite des Parkes und Schlosses von Schönbrunn und Teil der Trajanssäule
418 x 283 mm
Wasserzeichen: Fragment einer Lilie im Doppelkreis

Ausführlich bezeichnet mit Beschreibungen von Monumenten, Vasen, Tempeln etc., übernommen aus Fischer von Erlachs *Entwurff einer historischen Architectur*[1]

Nachlaß Junius S. Morgan und Geschenk von Henry S. Morgan; Inv.-Nr. 1966.11:17

This drawing and another in the Library's collection (Acc. no. 1966.11:18) are copies Piranesi made after details from the Austrian architect Fischer von Erlach's *Entwurff einer historischen Architectur,* published in Vienna in 1721. Fischer's pictorial history, which included Oriental as well as ancient buildings, was one of the first surveys of world architecture. Piranesi may have encountered the book through his first patron, the Venetian builder Nicola Giobbe, who opened his library to the young artist and introduced him to leading architects, among them Luigi Vanvitelli.[2] Fischer's attempt to imaginatively reconstruct antique buildings clearly had a formative influence on Piranesi, who likewise became fascinated with publishing reconstructions of ancient buildings as well as modern ones.

In copying Fischer's designs Piranesi worked his way through the book systematically, beginning at the upper left-hand side of the sheet and working down the page. He reproduced fairly accurately the central motif of each plate that interested him, including such monuments as the Mausoleum of Artemisia at Halicarnassus, the Temple of Diana at Ephesus, the Temple of Nineveh, the Pyramids of the Tomb of Sotis, and the Obelisk of Marcus Aurelius and Lucius Verus at Corinth. In many cases, he included an inscription to describe an aspect of its decoration in more detail and in a few places changed the orientation of a column or details of a monument.

Provenance
Mrs. J. P. Morgan, New York; her sons, Junius S. Morgan and Henry S. Morgan, New York.

Selected bibliography and exhibitions
Stampfle 1978, no. 17, repr.; Wilton-Ely 1978, p. 15, no. 12, repr.; Robison 1986, p. 14, fig. 8; Montreal 1993–94, no. 23 (includes full bibliography and exhibitions).

1. For a full transcription of the inscriptions and their relationship to Fischer von Erlach's book, see Montreal 1993–94, p. 40.
2. London 1978a, p. 20.

Diese und eine weitere Zeichnung aus der Sammlung der Pierpont Morgan Library (Inv.-Nr. 1966.11:18) sind Kopien Piranesis nach Details aus dem in Wien im Jahr 1721 publizierten *Entwurff einer historischen Architectur* des österreichischen Architekten Johann Bernhard Fischer von Erlach. Dessen illustrierte Historie, die sowohl orientalische als auch antike Baudenkmäler umfaßt, war eine der ersten Gesamtdarstellungen der Weltarchitektur. Piranesi mag auf das Buch durch seinen ersten Förderer, den venezianischen Baumeister Nicola Giobbe, aufmerksam geworden sein, der dem jungen Künstler seine Bibliothek öffnete und ihn mit führenden Architekten bekannt machte, darunter Luigi Vanvitelli.[2] Fischer von Erlachs Versuch, antike Bauwerke aus der Vorstellung heraus zu rekonstruieren, beeinflußte Piranesi nachhaltig, und auch ihn begann es zu faszinieren, Rekonstruktionen antiker und neuerer Bauwerke zu veröffentlichen.

Er arbeitete sich systematisch durch das Buch; setzte bei seinen Kopien in der oberen linken Ecke des Blattes an und führte seine Aufzeichnungen nach unten hin fort. Ziemlich genau gab er das zentrale Motiv einer jeden Tafel, die ihn interessierte, wieder, darunter auch Monumente wie das Artemisia-Mausoleum in Halikarnassos, den Diana-Tempel in Ephesos, den Tempel von Ninive, die Pyramiden des Sothis-Grabmals und den Obelisken von Marc Aurel und Luzius Verus in Korinth. Oftmals fügte er eine Beschriftung hinzu, um einen Aspekt der Dekoration genauer zu beschreiben, und einige Male veränderte er die Ausrichtung einer Säule oder Einzelheiten eines Bauwerkes.

1. Zur ausführlichen Transkription der Inschriften und ihrem Verhältnis zu Fischer von Erlachs Buch siehe Montreal 1993–94, S. 40.
2. London 1978a, S. 20.

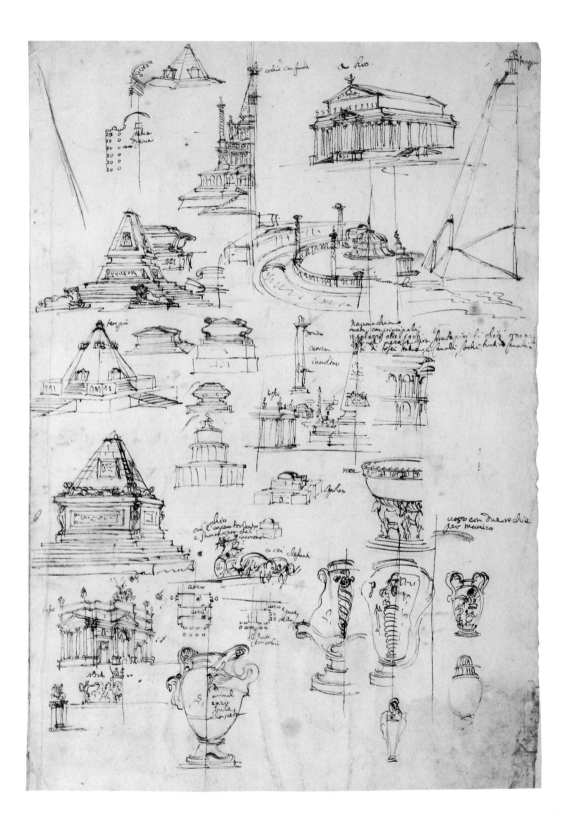

GIOVANNI BATTISTA PIRANESI

(Mogliano Veneto 1720–1778 Rome)

26

SAN GIOVANNI IN LATERANO:
LONGITUDINAL SECTION,
BEGINNING AT TRANSEPT AND
SHOWING PROPOSED SCHEME
FOR ALTERATION OF CHOIR

Pen and brown ink, brown wash, over
graphite
Verso: Ground plan of an apse in
graphite
320 x 545 mm
Watermark: none

Inscribed in pen and brown ink on
verso, *Ponte S. Angelo / Teatro di
Marcello / Piramide Nuova / Foro di
Nerva / Curia Ostilia / Tempio di
Cibelle / S. Urbano / Foro di Titto /
Portico d'Otavia / Interno*

Bequest of the late Junius S. Morgan
and gift of Henry S. Morgan;
Acc. no. 1966.11:56

SAN GIOVANNI IN LATERANO:
LÄNGSSCHNITT, IM QUER-
SCHIFF BEGINNEND, UND
VORSCHLÄGE FÜR VERÄNDE-
RUNGEN DES CHORES ZEIGEND

Feder in Braun, braune Lavierung über
Graphit
Verso: Grundriß einer Apsis in
Graphit
320 x 545 mm
Kein Wasserzeichen

Verso bezeichnet mit Feder in Braun:
*Ponte S. Angelo / Teatro di Marcello /
Piramide Nuova / Foro di Nerva /
Curia Ostilia / Tempio di Cibelle /
S. Urbano / Foro di Titto / Portico
d'Otavia / Interno*

Nachlaß von Junius S. Morgan und
Geschenk von Henry S. Morgan;
Inv.-Nr. 1966.11:56

On 20 September 1763, Charles-Joseph Na-
toire, director of the French Academy in Rome,
wrote to the marquis de Marigny informing
him that Clement XIII had commissioned a
new pontifical altar for San Giovanni in Late-
rano from Piranesi. This plan was eventually
expanded to include the tribune to the west of
the transept.[1] The proposed alterations of the
Lateran had to be abandoned in 1767, but a
number of preparatory drawings for the pro-
ject are in the Library's collection. The Avery
Architectural Library at Columbia University
owns a set of twenty-three presentation draw-
ings for the tribune, numbered from one to
twenty-five (numbers thirteen and twenty-
four are missing). The inscription on the first
sheet indicates that during 1764 Piranesi made
designs for the church at the request of Clem-
ent XIII and presented the drawings to the
pope's nephew Cardinal Rezzonico in 1767.

The present sheet is a preparatory drawing
for *Tavola Terza* of the Avery set. It depicts
the southern end of transept and includes Cav-
aliere d'Arpino's fresco of *The Ascension,*
which dates from the time of Clement VIII. In
this drawing, Piranesi explored the possibility
of introducing an ambulatory around the pres-
bytery, included in the section beyond the
apse. The decorative system of stars and
medallions connected with swags in the apse
indicates Piranesi's desire to harmonize his
design with Francesco Borromini's nave.

Provenance
Mrs. J. P. Morgan, New York; her sons, Junius S.
Morgan and Henry S. Morgan, New York.

Selected bibliography and exhibitions
Fischer 1968, pp. 209–11, fig. 5; Stampfle 1978, no. 56,
repr.; Rome 1992, no. 7, repr.; Montreal 1993–94,
no. 31 (includes full bibliography and exhibitions).

1. See Fischer 1968 and Wilton-Ely in Rome 1992.

Am 20. September 1763 unterrichtete Charles-
Joseph Natoire, Direktor der französischen
Akademie in Rom, den Marquis de Marigny
schriftlich darüber, daß Papst Clemens XIII.
einen neuen Altar für die Kirche San Giovanni
in Laterano bei Piranesi in Auftrag gegeben
habe. Später wurde dieses Vorhaben durch
Hinzunahme der Tribuna westlich des Quer-
schiffes erweitert.[1] Die vorgeschlagenen Um-
bauten des Lateran mußten 1767 aufgegeben
werden, doch finden sich viele Entwurfszeich-
nungen für das Projekt in der Pierpont Mor-
gan Library. Die Avery Architectural Library
der Columbia University besitzt eine Serie
von 23 Präsentationszeichnungen zur Tribuna,
numeriert von 1 bis 25 (die Nummern 13 und
24 fehlen). Aus der Beschriftung des ersten
Blattes geht hervor, daß Piranesi im Laufe des
Jahres 1764 Entwürfe für die Kirche im Auf-
trag von Clemens XIII. anfertigte und diese
Zeichnungen 1767 dem Neffen des Papstes,
dem Kardinal Rezzonico, überreichte.

Bei dem vorliegenden Blatt handelt es sich
um eine Entwurfszeichnung zur *Tavola Terza*
aus der Serie der Avery Architectural Library.
Es zeigt den südlichen Abschluß des Quer-
schiffes mit Cavaliere d'Arpinos Fresko der
Himmelfahrt Christi, das noch aus der Zeit
Clemens' VIII. stammt. In dieser Zeichnung
zog Piranesi die Möglichkeit in Erwägung,
einen Chorumgang anzufügen, den er im
Längsschnitt um die Apsis herumgehen ließ.
Die dekorative Ordnung von Sternen und mit
Girlanden verbundenen Medaillons in der
Apsis bezeugt Piranesis Bestreben, seinen Ent-
wurf mit dem Mittelschiff Francesco Borromi-
nis in Einklang zu bringen.

1. Siehe Fischer 1968 und Wilton-Ely in Rome 1992.

91

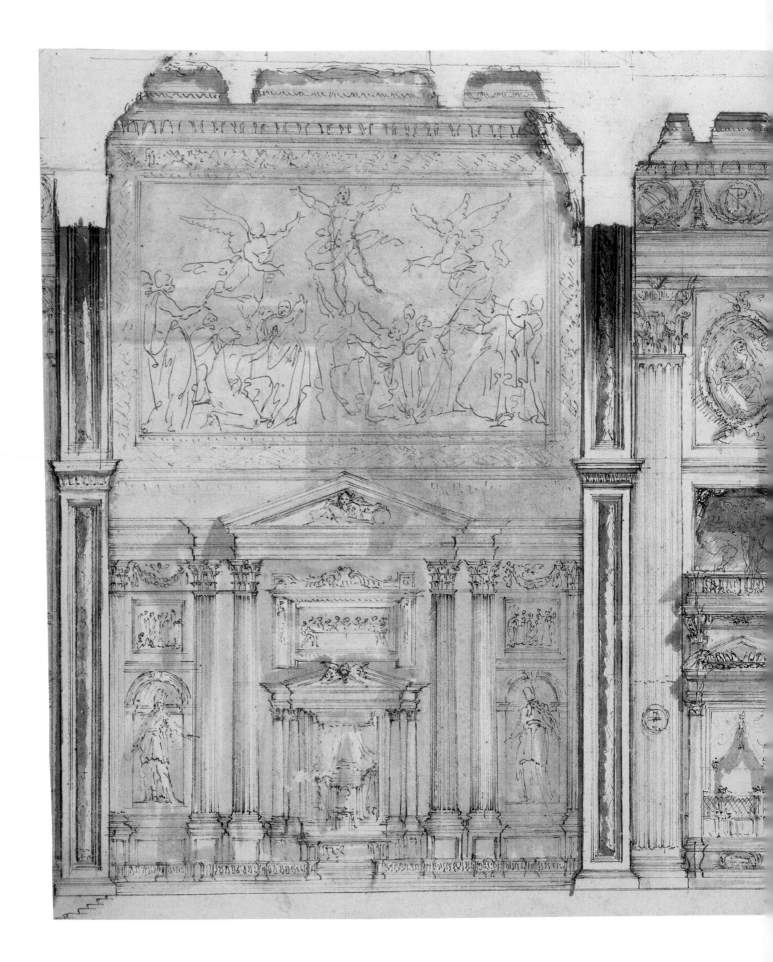

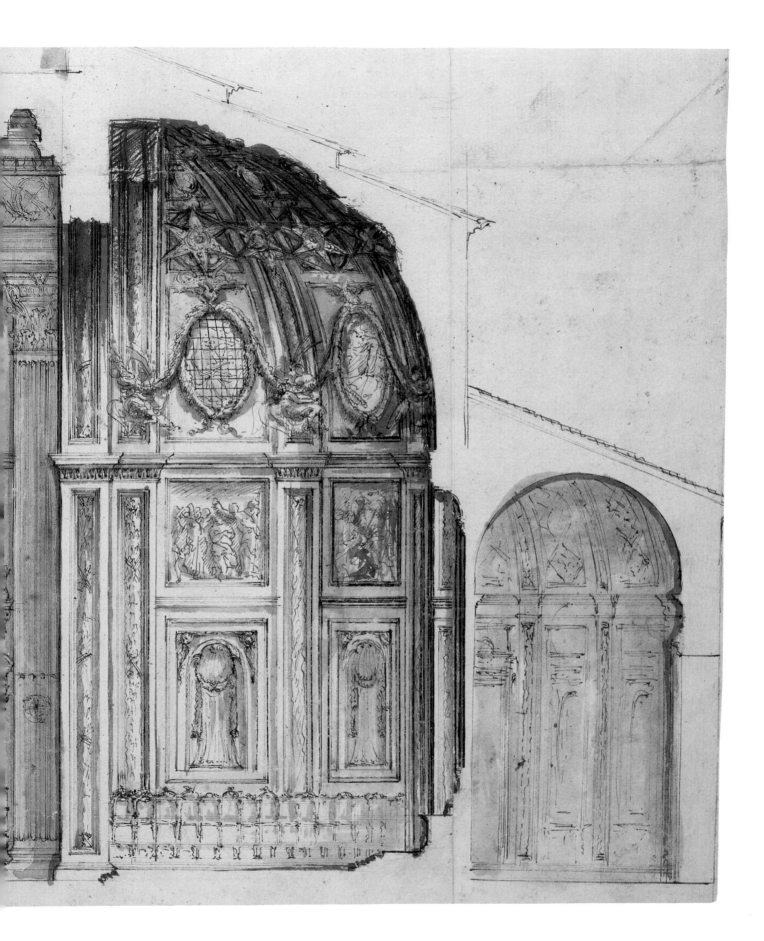

GIOVANNI BATTISTA PIRANESI
(Mogliano Veneto 1720–1778 Rome)

27

DESIGN FOR MANTELPIECE
WITH CONFRONTED ELEPHANT
HEADS

Pen and brown ink, brown wash, over
black chalk; smudges of red chalk, on
what seems to be a counterproof of a
print not yet identified
Verso: Fragment of Ottaviani etching
after Guercino
213 x 322 mm
Watermark: none

Inscribed at lower right, in pen and
brown ink, *Rotta de c . . . / Carioni.*

Bequest of the late Junius S. Morgan
and gift of Henry S. Morgan;
Acc. no. 1966.11:61

ENTWURF FÜR EINE KAMIN-
EINFASSUNG MIT EINANDER
GEGENÜBERGESTELLTEN
ELEFANTENKÖPFEN

Feder in Braun, braune Lavierung über
schwarzer Kreide, Flecken von Rötel,
offenbar auf dem Umdruck einer noch
nicht identifizierten Graphik
Verso: Fragment einer Radierung
Ottavianis nach Guercino
213 x 322 mm
Kein Wasserzeichen

Bezeichnet unten rechts mit Feder in
Braun: *Rotta de c . . . / Carioni.*

Nachlaß von Junius S. Morgan und
Geschenk von Henry S. Morgan;
Inv.-Nr. 1966.11:61

Designs for decoration constitute the largest single category of drawings in the Library's Piranesi collection; they number about forty. Several are connected with the artist's *Diverse maniere d'adornare i cammini,* a compilation of chimneypieces, furniture, and interior designs published in 1769 and dedicated to the artist's patron Cardinal Rezzonico. The majority of the designs are the sixty-one chimneypieces appearing in the first part of the book. They are highly complex, demonstrating a balance between the innovative and practical. Although there is little doubt that this drawing is connected with *Diverse maniere,* it does not appear in the publication. The bold penwork, rapid notation of ornament, and areas of wash and parallel hatching to convey the sculptural quality of the mantelpiece are characteristic of this group of drawings.

In 1764 Piranesi published *Raccolta di alcuni disegni del Barbieri da Cento detto il Guercino.* The present drawing was executed on the back of a fragment of an Ottaviani etching after Guercino. The print on the verso has been largely cut off but carries the partial inscription *oris Angli.* Based on the inscriptions that appear in the *Raccolta,* the text presumably once read *Ex Collectione Tomae Ienkins Pictoris Angli.* The plate, however, does not appear in any of the editions of the *Raccolta* that we know, suggesting that it may be an unused design for the book.

Provenance
Mrs. J. P. Morgan, New York; her sons, Junius S. Morgan and Henry S. Morgan, New York.

Selected bibliography and exhibitions
Stampfle 1978, no. 61, repr.; Montreal 1993–94, no. 18 (includes full bibliography and exhibitions).

Dekorationsentwürfe bilden die größte Einzelgattung unter den Piranesi-Zeichnungen der Pierpont Morgan Library; es handelt sich um ungefähr 40 Blätter. Mehrere von ihnen sind verbunden mit seinen *Diverse maniere d'adornare i cammini,* einer Sammlung von Entwürfen für Kamineinfassungen, Möbel sowie Innenarchitekturen, die 1769 veröffentlicht wurde und seinem Förderer, dem Kardinal Rezzonico, gewidmet ist. Den Hauptteil der Entwürfe bilden die 61 Kaminverkleidungen im ersten Teil des Buches. Sie sind hochkomplex, zugleich innovativ und funktional. Obwohl kaum Zweifel an der Verwandtschaft dieser Zeichnung mit den *Diverse maniere* besteht, erscheint sie nicht in jener Publikation. Der kraftvolle Federstrich, die rasche Notierung der Verzierungen, lavierte Flächen sowie Parallelschraffuren, welche die Plastizität der Kamineinfassung andeuten, sind charakteristisch für diese Gruppe von Zeichnungen.

1764 publizierte Piranesi die *Raccolta di alcuni disegni del Barbieri da Cento detto il Guercino.* Die vorliegende Zeichnung wurde auf der Rückseite des Fragmentes einer Radierung Ottavianis nach einem Werk Guercinos angefertigt. Die Graphik auf dem Verso ist stark beschnitten, trägt aber noch die partielle Bezeichnung *oris Angli.* Basierend auf den Beschriftungen, die in der *Raccolta* erscheinen, lautete der Text vermutlich *Ex Collectione Tomae Ienkins Pictoris Angli.* Die entsprechende Abbildung erscheint jedoch in keiner der uns bekannten Ausgaben der *Raccolta,* so daß es sich hier um einen nicht verwendeten Entwurf für das Buch handeln könnte.

94

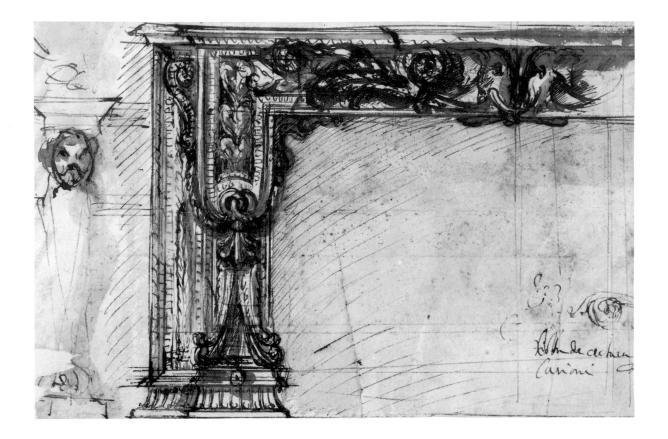

GIOVANNI BATTISTA PIRANESI

(Mogliano Veneto 1720–1778 Rome)

DESIGN FOR MANTELPIECE
WITH CORNER MEDALLION
WITH DOUBLE PORTRAIT
HEADS

Pen and brown ink, traces of black
chalk; smudges of red chalk
Verso: Fragment of etching, pl. XIV
of *Antichità d'Albano e di Castel
Gandolfo,* 1764
161 x 246 mm
Watermark: none

Inscribed in pen and brown ink at left,
fiacole

Bequest of the late Junius S. Morgan
and gift of Henry S. Morgan;
Acc. no. 1966.11:62

ENTWURF FÜR EINE KAMIN-
EINFASSUNG MIT DOPPEL-
PORTRAITS IM ECKMEDAILLON

Feder in Braun, Spuren von schwarzer
Kreide, Flecken von Rötel
Verso: Fragment einer Radierung,
Tafel XIV aus *Antichità d'Albano e di
Castel Gandolfo,* 1764
161 x 246 mm
Kein Wasserzeichen

Bezeichnet links mit Feder in Braun:
fiacole

Nachlaß von Junius S. Morgan und
Geschenk von Henry S. Morgan;
Inv.-Nr. 1966.11:62

In the opening plates of *Diverse maniere* (see No. 27), Piranesi illustrated two etchings of chimneypieces that had been executed for specific clients, including one for the earl of Exeter at Burghley House and another for the Dutch banker John Hope of Amsterdam (today in the Rijksmuseum). Incorporated within these chimneypieces are antique fragments, a reference to the artist's enterprising use of classical motifs and to his growing activity as a restorer.[1] This drawing with double portrait heads on the left side appears to be an experiment in much the same vein and probably reflects an early idea for an elaborate mantelpiece. The presence of the seated figure is an unusual addition. If Piranesi intended to use the figure to give some sense of scale, he clearly was imagining a mantelpiece of an imposing size.

The bold penwork is comparable to Piranesi's other designs, including No. 27, and, as was that drawing, this one is executed on the back of a proof of an etching. It is a fragment of the lower portion of plate XIV, *Steps to a Cistern,* which was included in *Antichità d' Albano e di Castel Gandolfo.* This series of views, published in 1764, was made by Piranesi at the request of Clement XIII.

Provenance
Mrs. J. P. Morgan, New York; her sons, Junius S. Morgan and Henry S. Morgan, New York.

Selected bibliography and exhibitions
Stampfle 1978, no. 62, repr.

1. Wilton-Ely 1993, p. 129.

Auf den ersten Tafeln zu *Diverse maniere d'adornare i cammini* (vgl. Kat.-Nr. 27) zeigte Piranesi zwei Radierungen mit Kaminumrahmungen, die er für bestimmte Auftraggeber angefertigt hatte, eine für den Earl of Exeter in Burghley House und eine andere für den holländischen Bankier John Hope aus Amsterdam (heute im Rijksmuseum). Eingearbeitet in diese Kamineinfassungen sind Antikenfragmente, ein Hinweis auf die einfallsreiche Verwendung klassischer Motive durch den Künstler und seine zunehmende Tätigkeit als Restaurator.[1] Diese Zeichnung mit dem Doppelbildnis auf der linken Seite scheint ein Experiment nahezu derselben Art zu sein und gibt vermutlich eine frühe Idee einer kunstvollen Kaminverkleidung wieder. Bei der sitzenden Figur handelt es sich dagegen um eine eher ungewöhnliche Ergänzung des Künstlers. Falls Piranesi mit der Figur einen Maßstab vermitteln wollte, dachte er offenkundig an eine Kamineinfassung stattlicher Größe.

Der kraftvolle Federstrich ist vergleichbar mit dem anderer Entwürfe Piranesis (etwa mit der Kat.-Nr. 27), und ebenso wie jene Zeichnung wurde auch diese auf der Rückseite des Abzugs einer Radierung ausgeführt. Es handelt sich dabei um ein Fragment des unteren Abschnitts der Tafel XIV, *Treppe zu einer Zisterne,* die in die *Antichità d'Albano e di Castel Gandolfo* aufgenommen wurde. Diese im Jahr 1764 publizierte Serie von Ansichten führte Piranesi im Auftrag von Papst Clemens XIII. aus.

1. Wilton-Ely 1993, S. 129.

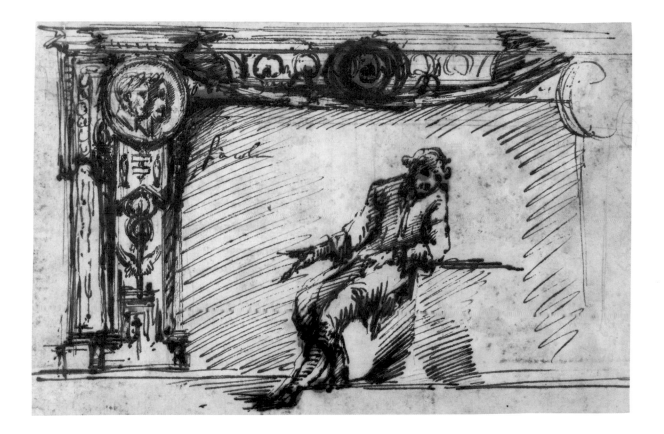

GIOVANNI BATTISTA PIRANESI

(Mogliano Veneto 1720–1778 Rome)

29

San Giovanni in Laterano:
Design for Wall Monu-
ment with Papal and
Ducal Crowns

Pen and brown ink, gray wash, over
black chalk
Verso: Fragment of a ground plan, in
black chalk
336 x 183 mm
Watermark: none

Bequest of the late Junius S. Morgan
and gift of Henry S. Morgan;
Acc. no. 1966.11:110

San Giovanni in Laterano:
Entwurf für ein Wand-
monument mit Papst- und
Herzogskronen

Feder in Braun, graue Lavierung über
schwarzer Kreide
Verso: Fragment eines Grundrisses,
in schwarzer Kreide
336 x 183 mm
Kein Wasserzeichen

Nachlaß von Junius S. Morgan und
Geschenk von Henry S. Morgan;
Inv.-Nr. 1966.11:110

This drawing was originally part of the same sheet as another drawing in the Library's collection, *Sketch for a Choir Wall* (Acc. no. 1966.11:58), which is connected with Piranesi's decorations for San Giovanni in Laterano. The empty oval surmounted by papal and ducal crowns suggests that it was intended to frame a papal portrait, as in the design for a papal wall monument in the Ashmolean Museum, Oxford.[1] The Ashmolean drawing and another in the Ornamentstichsammlung of the Berlin Kunstgewerbemuseum probably date to the same period as the Library's present drawing.

The plan on the verso of this drawing has been matched up with the verso of the *Sketch for a Choir Wall,* and from this connection Manfred Fischer was able to reconstruct the ground plan of a portion of Piranesi's projected renovation of the choir of the Lateran.[2]

Provenance
Mrs. J. P. Morgan, New York; her sons, Junius S. Morgan and Henry S. Morgan, New York.

Selected bibliography and exhibitions
Fischer 1968, p. 212, figs. 8a and 9a; Stampfle 1978, no. 110, repr. (for additional bibliography and exhibitions); Wilton-Ely 1978, no. 226, repr.; Wilton-Ely 1993, fig. 81.

1. Thomas 1952–55, pl. 45.
2. Fischer 1968, figs. 8b, 9b.

Diese Zeichnung war ursprünglich mit der *Skizze für eine Chorwand,* die ebenfalls in der Sammlung der Pierpont Morgan Library aufbewahrt wird und mit Piranesis Dekorationsentwürfen für San Giovanni in Laterano in Verbindung steht, Teil desselben Blattes (Inv.-Nr. 1966.11:58). Das leere Oval mit darüber angeordneten Papst- und Herzogskronen sollte wohl in Entsprechung zu dem Entwurf eines päpstlichen Monuments im Ashmolean Museum von Oxford als Rahmen für ein Papstportrait dienen.[1] Die Zeichnung in Oxford und eine weitere in der Ornamentstichsammlung des Berliner Kunstgewerbemuseums stammen wahrscheinlich aus demselben Zeitraum wie das vorliegende Blatt der Pierpont Morgan Library.

Der auf der Rückseite wiedergegebene Grundriß ist mit dem Verso der *Skizze für eine Chorwand* zusammengefügt worden. Aufgrund dieser Verbindung konnte Manfred Fischer einen Grundriß für einen Teil des von Piranesi geplanten Umbaus des Chors der Lateranbasilika rekonstruieren.[2]

1. Thomas 1952–55, Taf. 45.
2. Fischer 1968, Abb. 8b, 9b.

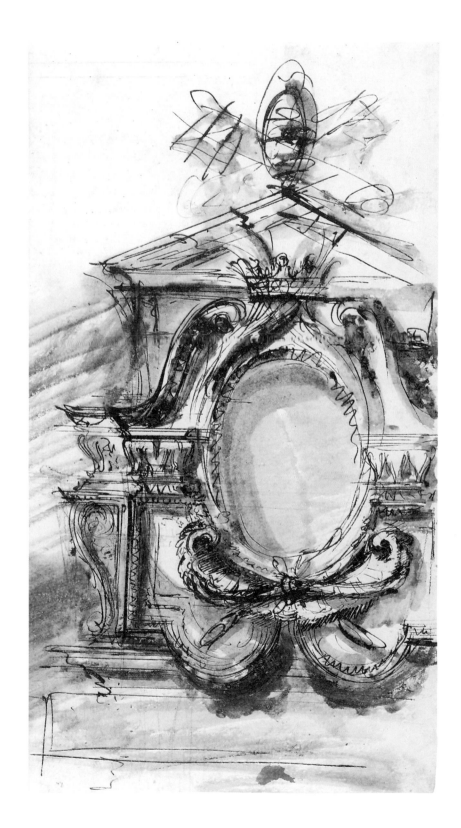

GIOVANNI BATTISTA PIRANESI

(Mogliano Veneto 1720–1778 Rome)

30

FIGURE STUDIES

Pen and brown ink
230 x 140 mm
Watermark: fragment of a circle

Gift of Janos Scholz; Acc. no. 1976.34

FIGURENSTUDIEN

Feder in Braun
230 x 140 mm
Wasserzeichen: Fragment eines Kreises

Geschenk von Janos Scholz;
Inv.-Nr. 1976.34

Piranesi's figure studies are difficult to place chronologically within the artist's oeuvre. On the basis of style and execution, this sheet and several others have been dated around 1760–65.[1] Piranesi did not indicate any setting but simply used parallel hatching around the figures to provide a background and ground line, implying that drawings of this kind were primarily studies of pose and movement. Accordingly, he was not interested in carefully delineating the form of the human body, which is evident in the way the extremities are schematically indicated; the hands, for example, terminate in extended multiple penstrokes. Academy studies are rare in Piranesi's oeuvre, although one of these, a standing man, appears on the verso of No. 23, where the subject's anatomy and pose are carefully studied in black chalk.

For the most part, Piranesi's figures represent types. They function as figural models for his prints rather than direct studies. Hylton Thomas compared Piranesi's compilation of figure studies to Watteau's accumulation of figural motifs, which he could then use later or borrow at will. Indeed, according to Janos Scholz's records, this drawing was originally part of an album of figure studies, broken up in 1946.

Provenance
J. A. Duval le Camus, Paris (Lugt 1441); Wertheimer, Paris 1947; Janos Scholz (no mark; see Lugt S. 2933b).

Selected bibliography and exhibitions
Thomas 1952–55, p. 60, no. 70, repr.; Stampfle 1978, no. A-9, repr.; Montreal 1993–94, no. 43 (includes full bibliography and exhibitions).

1. Thomas 1952–55, p. 26.

Piranesis Figurenstudien innerhalb seines Œuvres chronologisch einzuordnen, ist ein schwieriges Unterfangen. Aufgrund des Stils und der Ausführung ist dieses Blatt neben einigen anderen um 1760 bis 1765 datiert worden.[1] Piranesi gab hier keinerlei Hinweise zur Umgebung, sondern legte lediglich Parallelschraffuren um die Figuren an, um Hintergrund und Boden anzudeuten. Daraus geht hervor, daß Zeichnungen dieser Art in erster Linie Studien von Haltung und Bewegung waren. Dementsprechend ging es ihm nicht darum, menschliche Körperformen präzise zu umreißen, was insbesondere bei den schematisch angedeuteten Extremitäten zum Ausdruck kommt; die Hände beispielsweise enden in Federstrichbündeln. Akademische Aktstudien bilden die Ausnahme im Werk Piranesis, obgleich eine solche auf der Rückseite der Kat.-Nr. 23 in Form eines stehenden Mannes erscheint. Hier sind Anatomie und Pose des Dargestellten sorgsam in schwarzer Kreide nachvollzogen.

Zum größten Teil stellen Piranesis Figuren Typen dar. Sie dienen ihm als Repertoire figürlicher Motive für seine Druckgraphiken und nicht als unmittelbare Studien. Hylton Thomas hat Piranesis Kompilation von Figurenstudien mit Watteaus Sammlung von figürlichen Motiven verglichen, die er später je nach Belieben wiederverwenden und übernehmen konnte. Tatsächlich war diese Zeichnung, gemäß den Aufzeichnungen von Janos Scholz, ursprünglich Teil eines Albums mit Figurenstudien, das 1946 auseinandergenommen wurde.

1. Thomas 1952–55, S. 26.

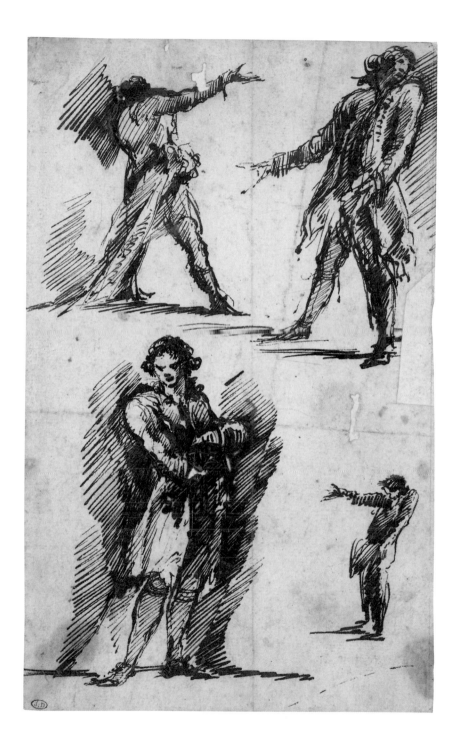

GIOVANNI BATTISTA PIRANESI

(Mogliano Veneto 1720–1778 Rome)

31

TEMPLE OF ISIS AT POMPEII

Quill and reed pen in black and some brown ink, black wash, over black chalk; perspective lines and squaring in graphite; several accidental oil stains
522 x 764 mm
Watermark: Shield with bend, fleur-de-lis and sword between letters *F* and *M* (Robison 1986, watermark 61)

Inscribed in pen and brown ink along lower right edge, *(on back) Veduta in angolo del tempio d'Isibe* and numbered by Piranesi from 1 through 23 in a different brown ink; on verso at upper center, *Tav. 12;* at lower left, *Part.2. / Tav. / 14;* at lower right, *veduta in angolo del tempio d'Iside.*

Thaw Collection, The Pierpont Morgan Library; Acc. no. 1979.41

DER ISIS-TEMPEL IN POMPEJI

Kiel- und Rohrfeder in Schwarz und Braun, schwarze Lavierung über schwarzer Kreide, Perspektivlinien und Quadrierung in Graphit, mehrere unbeabsichtigte Ölflecken
522 x 764 mm
Wasserzeichen: Schild mit Band, Lilie und Schwert zwischen den Buchstaben *F* und *M* (Robison 1986, Wasserzeichen 61)

Bezeichnet mit Feder in Braun entlang des unteren rechten Randes: *(on back) Veduta in angolo del tempio d'Isibe,* numeriert von Piranesi von 1 bis 23 mit Feder in anderer brauner Tinte; verso oben Mitte: *Tav. 12;* unten links: *Part.2. / Tav. / 14,* unten rechts: *veduta in angolo del tempio d'Iside.*

Sammlung Thaw, The Pierpont Morgan Library; Inv.-Nr. 1979.41

In the 1770s Piranesi undertook a number of trips to the ancient ruins around Naples to study and record them with the intention of publishing a series of etchings. This view of the Temple of Isis at Pompeii is taken from inside the north colonnade of the sanctuary. The temple and its precincts are seen from an angle that allows for a full view of the temple proper, on its high podium, as well as the sacred enclosure with its colonnade, the Egyptian temple, and various altars and pedestals. The drawings show that he studied the temple and its sanctuary from every point of view.[1]

Most of Piranesi's drawings of the ruins were eventually used, either directly or indirectly, by his son, Francesco, who published the three-volume series of elephant folios, *Les Antiquités de la Grande Grèce,* in Paris between 1804 and 1807. The Temple of Isis is illustrated in plates LIX through LXXII. A plate after the present drawing, reduced to approximately half its size, was engraved but apparently never used. The image that relates to this drawing appears on the verso of a copperplate depicting the *Dimonstrazione dell'impluvio della casa medesima*[2] that was published in the *Antiquités.*[3] Proofs of the verso were pulled in the 1960s.[4] Although the figures were entirely changed in the plate, the architectural details correspond closely to the present drawing.

Provenance
H. M. Calmann, London; George Ortiz, Geneva; Sydney J. Lamon, New York; sale, London, Christie's, 27 November 1973, lot 314; R. M. Light & Co., Inc., Boston.

Selected bibliography and exhibitions
Stampfle 1978, no. A-11, repr.; Thaw, Royal Academy, no. 36, repr. (includes full bibliography and exhibitions).

1. See Thomas 1952–55, p. 23. Another drawing in the Library depicts the temple from the northeast corner (Acc. no. 1963.12).
2. Focillon 1963, no. 1091.
3. Petrucci 1953, p. 305.
4. Focillon 1963, pl. 254.

In den 1770er Jahren unternahm Piranesi zahlreiche Reisen zu den antiken Ruinen in der Umgebung von Neapel. Er untersuchte und zeichnete sie in der Absicht, eine Folge von Radierungen herauszugeben. Diese Ansicht des Isis-Tempels in Pompeji ist aus dem Inneren des nördlichen Säulengangs des Heiligtumes heraus angefertigt. Der Tempel und sein Bezirk werden von einem Standort aus betrachtet, der einen Gesamtblick auf den eigentlichen Bau gewährt, auf sein hohes Podium wie auch auf den heiligen Bezirk mit seiner Kolonnade, den ägyptischen Tempel und verschiedene Altäre und Postamente. Die Zeichnungen zeigen, daß Piranesi den Tempel und sein Heiligtum von allen Seiten aus studierte.[1]

Die meisten Zeichnungen Piranesis nach den Ruinen wurden später, direkt oder indirekt, von seinem Sohn Francesco verwendet, der in Paris zwischen 1804 und 1807 die drei riesigen Foliobände der *Antiquités de la Grande Grèce* herausgab. Der Isis-Tempel ist auf den Tafeln LIX bis LXXII abgebildet. Nach der vorliegenden Zeichnung wurde zwar eine Platte, um etwa die Hälfte verkleinert, gestochen, aber anscheinend nie verwendet. Das Bild, das unserer Zeichnung entspricht, erscheint auf der Rückseite einer Kupferplatte, welche die *Dimonstrazione dell'impluvio della casa medesima*[2] darstellt und in den *Antiquités* veröffentlicht wurde.[3] Abzüge der Rückseite wurden in den sechziger Jahren des 20. Jahrhunderts hergestellt.[4] Obgleich die Figuren auf der Platte vollständig verändert sind, finden sich in den architektonischen Details enge Übereinstimmungen mit der vorliegenden Zeichnung.

1. Siehe Thomas 1952–55, S. 23. Eine andere Zeichnung der Pierpont Morgan Library zeigt den Tempel von der nordöstlichen Ecke aus (Inv.-Nr. 1963.12).
2. Focillon 1963, Nr. 1091.
3. Petrucci 1953, S. 305.
4. Focillon 1963, Taf. 254.

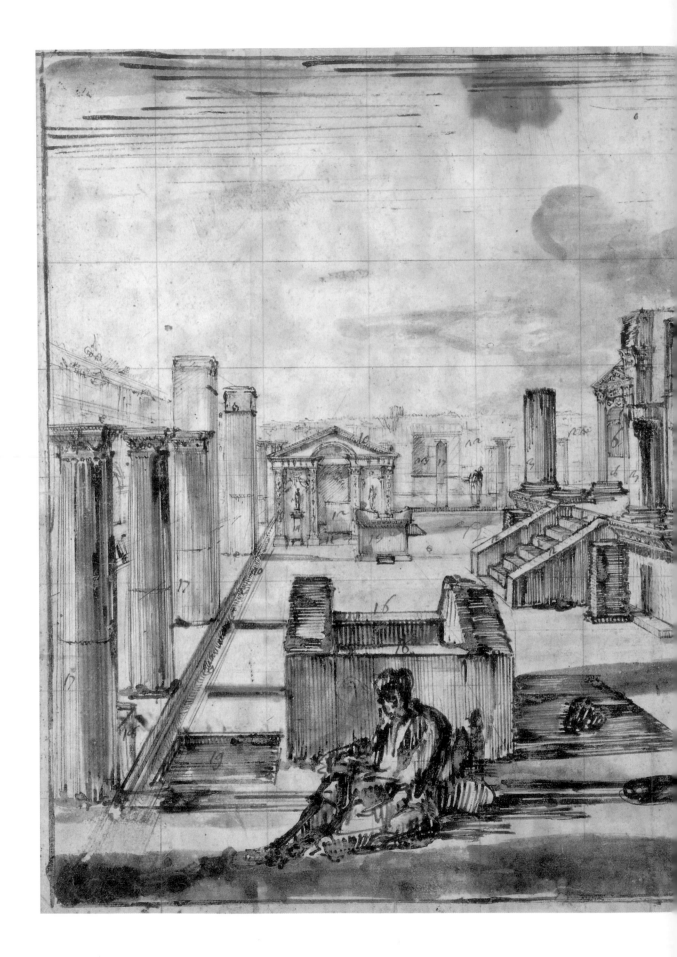

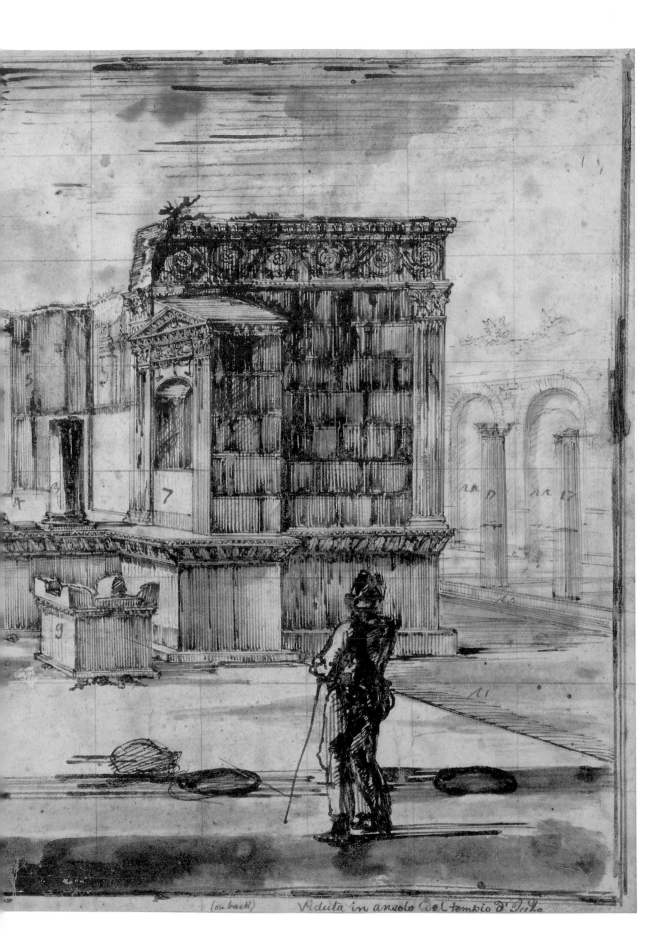

(on back) Veduta in angolo del tempio d'Tito

GIOVANNI DOMENICO TIEPOLO
(Venice 1727–1804 Venice)

ST. PETER HEALING
THE LAME MAN AT THE
BEAUTIFUL GATE

Pen and brown ink, brown wash, over black chalk
460 x 357 mm
Watermark: letter *W* below hand holding sword

Inscribed by the artist on plaque at right, *PORTA / SPETIOSA*

Purchased by Pierpont Morgan, 1910; Acc. no. IV, 150

DER HEILIGE PETRUS
HEILT DEN LAHMEN VOR DER
TEMPELPFORTE

Feder in Braun, braune Lavierung über schwarzer Kreide
460 x 357 mm
Wasserzeichen: Buchstabe *W*, darüber eine Hand, die ein Schwert hält

Vom Künstler rechts auf einer Tafel bezeichnet: *PORTA / SPETIOSA*

Erworben 1910 von Pierpont Morgan; Inv.-Nr. IV, 150

After his return from Spain, Domenico produced at least 250 drawings in the large format of this fine example, most likely as independent "album drawings," the kind of work to which he turned his attention as he painted less and less. The largest single group of the Large Biblical Series is the Recueil Fayet, the 138 sheets bound in the folio volume in the Département des arts graphiques at the Louvre. There were an additional 82 in the former collection of M. Cormier of Tours. While eight entered the Library with the Fairfax Murray collection in 1910, an additional group of thirteen bequeathed by Dr. and Mrs. Rudolf Heinemann in 1996 have greatly increased the holdings.

The friezelike arrangement of a crowd of figures in the lower portion of the sheet, leaving a lofty space above, is a compositional device often favored by Domenico in the Large Biblical Series. The story of the healing of the lame man is recounted in Acts 3:1–7.

Provenance
Charles Fairfax Murray; purchased by Pierpont Morgan, 1910.

Selected bibliography and exhibitions
New York 1971, no. 259, repr. (includes previous bibliography and exhibitions); Udine and Bloomington 1996–97, no. 107, repr. in color.

Nach seiner Rückkehr aus Spanien schuf Domenico wenigstens 250 Zeichnungen im großen Format dieses schönen Beispiels, sehr wahrscheinlich als autonome »Albumzeichnungen«. Solchen Arbeiten wandte er seine Aufmerksamkeit zu, als er immer weniger malte. Das umfangreichste Einzelensemble der »Großen Bibelfolge« ist der 138 Blätter umfassende und als Foliant gebundene *Recueil Fayet* im Département des Arts Graphiques des Louvre. Weitere 82 befanden sich in der ehemaligen Sammlung von M. Cormier aus Tours. Während acht Blätter mit der Charles Fairfax Murray Collection 1910 in die Pierpont Morgan Library gelangten, verstärkte eine weitere Gruppe von 13 aus dem Nachlaß von Dr. und Mrs. Rudolf Heinemann 1996 den entsprechenden Bestand außerordentlich.

Die friesartige Anordnung einer Figurengruppe im unteren Teil des Blattes, mit einem hohen Freiraum darüber, ist ein Gestaltungsprinzip, das Domenico für die Große Bibelfolge bevorzugte. Die Erzählung von der Heilung des Lahmen ist in der Apostelgeschichte 3, 1–7, zu lesen.

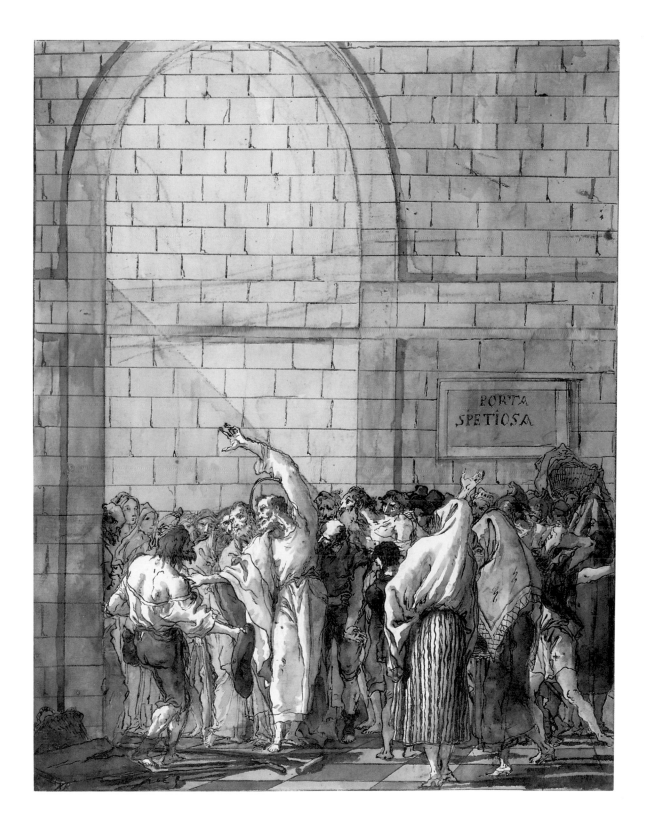

GIOVANNI DOMENICO TIEPOLO

(Venice 1727–1804 Venice)

SAINT JOHN THE BAPTIST IN PRAYER

Pen and brown ink, brown wash, over black chalk
464 x 365 mm
Watermark: letters *GRA* surmounted by a coronet or crown

Inscribed on banderole on cross, *ECCO*(?) *AGNUS DEI*

Purchased by Pierpont Morgan, 1910; Acc. no. IV, 151a

DER HEILIGE JOHANNES DER TÄUFER IM GEBET

Feder in Braun, braune Lavierung über schwarzer Kreide
464 x 365 mm
Wasserzeichen: Buchstaben *GRA,* darüber eine Krone

Bezeichnet auf dem Schriftband: *ECCO* (?) *AGNUS DEI*

Erworben 1910 von Pierpont Morgan; Inv.-Nr. IV, 151a

While there is no apparent textual reference in the Bible for this subject, it represents the Baptist in a moment of prayer in the mountains—which may be based on the range of mountains in the area of northern Italy that was familiar to the Tiepolos. Domenico was very much a late baroque eighteenth-century artist and as such subscribed to the concept of invention. To prove his originality he went so far as to prepare a suite of twenty-four etchings all based on the theme of the Flight into Egypt. In this drawing, the Baptist takes a moment to reflect on the Crucifixion, planting his crucifix with its banderole into the earth behind a large boulder that serves as a makeshift altar. Tall pines, swooping birds (storks?), and a sheer face of rock rise around him set the scene high in the mountains. The Baptist's lamb is curled up next to him and further to the right is a rude shed or barn with a thatched roof, complete with a ladder propped in front of the open doorway.

Domenico covered this entire page with a progression of graded washes, reserving portions of the white paper for the most strongly highlighted passages, achieving effects of remarkable brilliance.

Provenance
Charles Fairfax Murray; Pierpont Morgan, 1910
(no mark; see Lugt 1509).

Obwohl diesem Thema keine eindeutige Textstelle aus der Bibel zugrunde liegt, wird Johannes der Täufer beim Gebet in den Bergen gezeigt, welche vielleicht auf Gebirgszüge Norditaliens zurückzuführen sind, die den Tiepolo vertraut waren. Als Künstler des spätbarocken 18. Jahrhunderts war Domenico dem Konzept der Invention verschrieben. Um seinen Erfindungsreichtum unter Beweis zu stellen, ging er so weit, einen Zyklus mit 24 Radierungen anzufertigen, die alle die Flucht nach Ägypten zum Thema haben. In dieser Zeichnung besinnt sich Johannes der Täufer der Kreuzigung; er steckt sein Kreuz mit dem dazugehörigen Schriftband in die Erde hinter einen großen Felsblock, der ersatzweise als Altar dient. Hohe Pinien, hinabstürzende Vögel (Störche?) und eine steil hinter ihm abfallende Felswand verlegen den Schauplatz ins Hochgebirge. Neben ihm liegt das Lamm, und rechts davon steht ein einfacher, strohgedeckter Stall oder eine Scheune mit einer vor der offenen Eingangstür lehnenden Leiter.

Domenico überzog die gesamte Darstellung mit abgestuften Lavierungen, sparte dabei Stellen des weißen Papiers für die Partien mit den stärksten Glanzlichtern aus und erreichte Effekte von bemerkenswerter Brillanz.

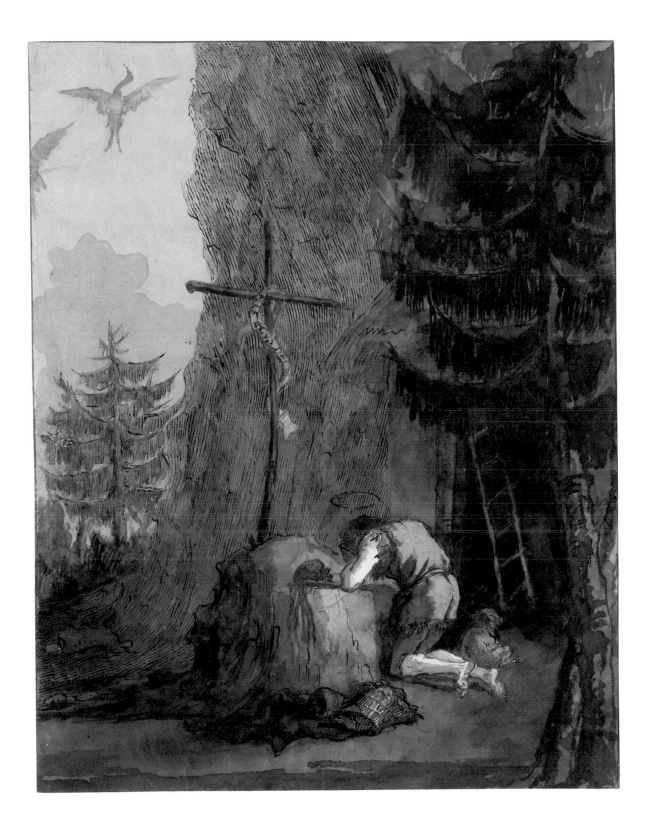

GIOVANNI DOMENICO TIEPOLO
(Venice 1727–1804 Venice)

PUNCHINELLO WITH AN ELEPHANT

Pen and brown ink, brown and ocher wash, over black chalk
294 x 411 mm
Watermark: graduated triple crescents

Signed in pen and brown ink on scroll at upper center, *Dom.° Tiepolo;* numbered in pen and brown ink on verso at lower left corner, *4*

Purchased by Pierpont Morgan, 1910; Acc. no. IV, 151b

PULCINELLA MIT EINEM ELEFANTEN

Feder in Braun, braune und ockerfarbene Lavierung über schwarzer Kreide
294 x 411 mm
Wasserzeichen: dreifacher Halbmond

Signiert oben Mitte mit Feder in Braun auf dem angehefteten Blatt: *Dom.° Tiepolo;* verso numeriert in der unteren linken Ecke mit Feder in Braun: *4*

Erworben 1910 von Pierpont Morgan; Inv.-Nr. IV, 151b

The latest and most complete of all Domenico's various series of drawings is the celebrated Punchinello cycle of 104 drawings, which he titled *Divertimento per li Regazzi* (Entertainment for Children). The series was produced at the very end of the artist's life, probably just a few years before his death in 1804, when he was living in retirement in the family villa at Zianigo. There he had earlier frescoed the "Camera dei Pagliacci" (1793) with scenes of the daily life of Punchinello and his fellows. The hero of the drawing series is also this commedia dell'arte character, first introduced on the stage by the Neopolitan actor Silvio Fiorillo around 1600. His history follows no known text.

At some point, the drawings were numbered in the upper left margin, whether by Domenico or his heirs is not known. The present drawing, which does not bear one of the old series numbers, came to the Library with the Fairfax Murray collection in 1910 and may have been detached from the group sometime prior to 1910. It is, however, a very logical companion to others in the series depicting circus subjects.

Provenance
Charles Fairfax Murray; purchased by Pierpont Morgan, 1910 (no mark; see Lugt 1509).

Selected bibliography and exhibitions
New York 1971, no. 276, repr. (includes previous bibliography and exhibitions); Bloomington and Stanford 1979, no. 29, repr.

Die zuletzt entstandene und vollständigste der verschiedenen Zeichnungsserien Domenicos ist mit 104 Zeichnungen der berühmte Pulcinella-Zyklus, den er *Divertimento per li Regazzi* (Unterhaltung für Kinder) nannte. Ausgeführt hat er die Folge wahrscheinlich nur wenige Jahre vor seinem Tod, als er zurückgezogen in der Villa der Familie in Zianigo lebte. Dort hatte er im früheren Freskenzyklus der »Camera dei Pagliacci« (1793) Szenen aus dem Leben Pulcinellas und seiner Freunde geschildert. Bei dem Helden der Zeichnungsserie handelt es sich ebenfalls um diese Figur der Commedia dell'arte, die von dem neapolitanischen Schauspieler Silvio Fiorillo um 1600 auf der Bühne eingeführt wurde. Seine Geschichte ist keinem bekannten Text entlehnt.

Irgendwann wurden die Blätter am oberen linken Rand numeriert, ob von Domenico oder seinen Erben, ist nicht bekannt. Die vorliegende Zeichnung, die mit keiner der alten Seriennummern versehen ist, gelangte mit der Fairfax Murray Collection 1910 in die Library und könnte vor 1910 von der Gruppe getrennt worden sein. Das Blatt bildet jedoch eine sehr sinnvolle Ergänzung zu anderen Zeichnungen der Serie, die Themen aus dem Bereich des Zirkus darstellen.

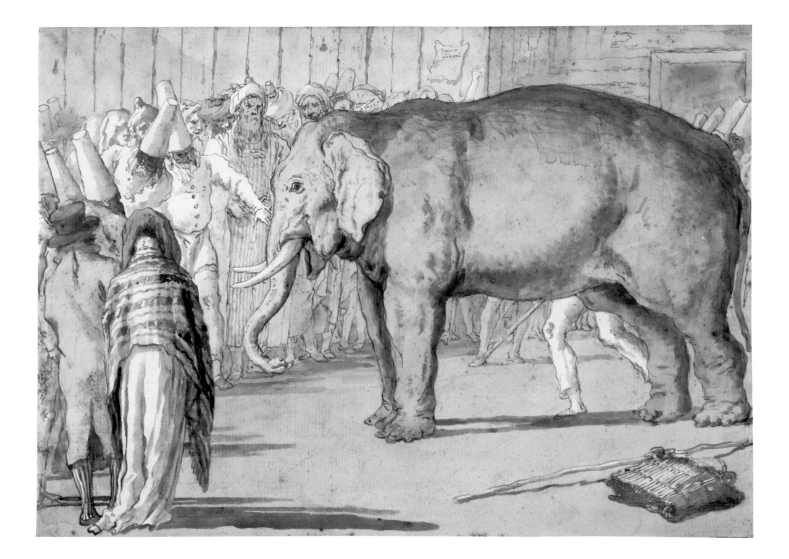

GIOVANNI DOMENICO TIEPOLO
(Venice 1727–1804 Venice)

35

SCENE OF CONTEMPORARY
LIFE: AT THE DRESSMAKER'S

Pen and brown ink, brown and gray-
brown and ocher washes over prelimi-
nary drawing in black chalk
288 x 418 mm
Watermark: monogram

Signed in pen and brown ink at lower
left: *Dom° Tiepolo/ f. 1791*

Purchased as Gift of the Fellows;
Acc. no. 1967.22

SZENE AUS DEM ZEITGENÖS-
SISCHEN ALLTAGSLEBEN:
BEI DER SCHNEIDERIN

Feder in Braun, braune, graubraune
und ockerfarbene Lavierung über einer
Vorzeichnung in schwarzer Kreide
288 x 418 mm
Wasserzeichen: Monogramm

Signiert und datiert unten links mit
Feder in Braun: *Dom° Tiepolo / f.1791*

Erworben als Geschenk der Associa-
tion of Fellows; Inv.-Nr. 1967.22

In 1967 the Library was fortunate to acquire two appealing genre subjects that typify Domenico's distinctive contribution to the Venetian art of his day. These two sheets, *At the Dressmaker's* and *A Visit to a Lawyer,* belong to the sequence, mostly dated 1791, that mirrors the contemporary Venetian scene with delightful wit. These drawings and other genre scenes of about the same time were made when the artist was in his sixties and was painting and drawing chiefly for his own pleasure. Without these works and his Punchi-nello series the artist would have been remembered only as the gifted but unoriginal son of a great artist.

At the Dressmaker's is a purely feminine subject in a rococo interior; it has been given a charming lightness through the use of an additional wash, almost apricot in hue, to vary the customary grays and browns. The tousled young hoyden submits docilely to the attentions of a stylish dressmaker—much to the satisfaction of her duenna—an episode one supposes the artist could have witnessed in his own household. The presence of the dress-maker's assistant holding a large bundle of what might be samples of materials suggests that the modiste has come to the house of her client rather than receiving the young lady and her chaperon at her shop.

Provenance
Alfred Beurdeley, Paris; sale, London, Sotheby's, 6 July 1967, lot 41, repr.; P. & D. Colnaghi, London.

Selected bibliography and exhibitions
New York 1971, no. 260, repr. (includes previous bibliography and exhibitions).

Im Jahr 1967 wurde der Pierpont Morgan Library das Glück zuteil, zwei Genredar-stellungen erwerben zu können, die charakte-ristisch für Domenicos einzigartigen Beitrag zur venezianischen Kunst seiner Zeit sind. Diese beiden Blätter, *Bei der Schneiderin* und *Besuch bei einem Rechtsanwalt,* gehören zu einer meist auf 1791 datierten Folge, die das zeitgenössische venezianische Leben auf wun-derbar humorvolle Weise widerspiegelt. Wie andere Genreszenen sind diese Zeichnungen zu einer Zeit entstanden, als der Künstler, im Alter zwischen 60 und 70, hauptsächlich zu seinem persönlichen Vergnügen malte und zeichnete. Ohne diese Arbeiten und seine Pulcinella-Serie wäre er lediglich als begabter, aber nicht eigenständiger Sohn eines großen Künstlers in Erinnerung geblieben.

Bei der Schneiderin zeigt, in einem Roko-kointerieur, eine Szene aus dem Leben einer Dame. Es erhält eine entzückende Leichtigkeit durch die Verwendung einer zusätzlichen, fast apricotfarbenen Lavierung, die die üblichen Grau- und Brauntöne variiert. Der zerzauste junge Wildfang erduldet sanftmütig das Maß-nehmen einer modisch gekleideten Schneide-rin – sehr zum Gefallen der Patronin: eine Epi-sode, die der Künstler, so könnte man anneh-men, in seinem eigenen Haushalt erlebt haben mag. Die Anwesenheit der Schneidergehilfin, die ein großes Bündel, vielleicht mit Stoffmu-stern, hält, spricht für einen Besuch der Modi-stin bei ihrer Kundin und nicht für einen Emp-fang der jungen Frau samt Begleiterin in deren Geschäftsräumen.

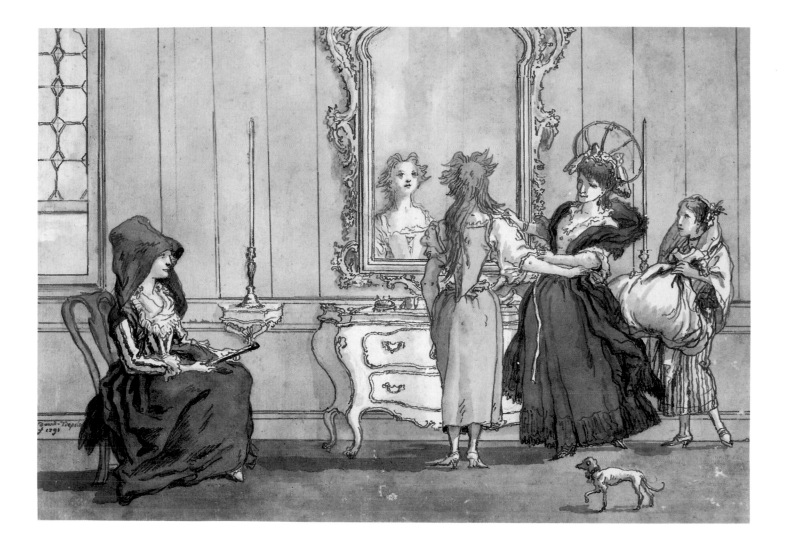

FRANCISCO JOSE DE GOYA Y LUCIENTES

(Aragon 1746–1828 Bordeaux)

A Young Man with Two
Majas

Verso: *Majo Watching a Gallant
Bowing to a Maja*
Brush and brown and gray wash, over
traces of black chalk
232 x 145 mm
Watermark: fragment of a coat of arms

Numbered by the artist at upper right,
in brush and gray wash, *39*; on verso,
at upper left, *40*

Thaw Collection, The Pierpont
Morgan Library

Ein junger Herr mit zwei
Majas

Verso: *Ein Majo sieht zu, wie ein
Kavalier sich vor einer Maja verbeugt*
Pinsel in Braun und Grau über Spuren
schwarzer Kreide
232 x 145 mm
Wasserzeichen: Fragment eines
Wappens

Numeriert vom Künstler oben rechts
mit Pinsel in Grau: *39*; verso oben
links: *40*

Sammlung Thaw, The Pierpont
Morgan Library

This sheet, numbered 39 and 40, was once part of the album of Goya's drawings generally known as the Madrid Album, or Album B. The Madrid Album designation was based on Valentín Carderera's observation that this suite of drawings was made by Goya either from nature or from memory in Madrid, although it is not certain that the album was begun there. Goya may have worked on them earlier, during the summer of 1796, when he lived with the duchess of Alba on her estate; the Sanlúcar Album, or Album A, was completed during this period. Both albums employ Netherlandish paper, with drawings on both sides of the sheet. They were dismembered, along with the artist's drawing books, by Goya's son, Javier, who mounted the sheets in pink paper albums. For the Madrid Album, which probably dates to 1796–97, Goya selected a larger format than that used for the Sanlúcar Album, numbering each page in brush and gray at the upper right corner of the recto and at the upper left corner of the verso.

The subject matter and style of Goya's pictorial journals reflect the artist's experience and ideas. In the Sanlúcar Album, his source of inspiration was clearly the duchess and the other young women he encountered on the estate. The first part of the Madrid Album also concentrates on the theme of individual women surrounded by other figures and escorted by men, as in the present sheet. Gassier observes that this young woman appears to be the one who appears on pages 5 and 6 (Biblioteca Nacional, Madrid). Eleanor Sayre has suggested that this flirtation scene may have been one source of inspiration for Goya's print *Tal para qual* (Birds of a Feather).[1]

Provenance
Paul Lebas, Paris(?); sale, Paris, Hôtel Drouot, 3 April 1877, lot 67; Paul Meurice, Galerie les Tourettes, Basel; Benjamin Sonnenberg, New York; his sale, New York, Sotheby's, 5–9 June 1979, lot 66, repr.

Selected bibliography and exhibitions
Gassier 1973, nos. B.39 and B.40, repr.; Gassier 1981, nos. 407 and 408, repr.; Thaw II, no. 29, repr. (includes full bibliography and exhibitions).

1. Boston and Ottawa 1974, p. 67.

Dieses mit den Ziffern 39 und 40 numerierte Blatt war einmal Teil des Albums mit Goyas Zeichnungen, das im allgemeinen als das *Album von Madrid* oder *Album B* bekannt ist. Die Bezeichnung basiert auf der Beobachtung Valentín Cardereras, wonach die Zeichnungsfolge von Goya entweder nach der Natur oder aus der Erinnerung in Madrid angefertigt wurde; es ist jedoch nicht gesichert, daß er das Album bereits dort begonnen hat. Goya kann bereits früher, im Sommer 1796, daran gearbeitet haben, als er mit der Herzogin von Alba auf deren Gut wohnte; das *Album von Sanlúcar* oder *Album A* wurde in dieser Zeit fertiggestellt. Beide Alben bestehen aus niederländischem Papier und enthalten beidseitig Zeichnungen. Zusammen mit Goyas Skizzenbüchern wurden sie von seinem Sohn Javier aufgelöst, der die Blätter dann in Alben mit rosafarbenem Papier klebte. Für das *Madrider Album*, das wahrscheinlich auf 1796 bis 1797 zu datieren ist, wählte Goya ein größeres Format als beim *Sanlúcar Album*. Er numerierte jede Seite mit dem Pinsel in grauer Tusche, auf dem Recto in der oberen rechten Ecke und auf dem Verso oben links.

Sowohl das Thema als auch der Stil der gezeichneten Tagebücher Goyas spiegeln die Erfahrung und Ansichten des Künstlers. Im *Sanlúcar Album* dienten ihm zweifellos die Herzogin und die anderen jungen Frauen, denen er auf dem Gut begegnete, als Inspirationsquelle. Der erste Teil des *Madrider Albums* konzentriert sich ebenfalls auf weibliche Einzelfiguren, die, wie im vorliegenden Blatt, entweder von anderen Figuren umgeben sind oder von Männern begleitet werden. Gassier beobachtete, daß diese junge Frau dieselbe wie die auf den Seiten 5 und 6 zu sein scheint (Biblioteca Nacional, Madrid). Eleanor Sayre hat darauf hingewiesen, daß diese Flirtszene eine der Quellen für Goyas Capricho *Tal para qual* (gleich und gleich gesellt sich gern) gewesen sein könnte.[1]

1. Boston und Ottawa 1974, S. 67.

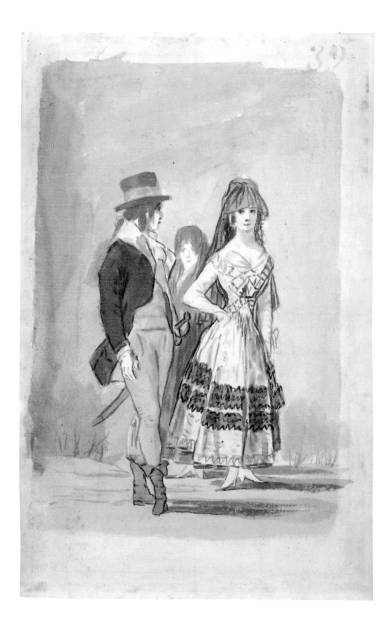
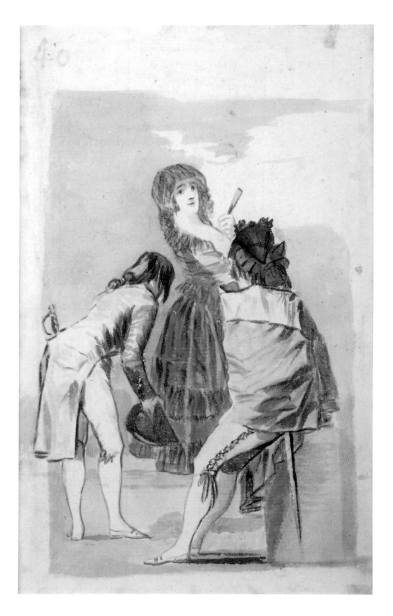

FRANCISCO JOSE DE GOYA Y LUCIENTES
(Aragon 1746–1828 Bordeaux)

LOCURA (MADNESS)

Brush and black wash
225 x 140 mm

Inscribed by the artist at lower center, in black chalk, *Locura;* numbered by the artist at upper center, in brush and brown wash, *11;* numbered by Javier Goya above this, in pen and brown ink, *21*

Thaw Collection, The Pierpont Morgan Library

LOCURA (WAHNSINN)

Pinsel in Schwarz
225 x 140 mm

Bezeichnet vom Künstler unten Mitte in schwarzer Kreide: *Locura;* numeriert vom Künstler oben Mitte mit Pinsel in Braun: *11;* darüber numeriert von Javier Goya mit Feder in Braun: *21*

Sammlung Thaw, The Pierpont Morgan Library

This drawing was once page 11 of Album D, or the Unfinished Album, which has been dated from about 1815 or a few years later.[1] The paper is the same as that in the Madrid Album (see No. 36), and Pierre Gassier surmised that it may have been one of the last unused leaves of the album. However, only one side of this sheet contains a drawing, and it is clearly closer in date to the Black Border Album, the shortest of Goya's books of drawings, with the highest known page being 23.[2]

It is difficult to interpret the meaning of this work. While Gassier suggested that the subject might be some sort of quack or buffoon in a fool's cap, the costume, along with the raised platform, made him think of a preacher. Since Goya often made religion the target of his scorn, this points toward a more satirical interpretation. As Manuela Mena Marqués observes, the term *locura* (insanity or folly) can refer not only to mental illness but also to extravagant or unusual behavior.[3]

Provenance
Paul Lebas, Paris; sale, Paris, Hôtel Drouot, 3 April 1877, no. 20 (as *Il le guérit*); E. Calando (Lugt 837), Paris; his sale, Paris, Hôtel Drouot, 11–12 December 1899, part of lot 75; Camille Groult, Paris; Paul Brame, Paris; Paul Rosenberg and Co., New York; R. M. Light & Co., Inc.

Selected bibliography and exhibitions
Gassier and Wilson 1971, no. 1372; Gassier 1973, no. D.11, repr.; Thaw I, no. 64, repr.; Frankfurt am Main 1981, no. L 38, repr.; Madrid and elsewhere 1988–89, p. 374, fig. 1.

1. Sayre dates it to about 1816–18; see Madrid and elsewhere 1989, p. cxv.
2. Ibid., p. cxvi, n. 1.
3. Mena Marqués in Madrid and elsewhere 1989, p. 375.

Diese Zeichnung war vormals Seite 11 des *Albums D,* auch *Unvollendetes Album* genannt, das auf etwa 1815 oder etwas später datiert wird.[1] Das Papier ist dasselbe, das auch schon im *Madrider Album* (vgl. Kat.-Nr. 36) Verwendung fand, und Pierre Gassier vermutete, daß es sich um eines der letzten unbenutzten Blätter des Albums handeln müsse. Allerdings ist das Blatt nur einseitig bezeichnet und steht zeitlich eindeutig dem *Black Border Album* näher, dem kleinsten unter Goyas Skizzenbüchern, dessen höchste bekannte Seitenzahl 23 ist.[2]

Der Sinn dieser Darstellung ist nur schwer zu entschlüsseln. Während Gassier einerseits annahm, daß es sich bei der Gestalt um eine Art Quacksalber oder Clown mit Narrenkappe handle, ließ ihn das Kostüm der Figur und das kanzelartige Podium an einen Prediger denken. Da Goya die Religion oftmals zur Zielscheibe seines Spottes machte, wäre dies eine stärker satirische Interpretation. Wie Manuela Mena Marqués bemerkte, kann sich der Begriff *locura* (Wahnsinn oder Verrücktheit) nicht nur auf eine psychische Erkrankung, sondern auch auf ein extravagantes oder unkonventionelles Verhalten beziehen.[3]

1. Sayre datiert es auf etwa 1816–18; siehe Madrid u. a. 1989, S. cxv.
2. Ebenda, S. cxvi, Anm. 1.
3. Mena Marqués in Madrid u. a. 1989, S. 375.

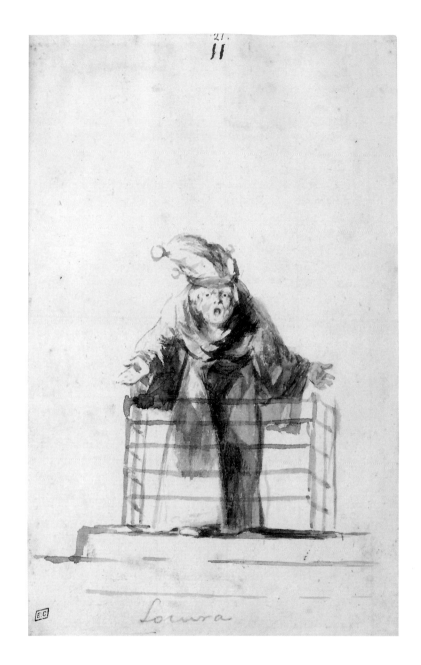

Locura

FRANCISCO JOSE DE GOYA Y LUCIENTES

(Aragon 1746–1828 Bordeaux)

38

PESADILLA (NIGHTMARE)

Point of brush, gray and black washes
264 x 171 mm
Watermark: J HO[NIG & ZOONEN]

Inscribed by the artist at bottom in
black chalk, *Pesadilla;* numbered by
him at top in brown ink, *20;* numbered
by another hand in black ink above
Goya's number, *41.*

Gift of Mr. and Mrs. Richard J.
Bernhard; Acc. no. 1959.13

PESADILLA (ALPTRAUM)

Pinsel in Grau und Schwarz
264 x 171 mm
Wasserzeichen: J HO[NIG &
ZOONEN]

Bezeichnet vom Künstler unten Mitte
in schwarzer Kreide: *Pesadilla*; von
ihm eigenhändig numeriert mit Feder
in Braun über der Einfassungslinie:
20; numeriert von fremder Hand
mit Feder in Schwarz über Goyas
Ziffern: *41*

Geschenk von Mr. und Mrs. Richard J.
Bernhard; Inv.-Nr. 1959.13

This sheet and No. 39 were originally part of the so-called Black Border Album, or Album E, which was divided by Goya's son, Javier, into the two series that were sold in Paris in 1877. The album—Goya's largest—has been dated to 1803–12, making it roughly contemporary with his celebrated etchings *Disasters of War.* More recently, Eleanor Sayre has suggested a later date of about 1814–17 based on stylistic as well as political reasons, the latter being connected with events occurring after the return of Fernando VII from France.[1]

This drawing was originally page 20 of the album. Although a woman on a bull generally personifies Europe, Goya inscribed the sheet with the word *Nightmare* and depicted the woman as terror-stricken with bulging eyes and an open mouth. When considered with the previous page, *He Doesn't Know What He's Doing,* which has been interpreted as reflecting events in Madrid after Fernando VII's return from France, it gains greater significance. Teresa Lorenzo de Márquez suggests that the subject of page 19, a figure with closed eyes smashing a statue, may allude to the destruction brought on by the abandonment of the 1812 Constitution of Cádiz as well as to the idea that the common man blindly helped to destroy a form of government that held the only hope for him.[2]

In light of this, the drawing may suggest the fear and horror of the repression that was to follow the restoration of Fernando VII and, given Goya's fascination with double meaning, the woman on a bull may refer to events occurring throughout Europe.

Provenance
Paul Lebas, Paris; his sale, Paris, Hôtel Drouot, 3 April 1877, one of lots 12, 78, or 79 (to E. Féral for 14 francs); E. Calando, Paris (Lugt 837); his sale, Paris, Hôtel Drouot, 11–12 December 1899, lot 73 (175 francs).

Selected bibliography and exhibitions
Gassier and Wilson 1971, no. 1393; Gassier 1973, E.20, repr.; New York 1981, no. 118, repr. (includes full bibliography and exhibitions); Morgan Library 1993, pp. 297–98.

1. Sayre in Madrid and elsewhere 1989, pp. cxiii–cxiv.
2. Lorenzo de Márquez in Madrid and elsewhere 1989, pp. 278–79.

Dieses Blatt gehörte ursprünglich gemeinsam mit Kat.-Nr. 39 zum sogenannten *Black Border Album* oder *Album E,* das Goyas Sohn Javier in jene zwei Folgen teilte, die 1877 in Paris versteigert wurden. Dieses Album – dem Umfang nach Goyas größtes – wurde auf 1803 bis 1812 datiert und wäre dann ungefähr zeitgleich mit seinen berühmten Radierungen der *Schrecken des Krieges* entstanden. Eleanor Sayre hat kürzlich eine spätere Entstehungszeit, um 1814 bis 1817, vorgeschlagen. Sie stützt sich dabei auf stilistische Untersuchungen wie auch auf politisch-historische Anhaltspunkte, wobei letztere mit Ereignissen nach der Rückkehr Ferdinands VII. aus Frankreich in Zusammenhang stehen.[1]

Vorliegende Zeichnung war ursprünglich die Seite 20 des Albums. Obwohl eine Frau auf einem Stier im allgemeinen Europa verkörpert, fügte Goya dem Blatt die Bildunterschrift *Alptraum* hinzu und stellte die Frau vor Schrecken erstarrt und mit aufgerissenen Augen dar. Wenn man die vorausgehende Seite des Albums *Er weiß nicht, was er tut* zum Vergleich heranzieht, die als Spiegelung der Madrider Ereignisse nach der Rückkehr Ferdinands VII. aus Frankreich interpretiert wurde, gewinnt das Blatt eine größere Bedeutung. Teresa Lorenzo de Márquez vermutete, daß das Sujet der Seite 19 – eine Figur, die mit geschlossenen Augen eine Statue zertrümmert – eine Anspielung auf die Verwüstungen sein könnte, die durch die Aufhebung der 1812 in Cadiz proklamierten Verfassung ausgelöst wurden. Es könnte ebenso Bezug nehmen auf die Vorstellung, daß der einfache Mann blindlings hilft, eine Regierungsform zugrunde zu richten, die seine einzige Hoffnung birgt.[2]

Unter diesem Aspekt bringt die Zeichnung möglicherweise die Furcht und den Schrecken der Unterdrückung nach der Wiedereinsetzung Ferdinands VII. zum Ausdruck. Angesichts Goyas Faszination für Doppeldeutigkeiten könnte die Frau auf einem Stier sich auf Ereignisse beziehen, die überall in Europa stattfinden.

1. Sayre in Madrid u. a. 1989, S. cxiii–cxiv.
2. Lorenzo de Márquez in Madrid u. a. 1989, S. 278–79.

41.

20.

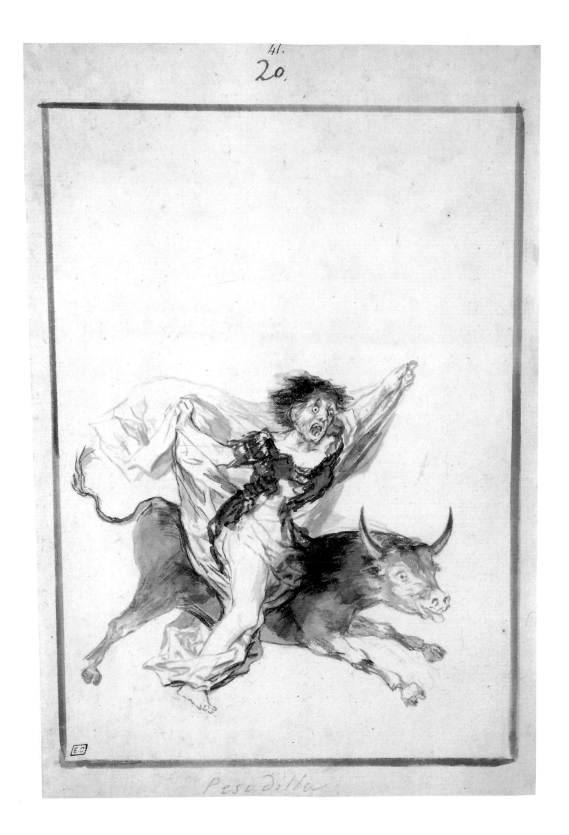

Pesadilla

FRANCISCO JOSÉ DE GOYA Y LUCIENTES
(Aragon 1746–1828 Bordeaux)

39

Dejalo todo a la probidencia (Leave it All to Providence)

Brush and black wash
268 x 185 mm
Watermark: none

Inscribed by the artist in pencil at lower center, *Dejalo todo a la probidencia;* numbered by the artist in pen and brown ink at upper center, *40*

Thaw Collection, The Pierpont Morgan Library

Dejalo todo a la probidencia (Überlass es alles der Vorsehung)

Pinsel in Schwarz
268 x 185 mm
Kein Wasserzeichen

Bezeichnet vom Künstler unten Mitte mit Bleistift: *Dejalo todo a la probidencia;* numeriert vom Künstler oben Mitte mit Feder in Braun: *40*

Sammlung Thaw, The Pierpont Morgan Library

This sheet was originally page 40 of the Black Border Album (see No. 38). The same model, wrapped in a cloak and leaning against a tree trunk, appeared earlier in the album as *Resignation* (Museum of Fine Arts, Boston). In the present drawing, the broadly brushed figure stands apparently resigned to her fate. Her passive attitude is in marked contrast with that of the man, depicted on the previous page, who rails against his lot (*You Won't Get Anywhere by Shouting;* private collection). Teresa Lorenzo de Márquez has suggested that the drawing on page 39 and the present drawing, both of which depict peasants, are intentionally followed on page 41 by a depiction of a finely dressed woman being abducted (*God Save Us from Such a Bitter Fate;* The Metropolitan Museum of Art, New York). Márquez believes that the contrast alludes to the uneasy coexistence of a poor agrarian proletariat and a limited, landowning aristocracy, which fostered a high occurrence of robbery, kidnapping, and other crimes; that the peasant, who had lost his lands, "had nothing to defend, nothing to lose, nor any reason to uphold the law."[1]

Provenance
Paul Lebas, Paris; sale, Paris, Hôtel Drouot, 3 April 1877, lot 104 (as *Elle laisse tout à la Providence*); De Beurnonville, Paris; his sale, Paris, Hôtel Drouot, 16–19 February 1885, part of lot 50; Clément, Paris; Alfred Beurdeley, Paris (Lugt 421); his sale, Paris, Galerie Georges Petit, 2–4 June 1920, lot 169; Hector Brame, Paris; Edith Wetmore, New York; Karl Kup, New York; Helmut Ripperger, New York; T. Edward Hanley, Bradford, Pennsylvania.

Selected bibliography and exhibitions
Gassier and Wilson 1971, no. 1406; Gassier 1973, pp. 193, 217, E.40, repr.; New York 1981, no. 119, repr.; Madrid and elsewhere 1988–89, p. 293; Thaw, Royal Academy, no. 45, repr. (includes full bibliography and exhibitions).

1. Lorenzo de Márquez in Madrid and elsewhere 1989, p. 293.

Dieses Blatt war ursprünglich Seite 40 des *Black Border Album* (vgl. Kat.-Nr. 38). Dasselbe Modell, in einen Umhang gehüllt und an einen Baumstumpf gelehnt, erscheint vorher in dem Skizzenbuch als *Resignation* (Museum of Fine Arts, Boston). Die mit großzügigen Pinselstrichen angelegte Figur in der vorliegenden Zeichnung ergibt sich anscheinend resigniert ihrem Schicksal. Die widerstandslose Haltung steht in starkem Kontrast zu derjenigen des Mannes, der auf der vorherigen Seite abgebildet ist und der dem Zorn über sein Los freien Lauf läßt (*Du wirst nichts mit Geschrei erreichen;* Privatsammlung). Teresa Lorenzo de Márquez nahm an, daß die vorliegende Zeichnung und diejenige von Seite 39, die beide jeweils Bauern darstellen, nicht zufällig der Seite 41 vorangestellt sind, die die Entführung einer schön gekleideten Frau zeigt (*Gott schütze uns vor so einem bitteren Schicksal;* The Metropolitan Museum of Art, New York). Márquez vermutete, daß der Kontrast auf die schwierige Koexistenz eines armen Bauernproletariats und einer kleinen, Land besitzenden Adelsschicht anspielt, welche in hohem Maß Raub, Entführung und andere Verbrechen förderte; daß der Bauer, der sein Land verlor, »nichts zu verteidigen, nichts zu verlieren, keinen Grund das Gesetz zu wahren hat«.[1]

1. Lorenzo de Márquez in Madrid u. a. 1989, S. 293.

120

40

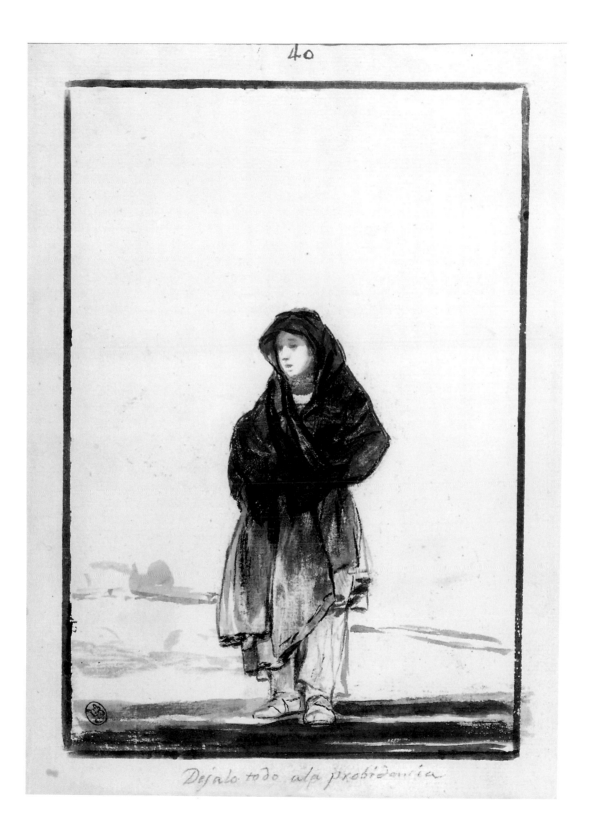

Dejalo todo ala probidencia

HENRY FUSELI / JOHANN HEINRICH FÜSSLI
(Zurich 1741–1825 London)

40

SATAN DEPARTING FROM THE COURT OF CHAOS

Pen and brown ink, brush and brown, reddish brown, and black washes, touches of red watercolor and white chalk
387 x 500 mm
Watermark: fleur-de-lis within a shield (cf. Heawood 1827)

Inscribed at left margin, in pen and brown ink, *London 81–82;* at lower left, in pen and black ink, *William Blake*

Gift of Louise Crane in memory of her mother, Mrs. W. Murray Crane; Acc. no. 1975.43

SATAN VERLÄSST DAS CHAOS

Feder und Pinsel in Braun, rotbraune und schwarze Lavierung, stellenweise rot aquarelliert und weiße Kreide
387 x 500 mm
Wasserzeichen: Lilie innerhalb eines Schildes (siehe Heawood 1827)

Bezeichnet am linken Rand mit Feder in Braun: *London 81–82;* unten links mit Feder in Schwarz: *William Blake*

Geschenk von Louise Crane in Gedenken an ihre Mutter Mrs. W. Murray Crane; Inv.-Nr. 1975.43

While Fuseli was a student in Zurich, the Swiss scholar Johann Jakob Bodmer introduced him to the works of Homer, Dante, Shakespeare, and Milton, all of which became important sources for the paintings and drawings the artist made later in life. *Satan Departing from the Court of Chaos,* based on a passage from Milton's *Paradise Lost* (Book II, 1010–16), depicts Satan's meeting with Chaos, who directs him to the newly created earth. The moment Fuseli chose to illustrate corresponds with Satan's hasty departure: "He ceas'd; and Satan stay'd not to reply, / But glad that now his Sea should find a shore, / With fresh alacrity and force renew'd / Springs upward like a Pyramid of fire / Into the wild expanse." The figure of Chaos is depicted with his arm raised, while Night appears to his left and the crowned figure of Chance to his right. The crouching figures of Chaos and Chance may have served as the inspiration for some figures in Blake's *Book of Urizen.*[1]

Although this drawing was once thought to date to the 1790s and to be an early study for a painting exhibited in Fuseli's Milton Gallery (*Satan Bursts from Chaos,* no. 11), its style and the inscription, *London 81–82,* reveal that it was made some three years after Fuseli had returned from his eight-year sojourn in Italy.[2] While there, Fuseli developed the distinctive style seen in this work, emphasizing broad, dramatic gestures and intense emotion, a style that essentially remained unchanged until the artist's death.

Provenance
Mrs. W. Murray Crane; her daughter, Louise Crane.

Selected bibliography and exhibitions
Schiff 1973, vol. 1, no. 1020; New Haven 1979, no. 48, repr.; New York 1981, no. 115, repr. (includes full bibliography and exhibitions).

1. Bindman 1977, p. 104.
2. New Haven 1979, p. 46.

Während Füsslis Studienzeit in Zürich machte ihn der Schweizer Professor Johann Jakob Bodmer mit den Werken von Homer, Dante, Shakespeare und Milton vertraut, die alle zu wichtigen Quellen seiner späteren Gemälde und Zeichnungen wurden. *Satan verläßt das Chaos* geht zurück auf eine Passage in Miltons Dichtung *Das verlorene Paradies* (Buch II, 1010–16) und schildert die Begegnung Satans mit der Gestalt des Chaos, die ihn zur neu erschaffenen Erde leitet. Der von Füssli für die Illustration gewählte Augenblick entspricht in der Textvorlage Satans hastigem Aufbruch: »Er endete; Satan verweilte nicht / zur Antwort länger, sondern frohgestimmt, / daß nun sein Meer ein Ufer finden sollte / schnellt mit erquickter Kraft und frisch gestählt / er aufwärts wie ein Riesenfeuerkeil ins pfadlos Weite« (Buch II, 1311–16, übertragen von Hans Heinrich Meier). Die Figur des Chaos ist mit erhobenem Arm dargestellt, während die Nacht zu seiner Linken und die bekrönte Figur der Fortuna zu seiner Rechten erscheint. Die kauernden Figuren von Chaos und Fortuna könnten einigen Figuren in Blakes *Book of Urizen* als Anregung gedient haben.[1]

Entgegen der früheren Annahme, diese Zeichnung sei in die 1790er Jahren zu datieren und eine frühe Studie für ein Gemälde, das in Füsslis Milton-Galerie (*Satan bricht aus dem Chaos hervor,* Nr. 11) ausgestellt war, zeigen ihr Stil und die Beschriftung *London 81–82,* daß sie drei Jahre nach der Rückkehr von Füsslis achtjährigem Italienaufenthalt entstanden ist.[2] In dieser Zeit entwickelte Füssli seinen unverwechselbaren Stil, der, wie auch in dieser Arbeit zu erkennen, ausladende, dramatische Gesten und heftige Emotion betont und den er bis zu seinem Tod beibehielt.

1. Bindman 1977, S. 104.
2. New Haven 1979, S. 46.

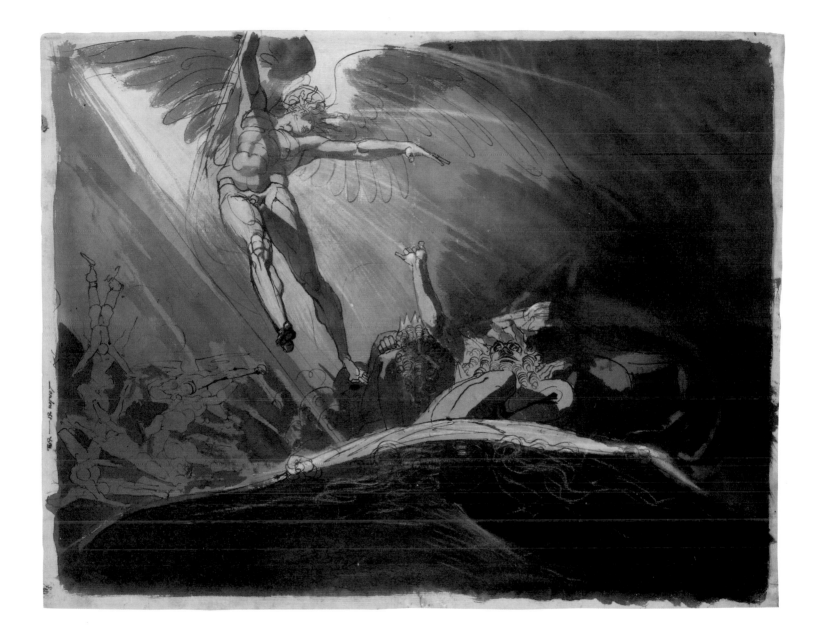

HENRY FUSELI / JOHANN HEINRICH FÜSSLI
(Zurich 1741–1825 London)

41

PSYCHOSTASY
(THE WEIGHING OF SOULS)

Pen and brown ink, brown and gray
wash, blue watercolor, over faint traces
of graphite
477 x 332 mm
Watermark: none visible through
lining

Inscribed by the artist in pen and
brown ink at upper right corner, *Febr.
1800,* and in Greek along lower edge
identifying the subject as Psychostasy.
περνε στραταρχου Αιδιοπων αφοβον
– Μεμνονα χαλκοραν "[who] killed
the fearless general of the Ethiopians—
Memnon"; ΨΥΧΟΣΤΙΑ (*"Psycho-
stasie").* Inscribed by another hand at
lower right, in pen and brown ink,
Will^m Blake.

Gift of Louise Crane in memory of her
mother, Mrs. W. Murray Crane;
Acc. no. 1974.44

PSYCHOSTASIE
(DAS WIEGEN DER SEELEN)

Feder in Braun, braune und graue
Lavierung, blau aquarelliert über
feinen Spuren von Graphit
477 x 332 mm
Wasserzeichen: nicht erkennbar auf-
grund der Montierung

Datiert vom Künstler mit Feder in
Braun in der oberen rechten Ecke:
Febr. 1800 und auf Griechisch entlang
des unteren Randes die Darstellung als
Psychostasie identifizierend: περνε
στραταρχου Αιδιοπων αφοβον —
Μεμνονα χαλκοραν (»[wer] tötete
den furchtlosen General der Äthiopier-
Memnon«); ΨΥΧΟΣΤΙΑ (»Psycho-
stasie«). Bezeichnet von fremder Hand
unten rechts mit Feder in Braun: *Will^m
Blake.*

Geschenk von Louise Crane in
Gedenken an ihre Mutter Mrs.
W. Murray Crane; Inv.-Nr. 1974.44

Provenance
Mrs. W. Murray Crane; her daughter,
Louise Crane.

Selected bibliography and exhibitions
Schiff 1973, no. 1365, repr.; Los An-
geles and Minneapolis 1993–94, no. 98,
repr. (includes full bibliography and
exhibitions).

The subject of this drawing is based on two
ancient sources, Pindar and Plutarch. In his
Odes, Pindar describes how Achilles alighted
from his chariot to slay the Ethiopian king
Memnon, son of Aurora and nephew of King
Priam. In the Library's drawing, the trium-
phant Achilles is shown against the backdrop
of the Trojan War with one foot placed on his
chariot, victoriously gesturing toward Jupiter
while the body of the slain Memnon domi-
nates the foreground. Above, Jupiter imperi-
ously weighs the souls of Achilles and Memnon,
with victory awarded to Achilles, the heavier
soul. In his description of the psychostasy of
the two warriors, Plutarch wrote that Thetis,
the mother of Achilles, and Aurora stood by
Jupiter's scales pleading for their sons.[1]

The Library's drawing is preparatory for a
painting of the subject, now lost, commis-
sioned from Fuseli by Sir Thomas Lawrence
and exhibited at the Royal Academy in 1803.[2]
A somewhat smaller pencil drawing, which if
undated might be considered an early idea for
the composition, apparently was made in July
1813.[3] Fuseli drew upon a variety of sources
for the figures, with ancient sculpture taking
center stage: The figure of Achilles is based on
Alexander from the pair of statues Alexander
and Bucephalus, also known as the *Horse
Tamers,* while the prone figure of Memnon
was influenced by antique sculpture represent-
ing dying gladiators as well as by Gavin Ham-
ilton's *Achilles Vents His Rage on Hector.*[4]
While Schiff has suggested that the composi-
tion of the Library's drawing was influenced
by Raphael's design for *The Transfiguration,*
Fuseli presumably also had in mind the device
of dividing a pictorial composition horizon-
tally into earthly and heavenly realms, which
Raphael used in the *Disputa.*

1. Los Angeles and Minneapolis 1993–94, pp. 294–95.
2. Schiff 1973, no. 63, p. 652.
3. Ibid., no. 1521.
4. Richard Campbell in Los Angeles and Minneapolis
1993–94, p. 295; Schiff 1973, p. 134, discusses the
various references in detail.

Das Thema dieser Zeichnung beruht auf zwei
antiken Quellen: Pindar und Plutarch. In sei-
nen *Oden* beschreibt Pindar, wie Achill aus sei-
nem Wagen steigt, um König Memnon aus
Äthiopien, den Sohn Auroras und Neffen des
Königs Priamus, zu erschlagen. In der Zeich-
nung der Library sieht man den triumphieren-
den Achill vor dem Getümmel des Trojanischen
Krieges. Einen Fuß noch auf dem Wagen, wen-
det er sich mit einer Siegesgeste Jupiter zu,
während der Körper des erschlagenen Memnon
den Vordergrund einnimmt. Darüber wiegt
Jupiter gebieterisch die Seelen von Achill und
Memnon, wobei der Sieg Achill, der schwereren
Seele, zuerkannt wird. In der Psychostasie der
beiden Krieger beschreibt Plutarch, wie Thetis,
die Mutter Achills, und Aurora neben Jupiters
Waage für ihre Söhne bitten.[1]

Die Zeichnung der Library ist zur Vorberei-
tung eines heute verlorenen Gemäldes entstan-
den, das Sir Thomas Lawrence bei Füssli in
Auftrag gegeben hatte und das 1803 in der Roy-
al Academy in London ausgestellt wurde.[2] Eine
etwas kleinere Bleistiftzeichnung könnte, wäre
sie undatiert, als eine frühe Idee für die Kom-
position angesehen werden, offensichtlich wur-
de sie aber im Juli 1813 ausgeführt.[3] Füssli
nutzte eine Vielzahl von Quellen für die Figu-
ren, wobei Beispiele der antiken Plastik hierbei
die Hauptrolle spielten: Die Gestalt des Achill
basiert auf dem Alexander aus der Skulpturen-
gruppe von Alexander und Bucephalus, auch
unter dem Titel *Rossebändiger* bekannt; die
hingestreckte Figur des Memnon wurde von
antiken Skulpturen sterbender Gladiatoren wie
auch von Gavin Hamiltons *Achill entlädt sei-
nen Zorn an Hector*[4] beeinflußt. Während Gert
Schiff annahm, daß die Zeichnung der Library
von Raffaels Entwurf zur *Verklärung Christi*
angeregt wurde, beabsichtigte Füssli wahr-
scheinlich eine horizontale Teilung der Bild-
komposition in einen irdischen und einen
himmlischen Bereich, wie Raffael sie in der *Dis-
putá* anwandte.

1. Los Angeles und Minneapolis 1993–94, S. 294–95.
2. Schiff 1973, Nr. 63, S. 652.
3. Ebenda, Nr. 1521.
4. Richard Campbell in Los Angeles und Minneapolis
1993–94, S. 295; Schiff 1973, S. 134, diskutiert die ver-
schiedenen Bezüge im Detail.

124

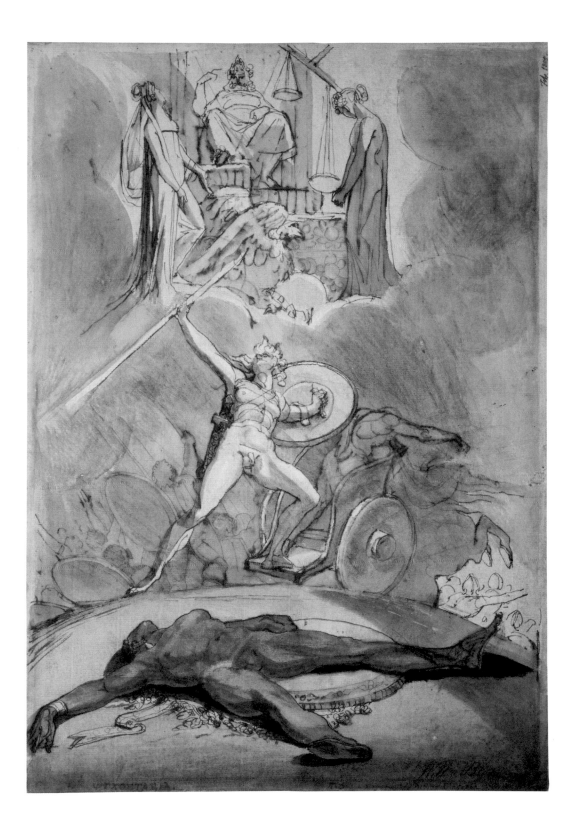

HENRY FUSELI / JOHANN HEINRICH FÜSSLI

(Zurich 1741–1825 London)

42

SKAMANDROS TRIES TO PREVENT ACHILLES FROM SLAYING THE TROJANS

Pen and brown ink, gray wash, heightened with white chalk, on blue paper
Verso: Faint sketches of a female nude and another head, in graphite
424 x 517 mm
Watermark: none

Inscribed at lower left, in pen and black ink, *W. Blake*

Gift of Louise Crane in memory of her mother, Mrs. W. Murray Crane;
Acc. no. 1975.44

SKAMANDROS VERSUCHT ACHILL DAVON ABZUHALTEN, DIE TROJANER ZU ERSCHLAGEN

Feder in Braun, graue Lavierung, gehöht mit weißer Kreide auf blauem Papier
Verso: blasse Skizzen eines weiblichen Aktes und eines Kopfes in Graphit
424 x 517 mm
Kein Wasserzeichen

Bezeichnet unten links mit Feder in Schwarz: *W. Blake*

Geschenk von Louise Crane in Gedenken an ihre Mutter Mrs. W. Murray Crane; Inv.-Nr. 1975.44

In Book XXI of Homer's *Iliad*, Achilles, determined to rout the Trojans, is stopped from carrying out his slaughter only by the river god Skamandros. The scene depicted in this highly charged drawing is the moment when the river rushed around Achilles with such strength that it thrust him backward, causing him to lose his footing. To steady himself, Achilles grasped

> an elm, shapely and tall, but it fell uprooted and tore away all the bank, and stretched over the fair streams with its thick branches, and dammed the River himself, falling all within him; but Achilles, springing forth from the eddy, hasted to fly with swift feet over the plain, for he was seized with fear. Howbeit the great god ceased not, but rushed upon him with dark-crested wave, that he might stay goodly Achilles from his labour, and ward off ruin from the Trojans.[1]

At the left side of the sheet Fuseli added a brief reference to the fleeing Trojans. Unlike the text, which immediately describes Achilles' fate, the drawing maintains suspense by focusing only on the moment at which Achilles faced defeat.

Gert Schiff dates this drawing to about 1800–1805 and points out that the subject was depicted—in various ways sometimes with more elaborate compositions and always with greater attention to detail—by such artists as Jakob Asmus Carstens (a chalk drawing of 1793), the Cologne painter Joseph Hoffmann (a prize-winning wash drawing of 1801), John Flaxman, and Philipp Otto Runge. The latter was inspired to depict the scene five times in connection with a competition organized by the Weimar Kunstfreunde.[2]

Provenance
Mrs. W. Murray Crane; her daughter, Louise Crane.

Selected bibliography and exhibitions
Schiff 1973, no. 1357, repr.

1. *The Iliad*, pp. 426–27.
2. Schiff 1973, pp. 311–12.

Im 21. Gesang von Homers *Ilias* kann Achill, der entschlossen ist, die Trojaner in die Flucht zu schlagen, nur noch durch den Flußgott Skamandros von der Ausführung seines Gemetzels abgehalten werden. Die dargestellte, spannungsgeladene Szene dieser Zeichnung gibt den Augenblick wieder, als der Fluß mit solcher Kraft um Achill aufschäumt, daß dieser zurückgestoßen wird und seinen Halt verliert. Um sein Gleichgewicht zurückzugewinnen, greift er nach einem Baum:

> Eine große und schön gewachsene Ulme / packte er gleich mit den Händen; der Baum, entwurzelt im Sturze / riß den Hang auseinander und, dichtbelaubt, mit den Ästen / hielt er die Fluten zurück und lag, den Strom überdämmend / ganz darin. Der Pelide nun schwang sich empor aus dem Wirbel, / lief und strebte, mit fliegenden Füßen das Feld zu gewinnen, / furchtsam; der mächtige Gott aber stürzte sich, ohne zu rasten, / dunkelwogend ihm nach, auf daß er den edlen Achilleus / hinderte endlich am Werk und wehrte die Not von den Trojern. (242–250, übertragen von Hans Rupé.)

Auf der linken Seite des Blattes fügte Füssli einen kurzen Hinweis auf die fliehenden Trojaner hinzu. Im Gegensatz zum Text, der sogleich das Schicksal Achills beschreibt, hält die Zeichnung die Spannung aufrecht, indem sie sich nur auf den Augenblick konzentriert, in dem Achill mit der Niederlage konfrontiert wird.

Gert Schiff datiert diese Zeichnung auf etwa 1800 bis 1805 und weist darauf hin, daß das gleiche Thema auf unterschiedliche Weise, bisweilen mit sorgfältiger ausgearbeiteten Kompositionen und stets stärkerer Beachtung der Details, auch von Künstlern wie Jakob Asmus Carstens (in einer Kreidezeichnung von 1793), dem Kölner Maler Joseph Hoffmann (einer preisgekrönten lavierten, Pinselzeichnung von 1801), John Flaxman und Philipp Otto Runge aufgegriffen wurde. Letzterer entwarf das Motiv im Zusammenhang mit einem von den Weimarer Kunstfreunden organisierten Wettbewerb insgesamt fünfmal.[1]

1. Schiff 1973, S. 311–12.

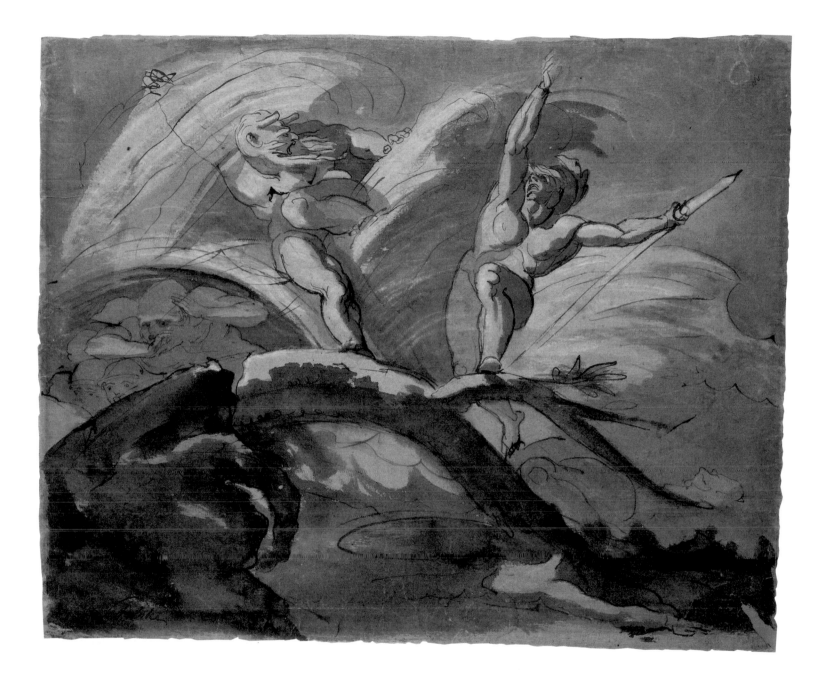

WILLIAM BLAKE
(London 1757–1827 London)

43

FIRE

Pen and brush and black ink, water-
color, graphite

309 x 424 mm

Watermark: none visible through
lining

Signed with monogram at lower right,
in pen and black ink, *WB*

Gift of Mrs. Landon K. Thorne;
Acc. no. 1971.18

FEUER

Feder und Pinsel in Schwarz, Aquarell,
Graphit

309 x 424 mm

Wasserzeichen: nicht erkennbar auf-
grund der Montierung

Monogrammiert unten rechts mit
Feder in Schwarz: *WB*

Geschenk von Mrs. Landon
K. Thorne; Inv.-Nr. 1971.18

From about 1779 to 1805 Blake was occupied with the theme of war and the misfortunes associated with it. *Fire*, the Library's watercolor, is part of a group of four, commissioned by Thomas Butts, that show Blake's final development of these themes. The other three are *War* (Fogg Art Museum, Harvard University, Cambridge, Massachusetts), *Pestilence*, and *Famine* (both in the Museum of Fine Arts, Boston).[1]

Anthony Blunt suggested that this series seems to refer not to the Bible but to the Litany; specifically, the Library's watercolor may symbolize "lightning and tempest."[2] David Erdman connects Blake's work in the 1780s on this theme with his unfinished poetic drama "King Edward the Third," the prologues "Intended for a Dramatic Piece of King Edward the Fourth" and "to King John," and "A War Song to Englishmen," all of which were published in Blake's *Poetical Sketches* in 1783. He interprets these writings as ironic commentaries on war and its appalling consequences.[3] The apocalyptic spirit of Blake's work in general points to contemporary events in England as well as on the Continent, and there is no doubt that the watercolors relate on some level to the French Revolution, which Blake initially supported but subsequently outraged him.

Provenance
Thomas Butts; his son, Thomas Butts, Jr.; his son, Captain F. J. Butts; sale, London, Sotheby's, 24 June 1903, lot 5 (bought in); Howard, then to his widow (according to Butlin 1981); W. Graham Robertson; sale, London, Christie's, 22 July 1949, no. 8; Mrs. Landon K. Thorne.

Selected bibliography and exhibitions
Gilchrist 1863, vol. 1, p. 54; Rossetti 1863, p. 207, no. 54, and 1880, p. 215, no. 60; Binyon 1922, pl. 67; Bindman 1977, p. 144; London 1978, no. 26, repr.; Butlin 1981, no. 194, pl. 192 in color (includes previous bibliography and exhibitions).

1. Butlin 1981, nos. 193–96.
2. Blunt 1959. p. 71, n. 10.
3. Erdman 1977, pp. 63–76; as referred to in Butlin 1981, p. 70.

Von ungefähr 1779 bis 1805 beschäftigte sich Blake mit dem Thema des Krieges und dem damit verbundenen Unglück. *Feuer*, das Aquarell aus der Pierpont Morgan Library, gehört zu einer Gruppe von insgesamt vier Werken, die von Thomas Butts in Auftrag gegeben wurden und Blakes letzte Entwicklung bezüglich dieser Thematik zeigen. Die anderen drei tragen die Titel *Krieg* (Fogg Art Museum, Harvard University, Cambridge, Massachusetts), *Pest* und *Hungersnot* (beide Museum of Fine Arts, Boston).[1]

Anthony Blunt nahm an, daß diese Folge sich nicht auf die Bibel, sondern auf die Fürbitten bezieht; so könnte insbesondere das Aquarell aus der Pierpont Morgan Library »Blitzschlag und Sturm« symbolisieren.[2] David Erdman verband Blakes Werke dieser Thematik mit den 1780er Jahren und mit seinem unvollendeten poetischen Drama »König Edward III.«, den Prologen »Beabsichtigt für ein dramatisches Stück von König Edward IV.«, »König Johann« und »Ein Kriegslied für die Männer Englands«, alle 1783 in Blakes *Poetischen Skizzen* veröffentlicht. Er deutete diese Schriften als ironische Kommentare zum Krieg und seinen entsetzlichen Konsequenzen.[3] Die apokalyptische Stimmung im Werk Blakes verweist im allgemeinen auf zeitgenössische Ereignisse sowohl in England als auch auf dem Kontinent, und es besteht kein Zweifel, daß das Aquarell in mancherlei Hinsicht auf die Französische Revolution hindeutet, die Blake anfangs unterstützte, schließlich aber fühlte er sich grob verletzt.

1. Butlin 1981, Nrn. 193–96.
2. Blunt 1959, S. 71, Anm. 10.
3. Erdman 1977, S. 63–76; zitiert wie in Butlin 1981, S. 70.

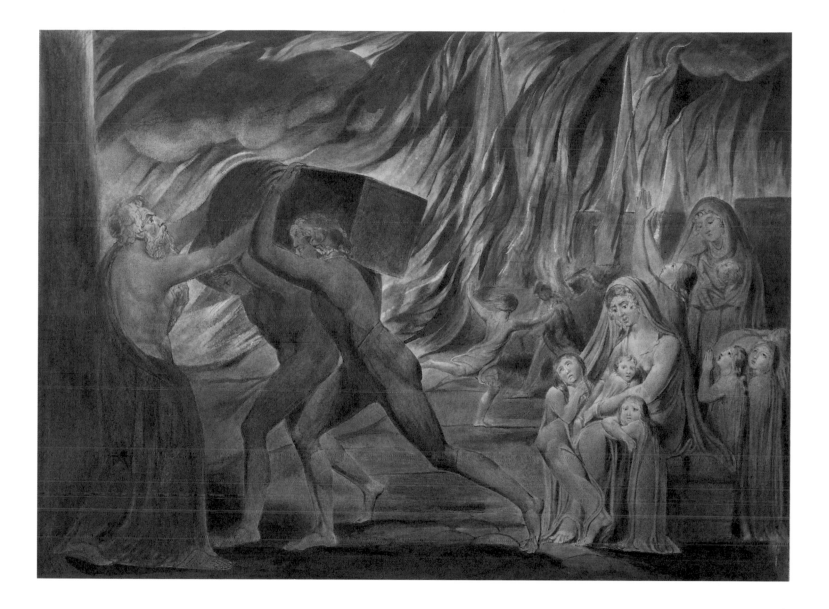

WILLIAM BLAKE

(London 1757–1827 London)

44

JOB'S SONS AND DAUGHTERS OVERWHELMED BY SATAN

ILLUSTRATION 3 to the BOOK OF JOB
Pen and black ink, watercolor, over
faint indications in graphite
287 x 223 mm
Watermark: none

Purchased by Pierpont Morgan, 1903;
Acc. no. Job, 3

HIOBS SÖHNE UND TÖCHTER VON SATAN ÜBERWÄLTIGT

ILLUSTRATION 3 zum BUCH HIOB
Feder in Schwarz, Aquarell über zarter
Vorzeichnung in Graphit
287 x 223 mm
Kein Wasserzeichen

Erworben 1903 von Pierpont Morgan;
Inv.-Nr. Job, 3

This watercolor and Nos. 45 and 46 belong to the first set of twenty-one illustrations to Blake's version of the *Book of Job*. The artist produced the series around 1805–10 for his most important patron, Thomas Butts. In 1821 John Linnell commissioned Blake to paint another set of Job watercolors over tracings from this set. These are now largely at the Fogg Art Museum, Harvard University, Cambridge, Massachusetts.[1]

As Martin Butlin has pointed out, Blake interpreted the biblical account of Job in such a way as "to give some less arbitrary reason for Job's sufferings, justifying them by Job's initial observance of the forms alone of institutional religion, unenlightened by true faith and imagination."[2] Joseph Wicksteed was the first to recognize Blake's transformation of the Job story, which has been elaborated on by later scholars.[3] *Job's Sons and Daughters Overwhelmed by Satan,* shows Satan with large bat-like wings hovering above Job's sons and daughters (Job 1:13, 18–19). The inverted crucifixion on the right has been interpreted as a reference to Blake's comment that "The Modern Church Crucifies Christ with the Head Downwards" and also may represent a condemnation of worldly pleasure.[4]

Provenance
Thomas Butts; Richard Monckton Milnes, first lord of Houghton; Robert Offley Ashburton Milnes, fourth baron and marquess of Crewe; his sale, London, Sotheby's, 30 March 1903, lot 17 (sold to Sabin and bought by Pierpont Morgan through Quaritch for £5,600 on 30 June 1903); Pierpont Morgan (no mark; see Lugt 1509).

Selected bibliography and exhibitions
Butlin 1981, no. 550, 3 (includes previous bibliography and exhibitions).

1. See Butlin 1981, no. 551, and, for the full explanation of the illustrations to the Book of Job, p. 409ff.
2. Butlin 1981, p. 410.
3. Ibid., p. 410.
4. Ibid., no. 550 (3), p. 412.

Dieses Aquarell gehört wie die Kat.-Nrn. 45 und 46 zur ersten Folge von 21 Illustrationen zu Blakes Version des *Buchs Hiob*. Der Künstler schuf die Serie ungefähr 1805 bis 1810 für seinen wichtigsten Mäzen Thomas Butts. Im Jahr 1821 beauftragte ihn John Linnell mit der Ausführung einer weiteren Folge von Aquarellen zum *Buch Hiob* nach den Durchzeichnungen der Serie für Butts. Diese befinden sich heute zum größten Teil im Fogg Art Museum der Harvard University in Cambridge, Massachusetts.[1]

Wie Martin Butlin dargelegt hat, suchte Blake in seiner Interpretation der biblischen Erzählung von Hiob »für Hiobs Leiden einen weniger willkürlichen Grund, indem er diese mit Hiobs anfänglichem Befolgen der bloßen Formen institutionalisierter Religion rechtfertigte, welche unerleuchtet von wahrem Glauben und der Vorstellungskraft waren«.[2] Joseph Wicksteed hat als erster Blakes Umwandlung der Geschichte Hiobs erkannt, die Wissenschaftler später weiter herausgearbeitet haben.[3] *Hiobs Söhne und Töchter von Satan überwältigt,* die dritte Illustration der Folge, zeigt Satan schwebend über Hiobs Söhnen und Töchtern mit großen fledermausartigen Flügeln (Hiob 1, 13, 18–19). Die auf dem Kopf stehende Kreuzigung auf der rechten Seite wurde als Hinweis auf Blakes Bemerkung ausgelegt, daß »die moderne Kirche Christus mit dem Kopf nach unten kreuzigt«; sie mag auch eine Verdammung der weltlichen Freuden symbolisieren.[4]

1. Siehe Butlin 1981, Nr. 551, und zur ausführlichen Erklärung der Illustrationen zum *Buch Hiob*, S. 409ff.
2. Butlin 1981, S. 410.
3. Ebenda, S. 410.
4. Ebenda, Nr. 550 (3), S. 412.

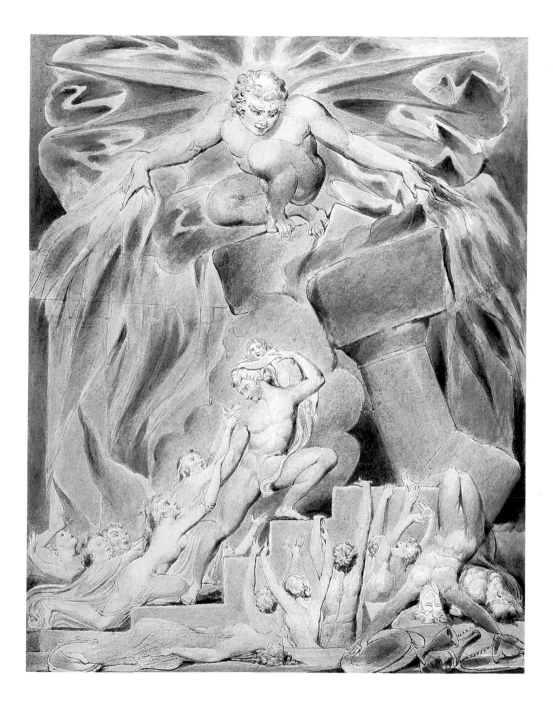

WILLIAM BLAKE

(London 1757–1827 London)

45

JOB REBUKED BY HIS FRIENDS

ILLUSTRATION 10 to the BOOK OF JOB
Pen and black ink, watercolor, over
faint indications in pencil
234 x 279 mm
Watermark: none

Signed at lower right, in pen and black
ink, *WB inv.*

Purchased by Pierpont Morgan, 1903;
Acc. no. Job, 10

HIOB WIRD VON SEINEN
FREUNDEN ZURECHTGEWIESEN

ILLUSTRATION 10 zum BUCH HIOB
Feder in Schwarz, Aquarell über
zarten Spuren in Bleistift
234 x 279 mm
Kein Wasserzeichen

Signiert unten rechts mit Feder in
Schwarz: *WB inv.*

Erworben 1903 von Pierpont Morgan;
Inv.-Nr. Job, 10

This watercolor is illustration 10 to Blake's *Book of Job*, commissioned by Thomas Butts (see also Nos. 44 and 46). The inscription on the related engraving, *The Just upright man is laughed to scorn*, refers specifically to Job 12:4, and Blake added emblems of the Fall around the printed image. The artist based the composition of the watercolor on an earlier engraving that was designed about 1786, *What is Man That thou shouldest Try him Every Moment*.[1] While the figures of Job and his wife are close to those in this earlier print, the poses of the friends are quite different. In the watercolor, they actively reproach Job, extending their arms to point accusingly at him. As David Bindman observed, the motif of the pointing finger may have been inspired by Fuseli's *Three Witches from Macbeth*, but it also, as David Lindberg noted, is a typological parallel to the mocking of Christ.[2]

Provenance
See No. 44.

Selected bibliography and exhibitions
Butlin 1981, no. 550, 10 (includes previous bibliography and exhibitions); Bindman 1982, no. 115a.2.

1. Bindman 1982, no. 15.
2. Ibid., pp. 174–75.

Bei diesem Aquarell handelt es sich um die zehnte Illustration in Blakes *Buch Hiob*, zu dem Thomas Butts den Auftrag erteilte (vgl. auch Kat.-Nrn. 44 und 46). Die Beschriftung auf dem ihm verwandten Kupferstich, *Der aufrechte Mann ist höhnisch verlacht worden*, bezieht sich auf die Stelle Hiob 12, 4; Blake umgab die gedruckte Fassung mit Sinnbildern des Engelssturzes. Als Vorlage für die Komposition des Aquarells diente dem Künstler ein früherer Kupferstich, *Was ist der Mensch, daß Du ihn nicht allezeit versuchen solltest*, den er um 1786 entworfen hatte.[1] Während die Figuren des Hiob und seiner Frau denen dieses früheren Druckes nahestehen, sind die Körperhaltungen der Freunde ziemlich verändert. Im Aquarell beschuldigen sie Hiob, indem sie ihre Arme ausstrecken, um ihn anzuklagen. Wie David Bindman feststellte, könnte das Motiv des zeigenden Fingers von Füsslis *Drei Hexen aus Macbeth* angeregt worden sein, es ist aber zugleich, wie David Lindberg anmerkte, eine typologische Parallele zur Verspottung Christi.[2]

1. Bindman 1982, Nr. 15.
2. Ebenda, S. 174–75.

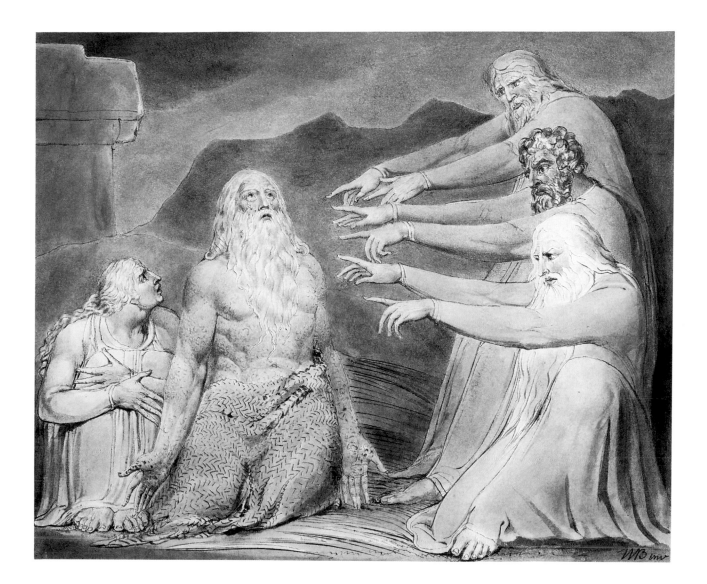

WILLIAM BLAKE

(London 1757–1827 London)

46

JOB'S EVIL DREAMS

ILLUSTRATION 11 to the BOOK OF JOB
Pen and black ink, watercolor, over
faint indications in pencil
237 x 287 mm
Watermark: none

Signed at lower right, in pen and black
ink, *WB inv,* and inscribed in Hebrew
on the Tables of the Law with excerpts
from the Ten Commandments

Purchased by Pierpont Morgan, 1903;
Acc. no. Job, 11

HIOBS BÖSE TRÄUME

ILLUSTRATION 11 zum BUCH HIOB
Feder in Schwarz, Aquarell über zarter
Vorzeichnung in Bleistift
237 x 287 mm
Kein Wasserzeichen

Signiert unten rechts mit Feder in
Schwarz: *WB inv* und auf den Geset-
zestafeln bezeichnet in Hebräisch mit
Auszügen aus den Zehn Geboten

Erworben 1903 von Pierpont Morgan;
Inv.-Nr. Job, 11

This watercolor is illustration 11 to Blake's *Book of Job* (see also Nos. 44 and 45). Job is depicted dreaming on his bed surrounded by flames and demons who grab him from below while a figure above points to the Tables of the Law. Although he is cast in the image of the Lord, his cloven hoof and the serpent wrapped around him identify him as Satan, marking the turning point of the series. There is comprehension of the depth of Job's despair but also a realization that it is Satan who threatens him.[1] From this Job will recognize the possibility of spiritual salvation, which is clarified in the inscription on the related engraving, *I know that my Redeemer liveth* (Job 19:25).[2]

Provenance
See No. 44.

Selected bibliography and exhibitions
Butlin 1981, no. 550, 11 (includes previous bibliography and exhibitions); Bindman 1982, no. 115a.3.

1. Butlin 1981, no. 550 (11), p. 414.
2. Ibid.

Bei diesem Aquarell handelt es sich um die elfte Illustration zu Blakes *Buch Hiob* (vgl. auch Kat.-Nrn. 44 und 45). Hiob ist träumend auf seinem Bett dargestellt, umgeben von Flammen und Dämonen, die von unten nach ihm greifen, während eine Figur über ihm auf die Gesetzestafeln zeigt. Obwohl diese Figur in der Rolle Gottes auftritt, kennzeichnen sie ihr Pferdefuß und die sich um ihren Körper windende Schlange als Satan. Dies markiert den Wendepunkt der Folge. Da ist Wissen von der Tiefe der Verzweiflung Hiobs, aber auch die Erkenntnis, daß es Satan ist, der ihn bedroht.[1] Im Anschluß wird Hiob die Möglichkeit geistiger Erlösung erkennen, was die Beschriftung des entsprechenden Kupferstichs klar ausspricht: *Ich weiß, daß mein Erlöser lebt* (Hiob 19, 25).[2]

1. Butlin 1981, Nr. 550 (11), S. 414.
2. Ebenda.

134

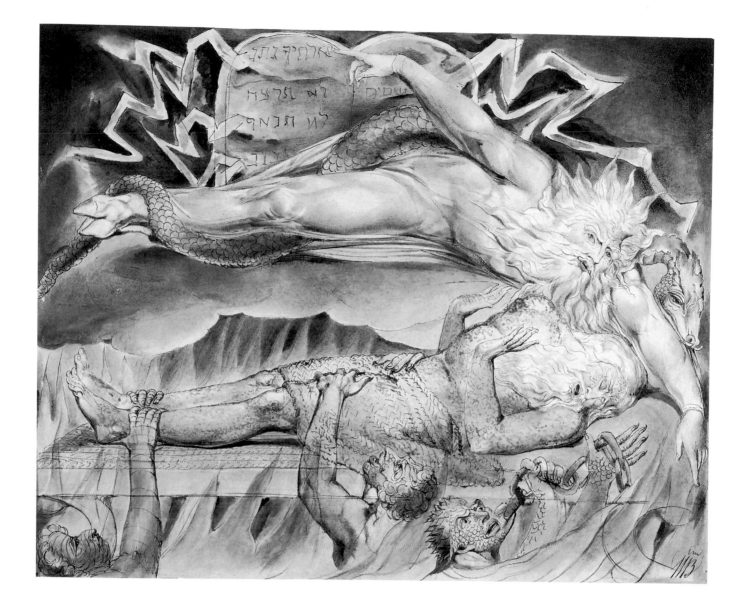

MUSIC MANUSCRIPTS
MUSIKHANDSCHRIFTEN

The Morgan Library houses a collection of autograph music manuscripts that in diversity and quality, if not quantity, is unequaled in the United States and surpassed by only a handful of archives abroad. But unlike most of the Library's collections, it goes back just thirty years. An account of how the Library came to house these manuscripts is easily summarized: two substantial gifts and a long-term loan. In 1968 the trustees of the Mary Flagler Cary Charitable Trust gave the Library Mrs. Cary's outstanding collection of music manuscripts, letters, and printed scores; in 1977 the Heineman Foundation donated the Dannie and Hettie Heineman Collection to the Library; and in 1972 Robin Lehman put on deposit his stellar collection of music manuscripts.

A fuller account of the Library's music collection begins with its founder, Pierpont Morgan, and his son, J. P. Morgan, Jr. Among their important acquisitions were a thirteenth-century Provençal chansonnier; an early-fifteenth-century manuscript with four of Machaut's *Poésies;* the unique complete copy of *Motetti e canzoni* (Venice, 1521, possibly printed by Andrea Antico); a document signed by Palestrina; the two earliest dated letters of Mozart, written when he was thirteen years old; the manuscript of Beethoven's Violin Sonata no. 10 in G Major, op. 96 (No. 58); and important groups of letters of Mendelssohn and Wagner.

One of the greatest collections of its kind, public or private, in the United States, the Mary Flagler Cary Music Collection was formed by Mrs. Melbert B. Cary, Jr., with the example and encouragement of her father, Harry Harkness Flagler. Mrs. Cary's collecting interests were firmly rooted in nineteenth-century Austro-Germanic traditions. Fully three quarters of the manuscripts she acquired come from that period, many from the pens of its luminaries. Her collection included Beethoven's Piano Trio in D Major, op. 70, no. 1 ("Geister"; No. 56), Schubert's *Schwanengesang* (No. 63) and String Quartet in D Minor ("Death and the Maiden"; No. 61),

Mendelssohn's *Meeresstille und glückliche Fahrt* (No. 68), Chopin's Mazurkas op. 50, Bruch's Violin Concerto no. 1 in G Minor (No. 75), Brahms's First Symphony (No. 80), and Strauss's Songs op. 10 and *Don Juan* (No. 84). Earlier autographs, although relatively few in number, were carefully selected and include Bach's Cantata 112 *(Der Herr ist mein getreuer Hirt;* No. 47), an early copyist's manuscript of Handel's *Messiah,* portions of Gluck's *Orfeo ed Euridice* and *Iphigenie auf Tauris* (No. 50), Mozart's Violin Sonata in F, K. 376, and Haydn's Symphony no. 91 in E-flat Major (No. 55).

One of the first large purchases the Library made after receiving the Cary collection was an important group of Italian manuscripts, including works of Bellini, Cimarosa, Donizetti, Giordano, Mascagni, Pacini, Ponchielli, Puccini, Rossini, Spontini, and Verdi. Only a few of these composers were already represented and none by a significant manuscript. The acquisition of these Italian manuscripts—in fact that of many important manuscripts bought since 1968—was made possible through funds provided by the Mary Flagler Cary Charitable Trust. Notable among these later purchases are Brahms's *Ungarische Tänze* for piano four-hands (No. 76); Mahler's Fifth Symphony (No. 89); Mozart's "Haffner" Symphony, K. 385 (No. 51), *Schauspieldirektor,* K. 486, and earliest known works, K. 1a–d (No. 49); Pergolesi's Mass in F; Schoenberg's *Gurrelieder* (No. 91) and *Erwartung;* Schubert's *Winterreise* and eight Impromptus for piano, D. 899 and 935 (No. 62); Strauss's *Tod und Verklärung;* Stravinsky's *Perséphone* (No. 94); Sullivan's *Trial by Jury;* and Weber's *Aufforderung zum Tanze* (No. 60). It is in large part because of the continued growth of the Cary collection that the Library has attracted so many valuable gifts and collections on deposit.

In 1962 the Heineman Foundation's collection of books and manuscripts was placed on deposit at the Library. Between the two world wars Dannie Heineman and his wife, Hettie,

built an outstanding collection of printed books and autograph letters and manuscripts of which the music section, although relatively small, was exceedingly well chosen. Among the notable manuscripts are the only extant portions of Bach's Cantata 197a *(Ehre sei Gott in der Höhe);* Mozart's Piano Concerti in C Major, K. 467 (No. 52), and D Major, K. 537 ("Coronation"), and his D-major Piano Rondo, K. 485; four early songs by Wagner; Chopin's Polonaise in A-flat Major, op. 53 (No. 70); Brahms's arrangement for piano four-hands of his String Sextet op. 18; and Mahler's *Klagendes Lied.* Two printed Wagner items deserve special mention: the proof sheets of the first edition of the full score of *Die Meistersinger von Nürnberg* (lacking the *Vorspiel*), with extensive annotations and corrections throughout in the hands of Hans von Bülow and Hans Richter, and at least one in Wagner's hand; and the composer's own copy of the rare first printing of the libretto for *Der Ring des Nibelungen* (Zurich, 1853), containing his extensive autograph changes (No. 71). The 1977 gift of the Heineman collection was one of the most important and valuable in the history of the Library.

Until recently the Library was not widely known for its printed music collection. Its holdings of printed scores, libretti, and rare books on music were never insignificant, however, and have grown considerably in the past decade. Noteworthy items in the printed music collection from before 1800 include works by Boccella (the unica copy of *Primavera di vaghi fiori musicali,* 1653), Burtius *(Opusculum musices),* Cerone *(El melopeo y maestro), Encomium musices,* Faber Stapulensis *(Musica),* Gaffurius *(Theorica musicae),* Higden *(Polychronicon),* Niger *(Grammatica),* Reuchlin *(Scenica progymnasmata),* Spechtshart *(Flores musicae),* and many editions of Sternhold and Hopkins's collections of metrical psalms (1556–1680). From the nineteenth and early twentieth centuries are large collections of first and early editions of Debussy, Massenet, Ravel, Schumann, and Verdi.

Music scholars can study autographs from one of the world's finest private collections of music manuscripts, the Robert Owen Lehman Collection. Highlights of Mr. Lehman's collection are Bach's Cantata 171 *(Gott, wie dein Name, so ist auch dein Ruhm);* Beethoven's *Rondo a capriccio,* op. 129 (also known as *The Rage over a Lost Penny);* Brahms's Symphony no. 2 and Clarinet Sonatas, op. 120; Chopin's Nocturnes, op. 48, and Variations on "Là ci darem la mano"; the short score of Debussy's *Prélude à l'après-midi d'un faune;* the Franck violin sonata and Liszt piano sonata; Mahler's *Kindertotenlieder, Lied von der Erde,* and Symphonies nos. 3 and 9; Mendelssohn's *Hebriden;* nine symphonies by Mozart; Ravel's *Bolero* and Piano Concerto for the Left Hand; Schoenberg's *Pierrot lunaire;* Schumann's Symphony no. 2; Stravinsky's *Petrushka;* and Weber's Clarinet Concerto no. 2. Mr. Lehman has, moreover, given the Library many manuscripts from his collection, including over thirty of Anton Webern.

The Library also has the most extensive archive of materials relating to the lives and works of the dramatist W. S. Gilbert (1836–1911) and the composer Arthur Sullivan (1842–1900). Founded by Reginald Allen, who brought his extraordinary collection to the Library in 1949 and for many years served as its curator, the Gilbert and Sullivan Collection has since grown to many times its original size, through additions by Mr. Allen and other donors as well as purchases.

The Sullivan archive, acquired in the early 1960s, consists of the composer's private and business papers. It also contains many original literary, dramatic, and music manuscripts, to which have been added the autograph scores of three Gilbert and Sullivan operas, a fourth by Sullivan, and two by other composers with libretti by Gilbert; several thousand letters, mostly to and from Gilbert and Sullivan; thousands of early programs; an extensive collection of early printed editions of their works; and a large number of original photographs, posters, playbills, ephemera, and memorabilia.

Although the collection now comprises some 75,000 individual items through which nearly every possible connection to the Gilbert and Sullivan operas is drawn, it concentrates on the productions and performances that took place under the direct supervision of the authors. In recent years the scope has been broadened to include manuscript and printed items relating to their closest and most important collaborators.

Music manuscripts, the unique records that transmit, however imperfectly, a written account of their author's passage through his compositional stages, from first thoughts to final copy, are part of our musical heritage. It is argued that when new critical editions of works are published they diminish the need for these manuscripts and reduce their value; however, even the most scrupulously prepared edition rarely, if ever, answers all the questions we may have about a work. To be sure, the manuscripts themselves leave us with uncertainties of meaning and ambiguities of interpretation, but they are an irreplaceable link in the documentary chain, and we would be the poorer for their loss.

Die Pierpont Morgan Library besitzt eine Sammlung von Musikautographen, deren Vielfalt und Qualität, wenn auch nicht Umfang, einzigartig in den Vereinigten Staaten ist und nur von ganz wenigen Musikarchiven anderer Länder übertroffen wird. Anders als die meisten anderen Sammlungen der Bibliothek besteht die der Musikalien erst seit 30 Jahren. Wie die Library in den Besitz dieser Manuskripte gelangte, läßt sich rasch zusammenfassen: durch zwei umfangreiche Schenkungen und eine Dauerleihgabe. 1968 übergaben die Trustees des Mary Flagler Cary Charitable Trust der Bibliothek Mrs. Carys herausragende Sammlung von Musikautographen, Briefen und gedruckten Partituren; 1977 schenkte die Heineman Foundation der Bibliothek die Sammlung von Dannie und Hettie Heineman; und 1972 vertraute ihr Robin Lehman seine exquisite Autographensammlung als Dauerleihgabe an.

Eine ausführlichere Entstehungsgeschichte der Musiksammlung der Pierpont Morgan Library beginnt mit ihrem Gründer, Pierpont Morgan, und seinem Sohn, J. P. Morgan jr. Unter ihren bedeutenden Erwerbungen befinden sich ein provenzalischer Chansonnier des 13. Jahrhunderts; ein Manuskript aus dem frühen 15. Jahrhundert mit vier *Poésies* von Guillaume de Machaut; das einzige vollständige Exemplar der 1521 in Venedig – vermutlich von Andrea Antico – gedruckten *Motetti e canzoni;* ein von Giovanni Pierluigi Palestrina unterschriebenes Dokument; die beiden frühesten datierten Briefe Wolfgang Amadeus Mozarts, die er im Alter von 13 Jahren schrieb; das Manuskript von Ludwig van Beethovens Violinsonate Nr. 10 in G-Dur, op. 96 (Kat.-Nr. 58), sowie eine große Anzahl von Briefen Felix Mendelssohn-Bartholdys und Richard Wagners.

Die Mary Flagler Cary Music Collection wurde von Mrs. Melbert B. Cary jr., nach dem Vorbild und mit der Unterstützung ihres Vaters, Harry Harkness Flagler, aufgebaut und war eine der bedeutendsten Sammlungen ihrer Art in den Vereinigten Staaten. Die Sammelinteressen von Mrs. Cary waren stark in den deutsch-österrei-

chischen Traditionen des 19. Jahrhunderts verwurzelt. Nicht weniger als drei Viertel der von ihr erworbenen Manuskripte stammen aus dieser Epoche, darunter viele aus der Feder der berühmtesten Komponisten jener Zeit. Die Sammlung umfaßte Ludwig van Beethovens Klaviertrio in D-Dur, op. 70, Nr. 1 (das »Geistertrio«, Kat.-Nr. 56), Franz Schuberts *Schwanengesang* (Kat.-Nr. 63) und sein Streichquartett in d-moll (»Der Tod und das Mädchen«, Kat.-Nr. 61), Felix Mendelssohn-Bartholdys *Meeresstille und glückliche Fahrt* (Kat.-Nr. 68), Frédéric Chopins Mazurken op. 50, Max Bruchs Violinkonzert Nr. 1 in g-moll (Kat.-Nr. 75), Johannes Brahms' Sinfonie Nr. 1 (Kat.-Nr. 80) sowie Richard Strauss' Lieder op. 10 und *Don Juan* (Kat.-Nr. 84). Die in vergleichsweise geringer Anzahl enthaltenen früher datierten Autographen wurden besonders sorgfältig ausgewählt. Darunter befinden sich Johann Sebastian Bachs Kantate Nr. 112 *(Der Herr ist mein getreuer Hirt*, Kat.-Nr. 47), eine frühe Kopistenabschrift von Georg Friedrich Händels *Messias,* Teile von Christoph Willibald Glucks *Orfeo ed Euridice* und *Iphigenie auf Tauris* (Kat.-Nr. 50), Wolfgang Amadeus Mozarts Violinsonate in F-Dur, KV 376, und Joseph Haydns Sinfonie Nr. 91 in Es-Dur (Kat.-Nr. 55).

Einer der ersten großen Ankäufe der Bibliothek nach der Schenkung der Mary Flagler Cary Music Collection war der einer bedeutenden Gruppe italienischer Manuskripte, zu denen Werke von Vincenzo Bellini, Domenico Cimarosa, Gaetano Donizetti, Umberto Giordano, Pietro Mascagni, Giovanni Pacini, Amilcare Ponchielli, Giacomo Puccini, Gioacchino Rossini, Gaspare Spontini und Giuseppe Verdi gehörten. Nur wenige dieser Komponisten waren bereits in der Sammlung vertreten und keiner von ihnen durch ein bedeutendes Autograph. Der Erwerb dieser italienischen Manuskripte und vieler anderer bedeutender, seit 1968 angekaufter Handschriften wurde durch Fördermittel des Mary Flagler Cary Charitable Trust ermöglicht. Von den späteren Erwerbungen sind folgende beson-

ders erwähnenswert: Johannes Brahms' *Ungarische Tänze* für Klavier zu vier Händen (Kat.-Nr. 76), Gustav Mahlers Sinfonie Nr. 5 (Kat.-Nr. 89), Wolfgang Amadeus Mozarts »Haffner-Sinfonie«, KV 385 (Kat.-Nr. 51), sein *Schauspieldirektor*, KV 486, und seine frühesten bekannten Werke, KV 1a–d (Kat.-Nr. 49), Giovanni Battista Pergolesis Messe in F-Dur, Arnold Schönbergs *Gurrelieder* (Kat.-Nr. 91) und *Erwartung*, Franz Schuberts *Winterreise* und acht Impromptus für Klavier, D 899 und 935 (Kat.-Nr. 62), Richard Strauss' *Tod und Verklärung*, Igor Strawinskys *Perséphone* (Kat.-Nr. 94), Arthur Sullivans *Trial by Jury* und Carl Maria von Webers *Aufforderung zum Tanze* (Kat.-Nr. 60). Dank des kontinuierlichen Anwachsens der Mary Flagler Cary Music Collection hat die Bibliothek so viele wertvolle Schenkungen und ganze Sammlungen als Dauerleihgaben erhalten.

1962 wurde der Bibliothek die Buch- und Autographensammlung der Heineman Foundation als Leihgabe übergeben. Zwischen den beiden Weltkriegen hatten Dannie Heineman und seine Frau Hettie eine bedeutende Sammlung von gedruckten Büchern, handgeschriebenen Briefen und Manuskripten aufgebaut, innerhalb derer die vergleichsweise kleine Musiksektion mit größtem Sachverstand ausgewählt war. Unter den bemerkenswerten Autographen befinden sich die einzigen erhaltenen Teile von Bachs Kantate Nr. 197a *(Ehre sei Gott in der Höhe)*, Mozarts Klavierkonzerte in C-Dur, KV 467 (Kat.-Nr. 52), und in D-Dur, KV 537 (»Krönungskonzert«), sowie sein Rondo für Klavier in D-Dur, KV 485. Dazu gehören auch vier frühe Lieder Wagners, Chopins Polonaise in As-Dur, op. 53 (Kat.-Nr. 70), Brahms' Bearbeitung seines Streichsextetts op. 18 für Klavier zu vier Händen sowie Mahlers *Klagendes Lied*. Zwei gedruckte Werke Wagners verdienen hier besondere Erwähnung: die Korrekturfahnen der ersten Ausgabe der vollständigen Partitur der *Meistersinger von Nürnberg* (ohne das *Vorspiel*) mit umfangreichen Anmerkungen und Korrekturen aus der Feder Hans von Bülows

und Hans Richters, wobei zumindest eine vom Komponisten selbst stammt. Sodann Wagners eigenes Exemplar des seltenen Erstdrucks seines Librettos für den *Ring des Nibelungen* (Zürich, 1853; Kat.-Nr. 71), in dem seine umfassenden handschriftlichen Änderungen enthalten sind. Die 1977 erfolgte Schenkung der Heineman Collection zählt zu den bedeutendsten und wertvollsten in der Geschichte der Pierpont Morgan Library.

Bis vor kurzem war die Bibliothek noch nicht für ihre Sammlung von Musikdrucken bekannt. Ihr Bestand an derartigen Partituren, Libretti und seltenen Musikbüchern war allerdings nie unbedeutend, und er ist im vergangenen Jahrzehnt beträchtlich angewachsen. Zu den erwähnenswertesten, aus der Zeit vor 1800 datierenden gedruckten Werken der Musiksammlung gehören Arbeiten von Francesco Boccella (das einzige Exemplar der *Primavera di vaghi fiori musicali* von 1653), von Nicolaus Burtius *(Musices opusculum)* und Pietro Cerone *(El melopeo y maestro)*, das *Encomium musices*, ferner Werke von Faber Stapulensis *(Musica)*, Franchinus Gaffurius *(Theorica musicae)*, Higden *(Polychronicon)*, Franciscus Niger *(Grammatica)*, Reuchlin *(Scenica progymnasmata)*, Hugo Spechtshart *(Flores musicae)* sowie mehrere Ausgaben von Sternhold und von Hopkins' Sammlung metrischer Psalmen (1556–1680). Aus dem 19. und frühen 20. Jahrhundert stammen große Sammlungen von Erstausgaben und früher Editionen von Werken Claude Debussys, Jules Massenets, Maurice Ravels, Robert Schumanns und Giuseppe Verdis.

Musikwissenschaftler können die Autographen einer der besten privaten Sammlungen von Musikmanuskripten, der Robert Owen Lehman Collection, studieren. Die Glanzstücke in Lehmans Sammlung sind Bachs Kantate Nr. 171 *(Gott, wie Dein Name, so ist auch Dein Ruhm)*, Beethovens *Rondo a capriccio*, op. 129 (auch als *Die Wut über den verlorenen Groschen* bekannt), Brahms' Sinfonie Nr. 2 und seine Klarinetten-

sonaten op. 120, Chopins Nocturnes op. 48 und die Variationen über »Là ci darem la mano«, das Particell von Debussys *Prélude à l'après-midi d'un faune,* César Francks Violin- und Franz Liszts Klaviersonate, Mahlers *Kindertotenlieder, das Lied von der Erde* und die Sinfonien Nr. 3 und 9, Mendelssohn-Bartholdys *Hebridenouvertüre,* neun Sinfonien von Mozart, Ravels *Bolero* und sein Klavierkonzert für die linke Hand, Schönbergs *Pierrot lunaire,* Robert Schumanns Sinfonie Nr. 2, Strawinskys *Petruschka* sowie von Webers Klarinettenkonzert Nr. 2. Überdies hat Lehman der Bibliothek viele Manuskripte aus seiner Sammlung vermacht, darunter mehr als 30 von Anton Webern.

Die Bibliothek verfügt auch über das umfassendste Archiv von Dokumenten zu Leben und Werk des Dramatikers W. S. Gilbert (1836–1911) und des Komponisten Arthur Sullivan (1842–1900). Die Gilbert and Sullivan Collection wurde von Reginald Allen aufgebaut, der 1949 seine außergewöhnliche Sammlung in die Bibliothek integrierte und sie über viele Jahre als Kurator betreute. Die Sammlung ist seither auf das Vielfache ihrer ursprünglichen Größe angewachsen, sowohl durch Ergänzungen Allens und anderer Donatoren als auch durch Ankäufe.

Das in den frühen sechziger Jahren erworbene Archiv Sullivans umfaßt den privaten und geschäftlichen Nachlaß des Komponisten. Es enthält auch viele literarische, dramatische und musikalische Originalmanuskripte, zu denen die Partiturautographen dreier Opern von Gilbert und Sullivan, das einer vierten von Sullivan stammenden Oper und die Opernpartituren zweier anderer Komponisten mit Libretti von Gilbert hinzugefügt worden sind. Weiterhin verwahrt das Archiv mehrere Tausend Briefe, wobei es sich bei den meisten um Korrespondenz zwischen Gilbert und Sullivan handelt, ferner Tausende früher Programmhefte, eine umfassende Sammlung früher gedruckter Werkausgaben sowie eine große Anzahl von Originalphotographien, Pla-

katen, Theaterzetteln, Alltagsgegenständen und Memorabilien.

Obgleich die Sammlung heute über mehr als 75 000 Einzelstücke verfügt, die Rückschlüsse auf nahezu jeden Aspekt der Opern von Gilbert und Sullivan erlauben, konzentriert sie sich doch auf diejenigen Produktionen und Aufführungen, die unter der direkten Leitung der Autoren stattfanden. In jüngster Zeit sind allerdings auch solche Manuskripte und gedruckte Materialien einbezogen worden, die in Verbindung mit den engsten und bedeutendsten Mitarbeitern von Gilbert und Sullivan stehen.

Musikautographen sind einzigartige Zeugnisse, durch die der schrittweise Kompositionsprozeß von der ersten Idee bis zur endgültigen Ausführung sichtbar wird – selbst bei unvollständiger Überlieferung. Sie sind fester Bestandteil unseres musikalischen Erbes. Mitunter wird behauptet, daß die Publikation neuer, kritischer Werkausgaben den Bedarf an diesen Manuskripten und damit zugleich ihren Wert mindert. Allerdings gibt auch die sorgfältigst vorbereitete Edition nur ganz selten, wenn überhaupt, Antwort auf alle denkbaren werkspezifischen Fragen. Natürlich bieten die Manuskripte oft selbst Anlaß zu Mehrdeutigkeit und entsprechendem Interpretationsspielraum. Gleichwohl sind sie ein nicht ersetzbares Glied in der Dokumentationskette, ohne das wir um vieles ärmer wären.

JOHANN SEBASTIAN BACH

(Eisenach 1685–1750 Leipzig)

Der Herr ist mein getreuer Hirt

Autograph manuscript of Cantata
no. 112 [1731]
340 x 210 mm

The Mary Flagler Cary Music
Collection; Cary 56

Der Herr ist mein getreuer Hirt

Autograph der Kantate Nr. 112 [1731]
340 x 210 mm

The Mary Flagler Cary Music
Collection; Cary 56

Bach spent the last twenty-seven years of his life as cantor at the Thomaskirche in Leipzig. He also held the position of civic director of music, which, with the cantorate, was among the most important positions in German musical life. As cantor, Bach was expected to write music for the main services on Sundays, as well as for other church feasts and festivities. In all, he composed five cycles of about sixty cantatas each—nearly three hundred, of which about two-fifths are lost. *The Lord Is My Faithful Shepherd* is one of three cantatas that Bach composed for the Second Sunday after Easter (Misericordias Domini); it was first performed, in Leipzig, on 8 April 1731. While it is probable that the entire manuscript was written around the same time, close study of it suggests that the first movement, notated in Bach's elegant calligraphy, had been composed some time before, possibly as early as April 1725, and copied into the 1731 manuscript. The text is a version, by Wolfgang Meuslin, of the Twenty-third Psalm. Both the Epistle and the Gospel for Misericordias Domini concern sheep gone astray and the Good Shepherd.

Provenance
Wilhelm Friedemann Bach; Karl Pistor; Marie Hoffmeister, née Lichtenstein; Ernst Rudorff; Max Abraham(?); Henri Hinrichsen; Walter Hinrichsen; Mary Flagler Cary.

Bach verbrachte die letzten 27 Jahre seines Lebens, von 1723 bis zu seinem Tod, als Thomaskantor in Leipzig. Er hatte zudem das Amt des Director musices, des städtischen Musikdirektors, inne, das zusammen mit der Kantorenstelle zu den wichtigsten Positionen innerhalb der deutschen Musikwelt gehörte. Es wurde von Bach erwartet, daß er in seiner Funktion als Kantor die Musik für die sonntäglichen Hauptgottesdienste wie auch für andere Kirchenfeste und Feierlichkeiten schrieb. Er verfaßte insgesamt fünf Zyklen zu jeweils etwa 60 Kantaten – fast 300 Werke insgesamt, von denen nahezu zwei Fünftel verloren sind. *Der Herr ist mein getreuer Hirt* ist eine der drei Kantaten, die Bach für den zweiten Sonntag nach Ostern, Misericordias Domini (die Barmherzigkeit des Herrn), komponierte; ihre Uraufführung fand am 8. April 1731 in Leipzig statt. Wahrscheinlich wurde das gesamte Manuskript etwa zur gleichen Zeit niedergeschrieben, doch läßt sich aufgrund näherer Untersuchungen auch vermuten, daß der in Bachs eleganter Handschrift notierte erste Satz schon einige Zeit zuvor komponiert wurde, möglicherweise bereits im April 1725, und 1731 in dieses Manuskript übertragen wurde. Als Text liegt ihm Psalm 23 in einer Übersetzung von Wolfgang Meuslin zugrunde. Sowohl die Apostelbriefe als auch das Evangelium zum Misericordias Domini befassen sich mit den verlorengegangenen Schafen und dem Guten Hirten.

JOHANN SEBASTIAN BACH

(Eisenach 1685–1750 Leipzig)

AUTOGRAPH LETTER

Signed, dated Leipzig, 2 November 1748, to his cousin Johann Elias Bach in Schweinfurt
260 x 350 mm

The Mary Flagler Cary Music Collection; MFC B1184.B118

HANDSCHRIFTLICHER BRIEF

Signiert, datiert Leipzig, 2. November 1748, an seinen Cousin Johann Elias Bach in Schweinfurt
260 x 350 mm

The Mary Flagler Cary Music Collection; MFC B1184.B118

Bach is known to have written fifty-seven letters, of which only twenty-nine are in his hand. Of the remaining letters, twelve were written by others on his behalf, and sixteen can be documented, although they do not survive. The letter of 2 November 1748 to Johann Elias Bach is one of only two Bach letters in the United States and is the last extant letter in his hand. The composer expresses regret that the distance between Schweinfurt and Leipzig will no doubt prevent his cousin from attending the marriage of Johann Sebastian's daughter Liessgen to Mr. Altnickol, the new organist in Naumburg. Bach then thanks his cousin for a cask of wine sent as a present, but in a postscript declines an offer for more: The cask arrived nearly two-thirds empty, and Bach had to pay so many carriage, customs, and delivery charges that each quart cost him nearly five Groschen—"which for a gift is really too expensive."

Provenance
The family of Johann Elias Bach; a member of the Emmert family; Hermann Schöne, Münster (Westphalia); Robert Ammann, Aarau, Switzerland; Mary Flagler Cary.

Es ist bekannt, daß Bach 57 Briefe verfaßt hat, von denen lediglich 29 aus seiner eigenen Hand stammen. Von den restlichen wurden zwölf in seinem Auftrag von anderen geschrieben; 16 weitere sind dokumentiert, jedoch nicht mehr erhalten. Der Brief vom 2. November 1748 an Johann Elias Bach ist einer der beiden Briefe, die sich als einzige heute in den Vereinigten Staaten befinden. Unter den erhaltenen ist er der letzte überlieferte aus der Hand Bachs. Der Komponist verleiht darin seinem Bedauern Ausdruck, daß die große Entfernung zwischen Schweinfurt und Leipzig seinen Cousin sicherlich von der Teilnahme an der Hochzeit von Johann Sebastian Bachs Tochter Ließgen mit Herrn Altnickol, dem neuen Organisten von Naumburg, abhalten werde. Bach dankt seinem Cousin für ein als Geschenk übersandtes Faß Wein, lehnt aber in einem Postscriptum das Angebot ab, noch mehr davon zu schicken: Denn das Faß war nurmehr mit einem Drittel seines Inhaltes angekommen, und Bach mußte so viel für Transport, Zoll und Zustellung bezahlen, daß ihn jedes Viertel nahezu fünf Groschen kostete – »welches denn vor ein Geschencke alzu kostbar ist«.

non auffhören, und bey jeder occasion zu belohnung
in etwas meiner Schuld abzutragen zu suchen.
Es ist freylich zu bedauern, daß die entfer-
nung unserer beyden Städte nicht verlaubet
persöhnlichen Besuch einander abzustatten;
Jch würde mir sonsten die freyheit nehmen, bey
Jhrem Vatter zu meiner Tochter Hochzeit,
so künfftig Monath Januar. 1749.
mit dem neuen Organisten in Naumburg, Hn.
Schniebes, vor sich gehen wird, Dienste zu
invitiren; Da aber Jhn gemeldter Zeit be-
greift, auch wahrscheinliche Jahrszeit es wohl
nicht verlaubet dürffte den Hn. Vatter persöhnlich
bey uns zu sehen; So will mir doch bitten in
abwesenheit mit einem Christl: Wunsche Jhn
zu assistiren; Hiermit mich dem lieben Hn.
Vatter bestens empfehle, und wohl schützeste
zuneigung an Jhn von uns allen beharre

D. V. Hochst.

 gantzergebener treüer Netz
 hr v. willigster Diener
 Joh: Seb: Bach.

P. M.

Obernachst der Herr Vatter sich er
mich offeriren, ferners mit deßo
sen liqueur zu assistiren, So muß
doch Wegen überauftiger fleißig aber
bey u depreviren, Die Zu die
frucht 16 gl. der Überbringer 2 gl.
die Visitator 2 gl. die Land accise
5 gl. 3 d. u. general accise 3 gl.
gekostet hat, als Können der Herr
Vatter selbsten ermeßen, daß mir
solches drum nur zu stehen Könne
Kostbar ist.
 Jch bin alzeit

WOLFGANG AMADEUS MOZART

(Salzburg 1756–1791 Vienna)

49

EARLIEST COMPOSITIONS,
K. 1A–D, 1761

Manuscripts in the hand of Leopold
Mozart
208 x 280 mm

The Mary Flagler Cary Music
Collection; Cary 201

FRÜHESTE KOMPOSITIONEN,
KV 1A–D, 1761

Manuskripte in der Handschrift von
Leopold Mozart
208 x 280 mm

The Mary Flagler Cary Music
Collection, Cary 201

The four pieces for keyboard on these two leaves are Mozart's earliest known works, composed shortly after his fifth birthday. They are in the hand of his father and are written on the blank pages of a notebook that he used in tutoring Wolfgang and his sister Maria Anna (known as Nannerl) in music. The note along the left margin on one page reads: *Compositions by Wolfgangerl, in the first three months after his fifth birthday.* Although these simple pieces survive only in Leopold's hand, they are likely to be at least partly Wolfgang's own works; as Stanley Sadie observes, "Leopold left enough of naive charm and harmonic solecism for plausibility." These leaves were discovered in London only in 1954, and their publication in 1956 was one of the happiest surprises of that bicentenary year.

Provenance
Nannerl Mozart; H. J. Laufer, London.

Die vier Stücke für Klavier auf den hier gezeigten beiden Blättern sind die frühesten bekannten Werke Mozarts; er komponierte sie kurz nach seinem fünften Geburtstag. Sie sind in der Handschrift seines Vaters ausgeführt und wurden auf die weißen Seiten eines Notenheftes geschrieben, das er für den Musikunterricht von Wolfgang und dessen Schwester Maria Anna, genannt Nannerl, verwendete. Die Notiz am linken Seitenrand verzeichnet: *Des Wolfgangerl Compositiones in den ersten 3 Monat[en] nach seinem 5ten Jahre.* Obwohl diese einfachen Stücke nur in Leopolds Handschrift erhalten sind, sind sie doch zumindest in Teilen Wolfgangs eigene Kompositionen. Stanley Sadie bemerkte dazu: »Leopold ließ zur Glaubwürdigkeit genug des naiven Charmes und der harmonischen Ungereimtheiten übrig.« Die Manuskripte wurden erst 1954 in London entdeckt, und ihre Veröffentlichung 1956 zählte zu den schönsten Überraschungen im 200. Geburtsjahr Mozarts.

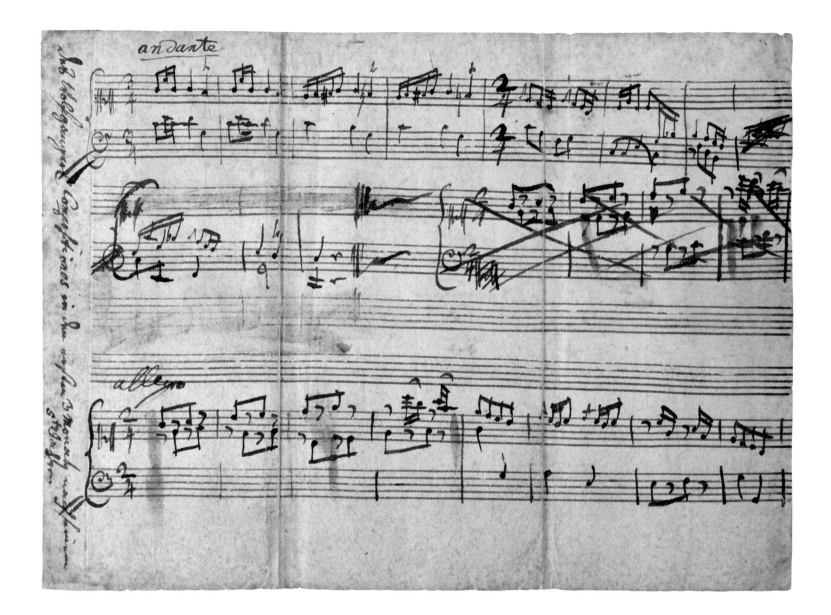

CHRISTOPH WILLIBALD GLUCK

(Erasbach, near Berching, 1714–1787 Vienna)

IPHIGENIE AUF TAURIS

Autograph manuscript of the voice parts from the middle of Act I, Scene 3, to the end of Act IV, Scene 3 [1781]
350 x 230 mm

The Mary Flagler Cary Music Collection; Cary 70

IPHIGENIE AUF TAURIS

Autograph der Singstimmen des Mittelteils von Akt I, Szene 3 bis zum Ende von Akt IV, Szene 3 [1781]
350 x 230 mm

The Mary Flagler Cary Music Collection; Cary 70

On 10 February 1780 Gluck wrote to Grand Duke Carl August of Saxe-Weimar: "I have now become very old and have lavished on the French nation most of my spiritual powers, notwithstanding which I still feel an inner urge to accomplish something for my nation, and I am filled with a burning desire to be able to hum something German to Your Serene Highness before my end. . . . "[1] Among the operas "lavished on the French nation" was *Iphigénie en Tauride;* the "something German" Gluck hoped to accomplish would become *Iphigenie auf Tauris,* his only opera with a German text. Nine months after its first production, at the Burgtheater, Vienna, in October 1781, two of the principal singers appeared as Belmonte and Osmin in Mozart's *Entführung aus dem Serail.* Indeed, Mozart attended most of the rehearsals of *Iphigenie,* which, with Gluck's *Alceste,* was in rehearsal at the Burgtheater.

Provenance
Joseph Püringer; Aloys Fuchs, Vienna; Felix Bamberg, Paris; Musikbibliothek Peters, Leipzig; Walter Hinrichsen, New York; Mary Flagler Cary.

1. Mueller von Asow 1962, p. 173.

Am 10. Februar des Jahres 1780 schrieb Gluck an den Großherzog Carl August von Sachsen-Weimar: »Ich bin nunmehr sehr alt geworden, und habe der französischen Nation die mehreste Kräffte meines geistes verschleidert, dessen ungeachtet Empfinde noch in mir einen innerlichen trieb Etwas vor meine Nation zu verfertigen, dass ich werde angefeyret von der Begierde, vor meinem Ende noch Etwas Teutsches Eyer Durchlaut vorlallen zu können ...«[1] Zu den Opern »verschleidert an die französische Nation« zählte *Iphigénie en Tauride.* Auf der anderen Seite sollte *Iphigenie auf Tauris,* die einzige Oper Glucks mit deutschem Text, dann zu dem werden, was Gluck als »Etwas Teutsches« zu erreichen hoffte. Neun Monate nach ihrer ersten Aufführung im Wiener Burgtheater, im Oktober 1781, traten zwei der Sänger von Hauptrollen als Belmonte und Osmin in Mozarts *Entführung aus dem Serail* auf. Mozart besuchte die meisten Proben der *Iphigenie,* die zusammen mit Glucks *Alceste* am Burgtheater einstudiert wurde.

1. Müller 1922–23, S. 652.

WOLFGANG AMADEUS MOZART

(Salzburg 1756–1791 Vienna)

51

SYMPHONY IN D MAJOR,
K. 385

Autograph manuscript of the
"Haffner" Symphony [1782–83]
230 x 310 mm

The Mary Flagler Cary Music
Collection; Cary 483

SINFONIE IN D-DUR, KV 385

Autograph der »Haffner-Sinfonie«
[1782–83]
230 x 310 mm

The Mary Flagler Cary Music
Collection; Cary 483

Mozart's "Haffner" Symphony began as a serenade written in the summer of 1782, at his father's request, to accompany festivities in Salzburg at the ennoblement of Sigmund Haffner, a boyhood friend of the composer's. In December 1782 Mozart found himself in need of a new symphony and asked his father to return the manuscript of the serenade to him in Vienna. He discarded an introductory march and added flutes and clarinets to the first and last movements. The result, as he wrote to his father in February 1783, was that "the new Haffner symphony has positively amazed me, for I had forgotten every single note of it. It must surely produce a good effect."[1] The new version was performed at Mozart's first public concert in Vienna, on 23 March 1783.

In 1864 the manuscript was presented to King Ludwig II of Bavaria on his twentieth birthday. The royal gift was housed in a case of turquoise velvet and chased silver, with a spring that elevates the manuscript slightly when the case is opened. The king's initial, the royal crown, and an emblem bearing the Bavarian arms are embossed in silver on the lid.

Provenance
Johann Anton André, Offenbach; Julius André, Frankfurt; Karl Mayer Rothschild; Ludwig II, king of Bavaria; Wittelsbach Trust, Munich; Max Pinette and Max Mannheim; Charles Scribner's Sons, New York; Mary Flagler Cary, New York; National Orchestral Association, New York.

1. Anderson 1985, p. 840.

Die »Haffner-Sinfonie« hatte Mozart ursprünglich im Sommer 1782 auf Wunsch seines Vaters als Serenade komponiert, um die Festlichkeiten in Salzburg anläßlich der Erhebung von Sigmund Haffner, einem Jugendfreund des Komponisten, in den Adelsstand musikalisch zu begleiten. Im Dezember 1782 war Mozart auf der dringenden Suche nach einer neuen Sinfonie und bat seinen Vater um die Rücksendung des Serenadenmanuskriptes nach Wien. Er verwarf den Eingangsmarsch und fügte statt dessen dem ersten und letzten Satz Flöten und Klarinetten hinzu. Über das Ergebnis schrieb er 1783 an seinen Vater: »die Neue Hafner Sinfonie hat mich ganz surprenirt – dann ich wusste kein Wort mehr davon; – die muß gewis guten Effect machen.«[1] Die neue Fassung wurde am 23. März 1783 bei Mozarts erstem öffentlichen Konzert in Wien aufgeführt.

Im Jahr 1864 erhielt König Ludwig II. von Bayern das Partiturautograph anläßlich seines 20. Geburtstages überreicht. Das königliche Geschenk wurde in ein silbern ziseliertes Kästchen verpackt, das außen mit türkisfarbenem Samt verkleidet und mit einer Feder versehen ist, die das Manuskript beim Öffnen leicht anhebt. Die Initiale des Königs, die königliche Krone und ein Emblem mit dem Wappen Bayerns sind auf dem Deckel in Silber eingeprägt.

1. Bauer-Deutsch 1963, S. 257.

152

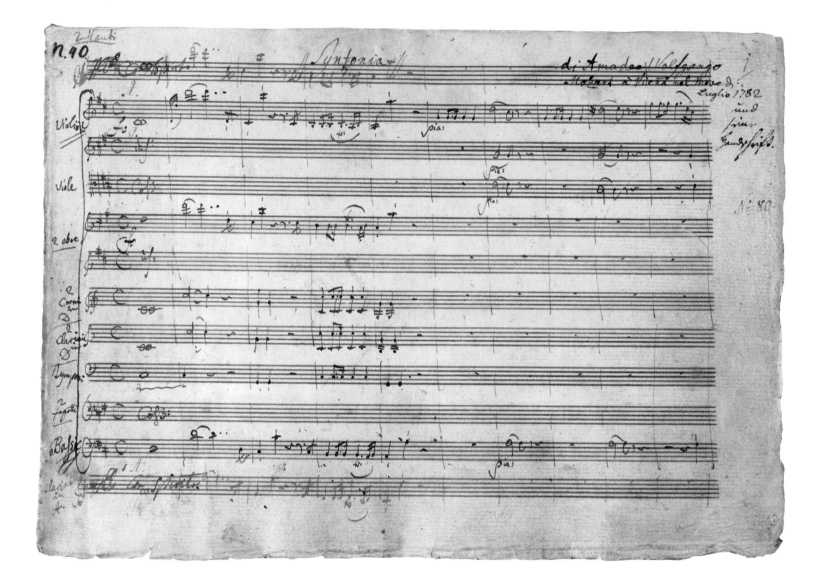

WOLFGANG AMADEUS MOZART

(Salzburg 1756–1791 Vienna)

PIANO CONCERTO IN
C MAJOR, K. 467

Autograph manuscript (1785)
225 x 320 mm

The Dannie and Hettie Heineman
Collection; Heineman MS 266

KLAVIERKONZERT IN C-DUR,
KV 467

Autograph (1785)
225 x 320 mm

The Dannie and Hettie Heineman
Collection; Heineman MS 266

This is one of the indisputable masterpieces among Mozart's twenty-seven piano concerti. Apparently having composed the concerto in just four weeks, he completed it on 9 March 1785 and performed it the next day at the Burgtheater in Vienna. The first movement displays a variety of thematic invention unmatched elsewhere in the piano concerti, and the sustained reverie of the second movement is justly famous. When Mozart's father, Leopold, saw a copyist's manuscript of the concerto in early 1786, he wrote to his daughter: "Indeed, the new concerto is astonishingly difficult. But I very much doubt whether there are any mistakes, as the copyist has checked it. Several passages simply do not harmonize unless one hears all the instruments playing together. . . . I shall get to the bottom of it all when I see the original score."[1] Mozart neglected to indicate the tempo of the first movement—a rare occurrence in his autographs. The first edition, published in 1800, prescribed *Allegro*, as did the *Neue Mozart-Ausgabe* as late as 1961. The true tempo marking, *Allegro maestoso*, is found in the *Verzeichnüss aller meiner Werke*, the thematic catalogue of his works that Mozart kept from February 1784 until shortly before his death.

Provenance
Johann Anton André, Offenbach; Jean Baptiste André, Frankfurt; Wilhelm Taubert, Berlin; Siegfried Ochs, Berlin; Wittgenstein family, Vienna; Dannie and Hettie Heineman.

1. Anderson 1985, p. 894, n. 4.

Dies ist eines der unbestrittenen Meisterwerke unter den 27 Klavierkonzerten Mozarts. Nach einer Kompositionszeit von offenbar nur vier Wochen beendete es Mozart am 9. März 1785 und führte es am folgenden Tag im Wiener Burgtheater auf. Der erste Satz entfaltet einen in keinem anderen Klavierkonzert übertroffenen thematischen Erfindungsreichtum, und die getragene Träumerei des zweiten Satzes ist zu Recht ebenso berühmt. Als Mozarts Vater Leopold Anfang 1786 die Kopistenabschrift des Konzertes sah, schrieb er seiner Tochter: »Das neue Concert ist freylich erstaunlich schwer. Ich zweifle aber ob etwas gefehlt ist, denn der Copist hat es durchgesehen. Manche Passagen mögen nicht recht stimmen, wenn man nicht die ganze Harmonie der Instrumenten hört. ... Es wird sich schon zeigen, wenn ich es [das Autograph] sehe.«[1] Mozart versäumte, das Tempo des ersten Satzes vorzugeben – eine Seltenheit in seinen Autographen. Die 1800 publizierte Erstausgabe schrieb *Allegro* vor, wie auch noch 1961 die *Neue Mozart-Ausgabe*. Die richtige Tempobezeichnung, *Allegro maestoso*, findet sich im *Verzeichnüss aller meiner Werke*, dem thematischen Katalog seiner Kompositionen, den Mozart ab Februar 1784 bis kurz vor seinem Tode fortsetzte.

1. Bauer-Deutsch 1963, S. 490.

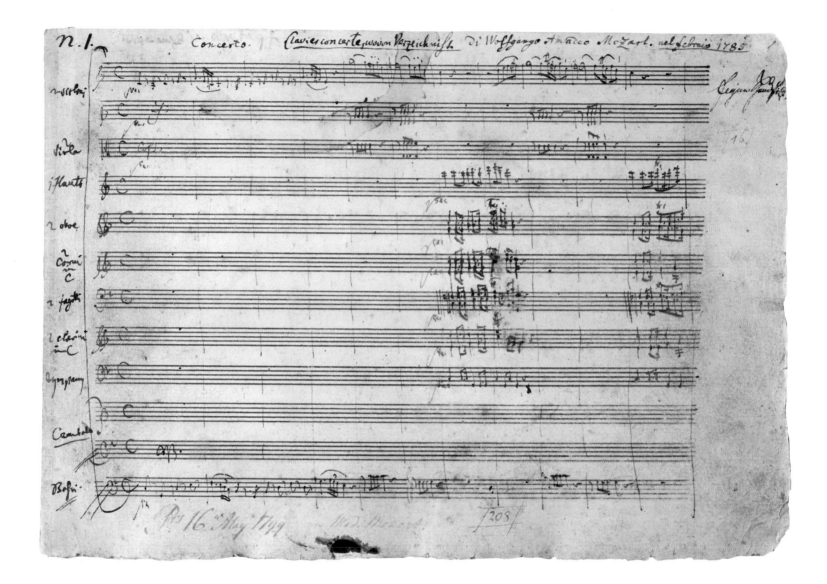

WOLFGANG AMADEUS MOZART

(Salzburg 1756–1791 Vienna)

"Non so più cosa son,"
from Le nozze di Figaro,
K. 492

Autograph manuscript of Mozart's
arrangement for voice, violin, and
piano [1786]
230 x 310 mm

The Dannie and Hettie Heineman
Collection; Heineman MS 157

»Non so più cosa son«, aus:
Le nozze di Figaro, KV 492

Autograph von Mozarts Bearbeitung
für Gesang, Violine und Klavier [1786]
230 x 310 mm

The Dannie and Hettie Heineman
Collection; Heineman MS 157

Le nozze di Figaro, the first of Mozart's three acclaimed collaborations with Lorenzo da Ponte, was first performed at the Burgtheater, in Vienna, on 1 May 1786. Cherubino, Count Almaviva's page, is introduced in the middle of Act I with an impetuous aria conveying the restless, unfocused desires of adolescence. Nothing is known about the occasion for which Mozart made this setting, although we may easily imagine that he found himself with the three performers at hand and quickly produced the pièce d'occasion. While the setting is characterized more by proficiency than inspiration—the violin doubles the voice almost throughout—it is apparently unique among Mozart's works, being the only complete arrangement of an aria from one of his operas he is known to have made. A study of the paper-type strongly suggests that Mozart made this arrangement between November 1785 and March 1786—that is, before work on the opera was completed.

Provenance
Julius André, Frankfurt; Dannie and Hettie Heineman.

Le nozze di Figaro, die erste der drei erfolgreichen Koproduktionen mit Lorenzo da Ponte, wurde am 1. Mai 1786 am Wiener Burgtheater uraufgeführt. Cherubino, Graf Almavivas Page, wird in der Mitte des ersten Aktes mit einer leidenschaftlichen Arie eingeführt, die all das ruhelose, unbestimmte Verlangen eines Heranwachsenden zum Ausdruck bringt. Über den Anlaß für die vorliegende Bearbeitung ist nichts bekannt, obgleich es denkbar ist, daß Mozart drei Künstler zur Hand hatte und für sie schnell diese pièce d'occasion anfertigte. Wenn sich der Satz auch mehr durch Fertigkeit als durch Inspiriertheit auszeichnet – die Violine verdoppelt die Gesangsstimme nahezu durchgängig –, so ist er doch als einzige vollständige Bearbeitung einer seiner Opernarien einmalig unter Mozarts Werken. Eine Untersuchung der Papiersorte läßt vermuten, daß Mozart diese Bearbeitung zwischen November 1785 und März 1786 anfertigte, also noch vor Vollendung der Oper.

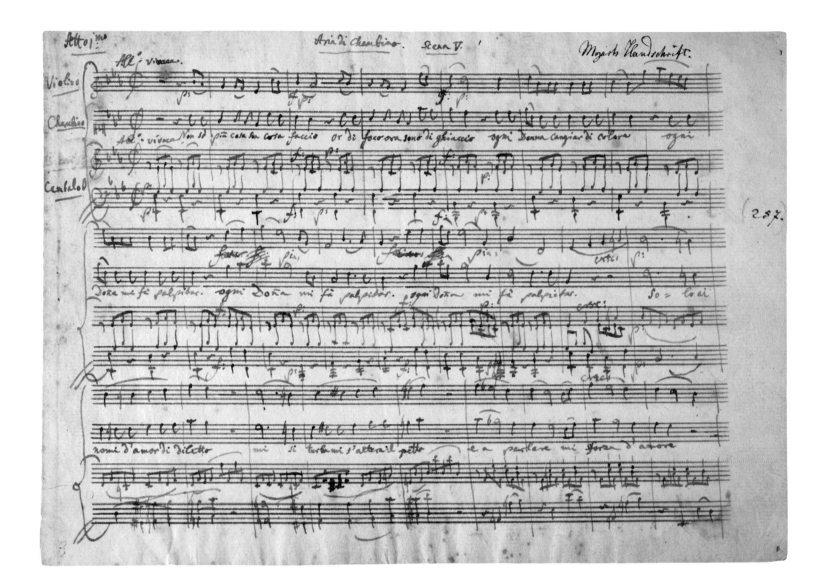

WOLFGANG AMADEUS MOZART

(Salzburg 1756–1791 Vienna)

54

HORN CONCERTO IN E-FLAT
MAJOR, K. 495

Extant leaves of the autograph
manuscript [1786]
215 x 280 mm

The Mary Flagler Cary Music
Collection; Cary 35

HORNKONZERT IN ES-DUR,
KV 495

Erhaltene Blätter des Autographs
[1786]
215 x 280 mm

The Mary Flagler Cary Music
Collection; Cary 35

It seems likely that Mozart's four completed horn concerti were written for Joseph Leutgeb (1732–1811), an Austrian horn player of exceptional skill. He may have been a musician of more proficiency than culture, for in these manuscripts Mozart makes many jokes at his expense. The six surviving leaves of the autograph of K. 495 contain passages written in red, blue, green, and black ink. Despite all the sarcasm directed at Leutgeb in the manuscripts, Mozart's letters reveal that both Wolfgang and his father felt genuine affection for him: Leopold lent him money in 1777, when he opened a cheese-monger's shop near Vienna; Wolfgang twice took him to see *Die Zauberflöte* in 1791; and in his last surviving letter Wolfgang wrote that Leitgeb (in Mozart's spelling) and the violinist Franz Hofer "are with me at the moment. The former is staying to supper with me."

Provenance
Julius André, Frankfurt; Ernst Rudorff, Berlin (fols. 13–14 and 21–22); Aloys Fuchs, Vienna; Carl August André, Frankfurt; Musikbibliothek Peters, Leipzig; Frau Elsa M. von Zschinsky-Troxler, Wiesbaden (fol. 15); August André, Offenbach; Preussische Staatsbibliothek, Berlin (fol. 23); Mary Flagler Cary.

Vieles spricht dafür, daß Mozart seine vier vollendeten Hornkonzerte für Joseph Leutgeb (1732–1811), einen österreichischen Hornisten von außergewöhnlicher Begabung, schrieb. Allerdings zeichnete sich Leutgeb als Musiker scheinbar eher durch sein Können als durch große Kultiviertheit aus, denn Mozart erlaubt sich in diesem Manuskript zahlreiche Scherze auf seine Kosten. Die sechs erhaltenen Blätter des Autographs von KV 495 enthalten Passagen, die in roter, blauer, grüner und schwarzer Tinte geschrieben wurden. Ungeachtet des im Manuskript gegen Leutgeb gerichteten Sarkasmus, belegen Mozarts Briefe, daß sowohl Wolfgang als auch sein Vater eine aufrichtige Zuneigung zu ihm verspürten. So lieh ihm Leopold Mozart 1777 Geld, als er einen Käseladen in der Nähe von Wien eröffnete; außerdem nahm ihn Wolfgang 1791 zweimal zu Aufführungen der *Zauberflöte* mit und notierte in seinem letzten erhaltenen Brief: »eben ist Leitgeb [so Mozarts Schreibweise] und Hofer [der Violinist Franz Hofer] bei mir; – ersterer bleibt bey mir beym Essen.«

JOSEPH HAYDN
(Rohrau, Lower Austria, 1732–1809 Vienna)

SYMPHONY NO. 91 IN E-FLAT
MAJOR

Autograph manuscript (1788)
230 x 310 mm

The Mary Flagler Cary Music
Collection; Cary 50

SINFONIE NR. 91 IN ES-DUR

Partiturautograph (1788)
230 x 310 mm

The Mary Flagler Cary Music
Collection; Cary 50

The Concert de la Loge Olympique was one of the celebrated concert organizations active in Paris in the 1780s. Among its backers was the comte d'Ogny, a wealthy French aristocrat who had commissioned Haydn's so-called Paris symphonies, nos. 82–87, composed in 1785 and 1786. Encouraged by their great success, d'Ogny commissioned three more symphonies, nos. 90–92, which Haydn wrote in 1788 and 1789. About that time a German patron, Prince Öttingen-Wallerstein, also requested new symphonies from Haydn—who complied by sending the same three works he had written for d'Ogny. Although Öttingen-Wallerstein had asked for exclusive rights to the symphonies and surely expected to receive the autograph scores, Haydn—citing severe eye pain and illegible handwriting—sent copyist's manuscripts of the orchestral parts instead. The composer then asked that, "owing to the many novel features" of these symphonies, they be rehearsed at least once before being performed. The autograph score of Symphony no. 91—which is entirely legible—quietly passed from d'Ogny through several hands and resurfaced only in 1945.

Provenance
Comte d'Ogny, Paris; Doazan; Lebonc; Barthélemy; Mary Flagler Cary.

Das Concert de la Loge Olympique galt in den 1780er Jahren als eine der berühmtesten Konzertorganisationen in Paris. Zu ihren Förderern zählte der Comte d'Ogny, ein wohlhabender französischer Aristokrat, der Haydns sogenannte Pariser Sinfonien, Nrn. 82–87, entstanden in den Jahren 1785 und 1786, in Auftrag gegeben hatte. Ermuntert durch ihren großen Erfolg, bestellte d'Ogny drei weitere Sinfonien, die Nrn. 90–92, die Haydn 1788 und 1789 komponierte. Etwa zur gleichen Zeit erbat ein deutscher Gönner, Prinz Öttingen-Wallerstein, die Komposition neuer Sinfonien von Haydn. Dieser übersandte ihm darauf in höflicher Pflichterfüllung dieselben drei Werke, die er für d'Ogny geschrieben hatte. Obwohl Öttingen-Wallerstein Exklusivrechte für die Sinfonien erbeten hatte und sicherlich erwartete, die Partiturautographen zu erhalten, schickte ihm Haydn, auf ein ernsthaftes Augenleiden und seine unleserliche Handschrift verweisend, statt dessen eine Kopistenabschrift der Orchesterstimmen. Zudem verlangte der Komponist, daß die Sinfonien »wegen so vielen Particularitäten« mindestens einmal vor ihrer Aufführung geprobt werden müßten. Das Partiturautograph der Sinfonie Nr. 91 – das vollkommen leserlich ist – gelangte von d'Ogny stillschweigend an verschiedene andere Besitzer und tauchte erst im Jahr 1945 wieder auf.

LUDWIG VAN BEETHOVEN

(Bonn 1770–1827 Vienna)

56

PIANO TRIO IN D MAJOR, OP. 70, NO. 1

Autograph manuscript [1808]
230 x 320 mm

The Mary Flagler Cary Music
Collection; Cary 61

KLAVIERTRIO IN D-DUR, OP. 70, NR. 1

Autograph [1808]
230 x 320 mm

The Mary Flagler Cary Music
Collection; Cary 61

Beethoven wrote the two piano trios of op. 70 in Vienna in 1808, the year during which he also completed the Fifth Symphony and composed the Sixth Symphony and Choral Fantasy. The trios are dedicated to the Countess Marie Erdödy, in whose house he was living when he composed them; they were first performed there in December 1808 and were published together the next year. The first is popularly called the "Ghost Trio," an allusion to the mysterious atmosphere of the second movement *(Largo assai ed espressivo)* evoked by a languid metrical pulse, hushed tremolos on the piano, subtly shifting tone colors, and unsettled harmonies. (We do not know who gave the trio its nickname, but it was not Beethoven.) Because he continuously revised his works, most of Beethoven's manuscripts— even the so-called fair copies—could as well be called works in progress. While nearly all of the *Geister* manuscript shows evidence of compositional rethinking, on the last pages of the second movement one can (with considerable patience) discern no fewer than five attempts at the final bars.

Provenance
Max Friedländer, Berlin; Franz Roehn; Mary Flagler Cary.

Beethoven schrieb seine beiden Klaviertrios op. 70 in Wien im Jahr 1808, demselben Jahr, in dem er die Fünfte Sinfonie abschloß sowie die Sechste Sinfonie und die Chorfantasie komponierte. Die Trios sind Gräfin Marie Erdödy gewidmet, in deren Haus Beethoven zur Zeit ihrer Komposition zu Gast war; dort wurden sie auch im Dezember 1808 uraufgeführt, bevor sie im darauffolgenden Jahr gemeinsam veröffentlicht wurden. Das erste Trio ist allgemein als »Geistertrio« bekannt, in Anspielung auf die geheimnisvolle Atmosphäre des zweiten Satzes *(Largo assai ed espressivo),* die evoziert wird durch ein langsames Metrum, verhaltene Tremolos auf dem Klavier, einen subtilen Wechsel der Klangfarben und eine instabile Harmonik. (Unbekannt ist, wo der Zusatztitel des Trios seinen Ursprung hat; mit Sicherheit stammt er nicht von Beethoven selbst.) Da Beethoven seine Werke unablässig überarbeitete, könnten die meisten seiner Manuskripte – selbst die sogenannten Reinschriften – geradezu als »works in progress« bezeichnet werden. Während fast das gesamte Autograph des »Geistertrios« Spuren kompositorischer Überarbeitung trägt, kann man auf den letzten Seiten des zweiten Satzes – mit beträchtlicher Geduld – nicht weniger als fünf Versuche einer endgültigen Formulierung der Schlußtakte erkennen.

162

LUDWIG VAN BEETHOVEN

(Bonn 1770–1827 Vienna)

57

STRING QUARTET IN F MINOR,
OP. 95

Sketches for the scherzo and finale
[1810?]
230 x 330 mm

The Mary Flagler Cary Music
Collection; Cary 48

STREICHQUARTETT IN F-MOLL,
OP. 95

Entwürfe zum Scherzo und Finale
[1810?]
230 x 330 mm

The Mary Flagler Cary Music
Collection; Cary 48

Three chamber works written between 1810 and 1812—the String Quartet op. 95, the Violin Sonata op. 96, and the Piano Trio op. 97—have long been considered turning points in Beethoven's creative development. But these works are known to us only in versions, probably extensively reworked, that date from 1814 and 1815. Opus 95, the eleventh of Beethoven's sixteen string quartets, had an especially long gestation: It was composed in 1810 and 1811, first performed in 1814, and not published until 1816. Its nickname, *Quartetto serioso*, was coined by Beethoven himself—also an unusual occurrence—but appears only on the manuscript, not the first edition. The tempo of the third movement—*Allegro assai vivace, ma serioso*—occurs nowhere else in Beethoven's works. That the quartet held a special place among Beethoven's oeuvre is also suggested by a letter sent to Sir George Smart in London in October 1816. Writing in English, Beethoven told Smart that "The Quartett *[sic]* is written for a small circle of connoisseurs and is never to be performed in public." These leaves come from a sketchbook, the contents of which are now widely scattered, that also contained sketches for the Piano Trio op. 97 ("Archduke").

Provenance
Mary Flagler Cary.

Drei zwischen 1810 und 1812 komponierte Kammermusikwerke – das Streichquartett op. 95, die Violinsonate op. 96 und das Klaviertrio op. 97 – galten lange Zeit als Wendepunkte in Beethovens schöpferischer Entwicklung. Allerdings sind uns diese Werke nur in vermutlich ausgiebig überarbeiteten Fassungen, die aus den Jahren 1814 und 1815 datieren, bekannt. Für Opus 95, das elfte von Beethovens sechzehn Streichquartetten, ist eine besonders lange Entstehungszeit nachgewiesen: Komponiert wurde es in den Jahren 1810 und 1811, uraufgeführt im Jahr 1814, veröffentlicht wurde es jedoch erst 1816. Sein inoffizieller Titel, *Quartetto serioso*, war von Beethoven selbst geprägt worden – auch dies eine Seltenheit –, er erscheint jedoch nur im Autograph und nicht im Erstdruck. Das Tempo des dritten Satzes – *Allegro assai vivace, ma serioso* – taucht in keiner anderen Komposition Beethovens auf. Daß das Quartett eine Sonderstellung innerhalb von Beethovens Œuvre einnimmt, läßt auch ein Brief vom Oktober 1816 an Sir George Smart in London vermuten. In Englisch schreibend, berichtete Beethoven Smart, daß das Quartett nur für einen kleinen Kennerkreis geschrieben wurde und niemals öffentlich aufgeführt werden dürfe. Die vorliegenden Seiten stammen aus einem Skizzenbuch, dessen Inhalt heute weit verstreut ist und das außerdem Entwürfe für das Klaviertrio op. 97 (»Erzherzogtrio«) enthielt.

LUDWIG VAN BEETHOVEN
(Bonn 1770–1827 Vienna)

58

VIOLIN SONATA NO. 10 IN
G MAJOR, OP. 96

Autograph manuscript [1815]
350 x 240 mm

Purchased by Pierpont Morgan, 1907;
MA 16

VIOLINSONATE NR. 10 IN
G-DUR, OP. 96

Autograph [1815]
350 x 240 mm

Erworben 1907 von Pierpont Morgan;
MA 16

Beethoven composed his first nine sonatas for violin and piano between 1797 and 1803. This is the manuscript of the tenth, and last, of the sonatas, written in 1812, the year in which he completed the Seventh and Eighth Symphonies. The sonata was written for Pierre Rode, the greatest French violinist of his day, and was first performed by Rode and Archduke Rudolph, to whom the work is dedicated. In late December 1812, a few days before the performance, Beethoven wrote to the archduke: "I have not hurried unduly to compose the last movement merely for the sake of being punctual. . . . In our Finales we like to have fairly noisy passages, but R[ode] does not care for them—and so I have been rather hampered."[1] Despite Beethoven's having tailored the music to suit Rode's style, the violinist's skill had greatly deteriorated, and Beethoven expressed disappointment in the performance. Although the sonata itself dates from 1812, this manuscript, which is a revised version of the original work, was most likely written in early 1815. Pierpont Morgan bought the manuscript in Florence in 1907; the only major music manuscript he ever acquired, it was the first important Beethoven autograph to come to the United States.

Provenance
Graf Lützow, Moravia; Heinrich Steger, Vienna (?).

1. Anderson 1961, vol. 1, p. 391.

Beethoven komponierte seine ersten neun Sonaten für Violine und Klavier in den Jahren 1797 bis 1803. Das vorliegende Autograph ist das Manuskript seiner zehnten und letzten Violinsonate, die er 1812 schrieb. In diesem Jahr vollendete er auch die Siebte und Achte Sinfonie. Die Sonate wurde für Pierre Rode, den bedeutendsten französischen Geiger seiner Zeit, geschrieben und von Rode und Erzherzog Rudolph, dem Widmungsträger, uraufgeführt. Ende Dezember 1812, einige Tage vor der Uraufführung, schrieb Beethoven an den Erzherzog: »[Ich habe] um der blosen Pünktlichkeit willen mich nicht so sehr mit dem lezten Stücke beeilt. ... Wir haben in unsern *Finales* gern rauschendere Passagen, doch sagt dieses R[ode] nicht zu, und – schenirte mich doch etwas ...«[1] Auch wenn sich Beethoven bemüht hatte, seine Komposition Rodes Stil anzupassen, so hatte sich die Virtuosität des Violinisten ungemein verschlechtert, und Beethoven äußerte seine Enttäuschung über die Aufführung. Obgleich die Sonate selbst von 1812 datiert, stammt das vorliegende Manuskript, bei dem es sich um eine Überarbeitung des Originals handelt, vermutlich von Anfang 1815. Pierpont Morgan kaufte das Autograph 1907 in Florenz; es ist die einzige bedeutende von ihm selbst erworbene Musikhandschrift und zugleich das erste wichtige Autograph Beethovens, das in die Vereinigten Staaten gelangte.

1. *Beethoven: Briefwechsel*, Bd. 2, S. 302.

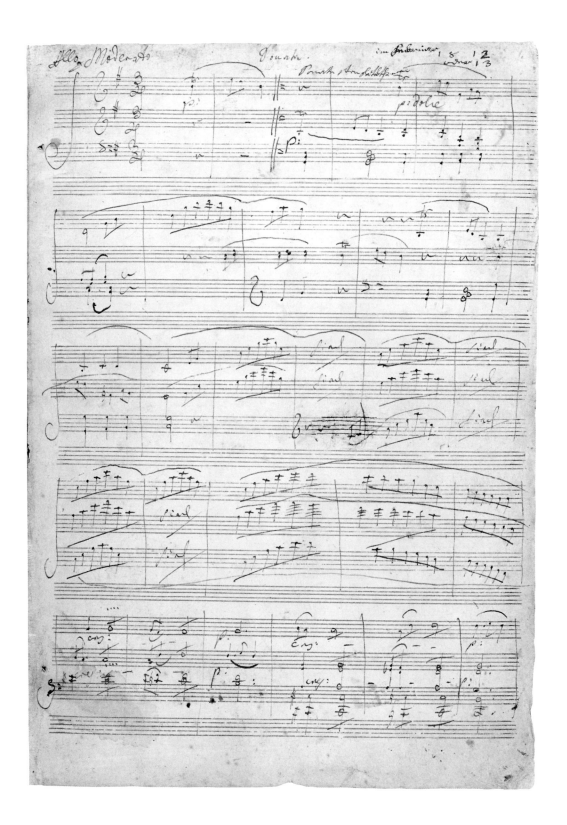

FRANZ SCHUBERT
(Vienna 1797–1828 Vienna)

ERLKÖNIG, D. 328

Autograph manuscript of the third
version [1816?]
305 x 220 mm

The Dannie and Hettie Heineman
Collection; Heineman MS 196

ERLKÖNIG, D 328

Autograph der dritten Fassung [1816?]
305 x 220 mm

The Dannie and Hettie Heineman
Collection; Heineman MS 196

The first version of Schubert's masterly setting of Goethe's *Erlkönig,* the autograph of which does not survive, dates from 1815, an uncommonly productive year in which Schubert composed (among other works) about 150 songs. In 1816 Schubert's friend Josef von Spaun sent the second version of *Erlkönig* (with a simplified piano part) and other Goethe settings to the poet in Weimar; Goethe returned them without comment. The third version was the most enigmatic, for we know neither when Schubert wrote it nor for what occasion. The song was not performed in public until 1821 and was published soon thereafter, in its fourth and final version, bearing the proud designation of Opus 1; the autograph of this version does not survive.

Goethe knew what made a good song—the composer's only obligation, he maintained, was to reproduce the poet's intention in music—and *Erlkönig* failed on several counts. For example, in the poem iambics depict the galloping horse ("Wer reitet so spät durch Nacht und Wind"); but Schubert ignored the poet's metrical scheme and rendered the hoofbeats through headlong triplets in the piano. Goethe also asserted that strophic ballads like *Erlkönig* should be set as lieder, songs "we imagine the singer has learned by heart somewhere and recalls from time to time. Therefore, these songs can and must have their own definite, well-rounded melodies that are attractive and easily remembered"[1]—an apt description of, say, Schubert's setting of Goethe's *Heidenröslein* but one mile removed from the composer's *Erlkönig.*

Provenance
Benedikt Randhartinger, Vienna; Clara Schumann;
Dannie and Hettie Heineman.

1. Bode 1912, vol. 1, p. 83.

Schuberts erste (nicht im Autograph erhaltene) Fassung seiner meisterhaften Vertonung von Goethes *Erlkönig* stammt von 1815, aus einem außergewöhnlich produktiven Jahr, in dem Schubert neben anderen Werken allein über 150 Lieder schrieb. Schuberts Freund Josef von Spaun übersandte die zweite Fassung des *Erlkönigs* (mit einem vereinfachten Klavierpart) und weitere Goethe-Vertonungen 1816 an den Dichter in Weimar; Goethe schickte sie kommentarlos zurück. Die dritte Fassung blieb die rätselhafteste, da weder bekannt ist, für welchen Anlaß, noch zu welchem Zeitpunkt Schubert sie schrieb. Die Uraufführung des Liedes fand erst 1821 statt, und kurze Zeit später erfolgte die Drucklegung in seiner vierten und endgültigen Fassung unter der stolzen Bezeichnung Opus 1; das Autograph dieser Fassung ist nicht erhalten.

Goethe hatte genaue Vorstellungen davon, was ein gutes Lied ausmache – die Aufgabe des Komponisten bestehe darin, die dichterische Intention möglichst genau musikalisch wiederzugeben –, und *Erlkönig* erfüllte diese Anforderung in verschiedenen Punkten nicht. Beispielsweise wird im Gedicht das jambische Metrum zur lautmalenden Betonung des galoppierenden Pferdes (»Wer reitet so spät durch Nacht und Wind«) eingesetzt. Schubert ignorierte diese Metrik und stellte den Hufschlag künstlerisch durch ungestüm vorantreibende Triolen in der Klavierstimme dar. Goethe bestand darauf, daß strophische Balladen wie der *Erlkönig* als Lieder vertont werden sollten, »von denen man supponiert, daß der Singende sie irgendwo auswendig gelernt und sie nur in ein oder der andern Situation anbringt. Sie können und müssen eigene, bestimmte und runde Melodien haben, die auffallen und jedermann leicht behält.«[1] Diese Beschreibung trifft zwar beispielsweise Schuberts Vertonung von Goethes *Heidenröslein* recht gut, von seinem *Erlkönig* ist sie jedoch weit entfernt.

1. Bode 1912, Bd. 1, S. 83.

Erlkönig.

CARL MARIA VON WEBER

(Eutin 1786 – 1826 London)

AUFFORDERUNG ZUM TANZE

Autograph manuscript (1819)
240 x 320 mm

The Mary Flagler Cary Music
Collection; Cary 342

AUFFORDERUNG ZUM TANZE

Autograph (1819)
240 x 320 mm

The Mary Flagler Cary Music
Collection; Cary 342

Aufforderung zum Tanze (Invitation to the Dance) was composed in 1819 and has been called an epoch-making work in piano literature. It is Weber's best-known solo piano work, was instantly successful, and has remained popular to the present day. Written in his most brilliant pianistic idiom, this series of exhilarating waltzes connected by more tranquil interludes, all in the form of a single-movement rondo, was without precedent. In it can be traced the antecedents of Chopin's waltzes and the waltz suites of Johann Strauss II. Orchestrated by Berlioz and performed as ballet music in his 1841 production of Weber's *Freischütz* in Paris, the work is best known today in this orchestral version. It is also familiar to the dance world through *Le Spectre de la rose,* the 1911 ballet by Diaghilev and Nijinsky.

Provenance
G. M. Clauss, Leipzig; Musikbibliothek Peters, Leipzig; Walter Hinrichsen, New York; Mary Flagler Cary.

Aufforderung zum Tanze, 1819 komponiert, gilt als bahnbrechendes Werk der Klavierliteratur. Das Stück, Webers bekanntestes Klavierwerk, erzielte sofort einen durchschlagenden Erfolg und erfreut sich bis heute großer Beliebtheit. In seinem brillantesten pianistischen Idiom geschrieben, war diese Folge mitreißender Walzer, die durch ruhigere Zwischenspiele verbunden sind und sich zu einem Rondo in einem Satz zusammenfügen, bis dahin beispiellos; sie wurde wegweisend für die Walzer von Chopin und die Walzersuiten von Johann Strauß Sohn. Das Werk ist heute am besten in der von Berlioz stammenden Orchesterfassung bekannt, die dieser 1841 in seiner Inszenierung von Webers *Freischütz* in Paris als Ballettmusik aufführte. Der Welt des Tanztheaters ist es auch durch *Le Spectre de la rose* vertraut, dem Ballett von Sergej Diaghilew und Waclaw Nijinski aus dem Jahr 1911.

Auffodrung zum Tanze. Rondo für das Pianoforte. von C. M. von Weber.
Op. 65.

FRANZ SCHUBERT
(Vienna 1797–1828 Vienna)

STRING QUARTET IN D
MINOR, D. 810 ("DER TOD
UND DAS MÄDCHEN")

Autograph manuscript (incomplete;
1824)
240 x 310 mm

The Mary Flagler Cary Music
Collection; Cary 72

STREICHQUARTETT IN D-MOLL,
D 810 (»DER TOD UND DAS
MÄDCHEN«)

Autograph (unvollständig; 1824)
240 x 310 mm

The Mary Flagler Cary Music
Collection; Cary 72

Schubert composed his penultimate string quartet between 1824 and 1826. Its nickname derives from the second movement, a theme with variations based on the piano accompaniment to his song "Der Tod und das Mädchen" (Death and the Maiden), composed in 1817. Although the quartet is today counted among Schubert's greatest chamber works, an early performer thought otherwise. After a private performance in the apartment of the composer Franz Lachner, the first violinist—who, owing to his advanced age, was clearly not up to the task—turned to Schubert and (according to Lachner) declared: "'My dear fellow, this is no good, leave it alone; you stick to your songs!' Whereupon Schubert silently packed up the sheets of music and shut them away in his desk forever—a self-denial and modesty that one would look for in vain in many a present-day composer."[1] This manuscript contains only the first movement and all but the last thirty measures of the second; the manuscript of the third and fourth movements is lost.

Provenance
Staatsbuchhalter von Schmied, Währing; Johann Wissiag, Vienna; William Kux, Chur, Switzerland; Mary Flagler Cary.

1. Deutsch 1958, p. 289.

Schubert schrieb sein vorletztes Streichquartett zwischen 1824 und 1826. Der Name, unter dem es bekannt wurde, rührt vom zweiten Satz her, einem Thema mit Variationen, das auf der Klavierbegleitung zu seinem 1817 komponierten Lied *Der Tod und das Mädchen* beruht. Auch wenn dieses Quartett heute als eines von Schuberts großartigsten Kammermusikwerken gilt, war jedoch ein zeitgenössischer Ausführender ganz anderer Meinung. Nach einer privaten Aufführung in der Wohnung des Komponisten Franz Lachner wandte sich der erste Geiger, der aufgrund seines fortgeschrittenen Alters der musikalischen Herausforderung nicht gewachsen war, laut Lachner mit den Worten an Schubert: »»Brüderl, das ist nichts, das laß gut sein; bleib du bei deinen Liedern!‹, worauf Schubert die Musikblätter still zusammenpackte und sie für immer in seinem Pulte verschloß – eine Selbstverleugnung und Bescheidenheit, die man bei manchem berühmten Komponisten der Gegenwart vergeblich suchen würde.«[1] Das hier ausgestellte Manuskript enthält lediglich den ersten und zweiten Satz (mit Ausnahme von dessen letzten 30 Takten); das Autograph des dritten und vierten Satzes ist verloren.

1. Deutsch 1966, S. 333.

FRANZ SCHUBERT

(Vienna 1797–1828 Vienna)

IMPROMPTUS FOR PIANO,
D. 935

Autograph manuscript (1827)
240 x 315 mm

The Mary Flagler Cary Music
Collection; Cary 341

IMPROMPTUS FÜR KLAVIER,
D 935

Autograph (1827)
240 x 315 mm

The Mary Flagler Cary Music
Collection; Cary 341

Dating from the last year of Schubert's life, these four pieces contain some of his most familiar piano music. Schubert sent them to B. Schott's Söhne, his publisher in Mainz, who forwarded them to their branch in Paris, who in turn sent them back to Mainz. When Schubert wrote to the Mainz office asking why he had not heard from them about the impromptus, they replied: "They were sent back to us from [Paris] with the suggestion that they were too difficult for trifles and would find no outlet in France. ... If at any time you should write something less difficult and yet brilliant in an easier key, please send it to us without delay."[1] This was Schott's last letter to Schubert, who died three weeks later. The impromptus were not published until 1838, ten years after the composer's death.

Provenance
Musikbibliothek Peters, Leipzig; Mary Flagler Cary.

1. Deutsch 1946, no. 1157.

Diese vier aus Schuberts letztem Lebensjahr stammenden Stücke zählen zu seinen bekanntesten Klavierwerken. Schubert übersandte sie seinem Verleger, B. Schott's Söhne in Mainz, der sie an seine Niederlassung in Paris weiterleitete, von wo sie allerdings nach Mainz zurückgeschickt wurden. Auf seine schriftliche Nachfrage beim Mainzer Verlagshaus wegen der ausbleibenden Resonanz auf seine Impromptus erhielt Schubert zur Antwort: »Wir erhalten solche von dort [Paris] zurück mit dem Bedeuten, daß diese Werke als Kleinigkeiten zu schwer seien und in Frankreich keinen Eingang finden würden. ... Wenn Sie gelegentlich etwas minder Schweres und doch Brillantes auch in einer leichteren Tonart komponieren, dieses belieben Sie uns ohne weiteres zuzusenden.«[1] Dies war Schotts letzter Brief an Schubert, der drei Wochen später verstarb. Die Impromptus wurden erst im Jahr 1838 veröffentlicht, zehn Jahre nach dem Tod des Komponisten.

1. Deutsch 1964, S. 544–45.

FRANZ SCHUBERT
(Vienna 1797 – 1828 Vienna)

63

SCHWANENGESANG, D. 957

Autograph manuscript of the songs
(1828)
240 x 315 mm

The Mary Flagler Cary Music
Collection; Cary 63

SCHWANENGESANG, D 957

Autograph der Lieder (1828)
240 x 315 mm

The Mary Flagler Cary Music
Collection; Cary 63

The title of this group of fourteen songs, composed in August and October 1828, did not, of course, originate with Schubert, since he could not have known they would be among his last compositions. The name was assigned by Tobias Haslinger, who published the songs some months after Schubert's death and called them "the last flowering of his noble strength." Seven of these songs have texts by Ludwig Rellstab, six by Heinrich Heine—Schubert's only Heine settings—and one by Johann Gabriel Seidl. Schubert's manuscript originally comprised only the thirteen Rellstab and Heine songs; it was Haslinger who added the final song, Seidl's "Taubenpost." Either "Die Taubenpost" or "Der Hirt auf dem Felsen" is Schubert's last song, written just two months before his death. *Schwanengesang* is sometimes called a song cycle but is not. Schubert wrote only two song cycles, *Die schöne Müllerin* and *Winterreise*, both to texts by Wilhelm Müller; most of the manuscript of *Die schöne Müllerin* is lost; the manuscript of *Winterreise* is in the Morgan Library.

Provenance
Tobias Haslinger, Vienna; Johann Nepomuk Kafka, Vienna; Carl Meinert, Dessau; Musikbibliothek Peters, Leipzig; Walter Hinrichsen, New York; Mary Flagler Cary.

Der Titel dieser 14 Liedkompositionen, die im August und Oktober 1828 entstanden, stammt natürlich nicht von Schubert, da er nicht ahnen konnte, daß sie zu seinen letzten Kompositionen gehören würden. Die Benennung geht vielmehr auf den Verleger Tobias Haslinger zurück, der die Lieder einige Monate nach Schuberts Tod veröffentlichte und sie als »die letzten Blüten seiner edlen Kraft« bezeichnete. Sieben der Vertonungen liegen Texte von Ludwig Rellstab zugrunde, sechs weitere beruhen auf Gedichten von Heinrich Heine – es handelt sich um Schuberts einzige Heine-Vertonungen –, und ein Text stammt von Johann Gabriel Seidl. Schuberts Manuskript enthielt ursprünglich nur die dreizehn Rellstab- und Heine-Lieder; Seidls »Taubenpost« wurde als letztes Lied erst durch Haslinger beigefügt. »Die Taubenpost« oder »Der Hirt auf dem Felsen« gilt als die letzte Liedkomposition, die Schubert knapp zwei Monate vor seinem Tode komponierte. *Schwanengesang* wird manchmal als Liederzyklus bezeichnet, was allerdings nicht zutrifft. Schubert schrieb lediglich zwei Liederzyklen, beide zu Gedichten von Wilhelm Müller: *Die schöne Müllerin* und *Winterreise*. Der größte Teil des Manuskriptes der *Schönen Müllerin* ist verloren; das Autograph der *Winterreise* befindet sich ebenfalls in der Pierpont Morgan Library.

HECTOR BERLIOZ
(La Côte-St-André, Isère, 1803–1869 Paris)

64

MÉMOIRES

Autograph manuscript of Chapter 26
[1830]
260 x 205 mm

Bequest of Sarah C. Fenderson

MÉMOIRES

Autograph des Kapitels 26 [1830]
260 x 205 mm

Vermächtnis von Sarah C. Fenderson

Berlioz's memoirs, the main source for our knowledge of his life, are among the most moving, revealing, and without doubt most readable of any artist's. Shown here is a page from Chapter 26, which relates events from 1830. Berlioz recalls that his first reading of Goethe's *Faust* made a strange and deep impression on him. He immediately set to music several pieces from it—published as *Huit scènes de Faust*—

and still under the influence of Goethe's poem, I wrote my Fantastic Symphony: very slowly and laboriously in some parts, with extraordinary ease in others. The adagio (the Scene in the Country), which always affects the public and myself so keenly, cost me nearly a month's arduous toil; two or three times I gave it up. On the other hand, the March to the Scaffold was written in a night.[1]

The Library owns nearly all of the surviving manuscripts of the *Mémoires*.

1. "... et toujours sous l'influence du poëme de Goëthe, j'écrivis La Symphonie Fantastique, avec beaucoup de peine pour certaines parties, avec une facilité incroyable pour d'autres. Ainsi l'adagio (scène aux champs) qui impressionne toujours si vivement le public et moi même, me fatigua pendant plus de trois semaines, je l'abandonnai et le repris deux ou trois fois; la Marche au supplice au contraire fut écrite en une nuit." Berlioz, *Memoirs*, p. 126.

Berlioz' *Mémoires,* die Hauptquelle unserer Kenntnis über sein Leben, zählen zu den bewegendsten, erhellendsten und ohne Zweifel lesenswertesten Lebenserinnerungen aus Künstlerhand. Gezeigt wird hier eine Seite aus Kapitel 26, in dem Ereignisse des Jahres 1830 festgehalten sind. Berlioz erinnert sich, daß seine erste Lektüre von Goethes *Faust* bei ihm einen ebenso befremdlichen wie tiefen Eindruck hinterlassen habe. Er vertonte sofort einige Passagen daraus, die als *Huit scènes de Faust* veröffentlicht wurden.

... und immer noch unter Goethes Einfluß, schrieb ich meine *Phantastische Symphonie,* teilweise mit großer Mühe, teilweise mit unglaublicher Leichtigkeit. Das Adagio *Auf dem Lande,* das auf das Publikum wie auf mich selbst stets einen so tiefen Eindruck macht, quälte mich mehr als drei Wochen lang; zwei- oder dreimal legte ich es beiseite und nahm es wieder auf. *Der Gang zum Richtplatz* dagegen wurde in einer Nacht geschrieben.[1]

Die Pierpont Morgan Library besitzt fast alle erhaltenen Manuskripte der *Mémoires.*

1. Berlioz, *Memoiren,* S. 112.

Immédiatement après cette composition sur Faust et toujours sous l'influence du poëme de Goëthe, j'écrivis la Symphonie Fantastique, avec beaucoup de peine pour certaines parties, avec une facilité incroyable pour d'autres. Ainsi l'adagio (Scène aux champs) qui impressionne toujours si vivement le public et moi même, me fatigua pendant plus de trois semaines, je l'abandonnai et le repris deux ou trois fois ; la marche au supplice au contraire fut écrite en une nuit. J'ai néanmoins beaucoup retouché ces deux morceaux et tous les autres du même ouvrage pendant plusieurs années.

Le théâtre des Nouveautés s'étant mis depuis quelque temps à jouer des opéras comiques avait un assez bon orchestre dirigé par Bloc. Celui-ci m'engagea à proposer ma nouvelle œuvre aux directeurs de ce théâtre et à organiser avec eux un concert pour la faire entendre. Ils y consentirent, séduits uniquement par l'étrangeté du programme de la symphonie, qui leur parut devoir exciter la curiosité de la foule. Mais voulant obtenir une exécution grandiose j'invitai au dehors plus de quatre-vingts artistes qui, réunis à ceux de l'orchestre de Bloc, formaient un total de cent trente musiciens. Il n'y avait rien de préparé dans ce théâtre pour y disposer convenablement une pareille masse instrumentale ; ni la décoration nécessaire, ni les gradins, ni même les pupitres. Avec ce sangfroid des gens qui ne savent pas en quoi consistent les difficultés, les directeurs répondaient à toutes mes demandes à ce sujet : «Soyez tranquille, on arrangera cela, nous avons un machiniste intelligent.» Mais quand le jour de la répétition arriva, quand mes cent trente musiciens voulurent se ranger sur la scène, on ne sut où les mettre. J'eus recours à l'emplacement du petit orchestre d'en bas ; mais ce fut à peine si les violons seulement purent s'y caser. Un tumulte à rendre fou un auteur même beaucoup plus calme que moi éclata sur le théâtre. On demandait des pupitres, les charpentiers cherchaient à confectionner précipitamment quelque chose qui pût en tenir lieu ; le machiniste jurait en cherchant ses fermes et ses portants ; on criait ici pour des

VINCENZO BELLINI

(Catania 1801–1835 Puteaux, near Paris)

65

LA SONNAMBULA

Autograph sketches and drafts for
Act I [1831]
280 x 405 mm

The Mary Flagler Cary Music
Collection; Cary 319

LA SONNAMBULA

Autographe Skizzen und Entwürfe für
Akt I [1831]
280 x 405 mm

The Mary Flagler Cary Music
Collection; Cary 319

La sonnambula, which Bellini wrote in less than two months, opened at the Teatro Carcano, in Milan, on 6 March 1831. On 24 October it was performed (to little acclaim) at the Théâtre-Italien in Paris, the first Bellini opera to be produced in the French capital. Three years later, after a triumphal performance at the same theater with two luminaries of the bel canto period—the tenor Giovanni Battista Rubini as Elvino and the soprano Giulia Grisi as Amina—Bellini wrote an ebullient (if hardly impartial) report to his friend Franceso Florimo:

> I hasten to send you news of the spectacular success of *La sonnambula* last evening. Rubini and Grisi sang with such passion and élan that no one in the immense hall remained dry-eyed or unmoved. The finale of Act I—Largo and Stretta—in particular had a remarkable effect. Halfway through, the audience could no longer restrain itself; it seemed as though all nerves were charged with electricity. . . . Act II was no less successful, and it, too, moved all to tears. . . . Last night the French and Italians finally experienced my music in a way that, until now, happened only with audiences in Italy.[1]

1. "Mi affretto a darti la novella che iersera la *Sonnambula* ha fatto un fanatismo al Teatro Italiano. Rubini e la Grisi hanno cantato con tale passione e slancio, che non vi fu persona in tutto l'immenso uditorio che non sparse lagrime, o non restò commossa. Il finale del primo atto particolarmente fece un effetto magico, largo e stretta. Alla metà di questa il pubblico non si potea piú frenare; pareva che i nervi di tutti fossero stati tocchi da elettricismo…. Il secondo atto non fece meno piacere, né mancò di commuovere tutti alle lagrime… Francesi ed Italiani finalmente iersera hanno provato delle sensazioni eguali a quelle che si sono provate finora in Italia nell'assistere alle mie musiche."
Bellini 1943, pp. 461–62.

La sonnambula, die Bellini in weniger als zwei Monaten komponierte, wurde erstmals am 6. März 1831 am Teatro Carcano in Mailand gegeben. Am 24. Oktober fand eine Aufführung der Oper am Théâtre-Italien in Paris statt, allerdings ohne Erfolg; es war die erste Bellini-Oper, die in der französischen Hauptstadt aufgeführt wurde. Drei Jahre später, nach einer triumphalen Aufführung am selben Theater unter Mitwirkung zweier Gesangsstars der Belcanto-Epoche – dem Tenor Giovanni Battista Rubini als Elvino und der Sopranistin Giulia Grisi in der Rolle der Amina –, schrieb Bellini einen überschwenglichen (wenn auch wenig objektiven) Bericht an seinen Freund Francesco Florimo:

> Ich möchte Dir gleich die Neuigkeiten mitteilen, daß die *Sonnambula* gestern abend im Théâtre-Italien fanatische Begeisterung ausgelöst hat. Rubini und die Grisi haben mit so viel Passion und Elan gesungen, daß niemand im riesigen Auditorium war, der nicht Tränen vergoß oder ergriffen war. Besonders das Finale des ersten Aktes – Largo und Stretta – war von magischer Wirkung. Mittendrinnen konnte sich das Publikum nicht mehr zurückhalten; es schien, als stünden die Nerven aller unter elektrischer Spannung. … Aber der zweite Akt gefiel nicht weniger, auch er rührte alle zu Tränen. … Endlich haben gestern abend Franzosen und Italiener die gleichen Empfindungen gehabt, wie sie bisher das Hören meiner Musik nur in Italien auslöste.[1]

1. Degrada 1985, S. 29–30.

FREDERIC CHOPIN

(Żelazowa-Wola, near Warsaw, 1810–1849 Paris)

66

ETUDE FOR PIANO IN C
MAJOR, OP. 10, NO. 7

Autograph manuscript [1832]
260 x 330 mm

Gift of Mrs. Janos Scholz; MA 2473

KLAVIER-ETÜDE IN C-DUR,
OP. 10, NR. 7

Autograph [1832]
260 x 330 mm

Schenkung von Mrs. Janos Scholz;
MA 2473

Chopin wrote the twelve studies op. 10 between 1829 and 1832. When they were published, in 1833, they bore a dedication to Franz Liszt, who, at the time, might have been the only pianist (Chopin possibly excepted) capable of doing justice to these works, which demand not only a formidable technique but also an interpretative sensibility of the highest order. Chopin himself envied Liszt's mastery of these pieces: "I am writing without knowing what my pen is scribbling," he wrote to Ferdinand Hiller in 1833, "because at this moment Liszt is playing my studies and putting honest thoughts out of my head: I should like to rob him of the way to play my own studies."[1] This manuscript comes from the collection of Ernest Schelling, the American pianist, composer, and conductor who studied piano at the Paris Conservatoire with Georges Mathias, himself a pupil of Chopin's in the 1840s.

Provenance
Eduard Franck, Berlin; Richard Franck, Basel; Ernest Schelling, New York.

1. "Je vous écris sans savoir ce que ma plume barbouille parce que Liszt dans ce moment joue mes Etudes et me transporte hors de mes idées honnêtes. Je voudrais lui voler la manière de rendre mes propres Etudes." Eigeldinger 1979; p. 179; Eigeldinger 1986; p. 124.
.

Chopin schuf seine zwölf Etüden op. 10 in den Jahren 1829 bis 1832. Als sie 1833 gedruckt wurden, trugen sie eine Widmung an Franz Liszt, dem zu dieser Zeit neben Chopin selbst wohl einzigen Pianisten, der diesen Werken gerecht zu werden vermochte, da sie nicht nur vorzüglichste Spieltechnik, sondern auch interpretatorische Sensibilität von höchstem Rang erfordern. Chopin selbst beneidete Liszt um dessen meisterhafte Interpretation dieser Etüden. So schrieb er 1833 an Ferdinand Hiller: »Ich schreibe Ihnen, ohne zu wissen, was meine Feder kritzelt, weil Liszt in diesem Augenblick meine Etüden spielt und mich aus meinen ehrbaren Gedanken hinausdrängt. Ich möchte ihm die Art stehlen, wie er meine eigenen Etüden interpretiert.«[1] Das Autograph stammt aus der Sammlung von Ernest Schelling, dem amerikanischen Pianisten, Komponisten und Dirigenten, der am Pariser Conservatoire bei Georges Mathias, der in den 1840er Jahren selbst ein Schüler Chopins war, Klavier studierte.

1. Kobylańska 1983, S. 145.

ROBERT SCHUMANN
(Zwickau, Saxony, 1810–1856 Endenich, near Bonn)

67

SEHNSUCHTSWALZER
VARIATIONEN

Drafts (1832–33)
260 x 330 mm

Bequest of Alice Tully

SEHNSUCHTSWALZER
VARIATIONEN

Entwürfe (1832–33)
260 x 330 mm

Vermächtnis von Alice Tully

Carnaval is one of Schumann's most popular works and has remained a staple of the piano repertory since it was published in 1837. But it will come as a surprise to many that the "Préambule" that opens *Carnaval* was originally written as the beginning of another work altogether. In these manuscripts the marchlike "Préambule" is followed by music that bears little obvious resemblance to *Carnaval*. The unfamiliar passages are drafts for variations, later abandoned, on themes by Franz Schubert. They are known as the *Sehnsuchtswalzer Variationen* (Yearning Waltz Variations), after a dance for piano by Schubert that was immensely popular at the time—although the connection between Schubert's tune and Schumann's variations on it is not immediately apparent. The working titles on the manuscripts are *Scenes mignonnes* and *Scenes musicales sur un thème connu de Franc. Schubert, comp. p. le Pfte et dediées à Mad. Henriette Voigt par R. Schumann. Œuv. 10;* when *Carnaval* was published it bore the subtitle *Scènes mignonnes sur quatre notes.* Henriette Voigt, to whom Schumann's Piano Sonata in G Minor, op. 22, is dedicated, and her husband, Carl, were wealthy patrons in Leipzig.

Provenance
Gisela von der Goltz-Vietinghoff, Munich; L. von Vietinghoff-Scheel, Berlin; Alice Tully, New York.

Carnaval zählt zu den beliebtesten Stücken von Schumann und hat seit seiner Veröffentlichung im Jahr 1837 einen festen Platz im Klavierrepertoire erhalten. Es mag daher überraschen, daß der »Préambule«, mit dem *Carnaval* beginnt, ursprünglich als Anfang eines ganz anderen Stückes komponiert worden war. In den vorliegenden Manuskripten folgt auf den marschähnlichen »Préambule« Musik, die kaum Ähnlichkeit mit dem *Carnaval* hat. Bei den unbekannten Passagen handelt es sich um später verworfene Entwürfe für Variationen über Themen von Franz Schubert. Sie sind als *Sehnsuchtswalzer-Variationen* bekannt, nach einem zur damaligen Zeit ungemein populären Tanz, den Schubert für Klavier komponiert hatte, wenn auch die Verbindung zwischen Schuberts Melodie und Schumanns Variationen nicht unmittelbar offenkundig ist. Die Arbeitstitel auf den Manuskriptseiten lauten *Scenes mignonnes* und *Scenes musicales sur un thème connu de Franc. Schubert, comp. p. le Pfte et dediées à Mad. Henriette Voigt par R. Schumann. Œuv. 10;* als *Carnaval* veröffentlicht wurde, trug das Stück den Untertitel *Scènes mignonnes sur quatre notes.* Henriette Voigt, der Schumann seine Klaviersonate in g-moll, op. 22, widmete, und ihr Ehemann Carl waren wohlhabende Mäzene in Leipzig.

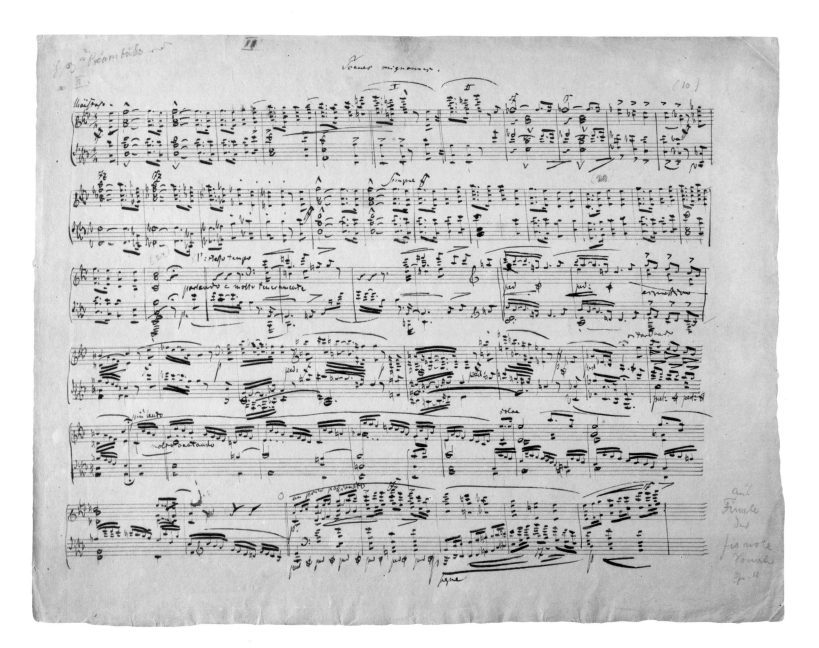

FELIX MENDELSSOHN-BARTHOLDY
(Hamburg 1809–1847 Leipzig)

MEERESSTILLE UND
GLÜCKLICHE FAHRT

Autograph manuscript of the full score
of the concert overture [1835]
235 x 300 mm

The Mary Flagler Cary Music
Collection; Cary 62

MEERESSTILLE UND
GLÜCKLICHE FAHRT

Partiturautograph der Konzert-
Ouvertüre [1835]
235 x 300 mm

The Mary Flagler Cary Music
Collection; Cary 62

Mendelssohn was apparently the first to use the term "concert overture" in the title of a work. Robert Schumann, who thought highly of these overtures, observed that in them Mendelssohn "had compressed the idea of the symphony into narrower confines"[1] and declared that, among instrumental composers of his day, Mendelssohn merited the crown and scepter. The composition of *Ein Sommernachtstraum* (A Midsummer Night's Dream), *Meeresstille und glückliche Fahrt* (Calm Sea and Prosperous Voyage), and *Die Hebriden* (The Hebrides, also known as Fingal's Cave), the best-known of Mendelssohn's concert overtures, was unusually protracted. Although Mendelssohn first mentioned the *Midsummer Night's Dream* overture in a letter to his sister Fanny in 1826, nine years would elapse before the three overtures were published, by Breitkopf & Härtel, in 1835. Inspired by Goethe's poems *Meeresstille* and *Glückliche Fahrt,* this overture was first performed, in Berlin, in 1830. On 4 October 1835 Mendelssohn included a revised version of it in his first concert with the Leipzig Gewandhaus Orchestra, of which he had recently been named conductor. In his review of this concert, Schumann wrote that the overture evoked an image of the Venetian lagoon: "The sea, calm and vast, lay stretched out before us; but on the farthest horizon a delicate sound danced about as though the wavelets were speaking among themselves in a dream."[2]

Provenance
Breitkopf & Märtel Archive; Mary Flagler Cary.

1. Plantinga 1976, p. 193.
2. *Neue Zeitschrift* 1835, p. 127.

Mendelssohn war offensichtlich der erste Komponist, der die Bezeichnung »Konzert-Ouvertüre« im Titel eines Stückes verwendete. Robert Schumann, der diesen Ouvertüren höchste Anerkennung zollte, bemerkte, daß Mendelssohn in ihnen »die Idee der Symphonie in einen kleinern Kreis zusammendrängte«,[1] und er bekundete, daß sich Mendelssohn »Kron' und Scepter über die Instrumentalkomponisten des Tages« errang. Die Komposition der bekanntesten Ouvertüren – *Ein Sommernachtstraum, Meeresstille und glückliche Fahrt* und *Die Hebriden* (auch *Fingalshöhle* genannt) – war außergewöhnlich langwierig. Obwohl Mendelssohn bereits 1826 die Ouvertüre *Ein Sommernachtstraum* in einem Brief an seine Schwester Fanny erstmals erwähnt hatte, sollten bis zur Veröffentlichung der drei Ouvertüren bei Breitkopf & Härtel im Jahr 1835 noch neun Jahre vergehen. Die durch Goethes Gedichte *Meeresstille* und *Glückliche Fahrt* inspirierte Ouvertüre wurde 1830 in Berlin uraufgeführt. Am 4. Oktober 1835 nahm der Komponist eine überarbeitete Fassung in das Programm seines ersten Konzertes mit dem Leipziger Gewandhausorchester auf, zu dessen Leiter er kurz zuvor ernannt worden war. In seiner Konzertbesprechung schrieb Schumann, daß die Ouvertüre ein Bild von der venezianischen Lagune evoziere: »Das Meer lag vor uns ausgebreitet, still und ungeheuer, aber am äußersten Horizonte spielte ein feines Klingen auf und nieder, als sprächen die kleinen Wellen miteinander im Traume.«[2]

1. *Neue Zeitschrift* 1835, S. 34.
2. Ebenda, S. 127.

ROBERT SCHUMANN

(Zwickau, Saxony, 1810 – 1856 Endenich, near Bonn)

69

FRAUENLIEBE UND -LEBEN

Autograph draft (incomplete) of the
voice part (1840)
300 x 230 mm

The Mary Flagler Cary Music
Collection; Cary 68

FRAUENLIEBE UND -LEBEN

Handschriftlicher Entwurf (unvoll-
ständig) der Singstimme (1840)
300 x 230 mm

The Mary Flagler Cary Music
Collection; Cary 68

The year 1840 witnessed Schumann's most extraordinary outpouring of songs and song cycles; indeed, over half his entire song output—including *Myrthen* (Myrtles), *Liederkreis* (Song Cycle), *Dichterliebe* (A Poet's Love), and *Frauenliebe und -leben* (A Woman's Love and Life), as well as many individual songs—was composed in this so-called *Liederjahr*. According to the dates Schumann wrote on this manuscript, the voice parts of the eight songs of *Frauenliebe und -leben* were drafted in just two days, 11 and 12 July 1840. In the poems, by Adalbert von Chamisso, a woman muses on love, marriage, motherhood, and the loss of her husband. This portrayal of a submissive woman who lives only to please her husband—"I shall serve him, live for him, belong wholly to him, surrender myself and become transfigured in his radiance"—has long been derided, but Schumann's music, if it does not transfigure the poetry, easily transcends it. This manuscript contains drafts of two other Chamisso settings: *Die Löwenbraut* (The Lion's Betrothed) and *Die Kartenlegerin* (The Fortune Teller).

Provenance
Westley Manning; Mary Flagler Cary.

Im Jahr 1840 erreichte Schumanns ungeheure Schaffenskraft im Bereich des Liedes und der Liederzyklen ihren Höhepunkt; über die Hälfte aller seiner Liedkompositionen, darunter *Myrthen, Liederkreis, Dichterliebe, Frauenliebe und -leben* sowie viele Einzellieder, entstanden in diesem so treffend genannten *Liederjahr*. Den von Schumann im vorliegenden Manuskript vermerkten Datierungen zufolge entwarf er die Singstimme der acht Lieder von *Frauenliebe und -leben* innerhalb von nur zwei Tagen, am 11. und 12. Juli 1840. In diesen Gedichten von Adalbert von Chamisso sinniert eine Frau über Liebe, Ehe und Mutterschaft sowie den Verlust ihres Ehemannes. Dieses Portrait einer unterwürfigen Frau, deren vornehmster Lebensinhalt in der Erfüllung der Wünsche ihres Mannes liegt – »Ich will ihm dienen, ihm leben, / Ihm angehören ganz, / Hin selber mich geben und finden / Verklärt mich in seinem Glanz« –, wurde lange mit einer gewissen Abfälligkeit betrachtet. Doch Schumanns Musik gelingt es, die Dichtung, wenn auch nicht zu verklären, so doch mühelos zu überhöhen. Das vorliegende Manuskript enthält auch Entwürfe zu zwei weiteren Chamisso-Vertonungen: *Die Löwenbraut* und *Die Kartenlegerin*.

FREDERIC CHOPIN
(Żelazowa-Wola, near Warsaw, 1810–1849 Paris)

POLONAISE IN A-FLAT MAJOR,
OP. 53

Autograph manuscript [1842]
210 x 270 mm

The Dannie and Hettie Heineman
Collection; Heineman MS 42

POLONAISE IN AS-DUR,
OP. 53

Autograph [1842]
210 x 270 mm

The Dannie and Hettie Heineman
Collection; Heineman MS 42

The classic polonaise originated in Poland at the beginning of the nineteenth century. Although many composers wrote polonaises, Chopin's are surely the best known and, for many, define the genre. Chopin made the national dance a symbol of heroism and chivalry, and this is the most overtly patriotic of his works. It was written in the summer of 1842, when the composer and George Sand were together at Nohant, and has long since held an esteemed place in the piano repertory.

Pianists who ignore Chopin's "maestoso"—a mark governing both tempo and expression—should be reminded of the composer's own words on the subject. Sir Charles Hallé, the English pianist and conductor, wrote in his autobiography: "I remember how, on one occasion, in his gentle way, Chopin laid his hand upon my shoulder, saying how unhappy he felt, because he had heard his 'Grande Polonaise' in A flat *jouée vite!*, thereby destroying all the grandeur, the majesty, of this noble inspiration."[1]

Provenance
Breitkopf & Härtel; Clara Schumann; Dannie and Hettie Heineman.

1. Eigeldinger 1986, p. 82.

Die klassische Polonaise hat ihren Ursprung im frühen 19. Jahrhundert in Polen. Obgleich zahlreiche Komponisten Polonaisen schrieben, sind diejenigen von Chopin sicherlich die bekanntesten und gelten darüber hinaus als gattungsbildend. Chopin gestaltete den Volkstanz zum Sinnbild von Heldentum und Ritterlichkeit um, und die Polonaise in As-Dur wurde zum unverblümt patriotischsten unter seinen Werken. Entstanden im Sommer 1842, als sich der Komponist zusammen mit George Sand in Nohant aufhielt, hat sie seit dieser Zeit einen herausragenden Platz im Klavierrepertoire inne.

Pianisten, die Chopins Angabe *maestoso* – ein Hinweis, der sich auf Tempo und Ausdruck gleichermaßen bezieht – mißachten, sollten an die Worte des Komponisten zu diesem Thema gemahnt werden. Der englische Pianist und Dirigent Sir Charles Hallé schrieb in seiner Autobiographie: »Ich erinnere mich, wie Chopin mir bei einer Gelegenheit in der ihm eigenen freundlichen Art die Hand auf die Schulter legte und seiner Bekümmertheit Ausdruck verlieh, da er seine ›Grande Polonaise‹ in As-Dur ›jouée vite!‹ gehört habe, wodurch die Größe und Erhabenheit der ihr zugrundeliegenden Idee zerstört worden sei.«[1]

1. Eigeldinger 1986, S. 82.

RICHARD WAGNER
(Leipzig 1813–1883 Venice)

71

DER RING DES NIBELUNGEN.
EIN BÜHNENFESTSPIEL FÜR
DREI TAGE UND EINEN VOR-
ABEND.

Zürich: printed by E. Kiesling [1853]

Wagner's copy of the first edition of
the libretto
8°

The Dannie and Hettie Heineman
Collection; Heineman 739

DER RING DES NIBELUNGEN.
EIN BÜHNENFESTSPIEL FÜR
DREI TAGE UND EINEN VOR-
ABEND

Zürich: Verlag E. Kiesling [1853]

Wagners eigenes Exemplar der
Erstausgabe des Librettos
8°

The Dannie and Hettie Heineman
Collection; Heineman 739

Wagner began work on what would become the libretto for *Der Ring des Nibelungen* (The Nibelung's Ring) in 1848 and completed it in 1852. He wrote the libretto in reverse order, beginning with *Siegfrieds Tod* (Siegfried's Death), which was later renamed *Götterdämmerung* (Twilight of the Gods); then *Der junge Siegfried* (later called *Siegfried*); next *Die Walküre* (The Valkyrie); and finally *Das Rheingold* (The Rhinegold). The music, however, was composed in the "correct" order. The libretto was printed in 1853, at Wagner's expense, in an edition of fifty copies. This copy is the composer's own and contains his alterations to the text on the interleaved pages. The changes in *Siegfried*, pages of which are seen here, are the most extensive. Wagner finished composing the *Ring* in 1874—twenty-six years after the initial drafts—and the four operas were first performed as an integral cycle in Bayreuth on 13, 14, 16, and 17 August 1876.

Provenance
Franz Müller; Dannie and Hettie Heineman.

Wagner begann 1848 mit der Arbeit an dem 1852 abgeschlossenen Libretto zum *Ring des Nibelungen.* Er schrieb es in umgekehrter Reihenfolge, beginnend mit *Siegfrieds Tod* (später in *Götterdämmerung* umbenannt), gefolgt von *Der junge Siegfried* (dem späteren *Siegfried),* dann *Die Walküre* und schließlich *Das Rheingold.* Die Musik hingegen wurde in chronologisch »korrekter« Abfolge komponiert. Wagner ließ das Libretto 1853 auf eigene Kosten in einer Auflage von 50 Stück drucken. Gezeigt wird hier das Handexemplar des Komponisten, das auf den Durchschußblättern seine Textänderungen enthält. Die in *Siegfried* vorgenommenen Korrekturen waren, wie die hier aufgeschlagenen Seiten zeigen, die umfangreichsten. Wagner vollendete die kompositorische Arbeit am *Ring* im Jahr 1874, 26 Jahre nach den ersten Entwürfen. Die Uraufführung der vier Opern als ein vollständiger Zyklus fand am 13., 14., 16. und 17. August 1876 in Bayreuth statt.

192

= kannst du was rechts,
nun zeig' deine Kunst!
Täusche mich nicht
mit schlechtem Tand:
den Trümmern allein
trau' ich was zu.
Find' ich dich Faul,
fügst du sie schlecht,
flickst es du mit Flausen
den festen Stahl, —
Dir Zeigem fahr' ich zu Leib,
das Fegen lernst du von mir!
Denn heute noch, schwör' ich,
will ich das Schwert;
die Waffe gewinn' ich noch heut? +

He! Siegfried!
Siegfried! He! —

Da stürmt es hin: —
nun sitz' ich da: —
zur alten Noth
hab' ich die neue;
vernagelt bin ich nun ganz. —

Wie helf' ich mir jetzt?
Wie halt' ich ihn fest?
Wie führ' ich den Huien
zu Fafner's Nest? —
Wie füg' ich die Stücken
des tückischen Stahl's?
Keines Ofens Gluth
glüht mir die Sächsen;
keines Zwerges Hammer
zwingt mir die harten:
des Niblungen Neid,
Noth und Schweiss
nietet und Nothung nicht,
schweisst mir das Schwert nicht zu ganz!

Er knickt verzweifelnd auf dem Schemel hinter
dem Amboss zusammen.

(folgt S. 84)

MIME.

Entfiel er mir wohl? doch halt!
Sieglinde mochte fie heifsen,
die dich in Sorge mir gab. —
»Ich hütete dich
wie die eig'ne Haut«...

SIEGFRIED.

Dann frag' ich, wie hiefs mein Vater?

MIME.

barfch.

Den hab' ich nie gefeh'n,

SIEGFRIED.

Doch die Mutter nannte den Namen?

MIME.

Erfchlagen fei er,
das fagte fie nur;
dich Vaterlofen
befahl fie mir da: —
»und wie du erwuchfeft,
wartet' ich dein';
dein Lager fchuf ich,
dafs leicht du fchlief ft«...

SIEGFRIED.

Still mit dem alten
Staarenlied! —
Soll ich der Kunde glauben,
haft du mir nichts gelogen,
fo lafs mich nun Zeichen feh'n!

MIME.

Was foll dir's noch bezeugen?

SIEGFRIED.

Dir glaub' ich nicht mit dem Ohr',
dir glaub' ich nur mit dem Aug':
welch' Zeichen zeugt für dich?

MIME

*holt nach einigem Befinnen die zwei
Stücken eines zerfchlagenen Schwertes
herbei.*

Das gab' mir deine Mutter:
für Mühe, Koft und Pflege
liefs fie's als fchwachen Lohn.
Sieh' her, ein zerbrochnes Schwert!

Dein Vater, fagte fie, führt' es,
als im letzten Kampf er erlag.

SIEGFRIED.

Und diefe Stücken
follt du mir fchmieden:
dann fchwing' ich mein rechtes Schwert!
Eile dich, Mime,
mühe dich rafch;
dafs ich heut' noch die Waffe gewinn'!

+ MIME, *Schmelz?*

erfchrocken.

Was willft du noch heut' mit der Waffe

SIEGFRIED.

Aus dem Wald fort
in die Welt zieh'n:
nimmer kehr' ich zurück.
Wie ich froh bin,
dafs ich frei ward,
nichts mich bindet und zwingt!
Mein Vater bift du nicht;
in der Ferne bin ich heim;
dein Herd ift nicht mein Haus,
meine Decke nicht dein Dach.
Wie der Fifch froh
in der Fluth fchwimmt,
wie der Fink frei
fich davon fchwingt:
flieg' ich von hier,
fluthe davon,
wie der Wind über'n Wald
weh' ich dahin —
dich, Mime, nie wieder zu feh'n!
Er ftürmt in den Wald fort.

MIME

in höchfter Angft.

Halte! halte! wohin?
höre mich, Siegfried, hör'!
Er ftürmt mir fort! — ho, Siegfried!
Wie halt' ich das Kind mir feft?
*Er ruft mit der gröfsten Anftrengung in
den Wald.*

11

FRANZ LISZT

(Raiding, near Sopron, 1811 – 1886 Bayreuth)

First Mephisto Waltz

Autograph manuscript (1859)
225 x 280 mm

Purchased as the gift of the Fellows,
with the special assistance of Mrs.
W. Rodman Fay

Erster Mephisto-Walzer

Autograph (1859)
225 x 280 mm

Erworben mit Mitteln der Association
of Fellows mit besonderer Unter-
stützung von Mrs. W. Rodman Fay

Liszt dated this manuscript of one of his best-known piano works 1 September 1859. Originally published as *Der Tanz in der Dorfschenke* (The Dance in the Village Inn) but now known as the First Mephisto Waltz, the work was inspired by Nikolaus Lenau's *Faust* and is based on one of the many episodes of the legend not found in Goethe's version. Faust and Mephistopheles have wandered into a village where wedding festivities are in progress. Mephistopheles seizes a violin and, through the demoniacal fire of his playing, whips the dancers into a frenzy. Faust leads a woman into the open where, amid the sounds of Mephistopheles' violin and the song of a nightingale, the couple "is overcome by ardent desire and swallowed by the roaring sea of lust." This is one of the few works by Liszt written after the B-minor Piano Sonata (1852–53) to have remained in the standard repertory, although he continued to compose until his death in 1886. Liszt later orchestrated the "First Mephisto Waltz," a brilliant arrangement that is unjustly neglected.

Provenance
Robert Pflughaupt; Alfred Cortot; Robert Owen Lehman.

Liszt datierte dieses Manuskript eines seiner bekanntesten Klavierwerke auf den 1. September 1859. Ursprünglich unter dem Titel *Der Tanz in der Dorfschenke* veröffentlicht, ist es heute als *Erster Mephisto-Walzer* bekannt. Die Komposition wurde von Nikolaus Lenaus *Faust* angeregt und beruht auf einer der zahlreichen Episoden der Legende, die von Goethe nicht verwendet wurden. Faust und Mephisto sind in ein Dorf spaziert, in dem Hochzeitsfeierlichkeiten in vollem Gange sind. Mephisto ergreift eine Violine und peitscht die Tänzer durch das teuflische Feuer seines Spieles zur Ekstase. Faust führt eine Frau ins Freie, wo sich das Paar unter den Klängen von Mephistos Violinspiel und des Schlagens einer Nachtigall einander hingibt: »Da zieht sie nieder die Sehnsucht schwer, / Und brausend verschlingt sie das Wonnemeer.« Dieser Walzer ist eines der wenigen nach der Klaviersonate in h-moll (1852–53) entstandenen Stücke, die im Standardrepertoire verblieben sind, obgleich Liszt bis zu seinem Tod im Jahr 1886 weiterkomponierte. Liszt schrieb später noch eine Orchesterfassung des *Ersten Mephisto-Walzers,* eine brillante Bearbeitung, der zu Unrecht zu wenig Aufmerksamkeit geschenkt wird.

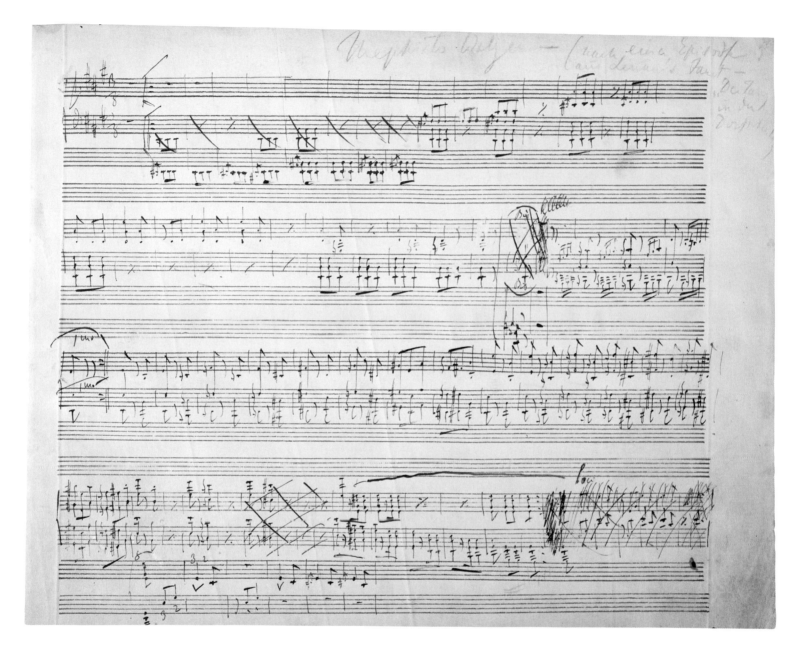

RICHARD WAGNER

(Leipzig 1813–1883 Venice)

73

Die Meistersinger von
Nürnberg

Autograph manuscript of the libretto
[1862]
290 x 220 mm

Gift of Arthur A. Houghton, Jr.;
MA 2837

Die Meistersinger von
Nürnberg

Autograph des Librettos [1862]
290 x 220 mm

Schenkung von Arthur A. Houghton jr.;
MA 2837

In July 1845, while on a rest cure at the Bohemian town of Marienbad, Wagner wrote the first prose draft of what would become *Die Meistersinger von Nürnberg* (The Mastersingers of Nuremberg). He did not return to the project for sixteen years, until he wrote a second and third prose scenario in mid-November 1861. The poem itself was completed between 25 and 31 January 1862 in Paris. On 25 September, Wagner sent a fair copy of the libretto to the publisher Schott, and it is this state that is preserved in this manuscript.

In October 1861 Wagner had proposed to Schott his plan for a popular comic opera of modest scale that, unlike *Tristan und Isolde* (completed in 1859), would not call for an outstanding tenor or for a great tragic soprano. As it turned out, *Die Meistersinger* called for a tenor and soprano of the first order, included a bass-baritone role that is among the most taxing in the repertory, became the longest opera ever written, and, when published, the largest score yet printed. It was completed on 24 October 1867. In the twenty-two years since the Marienbad draft, Wagner had composed *Lohengrin, Das Rheingold, Die Walküre,* two-thirds of *Siegfried,* all of *Tristan und Isolde* and had prepared the Paris version of *Tannhäuser.*

Provenance
Kaiser Wilhelm II; George Clifford Thomas;
A. S. W. Rosenbach; Arthur A. Houghton, Jr.

Im Juli 1845 verfaßte Wagner während eines Kuraufenthaltes im böhmischen Marienbad den ersten Prosaentwurf der späteren *Meistersinger von Nürnberg*. Danach ruhte das Projekt 16 Jahre lang, ehe Mitte November 1861 eine zweite und dritte Prosafassung entstanden. Das Gedicht selbst wurde zwischen dem 25. und 31. Januar 1862 in Paris vollendet. Am 25. September sandte Wagner eine Reinschrift des Librettos an seinen Verleger Schott. Diese Fassung ist im vorliegenden Autograph erhalten.

Wagner hatte im Oktober 1861 Schott seinen Plan für eine volkstümliche, heitere Oper von mittlerem Schwierigkeitsgrad unterbreitet, die im Gegensatz zu *Tristan und Isolde* (1859 vollendet) weder einen Heldentenor noch einen hochdramatischen Sopran verlangen sollte. Im Ergebnis erfordern *Die Meistersinger* freilich eine Tenor- und Sopranstimme von höchster Virtuosität, dazu einen Baß-Bariton, der zu den anspruchvollsten Rollen im Repertoire gehört. Sie wurde zur längsten je geschriebenen Oper und wurde publiziert als die damals umfangreichste Partitur der Musikgeschichte. *Die Meistersinger* wurden am 24. Oktober 1867 vollendet. In den 22 Jahren, die seit seinem Marienbader Entwurf vergangen waren, hatte Wagner zwischenzeitlich *Lohengrin, Das Rheingold, Die Walküre,* zwei Drittel von *Siegfried* sowie *Tristan und Isolde* komponiert und die Pariser Fassung des *Tannhäuser* vorbereitet.

Es, ist mir um den Lehrbuben leid:
 Der verliert mir allen Respekt;
die Lern' macht ihn schon nichts recht gescheit,
 dass er Töpf' und Teller zerleckt!
Wo Teufel er jetzt wieder steckt?
(Er stellt sich als wolle er nach David sehen.)

(hält Sachs, und zieht ihn von Neuem an sich.)
O Sachs! Mein Freund! Du theurer Mann!
Wie ich der Edlen lohnen kann!
 Was ohne deine Liebe,
 was wär' ich ohne dich,
 ob je auch Kind ich bliebe,
 erwecktest du nicht mich?
 Durch dich gewann ich,
 was man preist,
 durch dich ersann ich,
 was ein Geist!
 Durch dich erwacht,
 durch dich nur dacht'
 ich edel, frei und kühn:
 du liessest mich erblühn!
O lieber Meister! schilt mich nur!
Ich war doch auf der rechten Spur:
 denn, hatte ich die Wahl,
 nur dich erwählt' ich mir:
 du warest mein Gemahl,
 den Preis nur reicht' ich Dir!
 Doch nun hat's mich gewählet
 zu nie gekannter Qual:
 und werd' ich heut' vermählet,
 so war's ohn' alle Wahl!
Das war ein Müssen, war ein Zwang!
Euch selbst, mein Meister, wurde bang.

 Sachs.
 Mein Kind:
von Tristan und Isolde
kenn' ich ein traurig Stück:
Hans Sachs war klug, und wollte
nichts von Herrn Marke's Glück.-
's war Zeit, dass ich den Rechten erkannt:
wär' sonst am End' doch hineingerannt.-
Aha! da streicht schon die Lene um's Haus.
Nur herein!-He, David! Kommst nicht heraus.

(Magdalene, in festlichem Staate, tritt durch die Laden-
thüre herein; aus der Kammer kommt zugleich David,
ebenfalls im Festkleid, mit Blumen und Bändern sehr
reich und zierlich ausgeputzt.)
 Die Zeugen sind da, Gevatter zur Hand;
 jetzt schnell zur Taufe! Nehmt euren Stand!
 (Alle blicken ihn verwundert an.)
 Ein Kind ward hier geboren:
 jetzt sei ihm ein Nam' erkoren.
So ist's nach Meister Weis' und Art,
wenn eine Meisterweise geschaffen ward:
dass die einen guten Namen trag',
dran Jeder sie erkennen mag.

JOHANNES BRAHMS
(Hamburg 1833–1897 Vienna)

74

SONATA FOR TWO PIANOS IN
F MINOR, OP. 34b

Autograph manuscript [1864]
255 x 325 mm

The Mary Flagler Cary Music
Collection; Cary 4

SONATE FÜR ZWEI KLAVIERE
IN F-MOLL, OP. 34b

Autograph [1864]
255 x 325 mm

The Mary Flagler Cary Music
Collection; Cary 4

The genesis of this sonata is one of the more complicated among Brahms's oeuvre. It began, around 1862, as a string quintet and circulated in that form among his friends. The violinist Joseph Joachim wrote to Brahms that he did not want to perform the quintet in public— "but only because I hope that here and there you both smooth out some rough passages I find too harsh and brighten the color."[1] Brahms soon abandoned the quintet and by early 1864 had recast it as the Sonata for Two Pianos, op. 34b. Later that year he revised the work once again, this time as the Piano Quintet, op. 34, which is ranked among his masterpieces of the 1860s. Owing to its unusual scoring, the Sonata for Two Pianos—one of the great works in the genre—is heard less often. In the summer of 1864 Brahms and Clara Schumann played it for Countess Anna von Hessen, who was so enchanted by the work that the composer dedicated both op. 34 and op. 34b to her; the countess, in turn, presented Brahms with the autograph manuscript of Mozart's Symphony in G Minor, K. 550.

Provenance
Hermann Levi; Frau Michael Balling, Darmstadt; Paul Gottschalk; Mary Flagler Cary.

1. *Brahms Briefwechsel VI*, p. 6.

Die Entstehungsgeschichte dieser Sonate gehört zu den komplizierteren in Brahms' Œuvre. Sie entstand um 1862 zunächst als Streichquintett und kursierte in dieser Form unter seinen Freunden. Der Geiger Joseph Joachim schrieb an Brahms, er wolle das Quintett nicht öffentlich aufführen, »aber nur weil ich hoffe, Du änderst hie und da einige selbst mir zu große Schroffheiten, und lichtest hier und da das Kolorit«.[1] Brahms zog das Quintett bald zurück und hatte es bereits Anfang 1864 zur Sonate für zwei Klaviere op. 34b umgearbeitet. Im weiteren Verlauf desselben Jahres überarbeitete er das Werk erneut, diesmal als Klavierquintett op. 34, das zu seinen Meisterwerken der 1860er Jahre zählt. Aufgrund ihrer ungewöhnlichen Instrumentierung ist die Sonate für zwei Klaviere, die eine der herausragenden Kompositionen dieses Genres ist, ungleich seltener zu hören. Im Sommer des Jahres 1864 spielte sie Brahms zusammen mit Clara Schumann der Gräfin Anna von Hessen vor, die so entzückt war von der Musik, daß ihr der Komponist sowohl op. 34 als auch op. 34b widmete; die Gräfin bedankte sich bei Brahms mit Mozarts Partiturautograph der Sinfonie in g-moll, KV 550.

1. *Brahms Briefwechsel VI*, S. 6.

MAX BRUCH

(Cologne 1838–1920 Berlin-Friedenau)

Violin Concerto no. 1 in
G Minor, op. 26

Autograph manuscript (1867)
225 x 335 mm

The Mary Flagler Cary Music
Collection; Cary 54

Violinkonzert Nr. 1 in
g-moll, op. 26

Autograph (1867)
225 x 335 mm

The Mary Flagler Cary Music
Collection; Cary 54

After the April 1866 premiere of this concerto, Bruch revised it in consultation with Joseph Joachim, the outstanding violinist of his day—he also gave Brahms valuable suggestions in writing and revising the solo part of his Violin Concerto—although Bruch would never publicly acknowledge the extent of Joachim's advice. Joachim, to whom the concerto is dedicated, gave the formal premiere of the revised version in January 1868. Bruch eventually came to resent the extraordinary popularity of this work. Twenty years later, in a letter to the publisher Fritz Simrock, he wrote:

> Nothing compares to the laziness, stupidity, and dullness of many German violinists. Every two weeks another one comes to me wanting to play—the first concerto; I have now become rude and have told them: "I cannot listen to this concerto anymore—did I perhaps write just this one? Go away and once and for all play the other concerti, which are just as good, if not better."[1]

Bruch sold the concerto outright to the publisher August Cranz for 250 talers—a naive decision he regretted for the rest of his life, since the considerable royalties from this, his most frequently performed work, would have continued until 1990.

Provenance
Mary Flagler Cary.

1. Fifield 1988, p. 77.

Nach der Uraufführung des Konzertes im April 1866 nahm Bruch in Zusammenarbeit mit Joseph Joachim, dem herausragenden Geiger seiner Zeit, eine Überarbeitung des Stücks vor, ohne allerdings das Ausmaß der Hilfestellung seitens Joachims öffentlich einzugestehen. Joachim, der auch Brahms bei der Niederschrift und nochmaligen Durchsicht des Soloparts seines Violinkonzertes mit wertvollen Ratschlägen unterstützt hatte und dem Bruch das Werk widmete, gab die offizielle Premiere der überarbeiteten Fassung im Januar 1868. Später ärgerte sich Bruch über die außergewöhnlich große Popularität des Stücks. So schrieb er 20 Jahre später in einem Brief an den Verleger Fritz Simrock:

> Nichts gleicht der Trägheit, Dummheit, Dumpfheit vieler deutscher Geiger. Alle 14 Tage kommt Einer und will mir das – *I. Concert* vorspielen; ich bin schon grob geworden, und habe ihnen gesagt: »Ich kann dies Concert nicht mehr hören – habe ich vielleicht bloß dies *eine* Concert geschrieben? Gehen Sie hin und spielen Sie endlich einmal die andern Concerte, die ebenso gut, wenn nicht besser sind!«[1]

Bruch verkaufte die Konzertrechte für 250 Taler vorbehaltlos an seinen Verleger August Cranz – eine unbedachte Entscheidung, die er für den Rest seines Lebens bedauerte, da die Rechte an den beträchtlichen Verkaufs- und Aufführungsantiemen aus seinem am häufigsten aufgeführten Werk bis ins Jahr 1990 galten.

1. Lauth 1970, S. 65.

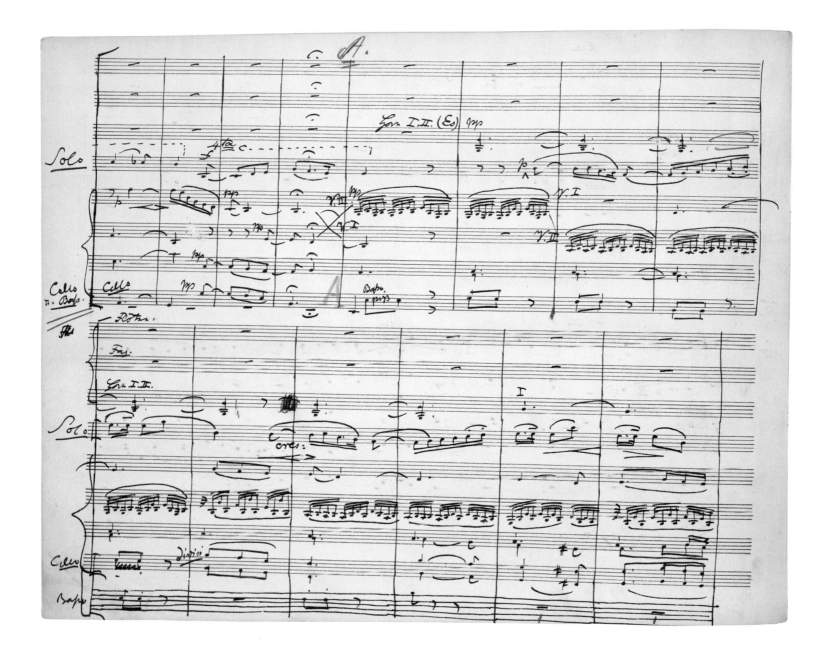

JOHANNES BRAHMS
(Hamburg 1833–1897 Vienna)

UNGARISCHE TÄNZE FOR
PIANO FOUR-HANDS,
BOOKS 1 AND 2

Autograph manuscript [1868]
250 x 340 mm

The Mary Flagler Cary Music
Collection; Cary 289

UNGARISCHE TÄNZE FÜR
KLAVIER ZU VIER HÄNDEN,
BUCH 1 UND 2

Autograph [1868]
250 x 340 mm

The Mary Flagler Cary Music
Collection; Cary 289

Brahms showed an early interest in folk music. In 1854 he sent Clara Schumann a collection of folk tunes, including two he would later use in the *Ungarische Tänze* for piano four-hands. The ten dances, published in 1869, soon became Brahms's best-known works by far. Although they are based on actual Hungarian folk music, early critics accused Brahms of plagiarism. Béla Kéler alleged that for his Hungarian Dance no. 5, Brahms had stolen *Bártfai emlék* (Memory of Bartfa), a *csárdás* for piano published under Kéler's name in 1859. (Kéler was born in Bartfa, Hungary, which is now Bardejov, Slovakia.) In fact, Kéler and Brahms drew on a common source. Like all of Brahms's arrangements, the Hungarian Dances were published without opus numbers. The title page on the first edition clearly states that they were only set, not composed, by Brahms, who himself referred to them as "genuine Puszta or Gypsy children, which I did not beget but only raised with milk and bread."[1] In the only recording of Brahms performing his music, a wax cylinder made in December 1889, he played part of the First Hungarian Dance.

Provenance
Simrock Archives; Louis Koch (Catalogue, no. 309).

1. *Brahms Briefwechsel IX*, p. 61.

Brahms' Interesse an Volksmusik reichte weit zurück. Bereits 1854 übersandte er Clara Schumann eine Sammlung von Volksweisen, von denen er später zwei in seinen *Ungarischen Tänzen* für Klavier zu vier Händen aufgriff. Die zehn Tänze, veröffentlicht im Jahr 1869, gehörten bald zu den bekanntesten Werken von Brahms. Obwohl sie auf traditionellen ungarischen Volksweisen basieren, wurde Brahms von frühen Kritikern des Plagiats beschuldigt. Béla Kéler nahm für sich in Anspruch, daß sich Brahms für seinen *Ungarischen Tanz Nr. 5* seines Stückes *Bártfai emlék* (Erinnerung an Bartfeld) bedient habe, einem Csárdás für Klavier, der 1859 unter Kélers Namen veröffentlicht worden war. (Kéler wurde im damals ungarischen Bartfa geboren, dem heutigen Bardejov in der Slowakischen Republik.) Tatsächlich griffen jedoch Kéler und Brahms auf eine gemeinsame Quelle zurück. Wie alle Bearbeitungen von Brahms wurden auch die *Ungarischen Tänze* ohne Opuszahl veröffentlicht. So steht auf der Titelseite der Erstausgabe, daß Brahms sie lediglich gesetzt und nicht komponiert habe; Brahms selbst bezeichnete sie als »echte Pußta- und Zigeunerkinder. Also nicht von mir gezeugt, sondern nur mit Milch und Brot aufgezogen.«[1] In der einzigen Originalaufnahme mit Brahms als Pianist, aufgezeichnet auf einem Wachszylinder im Dezember 1889, spielt er einen Teil des *Ungarischen Tanzes Nr. 1*.

1. *Brahms Briefwechsel IX*, S. 61.

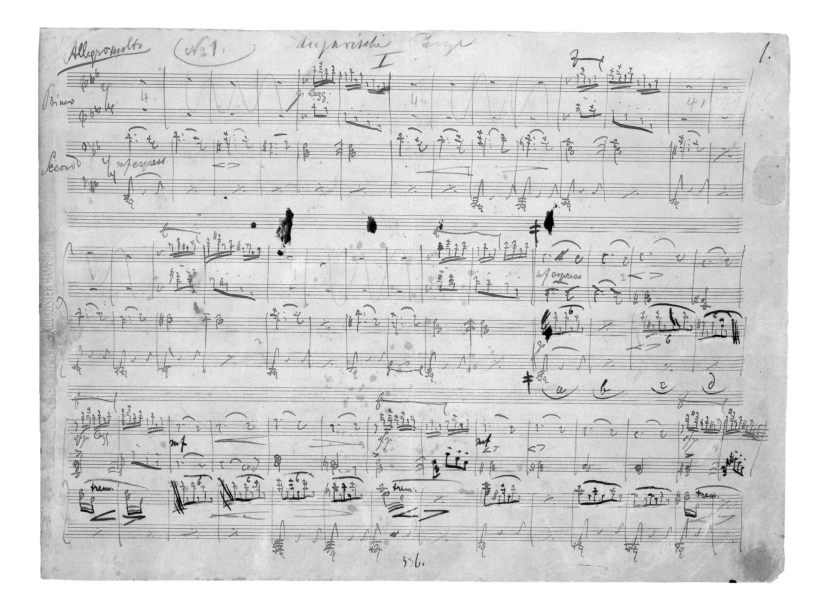

HENRI DUPARC
(Paris 1848–1933 Mont-de-Marsan)

L'INVITATION AU VOYAGE

Autograph manuscript [1870]
350 x 265 mm

The Mary Flagler Cary Music
Collection; Cary 434

L'INVITATION AU VOYAGE

Autograph [1870]
350 x 265 mm

The Mary Flagler Cary Music
Collection; Cary 434

The fame of few composers rests on so small a body of works as Duparc's, whose completed and acknowledged artistic legacy comprises just thirteen songs composed between 1868 and 1885.[1] Neurasthenic and beset by assorted maladies, he lived on, blind and eventually paralyzed, until 1933. The most famous of the songs, his setting of *L'Invitation au voyage* from Baudelaire's *Fleurs du mal*, was composed during the siege of Paris in October 1870. The tranquility and repose of this piece—especially in the celebrated refrain "Là, tout n'est qu'ordre et beauté / Luxe, calme et volupté"—belie the adverse physical and social conditions under which it was written. The memory of these circumstances remained unblurred forty years later: "You cannot imagine all that is evoked for me by the few pages of this short *Invitation au voyage*, which was written during the siege," he wrote to a friend in 1910.[2] This manuscript is inscribed to the soprano Georgette Leblanc, the mistress of Maurice Maeterlinck, who wanted her to create the role of Mélisande in Debussy's *Pelléas et Mélisande;* Debussy insisted on (and got) Mary Garden for the part.

1. *The New Grove* 1980, vol. 5, p. 726.
2. "Vouz n'avez pas idée de tout ce qu'évoquent pour moi les trois ou quatre pages de cette petite *Invitation au voyage*, écrite pendant le siège." Stricker 1996, p. 49.

Es gibt nur wenige Komponisten, deren Ruhm auf einem so schmalen Œuvre beruht, wie dies bei Henri Duparc der Fall ist, dessen vollständiges und anerkanntes künstlerisches Vermächtnis lediglich 13, zwischen 1868 und 1885 komponierte Lieder umfaßt.[1] An Neurasthenie leidend und von den verschiedenen Krankheiten heimgesucht, lebte er, blind und zuletzt völlig gelähmt, bis 1933. Sein berühmtestes Lied, das er während der Belagerung von Paris im Oktober 1870 komponierte, ist eine Vertonung von *L'Invitation au voyage* aus Baudelaires *Fleurs du mal*. Die friedliche Stille und Gelassenheit dieses Stückes – sinnfällig im berühmten Refrain »Là, tout n'est qu'ordre et beauté / Luxe, calme et volupté« – steht in schroffem Widerspruch zu den physischen und sozialen Umständen, unter denen es geschrieben wurde. Die Erinnerung an diese äußeren Gegebenheiten blieb auch noch nach 40 Jahren lebendig. So äußerte sich Duparc 1910 einem Freund gegenüber: »Sie haben keine Vorstellung davon, welche Gefühle die wenigen Seiten dieser kurzen *Invitation au voyage*, die während der Belagerung komponiert wurden, in mir wachrufen.«[2] Das Manuskript ist der Sopranistin Georgette Leblanc zugeeignet, der Geliebten von Maurice Maeterlinck, der ihr die Rolle der Mélisande in Debussys *Pelléas et Mélisande* geben wollte; Debussy bestand dagegen erfolgreich auf Mary Garden.

1. *The New Grove* 1980, Bd. 5, S. 726.
2. Stricker 1996, S. 49.

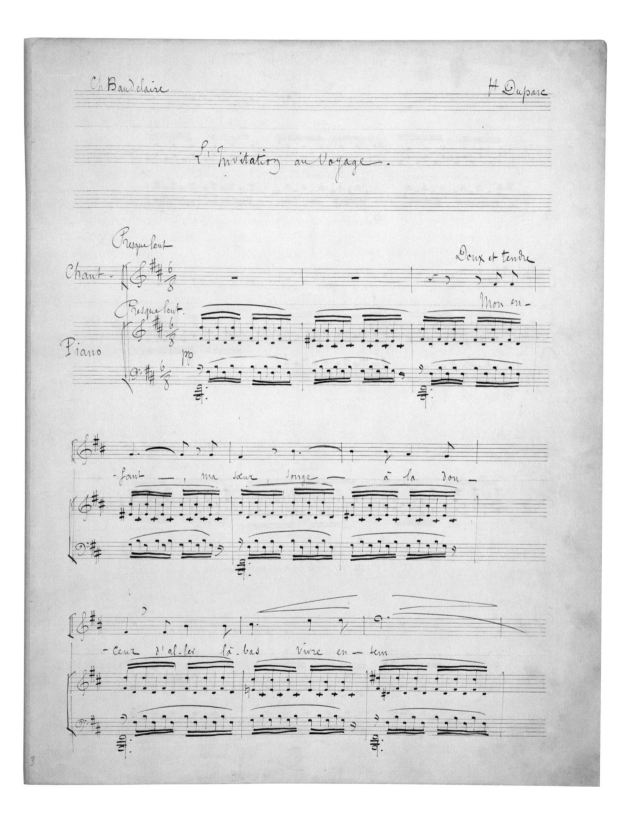

GIUSEPPE VERDI

(Le Roncole, near Busseto, 1813–1901 Milan)

AIDA. OPERA IN QUATTRO
ATTI, VERSI DI ANTONIO
GHISLANZONI

Milan: Ricordi [ca. 1871–72]

First edition of the libretto for the first
performance in Italy, with Verdi's
autograph notes, corrections, additions,
and stage directions
8°

The Mary Flagler Cary Music
Collection; PMC 95

AIDA. OPERA IN QUATTRO
ATTI, VERSI DI ANTONIO
GHISLANZONI

Mailand: Ricordi [circa 1871–72]

Erstausgabe des Librettos für die
Erstaufführung in Italien, mit Verdis
handschriftlichen Anmerkungen,
Korrekturen, Ergänzungen und
Bühnenanweisungen
8°

The Mary Flagler Cary Music
Collection; PMC 95

The premiere of *Aida* (which Verdi did not attend), in Cairo on 24 December 1871, was by all accounts a great success. The second performance (and the first in Italy) took place seven weeks later, on 8 February 1872 at La Scala, Milan. Verdi, as usual, oversaw all aspects of the production, including the mise-en-scène, or staging. He then went to Parma, where he supervised a production on 20 April, for which he annotated this libretto, sketching out his staging for the first three acts and specifying in detail the singers' placement, movements, and even gestures. The Verdi scholar Julian Budden suggests that these instructions were probably first jotted down during rehearsals for the La Scala production and merely served the composer as an aide-mémoire for the Parma performance. The day after this performance Verdi wrote to his friend Cesare De Sanctis: "Last night, *Aida* excellent. Good mise-en-scène, good orchestra, very good chorus. In other words, a rare success. So *amen*."[1]

1. Busch 1978, p. 297.

Die Uraufführung der *Aida* am 24. Dezember 1871 in Kairo (bei der Verdi nicht zugegen war) war ein grandioser Erfolg. Ihre zweite Aufführung – die erste in Italien – fand sieben Wochen später, am 8. Februar 1872, an der Mailänder Scala statt. Verdi überwachte wie gewöhnlich die gesamte Produktion, einschließlich der Inszenierung. Anschließend ging er nach Parma, um dort die Inszenierung der Aufführung am 20. April zu übernehmen. Er versah das vorliegende Libretto aus diesem Anlaß mit Annotationen, die seinen Bühnenbildentwurf für die ersten drei Aufzüge sowie genaueste Instruktionen zur Aufstellung, zu den Bewegungen und sogar zu einzelnen Gesten der Sänger enthalten. Der Verdi-Experte Julian Budden vermutet, daß diese Anweisungen während der Proben für die Aufführung an der Scala notiert wurden und dem Komponisten nurmehr als Gedächtnisstütze für die Produktion in Parma dienten. Am Tag nach dieser Aufführung schrieb Verdi an seinen Freund Cesare De Sanctis: »Gestern abend, *Aida* vorzüglich. Gute Inszenierung, gutes Orchester, ausgezeichneter Chor. Mit anderen Worten, ein außergewöhnlicher Erfolg. Somit *Amen*.«[1]

1. Busch 1978, S. 297.

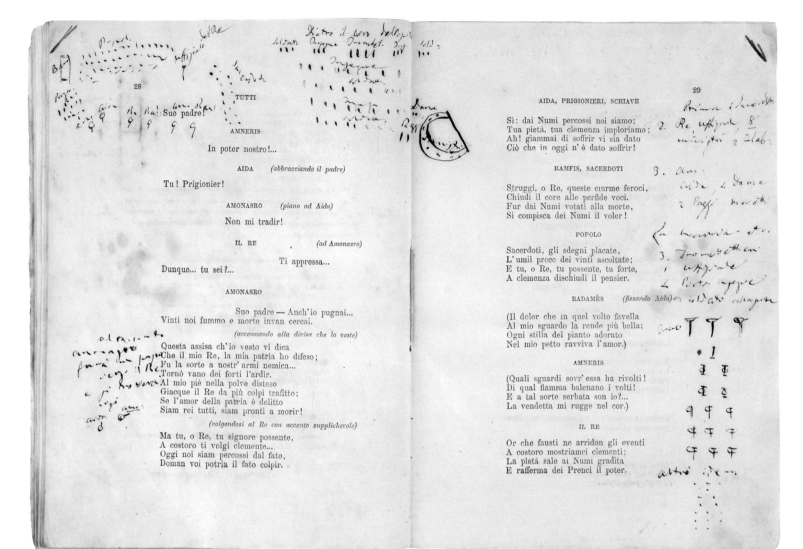

28

TUTTI

Suo padre!

AMNERIS

In poter nostro!...

AIDA *(abbracciando il padre)*

Tu! Prigionier!

AMONASRO *(piano ad Aida)*

Non mi tradir!

IL RE *(ad Amonasro)*

Ti appressa...

Dunque... tu sei?...

AMONASRO

Suo padre — Anch'io pugnai...
Vinti noi fummo e morte invan cercai.

(accennando alla divisa che lo veste)

Questa assisa ch'io vesto vi dica
Che il mio Re, la mia patria ho difeso;
Fu la sorte a nostr' armi nemica...
Tornò vano dei forti l'ardir.
Al mio piè nella polve disteso
Giacque il Re da più colpi trafitto;
Se l'amor della patria è delitto
Siam rei tutti, siam pronti a morir!

(volgendosi al Re con accento supplichevole)

Ma tu, o Re, tu signore possente,
A costoro ti volgi clemente...
Oggi noi siam percossi dal fato,
Doman voi potria il fato colpir.

29

AIDA, PRIGIONIERI, SCHIAVE

Si: dai Numi percossi noi siamo;
Tua pietà, tua clemenza imploriamo;
Ah! giammai di soffrir vi sia dato
Ciò che in oggi n' è dato soffrir!

RAMFIS, SACERDOTI

Struggi, o Re, queste ciurme feroci,
Chiudi il core alle perfide voci.
Fur dai Numi votati alla morte,
Si compisca dei Numi il voler!

POPOLO

Sacerdoti, gli sdegni placate,
L'umil prece dei vinti ascoltate;
E tu, o Re, tu possente, tu forte,
A clemenza dischiudi il pensier.

RADAMÈS *(fissando Aida)*

(Il dolor che in quel volto favella
Al mio sguardo la rende più bella
Ogni stilla del pianto adorato
Nel mio petto ravviva l'amor.)

AMNERIS

(Quali sguardi sovr' essa ha rivolti!
Di qual fiamma balenano i volti!
E a tal sorte serbata son io?...
La vendetta mi rugge nel cor.)

IL RE

Or che fausti ne arridon gli eventi
A costoro mostriamci clementi;
La pietà sale ai Numi gradita
E rafferma dei Prenci il poter.

JOHANNES BRAHMS

(Hamburg 1833–1897 Vienna)

79

O WÜSST ICH DOCH DEN WEG
ZURÜCK, OP. 63, NO. 8

Autograph manuscript (1874)
255 x 325 mm

The Mary Flagler Cary Music
Collection; Cary 71

O WÜSST ICH DOCH DEN WEG
ZURÜCK, OP. 63, NR. 8

Autograph (1874)
255 x 325 mm

The Mary Flagler Cary Music
Collection; Cary 71

The last three of the nine *Lieder und Gesänge* op. 63 are settings of texts by Klaus Groth. Brahms asked Groth to suggest a general title, or heading, for the three poems; Groth replied that "Heimweh" and "Sehnsucht" and the like were overused, constructions such as "Kinderglück" and "Mannessehnen" were too contrived, and suggested "Aus dem Kinderparadies." The songs were published as *Heimweh I, II,* and *III. Heimweh II* (also known as *O wüßt ich doch den Weg zurück*) was composed in the summer of 1874 in Rüschlikon, near Zurich, and was published later that year. The poet laments his isolation on life's barren shores and, forswearing his futile pursuit of happiness, seeks instead the sweet way back to the land of childhood. Groth found Brahms's settings extremely beautiful, especially *O wüßt ich doch.* But Brahms expressed regret that his song did not do the poem justice and told Groth that he had failed utterly to render in music the deep expression of the text.

Provenance
George Henschel; Edward Speyer; Frank Black; Mary Flagler Cary.

Die letzten drei der neun *Lieder und Gesänge* op. 63 sind Vertonungen von Texten Klaus Groths. Brahms hatte Groth um einen Vorschlag für einen Gesamttitel beziehungsweise eine Überschrift für die drei Gedichte gebeten. Groth erwiderte, daß »Heimweh«, »Sehnsucht« und ähnliches allzu abgenutzt und Wortbildungen wie »Kinderglück« oder »Mannessehnen« zu gekünstelt seien, und schlug daher den Titel »Aus dem Kinderparadies« vor. Veröffentlicht wurden die Lieder als *Heimweh I, II und III. Heimweh II,* auch bekannt als *O wüßt ich doch den Weg zurück,* entstand im Sommer 1874 in Rüschlikon in der Nähe von Zürich und wurde gegen Ende desselben Jahres veröffentlicht. Der Dichter beklagt seine Einsamkeit am öden Gestade des Lebens und sucht – seinem vergeblichen Streben nach Glück abschwörend – statt dessen den lieben Weg zum Kinderland. Groth fand die Brahmsschen Vertonungen überaus schön, besonders *O wüßt ich doch.* Trotzdem gab Brahms seinem Bedauern darüber Ausdruck, daß sein Lied dem zugrundeliegenden Gedicht nicht gerecht werde und daß es ihm völlig mißlungen sei, den tiefempfundenen Ausdruck des Textes musikalisch wiederzugeben.

JOHANNES BRAHMS
(Hamburg 1833–1897 Vienna)

80

SYMPHONY NO. 1 IN C MINOR, OP. 68

Autograph manuscript, lacking the first movement (1876)
240 x 315 mm

The Mary Flagler Cary Music Collection; Cary 27

SINFONIE NR. 1 IN C-MOLL, OP. 68

Autograph, ohne den ersten Satz (1876)
240 x 315 mm

The Mary Flagler Cary Music Collection; Cary 27

Brahms had already composed several large orchestral works, including the First Piano Concerto, the two Serenades, the Haydn Variations, and the *German Requiem,* before he felt ready, at the age of forty-three, to release his First Symphony. The pressure to write a symphony—a genre held in the highest regard by adherents to the classical tradition—was daunting; in the early 1870s, Brahms told his friend Hermann Levi, "I will never compose a symphony! You have no idea how much courage one must have when one hears marching behind him such a giant [as Beethoven]."[1] (He is also quoted as saying that "after Haydn, writing a symphony is no longer a joke but rather a matter of life and death."[2]) Brahms began work on the First Symphony in 1862; he sent a manuscript of the first movement (without the slow introduction) to Clara Schumann in June of that year and in 1868 sent her an album leaf with the expansive Alpine horn theme from the last movement. He resumed work on the symphony in 1874, adding the slow introduction and the last three movements, and completed it in 1876. At the first performance, on 4 November in Karlsruhe, Otto Dessoff conducted from this manuscript. The autograph of the first movement does not survive.

Provenance
N. Simrock, Berlin; Paul Gottschalk, New York; Charles Sessler, Philadelphia; Hilda Emery Davis (Mrs. Meyer Davis); Mary Flagler Cary.

1. Kalbeck 1912–21; repr. Tutzing 1976, vol. 1, p. 165.
2. Crass 1957, p. 36.

Brahms hatte bereits mehrere Orchesterwerke komponiert, darunter das Klavierkonzert Nr. 1, die beiden Serenaden, die Haydn-Variationen und *Ein deutsches Requiem,* ehe er sich im Alter von 43 Jahren bereit fühlte, seine 1. Sinfonie der Öffentlichkeit vorzustellen. Der auf ihm lastende Druck, eine Sinfonie – das unter den Anhängern der klassischen Tradition am höchsten geschätzte Genre – zu komponieren, hatte ihn entmutigt. In den frühen 1870er Jahren schrieb er seinem Freund Hermann Levi: »Ich werde nie eine Symphonie komponieren! Du hast keinen Begriff davon, wie es unsereinem zu Mute ist, wenn er immer so einen Riesen [Beethoven] hinter sich marschieren hört!«[1] Eine weitere Äußerung von Brahms lautete: »Die Symphonie ist seit Haydn kein bloßer Spaß mehr, sondern eine Angelegenheit auf Leben und Tod.«[2] Brahms begann 1862 mit der Arbeit an der 1. Sinfonie; er schickte ein Manuskript des ersten Satzes (ohne die langsame Einleitung) im Juni desselben Jahres an Clara Schumann. 1868 übersandte er ihr ein Albumblatt mit dem ausgedehnten Alphornthema des letzten Satzes. 1874 nahm er die Arbeit an der Sinfonie erneut auf, fügte die langsame Einleitung sowie die drei letzten Sätze hinzu und vollendete sie im Jahr 1876. Bei ihrer Uraufführung am 4. November desselben Jahres in Karlsruhe dirigierte Otto Dessoff die Sinfonie nach dieser Partitur. Das Autograph des ersten Satzes ist nicht erhalten.

1. Kalbeck 1912–21; repr. Tutzing 1976, Bd. 1, S. 165.
2. Crass 1957, S. 36.

212

JULES MASSENET
(Montaud, St-Etienne, 1842–1912 Paris)

MANON

Autograph manuscript of the
piano-vocal score (1882)
350 x 270 mm

The Mary Flagler Cary Music
Collection; Cary 64

MANON

Autograph des Klavierauszugs (1882)
350 x 270 mm

The Mary Flagler Cary Music
Collection; Cary 64

The premiere of *Manon,* with a libretto by Henri Meilhac and Philippe Gille, took place on 19 January 1884 at the Opéra-Comique in Paris. Reviews were mixed, but the opera was a popular triumph and has remained one of the most widely performed French operas. Massenet lived to hear of the 740th performance of his most successful work. (Between 1900 and 1950, only *Carmen* was performed more often at the Opéra-Comique.) The second act contains one of the best-known passages in the opera, Des Grieux's "En fermant les yeux"—the first page of which is reproduced here. It tells of his dream of a white cottage deep in a forest: tranquil shade, birds singing—paradise. But no, it is desolate because Manon is not there. It's only a dream, Manon says; no, Des Grieux replies, it will be our life if you want it. This brief passage—twenty-three measures—is of the utmost melodic and harmonic simplicity, but it epitomizes Massenet's undeniable gift for capturing a memory, a reverie, or a fleeting emotion with music that at once fixes the sensation in its dramatic moment and lingers long after the event.

Provenance
Mary Flagler Cary.

Die Uraufführung der *Manon* mit dem Libretto von Henri Meilhac und Philippe Gille fand am 19. Januar 1884 an der Opéra-Comique in Paris statt. Die Rezensionen waren gemischt, doch die Oper selbst war ein großer Publikumserfolg und ist bis heute eine der am häufigsten gegebenen französischen Opern geblieben. Massenet erlebte noch die 740. Aufführung seines erfolgreichsten Werkes. (Zwischen 1900 und 1950 wurde lediglich *Carmen* häufiger an der Opéra-Comique gespielt.) Im zweiten Akt findet sich eine der bekanntesten Partien der Oper, Des Grieux' Arie »En fermant les yeux«, deren erste Seite hier gezeigt wird. Sie erzählt von seinem Traum eines weißen Bauernhäuschens im tiefen Wald: friedvoller Schatten, Vogelgesang – ein Paradies. Doch nein, es ist einsam und verlassen, da Manon nicht dort ist. Dies sei nur ein Traum, antwortet Manon. »Keineswegs«, erwidert Des Grieux, »es wird unser gemeinsames Leben sein, wenn du es nur willst.« Diese kurze, 23 Takte umfassende Partie ist von äußerster melodischer und harmonischer Schlichtheit, doch ist sie ein gutes Beispiel für Massenets unbestrittene Begabung, eine Erinnerung, eine Träumerei oder ein flüchtiges Gefühl im Moment der größten dramatischen Intensität musikalisch einzufangen und noch lange nach dem Ereignis nachklingen zu lassen.

Andante très calme

Desprieux (à Manon)
(avec intimité)

En fermant les yeux je vois là bas ... une humble re-

- trai - te Une maison - nette Toute blanche au fond des bois!

Sous les tranquil - les om - bra - ges Les clairs et joyeux ruisseaux

où se mirent les feuil - la - ges chantent avec les oiseaux!

GABRIEL FAURE

(Pamiers, Ariège, 1845 – 1924 Paris)

PAVANE

Autograph manuscript of the full score
[1887]
350 x 265 mm

The Mary Flagler Cary Music
Collection; Cary 260

PAVANE

Partiturautograph [1887]
350 x 265 mm

The Mary Flagler Cary Music
Collection; Cary 260

Fauré's *Pavane,* composed in 1887, was origi-
nally written for orchestra and is among the
works by which the composer is best known
today. The chorus parts, with a text by Count
Robert de Montesquiou, were added later at
the suggestion of Elisabeth de Charaman
Chimay, Countess Greffulhe, to whom the work
is dedicated. (Montesquiou and his cousin
Greffulhe were the models for the Baron de
Charlus and the Duchesse de Guermantes in
A la recherche du temps perdu; Fauré himself
appears in Proust's novel.) In 1887 Fauré
wrote to the Countess Greffulhe that Montes-
quiou had accepted the thankless task of writ-
ing words for already completed music and
"has given it a delightful text: sly coquetries by
the female dancers and great sighs by the male
dancers will singularly enhance the music. If
the whole marvelous thing with a lovely dance
in fine costumes and an invisible orchestra and
chorus could be performed, what a treat it
would be!"[1] In 1917, with choreography by
Léonide Massine, the *Pavane* entered the
repertory of Diaghilev's Ballets Russes as *Las
Meninas.*

Provenance
Alexandrine de Rothschild.

1. "Il y a ajouté un ravissant verbiage: sournoiseries et
coquetteries des danseuses, et grands soupirs des
danseurs qui animeront singulièrement la musique. Si
tout ce merveilleux ensemble d'une jolie danse, avec de
beaux costumes, un orchestre et un chœur invisibles,
pouvait se réaliser quel régal ce serait!" Nectoux 1980,
p. 132; English translation, Nectoux 1984, p. 131.

Faurés 1887 komponierte *Pavane,* ursprüng-
lich für Orchester geschrieben, zählt heute zu
den bekanntesten Werken des Komponisten.
Die Chorstimmen auf einen Text von Graf
Robert de Montesquiou wurden erst später auf
Anregung von Elisabeth de Charaman Chimay,
Comtesse Greffulhe, hinzugefügt, der das
Werk auch gewidmet ist. (Montesquiou und
seine Cousine Greffulhe dienten als Vorbild für
den Baron de Charlus und die Duchesse de
Guermantes in *A la recherche du temps perdu;*
Fauré selbst tritt ebenfalls in Marcel Prousts
Roman in Erscheinung.) 1887 teilte Fauré in
einem Schreiben an Comtesse Greffulhe mit,
daß Montesquiou sich bereit erklärt habe, die
undankbare Aufgabe zu übernehmen, bereits
existierende Musik mit Worten zu unterlegen:
»er hat einen entzückenden Text dazu erson-
nen: listige Koketterien der Tänzerinnen und
tiefe Seufzer der Tänzer werden auf einzig-
artige Weise die Musik beleben. Wenn dieses
wunderbare Zusammenspiel mit einem lieb-
lichen Tanz in hübschen Kostümen und einem
unsichtbaren Orchester und Chor aufgeführt
werden könnte – welch ein Vergnügen könnte
dies sein!«[1] Im Jahr 1917 nahmen Sergej Dia-
ghilews Ballets Russes die *Pavane* in einer Cho-
reographie von Léonide Massine unter dem
Titel *Las Meninas* in ihr Repertoire auf.

1. Nectoux 1980, S. 132.

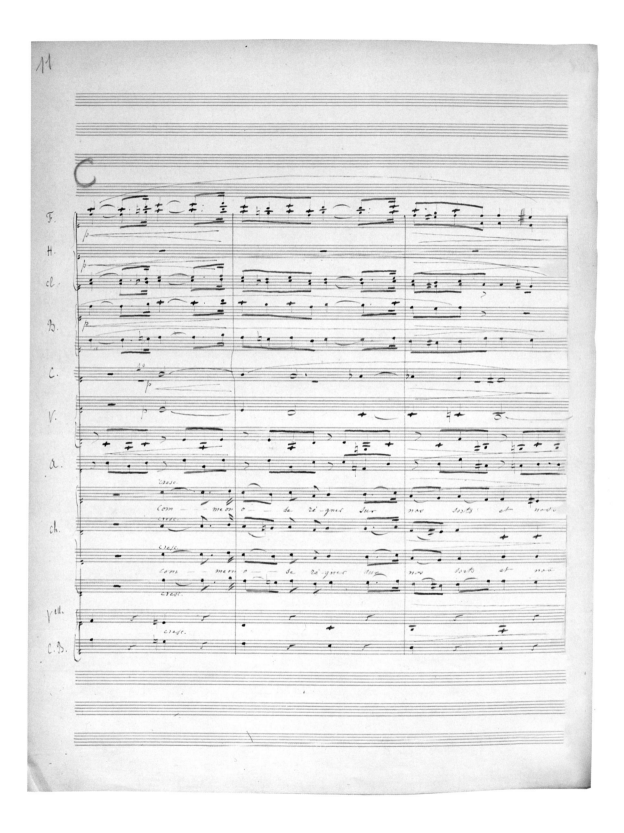

HUGO WOLF
(Windisch-Graez, Styria, 1860–1903 Vienna)

KARWOCHE

Autograph manuscript [1888]
340 x 265 mm

The Mary Flagler Cary Music
Collection; Cary 195

KARWOCHE

Autograph [1888]
340 x 265 mm

The Mary Flagler Cary Music
Collection; Cary 195

Schubert's *Erlkönig* (No. 59; 1816?) and Schumann's *Frauenliebe und -leben* (No. 69; 1840) are songs that date from extraordinarily fruitful years in the lives of their composers. A third master of the German lied, Hugo Wolf, also experienced an *annus mirabilis* of songwriting. In 1888 he composed no fewer than fifty-three songs, all to texts by Eduard Mörike, and all but one written in two periods of exuberant activity: mid-February to mid-May and 4–11 October. In Wolf's letter of 8 October 1888 to his friend and confidant Friedrich Eckstein we get a hint of the euphoric intensity and pace of the composer's work:

> Yes, dear Ecksteinderl, I have in recent days once again industriously "Möriked" *["gemörikelt"]* and, what is more, nothing but poems that you especially adore: *An den Schlaf, Neue Liebe* (both on 4 October), *Zum neuen Jahre* (5 October), *Schlafendes Jesuskind, Wo find ich Trost?* (both on 6 October). Just now I am working on *Karwoche,* which will be magnificent beyond all bounds. All the songs are truly shatteringly composed. Often enough the tears rolled down my cheeks as I wrote. They surpass in depth of conception all the other settings of Mörike.[1]

Provenance
Mary Flagler Cary.

1. Walker 1968, p. 212.

Schuberts *Erlkönig* (Kat.-Nr. 59; 1816?) und Schumanns *Frauenliebe und -leben* (Kat.-Nr. 69; 1840) sind Lieder aus äußerst produktiven Schaffensperioden im Leben beider Komponisten. Auch der dritte Meister des deutschen Liedes, Hugo Wolf, erlebte ein *annus mirabilis* der Liedkomposition. Allein 1888 komponierte er nicht weniger als 53 Lieder – ausschließlich Vertonungen von Gedichten Eduard Mörikes –, die mit einer Ausnahme alle innerhalb zweier überschwenglich schöpferischer Phasen von Mitte Februar bis Mitte Mai und vom 4. bis zum 11. Oktober entstanden. In Wolfs Brief vom 8. Oktober 1888 an seinen Freund und Vertrauten Friedrich Eckstein finden wir einen Hinweis auf die euphorische Intensität und Geschwindigkeit, mit der der Komponist ans Werk ging:

> Ja, liebes Ecksteinderl! Ich habe in den letzten Tagen wieder fleißig »gemörikelt«, u. z. lauter Gedichte, die Sie besonders adoriren. »An den Schlaf«, »Neue Liebe« (beide am 4. Oktb.), »Zum neuen Jahr« (5. Oktb.), »Schlafendes Jesuskind«, »Wo find ich Trost?« (beide am 6. Oktb.). Jetzt arbeite ich gerade an der »Charwoche«, die über die Maßen herrlich wird. Alle Lieder sind wahrhaft erschütternd componiert. Mir sind oft genug dabei die Thränen über die Wangen gerollt. Sie überragen an Tiefe der Auffassung alle Übrigen von Mörike.[1]

1. Schmalzriedt 1984, S. 43.

Charwoche.

Langsam.

O Wo-che, Zeu-gin heiliger Beschwerde! du stimmst so ernst zu die-ser Frühlingswonne, Du brei-test im ver-jüngten Strahl der Sonne des Kreuzes Schat-ten auf die lich-te Er-de, und sen-kest schwei-gend deine Flore nieder; der Früh-

RICHARD STRAUSS
(Munich 1864–1949 Garmisch-Partenkirchen, Bavaria)

84

DON JUAN

Autograph manuscript [1888]
355 x 260 mm

The Mary Flagler Cary Music
Collection; Cary 190

DON JUAN

Autograph [1888]
355 x 260 mm

The Mary Flagler Cary Music
Collection; Cary 190

Don Juan, inspired by a fragmentary verse play by Nikolaus Lenau, was Strauss's first major symphonic success, and the premiere, on 11 November 1889 in Weimar, established the twenty-four-year-old as Germany's most important composer since Wagner. There were few precedents in the repertory of the symphonic poem—Strauss called his works in the genre tone poems—for the grand sweep of this work: from the blazing E major of the opening to the final bars fading away in E minor, we follow the don from the fiery passion of youth to weary resignation. Strauss would, it is argued, later equal but rarely surpass the dramatic vitality of this early masterpiece. *Don Juan* also displays an orchestral virtuosity that made unprecedented demands on the players. After the first rehearsal with the whole orchestra, Strauss wrote to his father: "The orchestra wheezed and panted but did their part splendidly. . . . After 'Don Juan,' one of the horn players sat there dripping with sweat, completely out of breath, and sighed, 'Dear God! How have we sinned that You should have sent us this scourge!' . . . The horns in particular played without fear of death."[1]

Provenance
Mary Flagler Cary.

1. Schuh 1982, p. 184; Del Mar 1969, vol. 1, p. 76.

Don Juan, angeregt durch ein fragmentarisches Versdrama von Nikolaus Lenau, war der erste große sinfonische Erfolg von Richard Strauss. Die Premiere am 11. November 1889 in Weimar machte den 24jährigen zum bedeutendsten deutschen Komponisten seit Wagner. Es gab im Repertoire der sinfonischen Dichtung – Strauss nannte seine dieser Gattung zugehörigen Werke Tondichtungen – kaum Vorläufer, die seinem großen kompositorischen Gestus entsprochen hätten: Zwischen der flammenden E-Dur-Eröffnung und den in e-moll ausklingenden Schlußtakten begleiten wir Don Juan von der feurigen Leidenschaft seiner Jugend bis zu seiner resignativen Ermattung. Diese dramatische Vitalität seines frühen Meisterwerkes sollte Strauss, wie oft gesagt wird, später zwar erneut erreichen, jedoch nie übertreffen. *Don Juan* entfaltet zudem eine orchestrale Virtuosität, die noch nie dagewesene Ansprüche an das Ensemble stellt. Nach der ersten Gesamtprobe schrieb Strauss an seinen Vater: »Das Orchester pustete und keuchte, machte aber seine Sache famos. ... Nach dem ›Don Juan‹ saß ein Hornist schweißtriefend, ganz außer Atem da und seufzte: ›Du lieber Gott! Was haben wir denn verbrochen, daß du uns diese Rute (das bin ich) geschickt hast! ...‹ Dabei haben gerade die Hornisten mit Todesverachtung geblasen!«[1]

1. Schuh 1976, S. 190.

CLAUDE DEBUSSY

(St-Germain-en-Laye 1862–1918 Paris)

85

LA DAMOISELLE ÉLUE

Autograph manuscript of the short
score (1893)
345 x 260 mm

The Mary Flagler Cary Music
Collection; Cary 277

LA DAMOISELLE ÉLUE

Autograph des Particells (1893)
345 x 260 mm

The Mary Flagler Cary Music
Collection; Cary 277

The text of Debussy's *poème lyrique* for two sopranos, female chorus, and orchestra, is a French translation of *The Blessed Damozel* by Dante Gabriel Rossetti. It was composed in 1887 and 1888; in 1892 Debussy described it to a friend as "a little oratorio in a mystic, slightly pagan vein."[1] Having won the coveted Prix de Rome in 1884, Debussy was obliged to submit four works to the Académie des Beaux-Arts; their judgment of the third work, *La Damoiselle élue,* was not favorable: "The music . . . is not devoid of imagination or charm, but it still shows tendencies, popular at the moment, toward relying on expressive and formal systems."[2] The work was not publicly performed until 1893, the date of this manuscript. Debussy revised the orchestration in 1902; in 1904 *La Damoiselle élue* was given its first (and only) stage performance at the Opéra-Comique with Mary Garden as the title character. In 1902 Garden had created the eponymous heroine of Debussy's opera *Pélleas et Mélisande.*

Provenance
Edmond Bailly; Robert Owen Lehman.

1. "Une petit oratorio dans une note mystique et un peu païenne." Lesure and Nichols 1987, p. 38; English translation, Lesure 1993, p. 68.
2. "La musique . . . n'est dénuée ni de poésie ni de charme, quoiqu'elle se ressente encore de ces tendances systématiques en vogue dans l'expression et dans les formes." Ibid., p. 57; ibid., p. 26.

Als Text zu Debussys *Poème lyrique* für zwei Sopranstimmen, Frauenchor und Orchester diente die französische Übersetzung von Dante Gabriel Rossettis Gedicht *The Blessed Damozel.* Der Kompositionszeitraum fällt in die Jahre 1887 und 1888; Debussy beschrieb das *Poème* 1892 gegenüber einem Freund als »ein mystisch gehaltenes kleines Oratorium mit einem Hauch von Heidentum«.[1] Nach der Verleihung des begehrten Prix de Rome im Jahr 1884 war Debussy verpflichtet, der Académie des Beaux-Arts vier Werke vorzulegen; die Beurteilung der dritten Komposition, *La Damoiselle élue,* war alles andere als wohlwollend: »Der Musik … ermangelt es keineswegs an Poesie oder Anmut, sie leidet jedoch noch immer an der zur Zeit modischen Neigung zum Systematischen in Ausdruck und Formgebung.«[2] Das Werk wurde vor 1893, dem Entstehungsjahr des Autographs, nicht öffentlich aufgeführt. Debussy überarbeitete die Orchestrierung 1902; 1904 gelangte *La Damoiselle élue* zum ersten (und einzigen) Mal auf die Bühne der Opéra-Comique mit Mary Garden in der Titelrolle. 1902 hatte Garden die eponymische Heldin Mélisande in der Uraufführung von Debussys Oper *Pelléas et Mélisande* gesungen.

1. Lesure 1993, S. 68.
2. Ebenda, S. 57.

GIACOMO PUCCINI

(Lucca 1858–1924 Brussels)

86

La Bohème

Sketches for Act IV (1895)
415 x 315 mm

The Dannie and Hettie Heineman
Collection; Heineman MS 173B

La Bohème

Skizzen zu Akt IV (1895)
415 x 315 mm

The Dannie and Hettie Heineman
Collection; Heineman MS 173B

The first performance of *La Bohème* was not, as might be expected, at Milan's prestigious Teatro alla Scala. The theater was under the management of the publisher Edoardo Sonzogno, whose policy was to exclude from the repertory scores published by his rival, Ricordi. (Except for *La rondine,* all of Puccini's operas were published by Ricordi.) *La Bohème* opened at the Teatro Regio, in Turin, on 1 February 1896. The public response was mixed, and the critics were nearly unanimously hostile; most judged it weaker than *Manon Lescaut,* which had opened in the same theater exactly three years earlier. But Debussy, who generally held the contemporary Italian school in low esteem, reportedly said, "I know of no one who has described the Paris of that time as well as Puccini in *La Bohème."* This sketch ends with "Vecchia zimarra," the arietta in which Colline bids farewell to his overcoat, which he intends to pawn so as to help the dying Mimì. Puccini signed the sketch, added a self-caricature, and dated it Torre del Lago, 12 December 1895.

Provenance
Dannie and Hettie Heineman.

Die Uraufführung von *La Bohème* fand nicht, wie vielleicht zu vermuten wäre, im berühmten Teatro alla Scala in Mailand statt. Der Verleger Edoardo Sonzogno, der das Theater leitete, verfolgte die Politik, keine Stücke mit Partituren aus dem Verlag seines Konkurrenten Ricordi in sein Repertoire aufzunehmen. (Mit Ausnahme von *La rondine* wurden alle Opern Puccinis bei Ricordi veröffentlicht.) Die Uraufführung von *La Bohème* fand am 1. Februar 1896 im Teatro Regio in Turin statt. Die Reaktionen des Publikums waren gemischt, und die Kritiker urteilten nahezu einstimmig ablehnend. Die Mehrzahl hielt die Oper für weit weniger gelungen als *Manon Lescaut,* die im selben Theater drei Jahre zuvor ihre Premiere gehabt hatte. Debussy jedoch, der allgemein wenig von der zeitgenössischen italienischen Schule hielt, soll bemerkt haben: »Ich kenne niemanden, der ein so treffendes Bild vom Paris jener Zeit gezeichnet hat wie Puccini in *La Bohème.*« Die vorliegende Kompositionsskizze endet mit »Vecchia zimarra«, der Arietta, in der Colline sich von seinem Überzieher verabschiedet, den er beim Pfandleiher versetzen will, um der sterbenden Mimì zu helfen. Puccini signierte den Entwurf, fügte eine Selbstkarikatur bei und datierte ihn mit Torre del Lago, den 12. Dezember 1895.

RICHARD STRAUSS

(Munich 1864–1949 Garmisch-Partenkirchen, Bavaria)

87

MORGEN!, OP. 27, NO. 4

Autograph manuscript of Strauss's
orchestration of the song (1897)
345 x 270 mm

The Mary Flagler Cary Music
Collection; Cary 515

MORGEN!, OP. 27, NR. 4

Autograph von Strauss'
Orchestrierung des Liedes (1897)
345 x 270 mm

The Mary Flagler Cary Music
Collection; Cary 515

Morgen! has justly been called one of Strauss's finest songs. Both the text, by John Henry Mackay, and the music display a concision of expression possible only from artists who are masters of their craft, and the work has an ethereal, timeless beauty found in the greatest songs. Mackay, a Scottish-born poet and novelist who spent most of his life in Germany, was best known at this time for his advocacy of individualist anarchism. (Mackay was also homosexual, although is highly unlikely that Strauss knew that his poetry was inspired by his love of young boys.) Strauss composed the four songs of op. 27 in 1894 for voice and piano and gave them to his wife, the soprano Pauline de Ahna, on their wedding day. She was by all accounts, including the composer's, one of the outstanding interpreters of his songs. "She performed my songs with more expression and lyricism than I have ever heard since," Strauss once said. "No one came close to singing 'Morgen!' . . . as she did."[1] Strauss's instrumentation calls for an orchestra of harp, three horns, solo violin, and strings. One of the first of his songs that Strauss orchestrated, *Morgen!* in its refined simplicity is a paradigm of the art.

Provenance
Robert Owen Lehman.

1. Trenner 1954, p. 53.

Morgen! gilt zu Recht als eines der schönsten Lieder von Strauss. Sowohl der Text von John Henry Mackay als auch die Musik zeigen eine Prägnanz im Ausdruck, wie sie nur Künstler, die Meister ihres Faches sind, erreichen, und so ist dem Werk die ätherische, zeitlose Schönheit der bedeutendsten Lieder eigen. Der Dichter und Schriftsteller Mackay, ein gebürtiger Schotte, der den größten Teil seines Lebens in Deutschland verbrachte, war zu seiner Zeit vor allem als Befürworter eines individuellen Anarchismus bekannt. (Mackay war zudem homosexuell; allerdings hatte Strauss sehr wahrscheinlich keine Kenntnis davon, daß Mackays Dichtung durch dessen Liebe zu jungen Männern inspiriert wurde.) Strauss komponierte die vier Lieder op. 27 für Gesang und Klavier 1894 und schenkte sie seiner Frau, der Sopranistin Pauline de Ahna, zu ihrem Hochzeitstag. Sie galt nach allgemeiner Einschätzung, einschließlich der des Komponisten, als eine der herausragenden Interpretinnen seiner Lieder: »Sie hat auch meine Lieder mit einem Ausdruck und einer Poesie vorgetragen, wie ich sie nie mehr gehört habe«, sagte Strauss einmal. »›Morgen!‹ . . . hat ihr niemand auch nur annähernd nachgesungen.«[1] Strauss' Instrumentierung verlangt ein Orchester mit Harfe, drei Hörnern, Solovioline und Streichern. Als eines der ersten Lieder, für die der Komponist eine Orchesterfassung schrieb, ist *Morgen!* in seiner vornehmen Schlichtheit beispielgebend für das Genre.

1. Trenner 1954, S. 53.

3.) Morgen (John Henry Mackay)

Richard Strauss op. 27/IV.

GUSTAV MAHLER

(Kalischt, Bohemia, 1860–1911 Vienna)

"ICH BIN DER WELT
ABHANDEN GEKOMMEN"
FROM THE RÜCKERT-LIEDER

Three drafts (one incomplete) of the
song (1901)
250 x 340 mm

The Mary Flagler Cary Music
Collection; Cary 51

»ICH BIN DER WELT
ABHANDEN GEKOMMEN«,
AUS: RÜCKERT-LIEDER

Drei Liedentwürfe (einer davon
unvollständig) (1901)
250 x 340 mm

The Mary Flagler Cary Music
Collection; Cary 51

From 1897 until his death, Mahler's taxing
schedule of conducting and administrative
duties—first in Vienna, then in New York—
allowed him time to compose only during his
summer vacations. Many of these working
holidays were spent at his villa near Maiernigg,
in southern Austria. The most fruitful summer
was that of 1901, when he drafted (among
other works) several of the *Rückert-Lieder*,
three songs from *Kindertotenlieder,* and two
movements of the Fifth Symphony. Mahler's
friend Natalie Bauer-Lechner, who was with
the composer in Maiernigg, recalls his comment
on the unusually fulfilled and restrained nature
of "I Have Become Lost to the World": "It is a
feeling that rises to the lips but does not pass
beyond them! And he said: It is my very
self!"[1] The close similarities between the song
and the haunting Adagietto of the Fifth Sym-
phony, composed about the same time, have
often been noted. Widely considered Mahler's
finest song, "Ich bin der Welt" is also thought
to be the most autobiographical. These drafts
are more extensive than those preserved for
any other of his lieder.

Provenance
Mary Flagler Cary.

1. Bauer-Lechner 1923, p. 167.

Das kräftezehrende Arbeitspensum, das Mah-
ler als Dirigent und Operndirektor in Wien und
danach in New York absolvierte, gestattete ihm
von 1897 bis zu seinem Tod nur während der
Sommerferien freie Zeit zum Komponieren.
Zahlreiche dieser Arbeitsurlaube verbrachte er
in seiner Villa nahe Maiernigg im südlichen
Österreich. Der kompositorisch ertragreichste
Sommer war der des Jahres 1901, als er – neben
anderen Werken – einige der *Rückert-Lieder*,
drei der *Kindertotenlieder* und zwei Sätze der
Fünften Sinfonie entwarf. Mahlers Freundin
Natalie Bauer-Lechner, die sich mit dem Kom-
ponisten in Maiernigg aufhielt, erinnerte sich
seines Kommentars zu der außergewöhnlich
»erfüllte[n] und gehaltene[n] Art« des Liedes
»Ich bin der Welt abhanden gekommen«: »...es
sei Empfindung bis in die Lippen hinauf, die sie
aber nicht übertritt! Auch sagte er: Das sei er
selbst!«[1] Die starken Übereinstimmungen zwi-
schen dem Lied und dem betörenden Adagietto
der Fünften Sinfonie, das etwa zur gleichen
Zeit entstand, sind oft hervorgehoben worden.
»Ich bin der Welt abhanden gekommen« gilt
als eines der schönsten Mahler-Lieder und trägt
sicherlich die stärksten autobiographischen
Züge. Die Entwürfe hierzu sind weit umfang-
reicher als diejenigen, die für irgendein anderes
seiner Lieder überliefert sind.

1. Bauer-Lechner, 1923, S. 167.

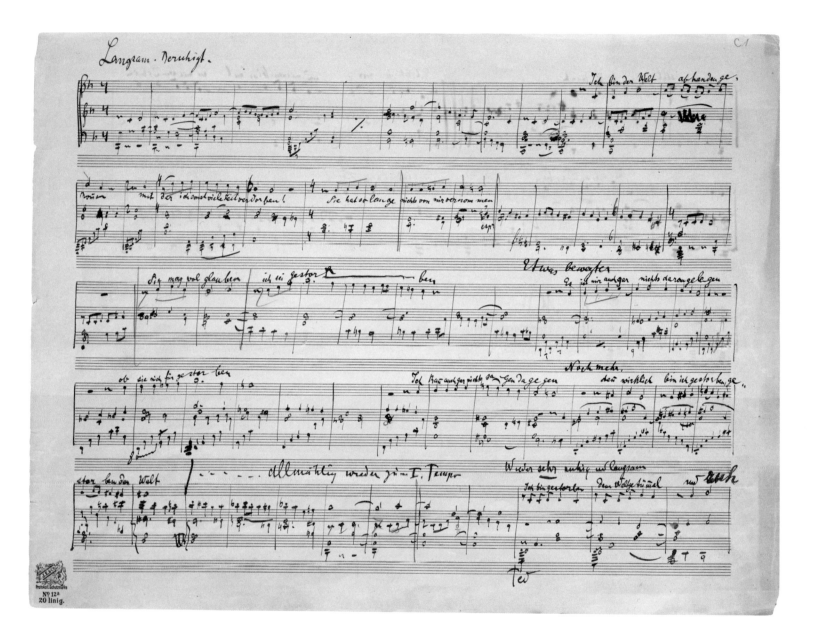

GUSTAV MAHLER

(Kalischt, Bohemia, 1860–1911 Vienna)

SYMPHONY NO. 5

Autograph manuscript (1903)
345 x 265 mm

The Mary Flagler Cary Music
Collection; Cary 509

SINFONIE NR. 5

Autograph (1903)
345 x 265 mm

The Mary Flagler Cary Music
Collection; Cary 509

Although Mahler completed his Fifth Symphony in 1903, he continued to revise it for the rest of his life. As he wrote to a friend in February 1911, shortly before his death, "It is clear that all the experience I had gained in writing the first four symphonies completely let me down in this one—for a completely new style demanded a new technique."[1] On 16 October 1904, after the first rehearsal of the Fifth, Mahler wrote to his wife, Alma:

> It all went off tolerably well. The Scherzo is the very devil of a movement. I see it is in for a peck of troubles! Conductors for the next fifty years will all take it too fast and make nonsense of it; and the public—Oh, heavens, what are they to make of this chaos of which new worlds are forever being engendered, only to crumble in ruin the moment after? What are they to say to this primeval music, this foaming, roaring, raging sea of sound, to these dancing stars, to these breathtaking, iridescent and flashing breakers? . . . Oh, that I might give my symphonies their first performance fifty years after my death![2]

Provenance
Alma Mahler; Robert Owen Lehman.

1. Martner 1979, p. 372.
2. Mahler 1968, p. 243.

Obgleich Mahler seine Fünfte Sinfonie im Jahr 1903 vollendete, überarbeitete er sie doch bis zu seinem Lebensende fortlaufend. So schrieb er im Februar 1911, also kurz vor seinem Tod, an einen Freund: »Offenbar hatte mich die in den ersten 4 Sinfonien erworbene Routine hier völlig im Stich gelassen – da ein ganz neuer Stil eine neue Technik verlangte.«[1] Nach der ersten Probe der Fünften schrieb Mahler am 16. Oktober 1904 an seine Frau Alma:

> Es ist Alles passabel gegangen. Das Scherzo ist ein verdammter Satz! Der wird eine lange Leidensgeschichte haben! Die Dirigenten werden ihn fünfzig Jahre lang zu schnell nehmen und einen Unsinn daraus machen, das Publikum – o Himmel – was soll es zu diesem Chaos, das ewig auf's Neue eine Welt gebärt, die im nächsten Moment wieder zu Grunde geht, zu diesen Urweltsklängen, zu diesem sausenden, brüllenden, tosenden Meer, zu diesen tanzenden Sternen, zu diesen verathmenden, schillernden, blitzenden Wellen für ein Gesicht machen? ... O, könnt ich meine Symphonien fünfzig Jahre nach meinem Tode uraufführen![2]

1. Blaukopf 1982, S. 404.
2. Mahler 1940, S. 309–10.

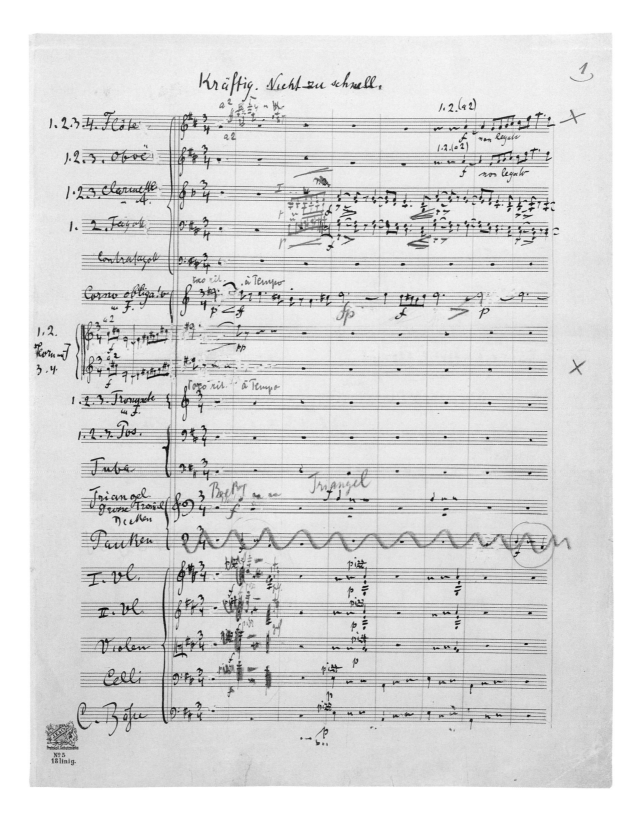

MAURICE RAVEL

(Ciboure, Basses-Pyrénées, 1875–1937 Paris)

OISEAUX TRISTES FROM
MIROIRS

Autograph manuscript [1904–5]
350 x 270 mm

The Mary Flagler Cary Music
Collection; Cary 297

OISEAUX TRISTES, AUS:
MIROIRS

Autograph [1904–05]
350 x 270 mm

The Mary Flagler Cary Music
Collection; Cary 297

Ravel composed the five piano pieces of *Miroirs*—*Noctuelles, Oiseaux tristes, Une Barque sur l'océan, Alborada del gracioso,* and *La Vallée des cloches*—in 1904 and 1905. He said that *Miroirs* (Mirrors) marked a significant change in his harmonic development—a shift that disconcerted those musicians who had become accustomed to his style. He added that the earliest piece, which he considered the most characteristic, was *Oiseaux tristes.* "In it," he said, "I evoke birds lost in the torpor of a tenebrous forest during the hottest hours of summer."[1] The piece is dedicated to Ricardo Viñes, an exceptionally gifted pianist and close friend of Ravel's who gave the first performances of, among other works, *Jeux d'eau, Miroirs,* and *Gaspard de la nuit.* This manuscript once belonged to Alfred Cortot, another notable interpreter of Ravel's music and an avid collector of manuscript and printed music. Ravel eventually had a falling out with both Viñes and Cortot, the former because he would not play "Le Gibet" from *Gaspard de la nuit* as Ravel wrote it, the latter because he wanted to play the Concerto for the Left Hand with both hands.

Provenance
Alfred Cortot.

1. "[J'y évoque] des oiseaux perdus dans la torpeur d'une forêt très sombre aux heures le plus chaudes de l'été." Orenstein 1989, p. 45.

Ravel komponierte die fünf Klavierstücke der *Miroirs* – *Noctuelles, Oiseaux tristes, Une Barque sur l'océan, Alborada del gracioso* und *La Vallée des cloches* – in den Jahren 1904 und 1905. Er betonte, daß *Miroirs* einen signifikanten Einschnitt in seiner Harmonieauffassung bedeutete – eine Veränderung, die all jene Musiker verwirrte, die sich an seinen Stil gewöhnt hatten. Er fügte hinzu, daß *Oiseaux tristes* das früheste und nach seiner Auffassung zugleich das charakteristischste Stück sei. »In ihm«, so Ravel, »evoziere ich das Bild von Vögeln, die während der heißesten Stunden des Sommers in der Erstarrung eines dunklen Waldes verloren sind.«[1] Das Stück ist Ricardo Viñes gewidmet, einem außergewöhnlich begabten Pianisten und guten Freund Ravels, der unter anderem die Uraufführungen von *Jeux d'eau, Miroirs* und *Gaspard de la nuit* gab. Das ausgestellte Manuskript gehörte früher Alfred Cortot, einem weiteren herausragenden Interpreten der Musik Ravels und einem begeisterten Sammler von Musikautographen und Notendrucken. Ravel überwarf sich jedoch sowohl mit Viñes als auch mit Cortot. Viñes hatte sich geweigert, »Le Gibet« aus *Gaspard de la nuit* gemäß Ravels kompositorischen Vorgaben zu spielen, und Cortot wollte das Konzert für die linke Hand mit beiden Händen spielen.

1. Orenstein 1989, S. 45.

ARNOLD SCHOENBERG
(Vienna 1874–1951 Los Angeles)

GURRELIEDER

Autograph manuscript (1911)
580 x 370 mm

The Mary Flagler Cary Music
Collection; Cary 282

GURRELIEDER

Autograph (1911)
580 x 370 mm

The Mary Flagler Cary Music
Collection; Cary 282

Gurrelieder, a setting of poems by the Danish novelist and poet Jens Peter Jacobsen, was Schoenberg's first great success. The work occupied the composer intermittently for over a decade: it was written between March 1900 and April 1901; orchestration was begun in 1901, continued in 1902 and 1903, then put aside until 1910, and finally completed in 1911. The first performance took place in Vienna on 23 February 1913—four months after Schoenberg's *Pierrot lunaire* in Berlin and three months before Stravinsky's *Sacre du printemps* in Paris. The work calls for such enormous vocal and instrumental forces—six soloists, four choruses, and an orchestra of about 150—that Schoenberg had to order special 48-stave music paper for this manuscript. Five days after the premiere, Schoenberg's old friend David Josef Bach wrote in the *Arbeiter-Zeitung* that when the work ended

> the audience's emotion erupted into an ovation lasting a quarter of an hour. This was genuine rejoicing, even if one or another member of the public may have introduced a jarring note of snobbery. What does it matter? Schoenberg has thirsted for recognition long enough; one may allow him to swallow a drop of harmless poison along with the honey of success.[1]

Provenance
Universal Edition, Vienna; Robert Owen Lehman.

1. Reich 1971, p. 72.

Die *Gurrelieder,* eine Vertonung von Gedichten des dänischen Schriftstellers und Dichters Jens Peter Jacobsen, waren Schönbergs erster großer Erfolg. Das Werk beschäftigte den Komponisten mit längeren Unterbrechungen mehr als ein Jahrzehnt: Komponiert wurde es zwischen März 1900 und April 1901; die Instrumentierung wurde 1901 begonnen und 1902 und 1903 weitergeführt, dann bis 1910 wieder zur Seite gelegt und schließlich im Jahr 1911 vollendet. Die Uraufführung fand am 23. Februar 1913 in Wien statt – vier Monate nach Schönbergs *Pierrot lunaire* in Berlin und drei Monate vor Igor Strawinskys *Sacre du printemps* in Paris. Das Werk erfordert eine so umfangreiche Vokal- und Instrumentalbesetzung – sechs Solisten, vier Chöre und ein 150köpfiges Orchester –, daß Schönberg für sein Manuskript spezielles Notenpapier mit 48 Linien ordern mußte. Fünf Tage nach der Premiere schrieb Schönbergs langjähriger Freund David Josef Bach in der *Arbeiter-Zeitung* über die Reaktion des Publikums am Ende der Aufführung:

> Die Ergriffenheit der Hörer entlud sich in minuten- und viertelstundenlangem Jubel. Der war echt, mag sich auch mit diesem oder jenem Besucher der falsche Ton des Snobismus eingeschlichen haben. Was tut's? Schönberg hat lange genug nach Anerkennung gedürstet, um mit der Süßigkeit des Erfolges nicht auch ein bißchen unschädliches Gift mitschlürfen zu dürfen.[1]

1. Reich 1968, S. 100.

CHARLES IVES

(Danbury, Connecticut, 1874–1954 New York)

92

ROBERT BROWNING OVERTURE

Drafts (1911)
330 x 265 mm
Gift of Frank Wigglesworth

ROBERT BROWNING OVERTURE

Entwürfe (1911)
330 x 265 mm
Geschenk von Frank Wigglesworth

Sometime before composing his *Concord* Sonata—which, after its first public performance, in 1939, one critic called the greatest music composed by an American—Ives had planned a series of overtures on "men of literature" that would depict William Wordsworth, Robert Browning, Ralph Waldo Emerson, and others. The Emerson overture became the first movement of the *Concord* Sonata, and others were later used in songs. Only the *Robert Browning Overture* was completed. When Ives's friend Carl Ruggles—one of the few contemporary composers for whom Ives had anything good to say—visited him many years later, Ives said of the *Browning Overture*:

> "To hell with the goddamn thing. . . . The goddamn thing is no good." And he took it and threw it clear across the dining room floor. I got up, went over to get that score back. I said, "I don't think I would say that, when I hear such phrases as here and here and here. Such magnificent music as that. I wouldn't talk like that." He said, "You think that?" I said, "I certainly do."[1]

The *Robert Browning Overture* has the distinction of containing what is apparently the first instance of a twelve-tone chord in music history.[2]

1. Perlis 1974, p. 173.
2. Forte 1977, p. 164.

Noch vor der Komposition der *Concord Sonata* – die ein Kritiker 1939 nach ihrer Uraufführung als die großartigste musikalische Leistung eines Amerikaners pries – hatte Charles Ives einen Ouvertüren-Zyklus zu großen Dichtern und Schriftstellern geplant, der unter anderem William Wordsworth, Robert Browning und Ralph Waldo Emerson musikalisch darstellen sollte. Aus der *Emerson Overture* wurde der erste Satz der *Concord Sonata,* andere Ouvertüren hat Ives später für Liedkompositionen verwendet. Nur die *Robert Browning Overture* wurde vollendet. Als sein Freund Carl Ruggles – einer der wenigen zeitgenössischen Komponisten, die Ives respektierte – ihn viele Jahre später besuchte, sagte Ives über die *Browning Overture:*

> »Zum Teufel mit dem gottverdammten Ding. ... Das gottverdammte Ding taugt zu überhaupt nichts.« Und er nahm die Partitur und schleuderte sie quer über den Eßzimmerboden. Ich stand auf, ging hinüber, um sie zurückzuholen, und sagte: »Ich glaube dies keineswegs, wenn ich solche Partien höre, wie hier und hier und hier. Solch großartige Musik. Ich würde nicht so daherreden.« Er antwortete: »Glaubst Du wirklich?«, und ich erwiderte: »Aber ganz gewiß!«[1]

Die *Robert Browning Overture* zeichnet sich dadurch aus, daß sie den anscheinend ersten Zwölftonakkord in der Musikgeschichte enthält.[2]

1. Perlis 1974, S. 173.
2. Forte 1977, S. 164.

IGOR STRAVINSKY

(Oranienbaum 1882–1971 New York)

93

FOUR RUSSIAN PEASANT
SONGS

Autograph manuscript (1914–17)
140 x 120 mm

The Mary Flagler Cary Music
Collection; Cary 525

VIER RUSSISCHE BAUERN-
LIEDER

Autograph (1914–17)
140 x 120 mm

The Mary Flagler Cary Music
Collection; Cary 525

In an old Russian Christmastide tradition, women place rings, earrings, and other trinkets in a bowl that is then covered with a table-cloth; while a song is sung, a trinket is drawn from the bowl and the owner's fate is foretold by the song. Between 1914 and 1917—a period, writes Richard Taruskin, characterized by "a preoccupation with folklore unparalleled in the history of Russian music"[1]—Stravinsky composed three such songs (and one for the New Year) for women's chorus under the title *Tri podblyudnikh pesni i odna pesn Ovsenyu* (Three Fortune-telling Songs and a New Year's Song). They were first performed, in Geneva, in 1917, and conducted by Vasiliy Kibalchich, to whom Stravinsky inscribed this manuscript. The choruses are also known in German as *Unterschalen* (a term coined by Stravinsky) and in English as *Saucers;* both are mistranslations, promulgated by the composer and others, of *podblyudnïye,* more accurately rendered as "fortune-telling songs." Simpler yet is *Four Russian Peasant Songs,* the subtitle assigned by J. & W. Chester, the first English publisher of the pieces.

1. Taruskin 1996, vol. 1, p. 15. The brief account of the *Four Russian Peasant Songs* given here is drawn almost entirely from vol. 2, pp. 1152–62, of Taruskin's book.

Gemäß einer alten russischen Weihnachtstradition legen Frauen ihre Ringe, ihren Ohrschmuck und anderes Geschmeide in eine Schale, die mit einem Tuch bedeckt wird. Während ein Lied gesungen wird, zieht jemand der Anwesenden ein Schmuckstück aus der Schale, und das Schicksal seiner Besitzerin wird im Lied vorausgesagt. In den Jahren 1914 bis 1917 – die laut Richard Taruskin durch eine in der russischen Musikgeschichte beispiellose Begeisterung für Volksmusik geprägt waren –[1] komponierte Strawinsky drei solcher Lieder (und eines für Neujahr) für Frauenchor unter dem Titel *Tri podblyudnikh pesni i odna pesn Ovsenyu* (Drei Wahrsagelieder und ein Neujahrslied). Sie wurden 1917 in Genf unter der Leitung von Wassily Kibalchich uraufgeführt, dem Strawinsky das vorliegende Manuskript zueignete. Die Chorpartien sind im Deutschen auch unter dem Titel *Unterschale* (ein von Strawinsky geprägter Begriff) und im Englischen als *Saucers* bekannt; beides sind vom Komponisten und anderen verbreitete Fehlübersetzungen von *podblyudnïye,* was genauer übersetzt »Wahrsagelieder« bedeutet. Noch einfacher ist der von B. Schott's Söhne, dem ersten deutschen Verleger der Stücke, verwendete Untertitel *Vier russische Bauernlieder.*

1. Taruskin 1996, Bd. 1, S. 15. Diese kurze Darstellung über die *Vier russischen Bauernlieder* ist fast vollständig aus dem zweiten Band der Publikation von Taruskin auf S. 1152–62 übernommen.

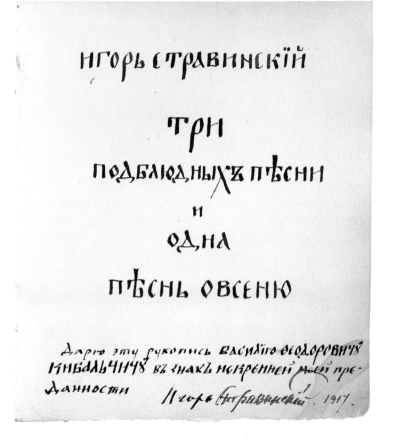

НГОРЬ СТРАВИНСКІЙ

ТРИ

ПОДБЛЮДНЫХЪ ПѢСНИ

И

ОДНА

ПѢСНЬ ОВСЕНЮ

Дарю эту рукопись ВАСИЛІЮ ѲЕОДОРОВИЧУ КИБАЛЬЧИЧУ въ знакъ искренней моей преданности Игорь Стравинскій. 1917.

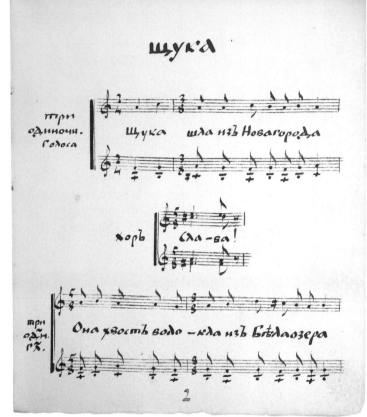

ЩУКА

IGOR STRAVINSKY

(Oranienbaum 1882–1971 New York)

94

PERSÉPHONE

Autograph manuscript of the short score; incomplete, breaking off after the sixth measure of the last number, "Ainsi vers l'ombre souterraine" (1936)

215 x 210 mm

The Mary Flagler Cary Music Collection; Cary 516

PERSÉPHONE

Autograph des Particells; unvollständig, bricht nach dem sechsten Takt der letzten Nummer, »Ainsi vers l'ombre souterraine«, ab (1936)

215 x 210 mm

The Mary Flagler Cary Music Collection; Cary 516

Perséphone was commissioned in 1933 by Ida Rubinstein, the dancer, actress, and patroness for whom Stravinsky had written *Le Baiser de la fée* in 1928. It was proposed that he set an early poem by André Gide based on the Homeric hymn to Demeter. The collaboration was not entirely happy. Stravinsky reported that when he first played the music for Gide at Mme Rubinstein's, the poet would say only "c'est curieux, c'est très curieux" »sehr merkwürdig, dies ist wirklich sehr merkwürdig«. Gide complained that Stravinsky's syllabic text-setting ignored conventions of French prosody—in short, Gide expected his text "to be sung with exactly the same stresses he would use to recite it."[1] Stravinsky's music, Gide maintained, should imitate or underline the poet's verbal pattern. "I would simply have to find pitches for the syllables," Stravinsky recalled, "since he considered he had already composed the rhythm. The tradition of *poesia per musica* [poetry written for music] meant nothing to him."[2] *Perséphone* is a melodrama—a work that combines the spoken word with musical accompaniment—for narrator, chorus, and orchestra. When asked many years later how he felt about the use of music as accompaniment to recitation, Stravinsky replied: "Do not ask. Sins cannot be undone, only forgiven."

Provenance
Victoria Ocampo; Robert Owen Lehman.

1. Stravinsky and Craft 1960, p. 75.
2. Ibid.

Perséphone wurde 1933 von Ida Rubinstein, einer Tänzerin, Schauspielerin und Förderin Strawinskys, für die er bereits 1928 *Le Baiser de la fée* geschrieben hatte, in Auftrag gegeben. Es war vorgesehen, daß er ein frühes Gedicht von André Gide, das auf einem Homerischen Hymnus auf die Göttin Demeter basiert, vertonte. Die Zusammenarbeit verlief nicht unbedingt glücklich. Strawinsky berichtete, daß der Dichter, als Strawinsky die Musik zum ersten Mal für Gide bei Ida Rubinstein vorspielte, lediglich »sehr merkwürdig, dies ist wirklich sehr merkwürdig« geäußert habe. Gide beklagte, daß Strawinskys syllabische Textvertonung die Konventionen französischer Prosodie vollkommen außer acht lasse – kurzum, Gide erwartete, daß seine Dichtung mit genau den gleichen Betonungen gesungen würde, die er beim Rezitieren verwendete.[1] Strawinskys Musik sollte das Versmaß des Gedichts nachahmen oder hervorheben. »Ich hätte eigentlich nurmehr bestimmte Tonhöhen für die Silben finden sollen«, erinnerte sich Strawinsky, »da er für sich in Anspruch nahm, den Rhythmus bereits vorgegeben zu haben. Die Tradition der *poesia per musica* (für die Musik geschriebene Dichtung) schien ihm nichts zu bedeuten.«[2] *Perséphone* ist ein Melodram, also eine Verbindung aus gesprochenem Wort und Musikbegleitung, für Erzähler, Chor und Orchester. Als Strawinsky viele Jahre später auf den Einsatz von Musik als Rezitationsbegleitung angesprochen wurde, erwiderte er: »Fragen Sie mich bitte nicht. Sünden können nicht ungeschehen gemacht werden, sie können nur vergeben werden.«

1. Stravinsky and Craft 1960, S. 75.
2. Ebenda.

Perséph.: Déméter tu m'attends et les bras sont ouverts Pour accueillir

Meno mosso ♩=72

— santes. Venez, venez. Forçons les portes du trépas. Non, le sombre Pl..

enfin ta fille renaissante Au plein soleil qui fait les ombres ravis-

ton ne nous retiendra pas. Nous reverrons bientôt, agités par les vents

FRANCIS POULENC

(Paris 1899–1963 Paris)

95

CHANSONS VILLAGEOISES

Autograph manuscript (1942–43)
350 x 265 mm

The Mary Flagler Cary Music
Collection; Cary 498

CHANSONS VILLAGEOISES

Autograph (1942–43)
350 x 265 mm

The Mary Flagler Cary Music
Collection; Cary 498

For Poulenc, Maurice Fombeure's texts for the *Chansons villageoises* evoked the Morvan, "where I spent so many wonderful summers! It was out of nostalgia for the Autun region that I composed these songs. I conceived them as a symphonic vocal showpiece for a *strong* Verdi baritone (Iago)."[1] (Autun, noted for its Roman architecture, was one of Poulenc's favorite towns.) Poulenc called most of his songs *mélodies* but specifically named several *chansons*, which he characterized as a type of song that, while not quite folkloric, allows complete freedom with the text. "I repeat words, I chop them up, I leave them incomplete, as at the end of 'Gars qui vont à la fête' [from *Chansons villageoises*]. I was influenced in this by the cast of vocal phrase used by Maurice Chevalier."[2] But Pierre Bernac, a longtime friend of Poulenc's and one of the outstanding interpreters of his songs, saw the distinction differently and observed that although the *Chansons villageoises* are written in the style of *chansons* (that is, in a more or less popular style), they are in reality *mélodies* (that is, art songs) and extremely difficult.

1. "où j'ai passé de si merveilleux étés! C'est pour nostalgie des environs d'Autun que j'ai composé ce recueil. Je les ai conçus comme un tour de chant symphonique pour un *fort* baryton Verdi (Iago)." Poulenc 1964, p. 55.
2. "Je reprends les mots, j'en coupe, j'en susentend même, comme dans la fin des 'Gars qui vont à la fête.' Le tour de chant de Maurice Chevalier m'en a appris long à cet égard." Poulenc 1947, p. 513.

Für Poulenc erweckten die seinen *Chansons villageoises* zugrundeliegenden Texte von Maurice Fombeure Erinnerungen an die Berge von Morvan, »wo ich so viele wundervolle Sommer verbrachte! Aus reiner Nostalgie für die Gegend um Autun habe ich diese Lieder komponiert. Sie sind als ein sinfonisches Paradestück für einen *starken* Verdi-Bariton (wie den Jago) gedacht.«[1] (Autun, berühmt für seine römische Architektur, gehörte zu Poulencs Lieblingsstädten.) Die meisten seiner Lieder bezeichnete Poulenc als *mélodies*, einige nannte er jedoch speziell *chansons*, was seiner Meinung nach eine Liedform war, die, wenn auch nicht ganz volksliedhaft, völlige Freiheit im Umgang mit dem Text erlaubte. »Ich wiederhole Worte, hacke sie in Stücke, lasse sie unvollständig, wie am Ende von ›Gars qui vont à la fête‹ [aus den *Chansons villageoises*]. Ich wurde hierbei von Maurice Chevaliers Art der Vokalphrasierung beeinflußt.«[2] Allerdings schätzte Pierre Bernac, ein langjähriger Freund Poulencs und einer seiner herausragenden Liedinterpreten, diese Unterteilung anders ein und bemerkte, daß die *Chansons villageoises* zwar im Stil der *chansons*, also im mehr oder weniger volkstümlichen Stil, geschrieben seien; tatsächlich seien sie jedoch *mélodies* (also Kunstlieder) und höchst schwierig.

1. Poulenc 1964, S. 55.
2. Poulenc 1947, S. 513.

JOHN CAGE

(Los Angeles 1912–1992 New York)

THREE DANCES

Autograph manuscript (1945)
340 x 270 mm

The Mary Flagler Cary Music
Collection; Cary 311

THREE DANCES

Autograph (1945)
340 x 270 mm

The Mary Flagler Cary Music
Collection; Cary 311

John Cage has been called the most influential American composer, worldwide, of the twentieth century. Among his many innovations was the prepared piano, in which various small objects—bolts, nuts, screws—are placed between the piano strings. In 1938 Cage wrote *Bacchanale,* his first work for prepared piano, and in the mid-1940s he wrote several more, including *Three Dances* in 1944 and 1945. They were written for the duo pianists Arthur Gold and Robert Fizdale, who played them at the New School for Social Research, in New York, in January 1945. Lou Harrison and Virgil Thomson both wrote highly favorable reviews of the concert. Thomson commended Cage's works as displaying "not only the most advanced methods now in use anywhere but original expression of the very highest poetic quality"; Harrison wrote that the works firmly established Cage as the newest member of the great American independents, along with Ives, Ruggles, Cowell, and Varèse. When Maro Ajemian and William Masselos played a revised version the following year at Carnegie Hall, a reviewer said that the clangorous third dance "sounded as if the excited inmates of a madhouse were improvising their own *Sacre du printemps* on any number of curious metallic instruments."[1]

1. Hague 1946, p. 19.

John Cage gilt als der amerikanische Komponist des 20. Jahrhunderts, der weltweit den größten Einfluß auf die musikalische Entwicklung ausgeübt hat. Zu seinen zahlreichen Innovationen gehört die Erfindung des präparierten Klaviers, bei dem verschiedenste kleine Objekte – wie Bolzen, Muttern, Schrauben – zwischen den Saiten befestigt werden. 1938 schrieb Cage *Bacchanale,* seine erste Komposition für präpariertes Klavier, und Mitte der vierziger Jahre folgten verschiedene weitere, wie beispielsweise *Three Dances* von 1944 und 1945. Letztere wurden für das Klavierduo Arthur Gold und Robert Fizdale komponiert, das sie im Januar 1945 an der New School for Social Research in New York aufführte. Die Konzertkritiken von Lou Harrison und Virgil Thomson waren beide voll des Lobes. Thomson hob hervor, daß Cages Werke »nicht nur die fortschrittlichsten Methoden der musikalischen Gegenwart, sondern auch einen schöpferischen Ausdruck von höchster poetischer Qualität entfalten«. Harrison schrieb, daß sich Cage mit diesen Kompositionen einen festen Platz innerhalb der Gruppe der großen amerikanischen Unabhängigen neben Ives, Ruggles, Cowell und Varèse gesichert habe. Als Maro Ajemian und William Masselos im folgenden Jahr eine überarbeitete Fassung in der Carnegie Hall spielten, bemerkte ein Musikkritiker, der klirrende dritte Tanz »klinge, als improvisierten die erregten Insassen eines Irrenhauses ihren eigenen *Sacre du printemps* auf einer Unzahl seltsamer Metallinstrumente«.[1]

1. Hague 1946, S. 19.

Yes! she was worthy of all love —
Such as I sought her from the time
My spirit with the tempest strove
When on the mountain ... alone
Ambition lent it a new tone
And bade it first to dream of crime
There were no holier thoughts than thine
I lov'd thee as an angel might
With ray of the all-living light
Which blazes upon Edis' shrine —
It is not surely sin to name
With such as mine that mystic flame
I had no being but in thee —
The world with all its train of bright
And happy beauty for to me

Literary and Historical Manuscripts
Literarische und historische Manuskripte

The Library's collection of literary and historical manuscripts includes complete manuscripts and working drafts of poetry and prose as well as correspondence, journals, and other documents of important British, American, and European authors, artists, scientists, and historical figures from the fifteenth to the twentieth century. Much of the collection comprises single or several examples of important individuals. Several figures are represented in considerable depth by tens or hundreds of items. Among them are Austen, the Brontës, Byron, Dickens, Goethe, Heine, Hawthorne, Lafayette, Keats, Ruskin, Scott, Steinbeck, and Voltaire. Prominent among broad categories that encompass several thousand items are artists' letters from the Renaissance to the twentieth century and documents related to British and European rulers from the fifteenth to eighteenth century.

The general pattern of the collection was established by Pierpont Morgan, who, in the 1890s, began to acquire literary and historical manuscripts on a large scale. He sought not to achieve comprehensiveness in any particular field, but rather to assemble primary sources essential to the study of historical events, the lives of notable individuals, and the creation of great literary works. Though interested primarily in representation of previous generations, he acquired several contemporary works, including Emile Zola's manuscripts of the controversial novel *Nana* and three of the author's public letters written in defense of Alfred Dreyfus.

Having grown to approximately 100,000 items, the collection broadly evinces the particular intimacy of handwritten documents. It is rich in authors' drafts and revisions, fascinating for the glimpses they give, in Dickens's telling phrase, of "the story-weaver at his loom." The manuscript of his own *Our Mutual Friend* makes palpable his method of composition: great rushes of writing, followed by slower, more careful drafting, then sudden returns to the flurry of creation. Balzac's manuscript, with corrected gal-

ley proofs, of *Eugénie Grandet* is a tortuous mass of revisions, corrections, and additions. To the great frustration of his printers, Balzac would revise heavily even after his novels were in galley proofs. He would shift whole chapters about as well as revise almost every passage with nearly indecipherable scribblings. Saint-Exupéry's manuscript of *Le Petit Prince,* rendered mostly in his near illegible scrawl on thin onionskin paper, reveals the laborious evolution of a book much admired, in its published form, for concision and grace. With many passages crossed out and others revised extensively, its pages vividly record the exertion behind seemingly effortless artistry. The manuscript bears unmistakable evidence of Saint-Exupéry's working habits. Coffee stains mark several leaves, and one preliminary drawing was burned through by a cigarette ash.

These and many other manuscripts in the collection are the sole surviving records of the creation of great literary works. Today, as technology changes the way authors work, they become even more precious. Because they are handwritten, they preserve a process of human creativity—from mind to hand to pen to paper—with an immediacy and power indiscernible in computer printouts.

Letters in the collection are an entrance into the private worlds of their writers. Also, by enticing us with the opportunity to read over someone's shoulder, these letters appeal to our natural curiosity about the private thoughts and emotions of other human beings. Jane Austen's correspondence often exemplifies her dictum that the art of letter writing "is to express on paper exactly what one would say to the same person by word of mouth." Particularly intriguing are the letters of lovers. Among the most passionate in the Library's collection are those of Napoleon to Josephine. "I draw from your lips, from your heart, a flame which consumes me," he wrote at the beginning of their romance. In contrast to Napoleon's intense ardor is the subdued

eloquence of Elizabeth Barrett Browning. In a letter to her brother George, posted when she eloped to the Continent with Robert Browning, she recounted her initial refusal of Browning's proposal because of her age and ill health, adding: "His answer was—not the common gallantries which come so easily to the lips of men—but simply that *he loved me*—he met argument with fact."

Some letters in the collection are interesting for the discrepancies they reveal between creative achievement and private conduct. Artistic geniuses, we regretfully learn, can sometimes be singularly deficient in interpersonal relations. One example is a note appended by Lord Byron to a plea from his homesick daughter Allegra barely five years old. From the convent where she had been placed, she begged in the neat, careful script of a child who had just learned to write, "I should so much like a visit from my Papa. . . . Will you not please your Allegrina who loves you so?" Forwarding the letter to a friend, Byron dismissed her entreaty as a mere attempt "to get some paternal gingerbread." The poet did not visit his child then, and, indeed, never saw her again, for she died the following year.

The collection is particularly strong in artists' letters. One of the most important is Alberti's 1454 letter, with sketch, conveying his plans for the transformation of the medieval church of San Francesco at Rimini into the Tempio Malatestiano. Writing to Matteo de'Pasti, the on-site architect of the project, Alberti defends his design with a succinct summation of principles published two years earlier in his monumental treatise *De re aedificatoria*. During the past twenty years, the collection of artists' letters has been substantially augmented by important acquisitions. Among them are art historian John Rewald's letters of impressionist and postimpressionist artists, art dealer Paul Rosenberg's collection of some 450 letters and documents of twentieth-century artists, and the Tabarant collection of papers and photographs related to Manet. In

1998, the collection was enriched by the Pierre Matisse Gallery Archives, the gift of the Pierre Matisse Foundation. The archives include over 1,500 letters and records of gallery installations of Balthus, Chagall, Dubuffet, Giacometti, Miró as well as other twentieth-century artists. Much of the material will be accessible to scholars in 1999.

The foregoing examples and those that follow are but a sample of the Library's collection of literary and historical manuscripts. As the collection grows, it will continue to contribute to a better understanding of American and European culture through public exhibitions and scholarly study.

Die Sammlung der literarischen und historischen Manuskripte der Pierpont Morgan Library umfaßt vollständige Manuskripte und Arbeitsentwürfe aus Dichtung und Prosa ebenso wie Korrespondenz, Tagebücher und andere Dokumente britischer, amerikanischer und europäischer Autoren, Künstler, Wissenschaftler und historischer Persönlichkeiten aus dem 15. bis 20. Jahrhundert. Der Großteil besteht aus einzelnen oder mehreren Niederschriften bedeutender Personen; einige von ihnen sind in beträchtlichem Umfang mit Dutzenden oder Hunderten von Einzelzeugnissen vertreten. Zu ihnen gehören Jane Austen, die Schwestern Brontë, Lord Byron, Charles Dickens, Johann Wolfgang von Goethe, Heinrich Heine, Nathaniel Hawthorne, der Marquis de Lafayette, John Keats, John Ruskin, Sir Walter Scott, John Steinbeck und Voltaire. Mehrere tausend Einheiten umfassen die Künstlerbriefe von der Renaissance bis ins 20. Jahrhundert und Dokumente zu britischen und kontinentaleuropäischen Herrschern des 15. bis 18. Jahrhunderts.

Das generelle Sammlungskonzept stammt von Pierpont Morgan, der seit den 1890er Jahren literarische und historische Manuskripte in großem Umfang erwarb. Ihm ging es nicht um Vollständigkeit in einem speziellen Bereich, sondern um das Sammeln von wichtigen Quellen für das Studium historischer Ereignisse, der Biographien herausragender Persönlichkeiten und der Entstehungsgeschichte großer literarischer Werke. Obgleich in erster Linie an älteren Zeugnissen interessiert, erwarb er auch mehrere zeitgenössische Werke, darunter Emile Zolas Manuskripte seines umstrittenen Romans *Nana* und zwei seiner Streitschriften zur Verteidigung von Alfred Dreyfus.

Auf einen Umfang von ungefähr 100 000 Einzelstücken angewachsen, veranschaulicht die Sammlung auf breiter Ebene die besondere Intimität handschriftlicher Zeugnisse. Sie ist reich an Entwürfen und Überarbeitungen, die, mit Dickens' treffenden Worten, faszinierende Einblicke in die Arbeit des »Geschichten-Webers an

seinem Webstuhl« bieten. Das Manuskript von Dickens' Roman *Our Mutual Friend* zeigt seine Kompositionsmethode: große kreative Schreibausbrüche, gefolgt von langsamerer, sorgfältigerer Arbeit am Entwurf, dann ein plötzliches Zurück zur aufbrausenden Schöpferkraft. Honoré de Balzacs Manuskript mit korrigierten Fahnen von *Eugénie Grandet* ist eine in sich verschlungene Anhäufung von Revisionen, Korrekturen und Ergänzungen. Zur großen Verzweiflung seiner Drucker nahm Balzac sogar noch umfangreiche Überarbeitungen vor, als seine Romane bereits in Druckfahnen vorlagen. Er stellte ganze Kapitel um und überarbeitete beinahe jeden einzelnen Absatz mit nahezu unentzifferbarem Gekritzel. Antoine de Saint-Exupérys Manuskript von *Le Petit Prince,* fast durchweg in seiner beinahe unleserlichen Handschrift auf dünnem Papier geschrieben, offenbart die mühselige Entstehung eines Buches, das veröffentlicht gerade seiner Prägnanz und Eleganz wegen bewundert wird. Die vielen durchgestrichenen oder völlig überarbeiteten Passagen zeugen von der Anstrengung, die sich hinter scheinbar müheloser künstlerischer Leistung verbirgt. Das Manuskript läßt Saint-Exupérys Arbeitsgewohnheiten erkennen: Auf mehreren Seiten befinden sich Kaffeeflecken, und eine Vorzeichnung ist durch Zigarettenasche angesengt.

Diese und viele andere Manuskripte in der Sammlung sind die einzigen erhaltenen Zeugnisse, die Aufschluß geben über die Entstehung großer literarischer Werke. In der heutigen Zeit gewinnen sie noch an Wert, da technische Veränderungen auch einen Wandel in der Arbeitsweise der Autoren mit sich bringen. Als handschriftliche Dokumente halten sie den schöpferischen Prozeß fest – vom Geist über die Hand zum Stift und zum Papier – mit der Unmittelbarkeit und Kraft, die auf Computerausdrucken nicht mehr vorkommt.

Die Briefe in der Sammlung öffnen den Blick in die Privatsphäre ihrer Schreiber. Sie locken uns mit der Möglichkeit, jemandem über die Schulter zu schauen und wecken dabei unsere natürliche

Neugierde auf die privaten Gedanken und Gefühle anderer Menschen. Jane Austens Korrespondenz belegt ihr Diktum, daß die Kunst des Briefeschreibens »darin besteht, auf dem Papier genau das schriftlich auszudrücken, was man derselben Person auch mündlich sagen würde«. Besonders faszinierend sind die Liebesbriefe. Zu den glühendsten in der Sammlung der Morgan Library gehören die Napoleons an Josephine. »Ich entlocke Deinen Lippen, Deinem Herzen eine Flamme, die mich verzehrt«, schrieb er zu Beginn ihrer Liebesbeziehung. Im Gegensatz zu Napoleons Leidenschaftlichkeit steht die gefaßte Eloquenz von Elizabeth Barrett Browning. In einem Brief an ihren Bruder George, abgesandt, als sie mit Robert Browning auf den Kontinent »durchbrannte«, berichtet sie, wie sie anfangs Brownings Vorschlag, das Land zu verlassen, wegen ihrer Jugend und ihrer Kränklichkeit abgelehnt habe. Nun fügt sie hinzu: »Seine Antwort war – nicht die üblichen Galanterien, die den Männern so leicht von den Lippen gehen – sondern einfach, daß *er mich liebe* – so begegnete er den Argumenten mit einer einfachen Tatsache.«

Einige Briefe in der Sammlung sind aufgrund der Diskrepanz von Interesse, die sie zwischen schöpferischer Kraft und privatem Verhalten offenbaren. Künstlerische Genies können, wie wir voller Bedauern erfahren, mitunter eigentümlich unzulänglich in ihren zwischenmenschlichen Beziehungen sein. Ein Beispiel dafür ist eine Notiz, die Lord Byron einer Bitte seiner kaum fünfjährigen, heimwehkranken Tochter Allegra beifügte. Von dem Nonnenkloster aus, in dem sie untergebracht war, bittet sie in der ordentlichen und sorgfältigen Handschrift eines Kindes, das gerade erst schreiben gelernt hat, ihren Vater inständig: »Ich würde mich so über einen Besuch von meinem Papa freuen. ... Willst Du nicht Deiner Allegrina, die Dich so liebt, diese Freude machen?« Den Brief an einen Freund weiterleitend, wies Byron ihre dringende Bitte als Versuch ab, »ein wenig väterliche Zuneigung zu erhaschen«. Der Dichter besuchte seine Tochter damals nicht, und tatsächlich sah er sie nie wieder, denn Allegra verstarb im darauffolgenden Jahr.

Eine besondere Stärke der Sammlung sind die Künstlerbriefe. Einer der bedeutendsten ist Leon Battista Albertis Brief mit einer Skizze aus dem Jahr 1454, in dem er seine Pläne für die Umgestaltung der mittelalterlichen Kirche von San Francesco in Rimini in den Tempio Malatestiano mitteilt. In diesem Schreiben an Matteo de' Pasti, den vor Ort für das Projekt verantwortlichen Architekten, verteidigt Alberti seinen Entwurf mit einer bündigen Zusammenfassung von Prinzipien, die er zwei Jahre zuvor in der monumentalen Abhandlung *De re aedificatoria* veröffentlicht hatte. Während der letzten zwanzig Jahre ist die Sammlung der Künstlerbriefe durch bedeutende Erwerbungen beträchtlich vergrößert worden. Darunter befinden sich die Briefsammlung impressionistischer und postimpressionistischer Künstler des Kunsthistorikers John Rewald, die Sammlung des Kunsthändlers Paul Rosenberg, die 450 Briefe und Dokumente von Künstlern des 20. Jahrhunderts umfaßt sowie die Sammlung Tabarant mit Dokumenten und Photographien zu Leben und Werk Edouard Manets. 1998 wurde die Sammlung durch das Archiv der Galerie Pierre Matisse bereichert, ein Geschenk der Fondation Pierre Matisse. Das Archiv enthält mehr als 1500 Briefe und Dokumente zu Galerieausstellungen von Balthus, Marc Chagall, Jean Dubuffet, Alberto Giacometti, Joan Miró und anderen Künstlern des 20. Jahrhunderts. Ein Großteil dieses Materials wird Wissenschaftlern ab 1999 zugänglich sein.

Die bislang genannten Beispiele und die im vorliegenden Katalog aufgeführten bieten lediglich einen kleinen Einblick in die literarischen und historischen Manuskripte der Pierpont Morgan Library. Die sich weiter vergrößernde Sammlung wird auch künftig durch Ausstellungen und durch die Arbeit der Wissenschaftler zu einem besseren Verständnis der amerikanischen und der europäischen Kultur beitragen.

BENVENUTO CELLINI

(Florence 1500–1571 Florence)

97

Autograph memorandum and letter

Dated [Florence], 16 December 1549, to Cosimo I de'Medici, through his majordomo Pier Francesco Ricci
295 x 215 mm

Purchased by J. P. Morgan, Jr., in 1920; MA 973

Eigenhändiges Rechnungsblatt und Brief

Datiert [Florenz], 16. Dezember 1549, gerichtet an Cosimo I. de'Medici über dessen Haushofmeister Pier Francesco Ricci
295 x 215 mm

Erworben 1920 von J. P. Morgan jr.; MA 973

Commissioned by Grand Duke Cosimo in 1545, Cellini's masterpiece *Perseus and Medusa* stands as a counterpart to Donatello's *Judith and Holofernes* in the Loggia dei Lanzi, Florence. Cellini's bronze was not completed until 1554 owing to the difficulty of casting such a massive work. Shown here is an account of expenditures, totaling 57 ducats, for the casting of *Perseus* and several lesser projects. Cellini reports to his patron that "a de 15 di settembre 1549 si cominiciò l'armatura di Perseo con tre opere" (on the 15th day of September 1549 we began to prepare the props for the casting of Perseus with three structures).

Cellini lists expenses for materials: wood, marble, and English pewter; services: furnace preparation and melting; and assistants: the smith and various workmen, adding, "Non conto le grosse spese che si disfá con tali gagliardi appetiti" (I do not reckon the heavy expenses I have incurred with such heavy eaters). He appeals to the duke for additional materials he cannot afford to supply, including files, rasps, chisel, hammers, and other tools as well as additional assistants, in particular those who hammer copper.

The Library's collection is particularly strong in letters and manuscripts of artists, statesmen, popes and cardinals, and other important figures of the Renaissance.

Cellinis Meisterwerk *Perseus und Medusa,* das 1545 von Großherzog Cosimo de'Medici in Auftrag gegeben wurde, steht in der Loggia dei Lanzi in Florenz als Gegenstück zu Donatellos *Judith und Holofernes.* Aufgrund der Schwierigkeiten, die das Gießen eines solch mächtigen Werkes mit sich bringt, wurde Cellinis Bronze erst 1554 fertiggestellt. Gezeigt wird hier eine Auslagenrechnung über insgesamt 57 Dukaten für den Guß des *Perseus* und verschiedene kleinere Arbeiten. Cellini berichtete seinem Auftraggeber, »a de 15 di settembre 1549 si cominiciò l'armatura di Perseo con tre opere« (am 15. September 1549 haben wir mit drei verschiedenen Stützformen das innere Gerüst für den Guß des Perseus begonnen).

Es finden sich Aufwendungen für Materialien aufgelistet, so für Holz, Marmor und englisches Zinn; für Dienstleistungen wie die Rüstung des Ofens und das Schmelzen; für Gehilfen wie den Schmied und verschiedene Arbeiter. Cellini fügte hinzu: »Non conto le grosse spese che si disfá con tali gagliardi appetiti« (Ich berechne nicht die großen Unkosten, die mir mit solch kräftigen Essern entstanden sind). Er wandte sich an den Großherzog mit der Bitte um weitere Werkzeuge, die er sich nicht leisten könne, darunter Feilen, Raspeln, Meißel, Hammer, und um andere Arbeitsmittel sowie zusätzliche Gehilfen, und zwar speziell für das Hämmern von Kupfer.

Die Sammlung der Pierpont Morgan Library ist besonders reich an Briefen und Handschriften von Künstlern, Staatsmännern, Päpsten, Kardinälen und anderen bedeutenden Persönlichkeiten der Renaissance.

Conto delle spese fatte nel gietto di perseo 118

A dde 15 di settembre 1549 si cominicio larmadura di Perseo
posre opere mo bartolomeo fabbro co dua sua lavoranti
no contando mia di bottegha bernardino osero
et marchionne silavoro tutti i siene gissino attutto
il mese di ottobre et dettesi al detto mo Ba
⅌ lui et sua lavoranti tre lire e mezo il giorno che
sono schudi Δ 23

⎧ acconci disomma
⎩ Δ 57

E piu p 150 libre di ferro i 2 barre lunghe che si
presono da i possessione di ms bindo altouiti pe
sere ferro vechio e buono quali seruirro ap
seo et dipo alla fornace chome ora sine de a dire
chea il cento somma Δ 2 ⅃

E piu pne giornate i fra mettere i sopa et i fonde
re co assai huomini buone et alti attale gran
di i priesa sietre loro schudi tredici Δ 13

E piu pma catasta e dua terzi di legne di honta
no auta da ms alessandro i mettre che si forde
ua schudi gnauo Δ 4

E piu da m ª ginevra del capretta una ca
tasta di legne di quercio auta i la medesima
necesita lire diciasette Δ 2 ⅃3

E piu p 22 peci di stagni i ghilesi cioe piatti gra
di et mezani et schodelle quali si gitorno nel
la fornace dato che si fu alla spina pche il
metalla correva male rispetto alla umi
sita che sebbe costommi schudi tre Δ 3

 8 4 7 2 4

98

HISTOIRE NATURELLE DES
INDES

Illustrated manuscript, [ca. 1586]
300 x 210 mm

Bequest of Clara S. Peck, 1983;
MA 3900

HISTOIRE NATURELLE DES
INDES

Illustrierte Handschrift, [um 1586]
300 x 210 mm

Vermächtnis von Clara S. Peck; 1983;
MA 3900

This remarkable manuscript is perhaps the most comprehensive extant portrait of the late sixteenth-century Caribbean world. With two mentions of Sir Francis Drake and over thirty geographical references to his known ports of call, the work has been dubbed the "Drake manuscript." Its formal name, *Histoire naturelle des Indes,* is taken from the title page that was inserted when the manuscript was bound in the eighteenth century. The drawings and accompanying French text record early European observations of West Indian flora and fauna as well as customs of the indigenous population. Evident are the hands of at least two artists and two scribes. If the anonymous authors were neither sophisticated botanists nor schooled ethnographers, they were nevertheless "thoroughgoing" observers. The manuscript offers rich primary source material from the anthropological to the linguistic to the ethnobotanical.

The manuscript became known in 1867, when it was offered for sale by the London dealer Bernard Quaritch. It was owned subsequently by two English collectors, Henry Huth and C. F. G. R. Schwerdt, before being acquired by the American collector Clara S. Peck in 1947. It was not accessible to scholars until 1983, when it was bequeathed to the Library.

In dieser bemerkenswerten Handschrift hat sich möglicherweise die umfassendste Darstellung der karibischen Welt aus dem späten 16. Jahrhundert erhalten. Da Sir Francis Drake in dem Manuskript zweimal erwähnt wird und sich darüber hinaus mehr als 30 Hinweise auf die von ihm angelaufenen Häfen finden, wird das Werk meist als »Drake-Handschrift« bezeichnet. Der offizielle Name, *Histoire naturelle des Indes,* stammt von der Titelseite, die man ergänzte, als die Handschrift im 18. Jahrhundert gebunden wurde. Die Zeichnungen und der französische Begleittext dokumentieren frühe europäische Beobachtungen zur westindischen Flora und Fauna sowie zu Sitten und Gebräuchen der Eingeborenen. Es lassen sich mindestens zwei Zeichner und zwei Schreiber unterscheiden. Wenngleich die anonymen Autoren keine geschulten Botaniker oder Ethnographen waren, so erweisen sie sich dennoch als überaus sorgfältige Beobachter. Das Manuskript bietet ein reiches Quellenmaterial, das in anthropologischer, linguistischer und ethnobotanischer Hinsicht von großem Interesse ist.

Von der *Histoire* erhielt man 1867 Kenntnis, als sie von dem Londoner Händler Bernard Quaritch zum Verkauf angeboten wurde. Später gelangte sie in den Besitz zweier englischer Sammler, Henry Huth und C. F. G. R. Schwerdt, bevor sie 1947 von der Amerikanerin Clara S. Peck erworben wurde. Erst seit 1983 – als sie der Pierpont Morgan Library vermacht wurde – ist die Handschrift der Forschung zugänglich.

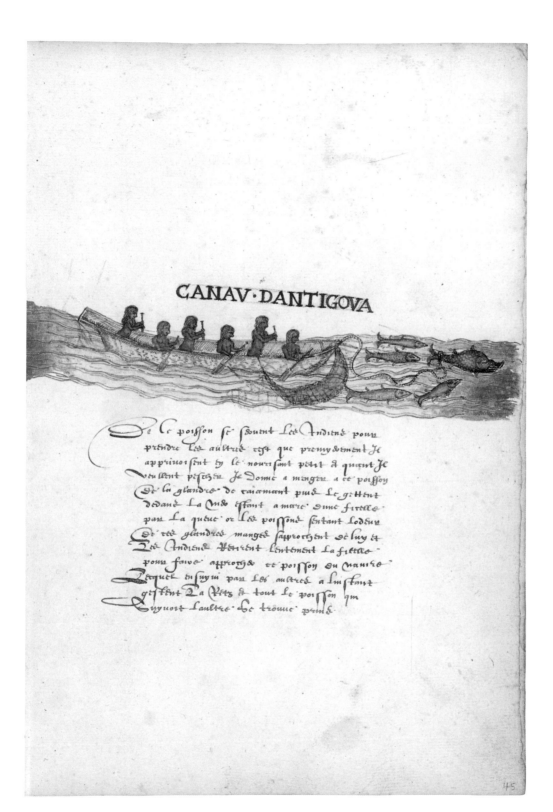

CANAV·DANTIGOVA

De ce poisson se servent Les Indiens pour
prendre Les aultres tels que premyerement Jl
apprivoisent ty le nourrisant petit a quant Jl
veullent pescher Je donne a manger a ce poisson
De la glandre de raisinant puis Le gittent
dedans La onde estant a mere avec ficelle
par La queue or Les poissons sentant l'oddeur
De ces glandres manges s'approchent de luy et
Les Indiens tirent lentement La ficelle
pour faire approche ce poisson en maniere
Lequel en suyvi par Les aultres a l'instant
gistent La Vers et tout le poisson qui
suyvoit l'aultre se treuve pris

PETER PAUL RUBENS

(Siegen, Germany, 1577–1640 Antwerp)

99

AUTOGRAPH LETTER

Signed, dated Antwerp, 5 November
1626, to Pierre Dupuy
320 x 205 mm

Gift of Ruth Saunders Magurn in
memory of Helen Delano Willard,
1979; MA 4339

EIGENHÄNDIGER BRIEF

Signiert, datiert Antwerpen,
5. November 1626, an Pierre Dupuy
320 x 205 mm

Schenkung 1979 von Ruth Saunders
Magurn im Gedenken an Helen
Delano Willard; MA 4339

Surviving letters of Rubens, the most influential northern European artist of the seventeenth century, reveal an extraordinarily versatile man deeply immersed in intellectual and political currents of his day. This sample of his correspondence with Pierre Dupuy, royal librarian and councillor to Louis XIII of France, exemplifies his knowledge of international affairs. Writing in Italian, the favored language of European diplomacy at the time, Rubens comments on one of the great contemporary political scandals, the Chalais conspiracy against Cardinal Richelieu; expresses his disappointment at the sluggish peace negotiations between Spain and England; and reports on movements of the English fleet.

Rubens was interested in politics not as a bystander but as a participant. His weekly exchange of letters with Dupuy, from 1626 to 1628, took place in the course of his service, from 1621 to 1630, as diplomat for the Spanish Habsburgs. Diplomacy served his art, as contacts he made through official visits to European courts often led to important commissions for paintings.

The Library's collection of Rubens documents includes his contract for the series of paintings commissioned for the Luxembourg Palace by Marie de'Medici in 1622. Many other artists, from the Renaissance to the twentieth century, are represented by letters and documents.

Die erhaltenen Briefe des einflußreichsten nordeuropäischen Künstlers aus dem 17. Jahrhundert zeigen Peter Paul Rubens als überaus gewandte Persönlichkeit inmitten der geistigen und politischen Strömungen seiner Zeit. Das vorliegende Beispiel aus seiner Korrespondenz mit Pierre Dupuy, dem königlichen Bibliothekar und Ratgeber Ludwigs XIII. von Frankreich, belegt seine Kenntnis in internationalen Angelegenheiten. Rubens kommentiert auf Italienisch, also in der bevorzugten Sprache der europäischen Diplomatie dieser Epoche, einen der größten zeitgenössischen politischen Skandale: die Verschwörung des Comte de Chalais gegen Kardinal Richelieu; zudem bringt Rubens seine Enttäuschung über die langwierigen Friedensverhandlungen zwischen Spanien und England zum Ausdruck und berichtet über englische Flottenbewegungen.

Rubens war an Politik nicht nur als Beobachter, sondern auch als aktiv Mitwirkender interessiert. Seine wöchentliche Korrespondenz mit Dupuy in den Jahren 1626 bis 1628 fiel in den Rahmen seiner Tätigkeit als Diplomat im Dienste der spanischen Habsburger. Dieses Amt kam auch seiner Kunst zugute, da die im Verlauf offizieller Missionen an den europäischen Höfen geknüpften Kontakte oft bedeutende Auftragsarbeiten mit sich brachten.

Die Sammlung der Rubens-Dokumente in der Pierpont Morgan Library enthält auch seinen Vertrag über den 1622 von Maria de' Medici für den Palais du Luxembourg in Auftrag gegebenen Gemäldezyklus.

Zahlreiche andere Künstler, von der Renaissance bis ins 20. Jahrhundert, sind in der Pierpont Morgan Library ebenfalls mit Briefen und Dokumenten vertreten.

nator di Bruges furono dal presidio di
quella piazza ricceuuti con Archebuggirate y
Cannonate con perdita d'alcuni et il Conte
sopradetto ebbe una ferita in faccia
È però stranissimo che essendo questo successi
se 29 d'Ottobre che son adesso non si sa
per precisamente la verità anzi sene par=
la tanto diuersamente che non si po affer=
mar niente di certo eccetto che la Impresa
è fallita ne hauendo altro farò fine
con baccar a VS et al S.r suo fratello humil=
mente le mani y racommandarmi nella lor buona
gratia

Adesso è Compassa quella Quistione Politica
della quale VS mi scrisse ni ancora un altro
libretto Intitulato Instructio secreta ad Comitem
Palatinum Jo gli mandarei a VS volentieri
se VS non me hauesse contremandata la Commissione
et a dir il vero queste bagattelle non vagliono
il porto et mi sono marauigliato piu volte
che Monsieur di Valauey le pagasse tanto
care Quando VS mi vorrà fauorire di
mandar quel libretto come quello, che VS
mi serue stamparsi adesso potra per
Monsieur di la Mothe farlo Consigniare al
S.r Ambasciatore di Franza che bem me
lo fara venire sicuramente et se qui
simil cose soffrira qualche cosa degna della Curiosità
de VS sen trouarò qualche Amico passaggiero
per darli il recapito

D'Anuersa il 5 d'Nouembre 1626

Di V.S. m.a
Molto Illustre

Seruitor aff.mo
Pietro Paaolo Rubens

JEAN-JACQUES ROUSSEAU

(Geneva 1712–1778 Ermenonville, France)

100

[JULIE: OU, LA NOUVELLE
HÉLOÏSE]

Autograph manuscript, [1759–60]
205 x 150 mm*

The Dannie and Hettie Heineman
Collection, gift of the Heineman
Foundation, 1977; Heineman MS 181A

[JULIE: OU, LA NOUVELLE
HÉLOÏSE]

Eigenhändiges Manuskript, [1759–60]
205 x 150 mm*

The Dannie and Hettie Heineman
Collection, Geschenk der Heineman
Foundation, 1977; Heineman MS 181A

Rousseau took special care in preparing the final draft of *Julie: ou, la Nouvelle Héloïse* for Marc-Michel Rey, his publisher in Amsterdam. Unwilling to travel there from his residence in Montmorency, France, to see the novel through publication, he agreed to simplify the compositor's task by submitting a clean, legible manuscript that would require minimal revision over the course of its production. Rousseau recopied from earlier drafts and submitted the work in parts from April 1759 to January 1760. His manuscript, with light revisions and careful punctuation, proves that he kept his promise. Rey, delayed by the necessity of having the author correct his proofs by mail, did not have the bound edition ready until November 1760.[1]

Rousseau's epistolary novel, a tale of passionate love between a tutor, Saint-Preux, and an aristocrat, Julie d'Etange, was an immediate success. *La Nouvelle Héloïse,* as the novel came to be known, was the most generally admired of Rousseau's works during his lifetime and one of the most widely read books of the eighteenth century.

Two of Rousseau's fellow Encyclopedists—and sometime philosophical adversaries—are also represented in the Library: Voltaire, by the largest collection of his letters in the United States, and Diderot, by his manuscript of *Le Neveu de Rameau.*

1. McEachern 1993, pp. 13–91.

*Note: Reproduction is enlarged.

Die endgültige Fassung des Manuskriptes von *Julie: ou, la Nouvelle Héloïse* bereitete Rousseau mit besonderer Sorgfalt für seinen Amsterdamer Verleger Marc-Michel Rey vor. Da er nicht bereit war, von seinem Wohnsitz im französischen Montmorency nach Amsterdam zu reisen, um persönlich bei den Vorbereitungen zur Drucklegung zugegen zu sein, willigte Rousseau ein, dem Schriftsetzer ein einwandfreies, gut lesbares Manuskript zu liefern, bei dem nur geringfügige Satzkorrekturen anfallen würden. Rousseau schrieb frühere Fassungen ab und legte das Werk von April 1759 bis Januar 1760 in mehreren Lieferungen vor. Sein nur wenig überarbeitetes und sorgfältig interpunktiertes Manuskript beweist, daß er sein Versprechen einhielt. Aufgehalten durch das umständliche Korrekturverfahren über den Postweg, konnte Rey die Buchausgabe erst im November 1760 fertigstellen.[1]

Rousseaus Briefroman, eine leidenschaftliche Liebesgeschichte zwischen einem Hauslehrer, Saint-Preux, und der Aristokratin Julie d'Etange, wurde sogleich ein großer Erfolg. Das zu Rousseaus Lebzeiten sehr bewunderte Werk erlangte unter dem Titel *La Nouvelle Héloïse* Bekanntheit und war zugleich eines der meistgelesenen Bücher des 18. Jahrhunderts.

Zwei andere Enzyklopädisten – zeitweise philosophische Gegner Rousseaus – sind ebenfalls in der Pierpont Morgan Library vertreten: Voltaire mit der umfangreichsten Sammlung seiner Briefe in den Vereinigten Staaten und Diderot mit dem Manuskript zu *Le Neveu de Rameau.*

1. McEachern 1993, S. 13–91.

*Anm.: Das Manuskript ist vergrößert abgebildet.

Lettre III. *

à Milord Edouard.

Nous avons eu des hôtes ces jours derniers. Ils sont
repartis hier, et nous recommençons entre nous trois une
Société d'autant plus charmante qu'il n'est rien resté
dans le fond des cœurs qu'on veuille se cacher l'un à
l'autre. Quel plaisir je goûte à reprendre un nouvel
être qui me rend digne de vôtre confiance! Je ne
reçois pas une marque d'estime de Julie et de son
mari, que je ne me dise avec une certaine fierté
d'ame; enfin j'oserai me montrer à lui. C'est par
vos soins, c'est sous vos yeux que j'espère honorer
mon état présent de mes fautes passées. Si l'amour
éteint jette l'ame dans l'épuisement, l'amour
subjugué lui donne avec la conscience de sa
victoire une élévation nouvelle, et un attrait plus
vif pour tout ce qui est grand et beau. Voudrois-on
perdre le fruit d'un sacrifice qui nous a coûté si
cher? Non, Milord, je sens qu'à vôtre exemple
mon cœur va mettre à profit tous les ardens sentimens
qu'il a vaincus. Je sens qu'il faut avoir été ce que
je fus pour devenir ce que je suis.

Après six jours perdus aux entretiens frivoles de
gens indifférens, nous avons passé aujourdui une
matinée à l'angloise, réunis et dans le silence,
goûtant à la fois le plaisir d'être ensemble et la
douceur du recueillement. Que les délices de cet état
sont connües de peu de gens! Je n'ai vû personne
France en avoir la moindre idée, ~~prendrai-je~~
~~pour un peu moins que pour des importuns~~. La
conversation des amis ne tarit jamais, disent-
Il est vrai, la langue fournit un babil facile
attachemens médiocres. Mais l'amitié, Milord, l'ami

* Deux Lettres écrites en différens tems rouloient sur le sujet
celle-ci, ce qui occasionnoit bien des répétitions inutiles. Pour les
retrancher, j'ai réuni ces deux Lettres en une
seule.

sentiment vif et celeste; quels discours font dignes de 47
toi? Quelle langue ose être ton interprète? Jamais ce
qu'on dit à son ami peut-il valoir ce qu'on sent à -
ses côtés? Mon Dieu! qu'une main serrée, qu'un
regard animé, qu'une étreinte contre la poitrine,
que le soupir qui la suit disent de choses, et que le
prémier mot qu'on prononce est froid après tout
cela! Ô veillées de Besançon! momens consacrés
au silence et recueillis par l'amitié! Ô Bomston!
ame grande, ami sublime! Non, je n'ai point
avili ce que tu fis pour moi, et ma bouche ne t'en
a jamais rien dit.

Il est sûr que cet état de contemplation fait un
des grands charmes des caractères tendres et sensibles:
Mais j'ai toujours trouvé que les importuns —
empêchoient de le goûter, et que les amis ont
besoin d'être sans témoin pour pouvoir ne se
rien dire, à leur aise. On veut être recueillis, -
pour ainsi dire, l'un dans l'autre: les moindres —
distractions sont désolantes, la moindre contrainte
est insupportable. Si quelquefois le cœur porte
un mot à la bouche, il est si doux de pouvoir le
prononcer sans gêne. Il semble qu'on n'ose penser
librement ce qu'on n'ose dire de même: il semble
que la présence d'un seul étranger retienne le
sentiment, et comprime des ames qui s'entendroient
si bien sans lui.

Deux heures se sont ainsi écoulées entre nous —
dans cette immobilité d'extase, plus douce mille
fois que le froid repos des Dieux d'Epicure. Après
le déjeuné, les enfans sont entrés comme à -
l'ordinaire dans la chambre de leur mère; mais
au lieu d'aller ensuite s'enfermer avec eux dans
le gynécée selon sa coutume; pour nous dédomager
en quelque sorte du tems perdu sans nous voir,
elle les a fait rester avec elle, et nous ne nous -

GIOVANNI BATTISTA PIRANESI
(Mogliano Veneto 1720–1778 Rome)

AUTOGRAPH LETTER

Signed, dated Rome, 2 August 1772, to Charles Townley, with study of the Warwick Vase drawn as a heading
310 x 215 mm

Purchased in memory of Mrs. J. P. Morgan, Jr., as the gift of Julia P. Wightman, Mrs. Charles Wrightsman, and John P. Morgan II, 1985; MA 4220

EIGENHÄNDIGER BRIEF

Signiert, datiert Rom, 2. August 1772, an Charles Townley, mit einer Zeichnung der »Warwick-Vase« als Briefkopf
310 x 215 mm

Erworben 1985 in Erinnerung an Mrs. J. P. Morgan jr., als Geschenk von Julia P. Wightman, Mrs. Charles Wrightsman und John P. Morgan II; MA 4220

In 1772 Piranesi headed this letter to Charles Townley, the great English collector of antiquities, with a drawing of one of the most celebrated archaeological finds of the day. Dating from the second century, the piece that came to be known as the Warwick Vase had been unearthed in fragments during the excavation of Hadrian's Villa at Tivoli in 1771. Piranesi's drawing very likely provided Townley his first view of the vase's restoration. In his draft for a response, which is also in the Library, Townley gratefully acknowledges "une nouvelle existence et parfait" (a new and perfect existence) for the vase from "les mains merveilleuses de l'admirable Piranesi" (the marvelous hands of the admirable Piranesi).

The artist's later etching of the vase, published in his collection *Vasi, candalabri, cippi* (1778), was dedicated to Sir William Hamilton, collector and British ambassador to the Court of Naples, who had purchased the pieces and funded the reconstruction. After an unsuccessful attempt to sell the vase to the British Museum, Hamilton sold it to his nephew, the earl of Warwick. It remained at Warwick Castle until 1979, when it was acquired by the Burrell Collection, Glasgow.

1772 versah Piranesi den Briefkopf dieses Schreibens an Charles Townley, den großen englischen Antikensammler, mit der Zeichnung eines der berühmtesten archäologischen Fundstücke seiner Zeit. Das als »Warwick-Vase« bezeichnete, aus dem 2. Jahrhundert stammende Gefäß war bei der Ausgrabung der Hadriansvilla in Tivoli 1771 in Bruchstücken gefunden worden. Vieles spricht dafür, daß Piranesis Zeichnung Townley die erste Ansicht seiner Restaurierung der Vase lieferte. Im Entwurf eines Antwortschreibens, der sich ebenfalls in der Pierpont Morgan Library befindet, erkennt Townley dankbar an, daß die Vase durch »les mains merveilleuses de l'admirable Piranesi ... une nouvelle existence et parfait« (die wunderbaren Hände des bewunderungswürdigen Piranesi ... eine neue und vollständige Existenz) erhalten habe.

Der später entstandene Kupferstich der Vase, 1778 in *Vasi, candalabri, cippi* veröffentlicht, war Sir William Hamilton gewidmet, dem Sammler und britischen Botschafter am Hof von Neapel, der die Fragmente erworben und die Rekonstruktion finanziell ermöglicht hatte. Nach einem gescheiterten Versuch, die Vase an das British Museum in London zu verkaufen, veräußerte Hamilton sie an seinen Neffen, den Earl of Warwick. Sie verblieb in Warwick Castle bis 1979, als sie von der Burrell Collection in Glasgow erworben wurde.

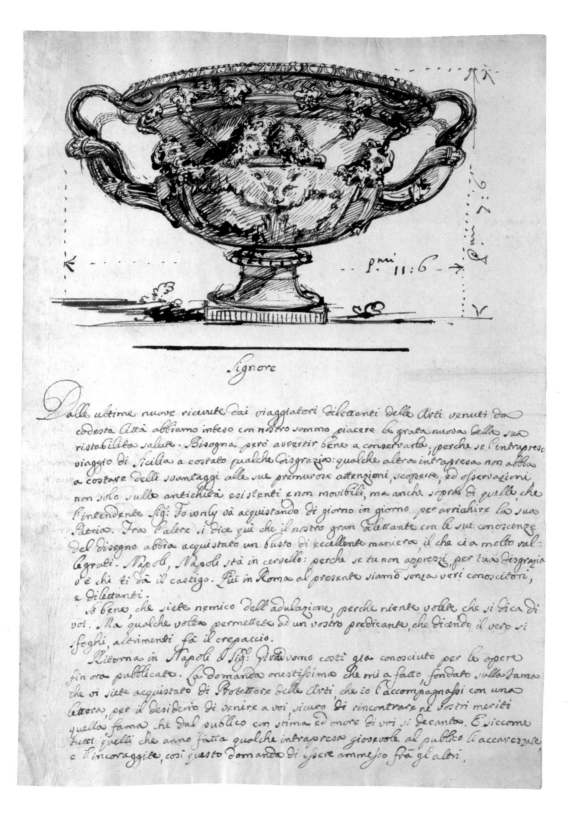

P.mi 11:6 — p.mi 7:6

Signore

Dalle ultime nuove ricevute dai viaggiatori dilettanti delle Arti venuti da codesta Città abbiamo inteso con nostro sommo piacere la grata nuova della sua ristabilita salute. Bisogna però avvertir bene a conservarla, perche se l'intrapreso viaggio di Sicilia a costato qualche disgrazia: qualche altra intrapresa non abbia a costare delli svantaggi alle sue premurose attenzioni, scoperte, ed osservazioni non solo sulle antichità esistenti e non movibili, ma anche sopra di quelle che l'intendente Sig: Townly va acquistando di giorno in giorno per arricchire la sua Patria. Fra l'altre si dice già che il nostro gran dilettante con le sue conoscenze del disegno abbia acquistato un busto di eccellente maniera, il che ci a molto rallegrati. Napoli, Napoli stà in cervello: perche se tu non apprezzi, per tua disgrazia v'è chi ti dà il castigo. Più in Roma al presente siamo senza veri conoscitori, e dilettanti.

Sò bene che siete nemico dell'adulazione, perche niente volete che si dica di voi. Ma qualche volta permettete ad un vostro predicante, che dicendo il vero si sfoghi, altrimenti fà il crepaccio.

Ritorna in Napoli il Sig: Jenkins così già conosciuto per le opere fin ora pubblicate. La domanda onestissima che mi a fatto fondato sulla fama che vi siete acquistato di Protettore delle Arti che io l'accompagnassi con una lettera, per il desiderio di venire a voi sicuro di rincontrare ne vostri meriti quella fama che dal publico con stima ed onore di voi si decanta. E siccome tutti quelli che anno fatta qualche intrapresa gioievole al publico li accarezzate e l'incoraggite, così questo domanda di essere ammesso frà gl'altri.

JANE AUSTEN

(Steventon, Hampshire, 1775–1817 Winchester, Hampshire)

LADY SUSAN

Autograph manuscript, [1805]
325 x 265 mm

Purchased in 1947; MA 1226

LADY SUSAN

Eigenhändiges Manuskript, [1805]
325 x 265 mm

Erworben 1947; MA 1226

Lady Susan is the sole surviving complete manuscript of a novel by Jane Austen. Of her major novels, the only extant manuscripts are a draft title page of *Northanger Abbey,* also in the Library, and two chapters of *Persuasion.* The manuscripts of the rest of those works and of the other novels published in her lifetime were likely destroyed after serving as printer's copy. Written in 1805, *Lady Susan* was not published until 1871, fifty-four years after Austen's death. It is a novel in letters, a form brought to great popularity by Samuel Richardson, Tobias Smollett, Fanny Burney, and others. Though an inveterate writer of letters socially, professionally Austen found the epistolary method uninspiring. *Lady Susan* concludes abruptly, "This Correspondence, by a meeting between some of the Parties & a separation between the others, could not, to the great detriment of the Post office Revenue, be continued longer."

After Austen's death, her sister Cassandra distributed her manuscripts among family members, with whom they remained until this century, when many were sold. Today the Morgan Library and the British Library are the major repositories of Austen manuscripts. The Morgan Library's holdings include *Plan of a Novel,* the aforementioned fragment of *Northanger Abbey,* the first six leaves of *The Watsons,* and, with over fifty of the 125 letters that survive, the largest single collection of her extant correspondence.

Von den Manuskripten der großen Romane Jane Austens ist das von *Lady Susan* als einziges vollständig überliefert; lediglich der Entwurf des Titelblattes von *Northanger Abbey,* ebenfalls in der Pierpont Morgan Library, und zwei Kapitel aus *Persuasion* sind in dieser Form erhalten. Die restlichen Manuskripte dieser und der übrigen zu ihren Lebzeiten veröffentlichten Romane wurden vermutlich zerstört, nachdem sie als Druckvorlage gedient hatten. 1805 verfaßt, wurde *Lady Susan* erst 1871, also 54 Jahre nach Austens Tod, publiziert. Es handelt sich um einen Briefroman – eine literarische Gattung, die durch Samuel Richardson, Tobias Smollett, Fanny Burney und andere Popularität erlangt hatte. Obgleich Austen im gesellschaftlichen Umgang eine passionierte Briefschreiberin war, fand sie die Briefform für ihre Arbeit als Schriftstellerin wenig inspirierend. So endet denn auch *Lady Susan* ganz abrupt: »This Correspondence, by a meeting between some of the Parties & a separation between the others, could not, to the great detriment of the Post office Revenue, be continued longer« (Zum großen Schaden der Einnahmen im Postwesen konnte dieser Briefwechsel nicht fortgesetzt werden, da es unter einigen der Beteiligten zu einem persönlichen Zusammentreffen, bei den übrigen hingegen zu einer endgültigen Trennung kam).

Nach Austens Tod verteilte ihre Schwester Cassandra ihre Manuskripte unter den Familienmitgliedern. Dort verblieben sie bis zu ihrem Verkauf in diesem Jahrhundert. Heute besitzen die Pierpont Morgan Library und die British Library die größten Sammlungen von Austen-Manuskripten. Zum Bestand der Pierpont Morgan Library gehören *Plan of a Novel,* das bereits erwähnte Fragment von *Northanger Abbey,* die ersten sechs Blätter von *The Watsons* sowie die mit mehr als 50 der insgesamt 125 überlieferten Briefe größte Einzelsammlung ihrer erhaltenen Korrespondenz.

=tage. There cannot be a more gentle, affectionate
heart, or more obliging manners, when acting
without restraint. Her little Cousins are all very
fond of her.— Yr. affec:ly

Cath Vernon

Letter 19.

Lady Susan to Mrs Johnson

Churchill.

You will be eager I know to hear something
farther of Frederica, & perhaps may think me neg:
:ligent for not writing before.— She arrived with
her Uncle last Thursday fortnight, when of course
I lost no time in demanding the reason of her be:
:haviour, & soon found myself to have been perfectly
right in attributing it to my own letter.— The pur:
:port of it frightened her so thoroughly that with a
mixture of true girlish peeveisness & folly, without

THOMAS JEFFERSON

(Shadwell, Virginia, 1743–1826 Monticello, Virginia)

Thomas Jefferson received immense pleasure from his correspondence with Baron von Humboldt, pioneer in the remarkably wide-ranging study of the geography, politics, economy, and plants and animals of the Americas. In this letter, Jefferson thanks Humboldt for sending recently published installments of his works *Essai sur la Royaume de la Nouvelle-Espagne* and *Astronomie*. They were part of the Prussian explorer's 35-volume account of his 6,000-mile journey through Latin America from 1799 to 1804, *Voyage de Humboldt et Bonpland aux régions équinoxiales du nouveau continent* (1805–34). Praising Humboldt for making countries "known to the world in the moment when they were about to become actors on its stage," the American revolutionary leader predicted hopefully—and accurately—that "they will throw off their European dependence."

A scientist and outspoken opponent of slavery, Humboldt recognized a kindred spirit in the author of *Notes on the State of Virginia* (1784) and the American Declaration of Independence (1776). In 1808 he sent Jefferson an earlier installment of his *Essai,* wherein he extolled Jefferson's support of science and commended *Notes* for its persuasive denunciation of slavery. In the accompanying letter, which is also in the Library, he told Jefferson, "There you will see your name quoted with that enthusiasm which it has always inspired among friends of humanity."[1]

The Library's holdings include extensive correspondence of another great European friend of the American Revolution, the marquis de Lafayette.

1. Alexander von Humboldt, autograph letter signed, dated Paris, 30 May 1808, acc. no. MA 6020, The Pierpont Morgan Library.

Thomas Jefferson zog das größte Vergnügen aus seiner Korrespondenz mit dem Baron von Humboldt, dem Pionier einer außerordentlich weitreichenden Erforschung der Geographie, Politik, Ökonomie sowie der Pflanzen- und Tierwelt Nord- und Südamerikas. In diesem Brief dankt Jefferson Humboldt für die Übersendung kurz zuvor erschienener Lieferungen seiner beiden Werke *Essai sur le Royaume de la Nouvelle-Espagne* und *Astronomie.* Sie waren Teil des 35bändigen Berichtes des preußischen Forschers über seine zwischen 1799 und 1804 unternommene, über rund 10 000 Kilometer führende Reise durch Lateinamerika: *Voyage de Humboldt et Bonpland aux régions équinoxiales du nouveau continent* (1805–34). Der Führer der Unabhängigkeitsbewegung hebt im vorliegenden Brief hervor, daß Humboldt die Länder Lateinamerikas »der übrigen Welt gerade in dem Moment erschließe, da sie selbst dabei seien, als Akteure die Bühne des Weltgeschehens zu betreten«, und verband sein Lob mit der hoffnungsvollen – und zutreffenden – Voraussage, »daß sie ihre Abhängigkeit von Europa abschütteln werden«.

Als Wissenschaftler und offener Gegner der Sklaverei erkannte Alexander von Humboldt in dem Verfasser der *Notes on the State of Virginia* (1784) und der Amerikanischen Unabhängigkeitserklärung (1776) einen Verwandten im Geist. 1808 übersandte er Jefferson eine frühere Lieferung seines *Essais,* in dem er nicht nur dessen Förderung der Wissenschaft in höchstem Maße pries, sondern auch Jeffersons *Notes* aufgrund ihrer überzeugenden Verurteilung der Sklaverei nachhaltig empfahl. In seinem ebenfalls im Besitz der Pierpont Morgan Library befindlichen Begleitschreiben äußerte Humboldt gegenüber Jefferson: »Sie werden Ihren Namen darin mit dem gleichen Enthusiasmus zitiert finden, den er unter Freunden der Menschheit stets hervorgerufen hat.«[1]

Im Besitz der Bibliothek befindet sich auch die umfangreiche Korrespondenz eines anderen großen europäischen Anhängers der amerikanischen Unabhängigkeitsbewegung, des Marquis de Lafayette.

1. Alexander von Humboldt, eigenhändiger Brief, signiert, datiert Paris, 30. Mai 1808, Inv.-Nr. MA 6020, The Pierpont Morgan Library.

my dear friend and Baron. Dec. 6. 13.

I have to acknolege your two letters of Dec. 20. & 26. 1811. by mr
Correa. and am first to thank you for making me acquainted with that
most excellent character. he was so kind as to visit me at Monticello,
and I found him one of the most learned and amiable of men. it was a
subject of deep regret to separate from so much worth in the moment of
it's becoming known to us. the livraison of your Astronomical
observations, and the 6th. and 7th on the subject of New Spain, with the
corresponding Atlasses are duly received, as had been the preceeding
Cahiers. for these treasures of a learning so interesting to us, accept my
sincere thanks. I think it most fortunate that your travels in those
countries were so timed as to make them known to the world in the mo-
-ment they were about to become actors on it's stage. that they will throw
off their European dependance I have no doubt; but in what kind of
government their revolution will end is not so certain. history, I believe
furnishes no example of a priest-ridden people maintaining a free
civil government. this marks the lowest grade of ignorance, of which
their civil as well as religious leaders will always avail themselves for
their own purposes. the vicinity of New Spain to the US. and their con-
-sequent intercourse may furnish schools for the higher, and example for
the lower classes of their citizens. and Mexico, where we learn from you
that men of science are not wanting, may revolutionise itself under
better auspices than the Southern provinces. these last, I fear, must end
in military despotisms. the different casts of their inhabitants, their
mutual hatreds and jealousies, their profound ignorance & bigotry, will be
played off by cunning leaders, and each be made the instrument of ensla-
-ing the others. but all this you can best judge, for in truth we have little
knolege of them, to be depended on, but through you. but in whatever
governments they end, they will be American governments, no longer to be
involved in the never-ceasing broils of Europe. the European nations
constitute a separate division of the globe; their localities make them part
of a distinct system; they have a set of interests of their own in which it is our
business never to engage ourselves. America has a hemisphere to itself:
it must have it's separate system of interests, which must not be subordinated

GEORGE GORDON, LORD BYRON

(London 1788–1824 Missolonghi, Greece)

104

MANFRED

Autograph manuscript, [1816–17]
400 x 280 mm

Purchased by Pierpont Morgan, 1900;
MA 59

MANFRED

Eigenhändiges Manuskript, [1816–17]
400 x 280 mm

Erworben 1900 von Pierpont Morgan;
MA 59

This is Lord Byron's working draft of the first scene of his dramatic poem *Manfred,* written in his fluid hand and, customarily, revised only lightly. In refining the opening speech of his remorseful hero, Manfred, the poet has added several memorable lines crosswise:

> But grief should be the instructor of the wise;
> Sorrow is knowledge: they who know the most
> Must mourn the deepest o'er the fatal truth,
> The Tree of Knowledge is not that of Life.

Manfred is set in the Swiss Alps, where Byron was traveling in 1816 when he began the poem. Like his protagonist in the opening scene, the author was despondent. Estranged from his wife, Anne Isabella Milbanke, and plagued by rumors of incest with his sister, Augusta, he had left England hoping for solace amid the magnificent scenery of the Alps. He wrote in his journal that he could not, however, help recalling his personal difficulties: "Neither . . . the torrent, the mountain, the glacier, the forest, nor the cloud have for one moment . . . enabled me to lose my own wretched identity in the majesty and the power and the glory around, above, and beneath me."[1]

The Library's extensive collection of Byron manuscripts includes all of those given by the poet to his lover Teresa Guiccioli in 1823, when he left Italy to join Greek rebels fighting against Turkey. He died in Greece the following year.

1. Marchand 1976, p. 105.

Es handelt sich bei diesem Manuskript um Lord Byrons Entwurf für die erste Szene seines dramatischen Gedichtes *Manfred.* Der Text ist in der ihm eigenen flüssigen Handschrift niedergeschrieben und weist, wie es Lord Byrons Arbeitsweise entsprach, nur leichte Überarbeitungen auf. Zur Verbesserung der Eingangsrede seines reumütigen Helden hat der Dichter einige denkwürdige Verse quer auf dem Blatt hinzugefügt:

> Doch Gram soll ja des Weisen Lehrer sein:
> Leiden ist Wissen: wer am meisten weiß,
> Beklagt am tiefsten die unseel'ge Wahrheit:
> Der Baum des Wissens ist kein Baum des Lebens. (Übertragen von Otto Gildemeister.)

Ort der Handlung dieses Dramas sind die Schweizer Alpen, wo sich Lord Byron 1816 aufhielt, als er mit der Niederschrift des *Manfred* begann. Wie sein Protagonist in der Eingangsszene, so erlebte auch der Autor eine Zeit völliger Niedergeschlagenheit. Von seiner Frau Anne Isabella Milbanke entfremdet und geplagt durch Gerüchte über ein inzestuöses Verhältnis mit seiner Schwester Augusta, hatte er England in der Hoffnung verlassen, Trost inmitten der großartigen Alpenlandschaft zu finden. In seinem Tagebuch hielt er allerdings fest, daß ihn seine persönlichen Schwierigkeiten dennoch weiterhin quälten: »Kein Gebirgsbach, Berg, Gletscher oder Wald, und keine Wolke machten es mir auch nur für einen Augenblick möglich, mich meiner jämmerlichen Identität angesichts der Erhabenheit und der Macht und der Herrlichkeit um mich herum, über mir und unter mir zu entledigen.«[1]

Die umfangreiche Sammlung von Lord Byrons Manuskripten in der Pierpont Morgan Library umfaßt all jene Schriftstücke, die der Dichter seiner Geliebten Teresa Guiccioli im Jahr 1823 übergab, als er Italien verließ, um die griechischen Rebellen in ihrem Kampf gegen die Türkei zu unterstützen. Im darauffolgenden Jahr verstarb er in Griechenland.

1. Marchand 1976, S. 105.

Scene 1.st Act 1.st
 Manfred

The lamp must be replenished but even then
It will not burn so long as I must watch.
My slumbers — if I slumber — are no sleep
But a continuance of enduring thought
Which then I can resist not — in my heart
There is a vigil; — and these eyes but closed
To look within — and yet I live & bear
The aspect & the form of living men

Philosophy and science — and the springs
Of wonder — and the wisdom of the world
I have essayed — and in my mind there is
A power to make these subject to itself
But they avail not; — I have done men good
And I have met with good even among men
But this availed not — I have had my foes
And none have baffled — many fallen
But this availed not — good or evil; — the
Power — passions — all I see in other beings
Have been to me as rain unto the sands
Since that all nameless hour; — I have no dread

EDGAR ALLAN POE

(Boston 1809–1849 Baltimore)

105

TAMERLANE

Autograph fragment, [1828?]
225 x 185 mm

Purchased by Pierpont Morgan, 1909;
MA 570

TAMERLANE

Handschriftliches Fragment, [1828?]
225 x 185 mm

Erworben 1909 von Pierpont Morgan;
MA 570

Tamerlane and Other Poems, Poe's first book, was published and bound in a simple paper wrapper in 1827. The author was identified only as "A Bostonian." The eighteen-year-old Poe had moved to Boston from Richmond, Virginia, after quarreling with his guardian, John Allan, over gambling debts incurred at the University of Virginia. This collection of his early poetry is suffused with images of youth, love, beauty, and death—the prevailing themes of his life's work.

The Library's fragment of *Tamerlane,* the sole surviving manuscript of the poem, records the young poet's extensive changes for a revised version published in 1829. *Tamerlane* is a narrative poem framed as the fourteenth-century Tartar conqueror's deathbed reminiscences of lost love. Poe likely had in mind his own unhappy love affair with Sarah Elmira Royster, a Richmond neighbor to whom he had been secretly engaged in 1825. In 1827 she broke off the engagement and, to Poe's deep regret, married Alexander B. Shelton. After the poet's death, she claimed that he told her that she was "the lost Lenore" in *The Raven* as well as the inspiration for *Annabel Lee.*[1]

This fragment and other Poe manuscripts were part of the Stephen H. Wakeman collection, which Pierpont Morgan purchased in 1909. The collection also included important manuscripts of Emerson, Hawthorne, Thoreau, and other American writers.

1. Mabbott 1969, p. 474.

Poes erste Publikation, *Tamerlane and Other Poems,* erschien 1827, in einen einfachen Papierumschlag eingebunden; der Autor wurde lediglich als »A Bostonian« identifiziert. Der 18jährige Poe war nach einem Streit mit seinem Vormund John Allan wegen Spielschulden an der Universität von Virginia von Richmond, Virginia, nach Boston umgezogen. Diese Sammlung seiner frühen Dichtung ist mit Bildern von Jugend, Liebe, Schönheit und Tod durchtränkt, also bereits mit den Themen, die sein Lebenswerk beherrschen sollten.

Das sich im Besitz der Bibliothek befindende Fragment von *Tamerlane,* bei dem es sich um das einzige erhaltene Manuskript des Gedichtes handelt, belegt die umfassenden Veränderungen, die der junge Dichter für die 1829 publizierte, überarbeitete Fassung vornahm. In dem Erzählgedicht *Tamerlane* hat Poe die Erinnerungen des auf dem Sterbebett liegenden tatarischen Eroberers aus dem 14. Jahrhundert an seine erste Liebe ausgestaltet. Vermutlich hatte Poe dabei seine eigene unglückliche Liebesbeziehung mit Sarah Elmira Royster, einer Nachbarin in Richmond, vor Augen. Mit ihr hatte er sich 1825 heimlich verlobt, doch 1827 löste sie die Verlobung und heiratete zu seiner großen Enttäuschung Alexander B. Shelton. Nach dem Tod des Dichters behauptete sie, Poe habe ihr anvertraut, daß sie »die verlorene Lenore« in *The Raven* sei und ihn auch zu *Annabel Lee* inspiriert habe.[1]

Dieses Fragment war zusammen mit weiteren Handschriften Poes Teil der Sammlung von Stephen H. Wakeman, die Pierpont Morgan 1909 erwarb. Die Sammlung enthielt auch wichtige Manuskripte von Ralph Waldo Emerson, Nathaniel Hawthorne, Henry David Thoreau und anderen amerikanischen Autoren.

1. Mabbott 1969, S. 474.

3

Yes! she was worthy of all love —
Such as I taught her from the time
My spirit with the tempest strove
When on the mountain peak alone,
Ambition lent it a new tone —
And bade it first to dream of crime
There were no holier thoughts than mine
I lov'd thee as an angel might
With ray of the all-living light
Which blazes upon Edis' shrine —
It is not surely sin to name
With such as mine that mystic flame.
I had no being but in thee —
The world with all its train of bright
And happy beauty — for to me
All was an undefin'd delight

JOHN RUSKIN

(London 1819–1900 Coniston, Lancashire)

106

THE STONES OF VENICE

Autograph manuscript, [1851–53]
450 x 285 mm

Purchased by Pierpont Morgan, 1907;
MA 398–400

THE STONES OF VENICE

Eigenhändiges Manuskript, [1851–53]
450 x 285 mm

Erworben 1907 von Pierpont Morgan;
MA 398–400

John Ruskin was the most influential art critic of the Victorian age. "To see clearly is poetry, prophecy, and religion—all in one," he wrote in *Modern Painters*. He further explored the possibilities of that assertion in *The Stones of Venice*. His monumental study of Venetian architecture offers plentiful evidence of a sharp, critical eye as well as a deep sense of moral purpose. Once the embodiment of luxury and power, Venice had become, by Ruskin's time, a symbol of decay. His text links the decline of Venice to the lost glory of ancient Tyre and admonishes England to heed the lesson of their tragic falls. Nevertheless, the majesty and ornate beauty of Venetian buildings lured and inspired him. A superb draughtsman, he illustrated the work with meticulous renditions of architectural details.

The Library's extensive holdings of Ruskin include his manuscript of *Modern Painters;* drafts of portions of *Fors Clavigera, Praeterita,* and other works; letters and documents concerning the annulment of his marriage to Euphemia Chalmers Gray; some 2,000 letters to pupils and friends; and photographs of him and his circle.

John Ruskin gilt als der einflußreichste Kunstkritiker des Viktorianischen Zeitalters. »Deutlich sehen«, so heißt es in *Modern Painters,* »das ist Dichtkunst, Prophetie und Religion – alles in einem.« Ruskin hat die Gestaltungsmöglichkeiten dieses Leitsatzes in *The Stones of Venice* weiter untersucht. Seine monumentale Studie zur venezianischen Architektur ist reich an Belegen für sein wachsames, kritisches Auge und seinen tiefen Sinn für moralische Zielsetzungen. Venedig, einstmals die Verkörperung von Luxus und Macht, war zur Zeit Ruskins zum Symbol des Verfalls geworden. Ruskins Text bringt den Niedergang Venedigs mit der verlorenen Pracht der phönizischen Stadt Tyrus in Verbindung und enthält die an England gerichtete Mahnung, Konsequenzen aus dem tragischen Niedergang dieser Städte zu ziehen. Gleichwohl fühlte sich Ruskin von der majestätischen und reichgeschmückten Schönheit der venezianischen Gebäude angezogen und inspiriert. Als hervorragender Zeichner illustrierte er sein Werk mit minutiös ausgeführten Wiedergaben architektonischer Details.

Zu dem umfangreichen Bibliotheksbestand an Ruskin-Dokumenten gehören das Manuskript der *Modern Painters,* Teilentwürfe zu *Fors Clavigera, Praeterita* und zu anderen Werken; enthalten sind außerdem Briefe und Dokumente im Zusammenhang mit der Annullierung seiner Ehe mit Euphemia Chalmers Gray, über 2000 Briefe an Schüler und Freunde sowie Photographien von ihm und seinem Kreis.

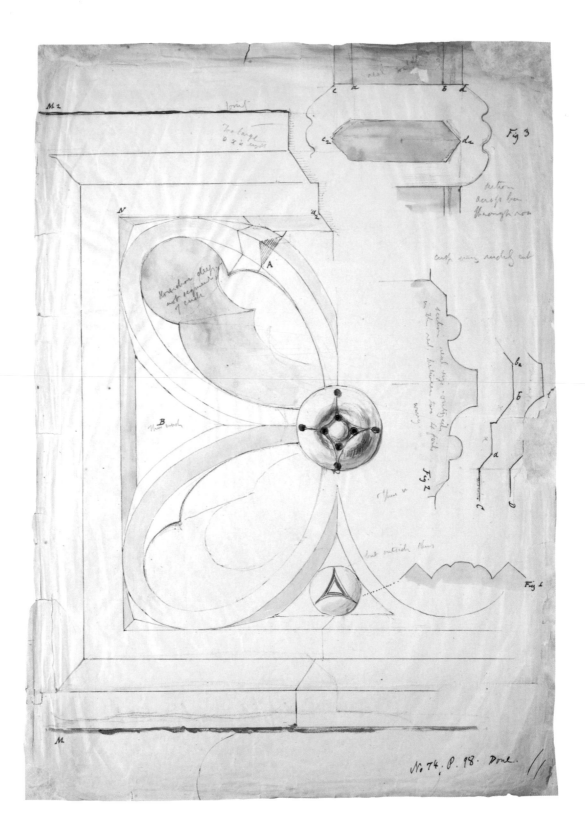

M. 2

too large
b x b

N

A

window deep
not required
of cills

B

Fig 3

return
across bar
through rose

cusps every arched cub

Fig 2

Fig 1

M

No. 74. P. 98. Done.

Introduction. new.

From Buildings — as from — like men — are required in the main — two kinds of goodness
or excellence: the first that they do their duty well: and the
second that they be graceful & pleasing in the doing it: which
at last is itself another form of duty: as far as men are responsible
for their buildings: and have not awkward forms given them by
nature or forced upon them by necessity: but — though a duty.
and sometimes the higher duty of the two — very distinct from
the practical and primary and business and practical functions
of either:

I assume — in saying this — that most buildings have a practical
duty — most of them have: and the building which does nothing
and takes up the piece of ground it occupies without a purpose
is of very generally a bad building: Nevertheless — as far as
they are works of great art — as far as they are architecture, be
not mere building: their mere practical purpose is not to be taken
into account: They are built to be gazed upon — and to make us
happy by their presence: or better for their presence — God has
made many things in this world — peacocks & lilies for instance — for
no better purpose nor more practical business. that I know of —
peacocks gulls are not worth more
than flocks of geese — and the peasants of Vevay whose
fields in the spring time are as white with lilies as the Dent du Midi
is with its snows, are not the happier more the better for them.
But I say their merely practical purpose: because buildings
have often a purpose which is not practical: but which is a
more to do with talking than with acting: but which is a
downright & serious purpose still: as of tombs — a triumphal
arches: to record facts — or to excite emotion: as
excite feeling: and as of churches & temples: which are partly
records of sacred history partly read in sculpture
either treated as great books of sacred history: read in sculpture
or by their majesty and quietness be made incitement to devotion.
And as it is as much — sometimes even more: the essence of
feel rightly as to do rightly — sometimes even more: the essence of
a buildings duty is often in its feeling more than its acting: and it
might more innocently fail in its lower function of protecting — as from
weather or from disturbance — than in its higher one of expressing
a smitting emotion.
W. have thus then three distinct branches of goodness in any building

EMILE ZOLA
(Paris 1840–1902 Paris)

NANA

Autograph manuscript signed, [1880]
320 x 265 mm

Purchased by Pierpont Morgan, 1909;
MA 525

NANA

Eigenhändiges, signiertes Manuskript,
[1880]
320 x 265 mm

Erworben 1909 von Pierpont Morgan;
MA 525

Nana is one of twenty novels in Zola's *Les Rougon-Macquart: l' histoire naturelle et sociale d'une famille sous le Second Empire* (1872–92). In his master plan of 1869, Zola noted the eventual inclusion of a "drama poignant d'une existence de femme perdue par l'appétit de luxe et des jouissances faciles"[1] (poignant drama of the life of a woman destroyed by an appetite for luxury and easy pleasures). Beginning work on *Nana* nine years later, he sought authenticity by drawing on his direct observations of café society, which he had covered as a journalist from the early 1860s, as well as frequenting haunts of the Parisian demimonde to interview its inhabitants. He asked librettist Ludovic Halévy for a tour backstage at the Variétés, the setting of the novel's opening. From Henry Céard, a writer and former medical student, he requested a description of a corpse disfigured by smallpox, which he used in his graphic account of Nana's death.

After achieving notoriety through serial publication in *Le Voltaire*, *Nana* was an immediate best-seller when published as a novel in 1880. It quickly sold 55,000 copies, at a time when a sale of 4,000 was regarded as successful.

Zola gave the manuscript to *Le Voltaire*'s editor, Jules Lafitte. They later quarreled bitterly, and Zola left the journal. He adamantly refused Lafitte's offer to return the manuscript for a price of 700 francs. In 1909 it was bought for 12,500 francs by Pierpont Morgan, who later acquired manuscripts of three of Zola's public letters in defense of Alfred Dreyfus.

1. Zola 1961, p. 1665.

Nana ist einer der 20 Romane aus Zolas Werk *Les Rougon-Macquart: l'histoire naturelle et sociale d'une famille sous le Second Empire* (1872–92). In seiner Gesamtkonzeption aus dem Jahr 1869 vermerkte Zola, daß er möglicherweise auch ein »drama poignant d'une existence de femme perdue par l'appétit de luxe et des jouissances faciles«[1] (ein erschütterndes Lebensdrama einer Frau, die durch ihre Begierde nach Luxus und leichtlebigen Vergnügungen zugrunde geht) einschließen werde.[1] Als Zola neun Jahre später mit der Niederschrift von *Nana* begann, strebte er auf der Grundlage seiner eigenen unmittelbaren Beobachtungen größtmögliche Authentizität an. Er konnte auf seine Berichte, die er in den frühen 1860er Jahren als Journalist über die Café-Zirkel geschrieben hatte, zurückgreifen. Er suchte die Schlupfwinkel der Pariser Halbwelt auf und befragte deren Bewohner. Den Librettisten Ludovic Halévy bat er um eine Führung hinter die Kulissen der Variétés, wo die Eingangsszene seines Romans spielte. Von dem Schriftsteller und ehemaligen Medizinstudenten Henry Céard erbat er die Beschreibung einer von Pocken entstellten Leiche, die er für seinen anschaulichen Bericht über Nanas Tod verwendete.

Durch den Vorabdruck als Fortsetzungsroman in *Le Voltaire* bereits berühmt und berüchtigt, wurde die Romanausgabe von *Nana* im Jahr 1880 sofort zu einem Bestseller. Innerhalb kurzer Zeit waren 55 000 Exemplare verkauft, und dies zu einer Zeit, als bereits ein Absatz von 4000 Stück als Erfolg gewertet wurde.

Zola übergab Jules Lafitte, dem Herausgeber von *Le Voltaire*, das Manuskript. Beide überwarfen sich später in heftigem Streit, und Zola verließ die Zeitschrift. Hartnäckig schlug er Lafittes Angebot aus, das Manuskript für einen Preis von 700 Francs zurückzukaufen. Pierpont Morgan erwarb es 1909 für 12 500 Francs. Später kamen noch die Manuskripte von drei offenen Briefen, die Zola zur Verteidigung von Alfred Dreyfus geschrieben hatte, in den Besitz der Library.

1. Zola 1961, S. 1665.

au fond, il restait enchanté des serments de la jeune femme,
~~qu'elle faisait de son vice, était pour lui une preuve décisive~~
~~de franchise, au sujet de Vandeuvres et des autres. Comme~~
~~elle le répétait il n'avait rien à dire du moment où elle gar-~~
~~dait la fidélité jurée.~~ Seulement, à partir de ce jour, Nana,
qui venait d'essayer sa puissance, ~~qu'il restait dompté,~~
commença à ne plus le ménager autant. Et, dès lors, Satin fut
installée dans la maison, ouvertement, sur le même pied que
ces messieurs. Vandeuvres n'avait pas eu besoin des lettres a-
nonymes pour comprendre; il cherchait, pour rire, des que-
relles de jalousie à Satin, tandis que Philippe et Georges la
traitaient en camarade, avec des poignées de main et des
plaisanteries très raides.

~~Il était arrivé une aventure à Nana, un soir~~
Nana eut une aventure un soir ~~qu'elle~~ que, lâchée par
Satin, elle était allée ~~dîner près des Martyrs~~, sans pouvoir met-
tre la main sur elle. Comme elle mangeait seule, furieuse, Da-
guenet avait paru; bien qu'il se fut rangé, il venait par-
fois, repris d'un besoin de vice, espérant qu'on ne le ren-
contrerait pas, dans ces coins noirs du Paris ordurier. Aussi, lors-
qu'il aperçut Nana, eut-il un geste de contrariété vive.
Mais il n'était pas l'homme ~~~~ à battre en retraite. Il s'a-
vança ~~avec un sourire~~, il demanda si madame voulait
bien lui permettre de dîner à sa table. En le voyant plai-
santer, Nana prit son grand air froid et répondit sèchement:
— Placez vous où il vous plaira, monsieur. Nous sommes
dans un lieu public.
Commencée sur ce ton, la conversation fut drôle. Mais
au dessert, Nana ennuyée, brûlant de triompher, mit les

GUY DE MAUPASSANT

(Château de Miromesnil, France, 1850–1893 Paris)

108

BEL-AMI

Autograph manuscript, [1884–85]
325 x 250 mm

The Dannie and Hettie Heineman
Collection, gift of the Heineman
Foundation, 1977; Heineman MS 140J

BEL-AMI

Eigenhändiges Manuskript, [1884–85]
325 x 250 mm

The Dannie and Hettie Heineman
Collection, Schenkung der Heineman
Foundation, 1977; Heineman MS 140J

The title of Maupassant's novel is the nickname of the protagonist, George Duroy, a cynical, ruthless arriviste who makes good in the corrupt world of Parisian journalism during the Third Republic. With ambition well served by cunning and good looks, Duroy maneuvers, by novel's end, to become the rich, powerful Baron du Roy.

This passage traces his stroll through the Bois de Boulogne, where he encounters an array of haughty members of high society. Duroy (here written *Leroy*, before Maupassant changed his name) amuses himself by recalling their sexual and financial secrets, which he has discovered through his work as a journalist. For him, they are contemptible hypocrites—at heart no more than *"crapules"* (debauchees) and *"escarpes"* (crooks).

Also in the Library are Maupassant's manuscripts of his stories "Boule de suif" and "Le Retour," his novel *Fort comme la mort*, and his one-act comedy *Une Répétition.* Among other nineteenth-century French writers represented by manuscripts in the collection are Alexandre Dumas *père (La reine Margot),* Honoré de Balzac *(Eugénie Grandet),* Anatole France *(Thaïs),* Georges Sand *(Valvèdre),* and Emile Zola *(Nana;* see No. 107).

Der Titel von Maupassants Roman *Bel Ami* greift den Spitznamen seines Protagonisten George Duroy auf, eines zynischen und skrupellosen Emporkömmlings, der in der korrupten Welt des Pariser Journalismus während der Dritten Republik zu Erfolg gelangt. Dem ehrgeizigen und oftmals voller List agierenden Duroy gelingt es am Ende des Romans, nicht zuletzt aufgrund seines guten Aussehens, zum wohlhabenden und mächtigen Baron du Roy aufzusteigen.

Die hier vorliegende Passage schildert, wie er durch den Bois de Boulogne flaniert und dabei auf eine Ansammlung arroganter Mitglieder der vornehmsten Gesellschaft trifft. Duroy (hier noch in der ursprünglichen Schreibweise *Leroy,* die Maupassant erst später änderte) findet Vergnügen daran, sich ihrer sexuellen oder finanziellen Geheimnisse zu erinnern, auf die er während seiner Arbeit als Journalist gestoßen war. Er betrachtet sie als verachtenswerte Heuchler, in Wirklichkeit nichts anderes als »crapules« (Lüstlinge) und »escarpes« (Hochstapler).

Im Besitz der Bibliothek befinden sich auch Maupassants handschriftliche Fassungen seiner Novellen *Boule de suif* und *Le Retour,* seines Romans *Fort comme la mort* und seiner Komödie in einem Akt, *Une Répétition.*

Zu den übrigen französischen Schriftstellern des 19. Jahrhunderts, die in der Sammlung mit Manuskripten vertreten sind, gehören unter anderem Alexandre Dumas d. Ä. *(La reine Margot),* Honoré de Balzac *(Eugénie Grandet),* Anatole France *(Thaïs),* George Sand *(Valvèdre)* und Emile Zola *(Nana;* vgl. Kat.-Nr. 107).

Il en vit beaucoup soupçonnés
à tricher au jeu, ~~beaucoup~~ pour qui
le cercle, en tous cas, était la grande
ressource, la seule ressource, ressource
suspecte à coup sûr.

D'autres, fort ~~riches~~ ^{célèbres}, vivaient ^{uniquement} ~~des~~
des rentes de leurs femmes, c'était connu,
d'autres des rentes de leurs maîtresses, on
l'affirmait. Beaucoup avaient payé
leurs dettes, (acte honorable), sans qu'on
eût jamais deviné d'où leur était
venu l'argent nécessaire, ~~mystère~~ (Mystère
bien louche) ~~Lorenzo~~ Il vit des hommes
de finance dont l'immense fortune avait
un vol pour origine, et qu'on recevait
partout dans les plus nobles maisons,
et des hommes si respectés que les petits bourgeois
se découvraient sur leur passage, et dont les
~~tripotages~~ ~~audacieux~~ effrontés, dans les
grandes entreprises nationales, n'étaient
un mystère pour aucun de ceux qui
savaient les dessous du monde.

Tous avaient l'air hautain, la
lèvre fière, l'œil insolent, ceux à
favoris et ceux à moustaches.

Leroy n'ait toujours, répétant
« c'est du propre, tas de crapules, tas
d'escarpes. » ~~Quand~~ ~~Soudain~~ ~~passa~~ et traînée
Mais une voiture (charmante,
au grand trot ~~par~~ deux ^{minces} chevaux blancs, ~~et conduite~~ dont
la crinière et la queue voltigeant, et
conduite, ~~malgré le froid~~ par une
petite jeune femme ~~enveloppée de~~ ^{blonde}
~~fourrures~~, une courtisane connue
qui avait deux grooms assis derrière
elle. Leroy s'arrêta, ~~si~~ avec une
envie de saluer et d'applaudir cette ~~femme~~
parvenue de l'amour qui étalait ~~leur~~
avec audace, dans cette promenade ~~d'à~~ ^{de cette heure}
~~des hypocrites~~ des hypocrites aristocrates,
le luxe crâne gagné sur ses draps.

ALBERT EINSTEIN

(Ulm, Germany, 1879–1955 Princeton, New Jersey)

109

AUTOGRAPH LETTER

Signed, dated (n.p.),1 September 1911,
to Erwin Finlay Freundlich
175 x 110 mm

Gift of Horace Wood Brock,
John Biddle Brock, and Hope Brock
Winthrop, in loving memory of their
parents, Horace Brock and Hope
Distler Brock, 1991; MA 4725 (1)

EIGENHÄNDIGER BRIEF

Signiert, datiert 1. September 1911
(ohne Angabe des Ortes), an Erwin
Finlay-Freundlich
175 x 110 mm

Schenkung von Horace Wood Brock,
John Biddle Brock und Hope Brock
Winthrop im liebenden Angedenken
an ihre Eltern Horace Brock und Hope
Distler Brock, 1991; MA 4725 (1)

In 1991 the Library's collection of manuscripts related to the history of science was enriched by the gift of twenty-five letters from Albert Einstein to Erwin Finlay Freundlich, his colleague at the Royal Observatory, Berlin. The correspondence began in 1911, when Einstein approached Freundlich for assistance in observing the motion of the planet Mercury. In the letter shown, Einstein refers to his colleague's attempt to measure the deflection of light caused by the planet Jupiter and discusses daylight observation of stars close to the sun. "If only we had a considerably larger planet than Jupiter!" he writes. "But nature has not made it a priority to make it easy for us to discover its laws."

During the next several years, Einstein formulated his general theory of relativity. Freundlich was the first scientist to become well versed in Einstein's theory, the first to attempt an experimental proof, and the author of *Die Grundlagen der Einsteinschen Gravitationstheorie* (Foundations of Einstein's Gravitation Theory; 1916), the first book on the topic.

Einstein is further represented in the Library's Dannie and Hettie Heineman collection, which includes his manuscript of an unpublished article about the theory of relativity, "Grundgedanken und Methoden der Relativitätstheorie in ihrer Entwicklung dargestellt," a travel diary kept in 1922–23, and eight letters.

Im Jahr 1991 wurde die Manuskriptsammlung zur Geschichte der Wissenschaften in der Pierpont Morgan Library durch die Schenkung von 25 Briefen Albert Einsteins an seinen Kollegen vom Königlichen Observatorium in Berlin, Erwin Finlay-Freundlich, bereichert. Die Korrespondenz begann 1911, als Einstein sich mit der Bitte an Finlay-Freundlich wandte, ihm bei der Beobachtung der Bewegung des Planeten Merkur zu helfen. In dem hier ausgestellten Brief bezieht sich Einstein auf den Versuch seines Kollegen, die durch den Planeten Jupiter verursachte Beugung des Lichtes zu messen, und er diskutiert die bei Tageslicht vorgenommene Beobachtung sonnennaher Sterne. »Wenn wir nur einen ordentlich grösseren Planeten als Jupiter hätten!« schrieb Einstein. »Aber die Natur hat es sich nicht angelegen sein lassen, uns die Auffindung ihrer Gesetze bequem zu machen.«

In den darauffolgenden Jahren formulierte Einstein seine Relativitätstheorie. Finlay-Freundlich war der erste Wissenschaftler, der mit Einsteins Theorie vertraut war, und auch der erste, der einen experimentellen Beweis zu liefern versuchte. Zudem war Finlay-Freundlich Autor des Buches *Die Grundlagen der Einsteinschen Gravitationstheorie* (1916), der ersten Publikation, die zu diesem Thema erschien.

Zu den weiteren Originalschriften von Einstein in der Dannie and Hettie Heineman Collection der Pierpont Morgan Library gehören das Manuskript eines unveröffentlichten Aufsatzes über die Relativitätstheorie (»Grundgedanken und Methoden der Relativitätstheorie in ihrer Entwicklung dargestellt«), ein Reisetagebuch der Jahre 1922 und 1923 sowie acht Briefe.

Prag. 1. IX. 11

Hoch geehrter Herr Kollege!

Ich danke Ihnen herzlich für Ihr Schreiben, das mich natürlich sehr interessierte. Es ist mir sehr lieb, wenn Sie sich dieser interessanten Frage annehmen. Dass deren Beantwortung durch die Erfahrung keine leichte Sache ist, das weiss ich wohl, weil eben die Refraktion der Sonnenatmosphäre mitspielen mag. Aber eines kann immerhin mit Sicherheit gesagt werden: Existiert keine solche Ablenkung, so sind die Voraussetzungen der Theorie nicht zutreffend. Man muss nämlich im Auge behalten, dass diese Voraussetzungen, wenn sie schon naheliegen, doch recht kühn sind.

Wenn wir nur einen ordentlich grösseren Planeten als Jupiter hätten! Aber die Natur hat es sich nicht angelegen sein lassen, uns die Auffindung ihrer Gesetze bequem zu machen.

Dass in Hamburg derartige Aufnahmen gemacht worden, hat mir schon der Observator der hiesigen Sternwarte mitgeteilt. Es wird sehr interessant sein, was Sie bei der Ausmessung der Platten herausfinden werden. Ich bitte Sie sehr, mir dann das Resultat der Untersuchung mitzuteilen.

Mit kollegialem Gruss
Ihr ganz ergebener
A. Einstein.

HENRI MATISSE
(Le Cateau Cambrésis, France, 1869–1954 Nice)

110

AUTOGRAPH LETTER

Signed, dated (n.p.), 12 January 1917, to Paul Rosenberg
212.5 x 137.5 mm

Gift of Mr. and Mrs. Alexandre P. Rosenberg, 1980; MA 3839

EIGENHÄNDIGER BRIEF

Signiert, datiert 12. Januar 1917 (ohne Angabe des Ortes), an Paul Rosenberg
212,5 x 137,5 mm

Schenkung von Mr. und Mrs. Alexandre P. Rosenberg, 1980; MA 3839

Matisse wrote to Paul Rosenberg in early 1917 from Issy-les-Molineaux, his residence for several months each year. Acknowledging a gift of mandarin oranges from the art dealer, Matisse headed his note of thanks with a sketch of the fruit. Many of the still lifes, which were then prominent in his painting, were done in the Issy studio. During the preceding two years Matisse had completed, among other works, *Nature morte d'après "La Desserte" de Jan Davidsz. De Heem; Les Coloquintes; Les Pommes sur la table, sur fond vert; Les Pommes;* and *La Fenêtre*. Matisse and Rosenberg were friends for two more decades before the artist signed a contract, in 1936, making Rosenberg his principal dealer.

The Rosenberg collection includes forty letters of Matisse as well as correspondence of Marie Laurencin, Jacques Lipchitz, Claude Monet, Paul Signac, Nicolas de Staël, and other artists.

Matisse schickte Anfang des Jahres 1917 aus Issy-les-Molineaux, wo er stets mehrere Monate des Jahres verbrachte, dieses Schreiben an Paul Rosenberg. Den Briefkopf versah er mit einer Zeichnung der Mandarinen, die ihm der Kunsthändler geschenkt hatte und die Anlaß des Dankes waren. Viele der Stilleben, die während dieser Zeit in seiner Malerei häufig waren, wurden in dem Atelier in Issy ausgeführt. In den vorangegangenen zwei Jahren hatte Matisse unter anderem folgende Werke vollendet: *Nature morte d'après »La Desserte« de Jan Davidsz. De Heem; Les Coloquintes; Les Pommes sur la table, sur fond vert; Les Pommes* und *La Fenêtre*. Matisse und Rosenberg waren weitere zwei Jahrzehnte miteinander befreundet, ehe der Künstler 1936 einen Vertrag unterzeichnete, der Rosenberg zu seinem bevorrechtigten Händler machte.

Zur Sammlung Rosenbergs gehören 40 Briefe von Matisse wie auch Korrespondenz von Marie Laurencin, Jacques Lipchitz, Claude Monet, Paul Signac, Nicolas de Staël und anderen bildenden Künstlern.

92, ROUTE DE CLAMART
ISSY-LES-MOULINEAUX
TÉLÉPHONE : 56

12 Janvier 1917.

Cher ami, voilà tout ce qui
reste des délicieuses mandarines que
vous nous avez envoyées. Il est grand

PABLO PICASSO

(Málaga 1881–1973 Mougins)

III

MANUSCRIPT DOCUMENT

Notated with signed autograph
receipts and sketches by the artist,
dated Paris, 21 and 25 June 1921
300 x 195 mm

Gift of Mr. and Mrs. Alexandre
P. Rosenberg, 1980; MA 3500

HANDSCHRIFTLICHES
DOKUMENT

Beschrieben mit unterzeichneten
eigenhändigen Quittungen und
Skizzen des Künstlers, 21. und
25. Juni 1921, Paris
300 x 195 mm

Schenkung von Mr. und Mrs.
Alexandre P. Rosenberg, 1980;
MA 3500

Acknowledging payment for paintings and
pastels consigned to the distinguished Parisian
art dealer Paul Rosenberg, Picasso made quick
sketches of the relevant works on the verso of
this document. His facile draughtsmanship is
evident on several receipts in the Library's
Rosenberg collection, which includes some
470 letters and documents from artists. Here
Picasso depicted two paintings, *Deux femmes
nues assises* and *Femme en chemise aux mains
croisées,* along with four pastels, *Deux femmes,
Femme s'essuyant le pied, Groupe de femmes
nues,* and *Groupe de trois femmes nues.*[1] These
works, from 1920–21, marked the beginning of
the artist's neoclassical period.

Picasso had become associated with Paul
Rosenberg in 1918. The art dealer, having
made his reputation with impressionist and
postimpressionist works, was then selectively
representing contemporary artists whose work
had proven marketable. Rosenberg attracted
Picasso from Galerie de l'Effort Moderne,
which belonged to Rosenberg's brother
Léonce, an early advocate of cubism. Over the
next decade, Georges Braque, Juan Gris, and
Fernand Léger likewise defected from Galerie
de l'Effort Moderne to Galerie Paul Rosen-
berg. In 1940 Rosenberg moved his gallery to
New York, where he continued to champion
contemporary French art.

1. Geelhaar 1993, p. 114.

Auf der Rückseite dieses Schriftstücks, auf
dem Picasso den Erhalt seines Honorars für
Gemälde und Pastelle bestätigte, verfertigte er
schnell hingeworfene Skizzen dieser Werke,
die er dem bekannten Pariser Kunsthändler
Paul Rosenberg anvertraut hatte. Seine leichte
Hand beim Zeichnen zeigt sich auf verschie-
denen Quittungen aus dem Besitz der Samm-
lung Rosenberg, die etwa 470 Briefe und
Dokumente verschiedener Künstler enthält.
Das Dokument zeigt zwei Gemälde: *Deux
femmes nues assises* und *Femme en chemise aux
mains croisées* sowie vier Pastelle: *Deux fem-
mes, Femme s'essuyant le pied, Groupe de fem-
mes nues* und *Groupe de trois femmes nues.*[1]
Diese Arbeiten aus den Jahren 1920 bis 1921
kennzeichnen den Beginn der klassizistischen
Schaffensperiode des Künstlers.

Rosenberg nahm Picasso 1918 unter Vertrag.
Der Kunsthändler hatte sich einen Namen mit
Werken des Impressionismus und Postimpres-
sionismus gemacht und vertrat nun ausge-
wählte zeitgenössische Künstler, deren Ar-
beiten sich als verkaufsträchtig erwiesen hatten.
Rosenberg warb Picasso von der Galerie de
l'Effort Moderne seines Bruders Léonce
Rosenberg ab, einem frühen Unterstützer des
Kubismus. Im Verlauf der nächsten zehn Jahre
wechselten dann auch Georges Braque, Juan
Gris und Fernand Léger von der Galerie de
l'Effort Moderne zur Galerie Paul Rosenberg.
1940 verlegte Rosenberg seine Galerie nach
New York, wo er sich weiterhin für die zeit-
genössische französische Kunst einsetzte.

1. Geelhaar 1993, S. 114.

Monsieur *Picasso*

	Doit	Avoir
2 grandes femmes nues		15.000 .
2 pendants - pastel - groupe de femmes		6.000 .
femme s'essuyant les pieds	pastel	6.000 .
Buste de femme		7.500 .
Deux femmes nues - pastel -		6.000 ..
Un cadre st relqué Lebrun	450 .	
Cadres exposition :	78,	
	103,95	
	26,80	
Carton j pêre	10,75	
Colle - / personnel	99,50	
Carton grenue	77,50	395,50
Solde créditeur		42.654,50
	43.500 .	43.500 .

B.P.F. 24.170

Recu le 22 juin 1921
un chèque de vingt quatre
mille cent soixante dix francs et
mille francs en espèces
Picasso

Recu le solde dix sept mille
quatre cent quatre vingt francs
Paris le 25 juin 1921
Picasso

Medieval and Renaissance Manuscripts

Handschriften des Mittelalters und der Renaissance

When Pierpont Morgan acquired his first medieval manuscripts in the last year of the last century, he laid the foundation for a collection that would contribute substantially to their study and appreciation in the United States. By the time of his death in 1913, his had already become the world's finest private collection of illuminated manuscripts, numbering about six hundred volumes. These treasures were inherited by his son, J. P. Morgan, Jr., who had added about two hundred manuscripts by 1937, when the eminent bibliographer Seymour de Ricci described the collection as the "most extensive and beautifully selected series of manuscripts existing on the American continent, and . . . superior in general quality to all but three or four of the greatest national libraries of the Old World." About the same time Charles Rufus Morey, the noted scholar of medieval illumination, observed that "there is scarcely a phase of the art . . . which can be fully illustrated and understood at present without reference to the Morgan manuscripts. The importance of the collection lies not only in its extent, but also in the first-rate quality of its specimens." Now, with over 1,300 manuscripts, not counting its important Egyptian, Greek, and Coptic papyri, the Library is even richer and more extensive than when de Ricci and Morey wrote about it over fifty years ago.

Manuscripts, written by hand and often sumptuously painted or illuminated, are important because they are our best surviving link with the religious, intellectual, and artistic life of Europe before and some time after the development of printing. For more than a thousand years they served as the principal carriers of the ideas and images that were essential to the development of Western civilization. Although only a small number are included here, they are representative of the very finest that comprise the range of the collection. Often commissioned by leaders of church and state, these manuscripts frequently were made of rare and precious materials, requiring long periods of work and the combined skills of parchment maker, scribe, editor, illuminator, and binder.

Of all the tangible artistic expressions of this age—sculpture, architecture, metalwork, enamels, ivories, panel paintings, and tapestries—illuminated manuscripts are the most numerous and usually the best preserved. Protected by bindings and usually closed up, they have been spared the damaging effects of exposure to light, air, and dirt as well as the altering hands of restorers. Often their intricate decorations and exquisite miniatures, painted in vivid colors and brightened by burnished gold, appear little changed by the centuries. Indeed, many seem as fresh as the day they were made. The Morgan collection is notable not only for the generally excellent preservation of its holdings but also for the large proportion of books that are intact (or nearly so), making it possible to examine the full sequence of images in relation to their proper texts, as their creators intended.

Leaving aside the earlier papyri, the collection dates from ancient codices of the fifth century to lavishly illustrated books produced during the Renaissance. From them much can be learned about how people lived, what they read and thought, and how they used and contributed to knowledge. One also can see, often in spectacular examples, the different ways in which books were written, decorated, illustrated, and bound over those centuries. For the earlier periods, many of the most important monastic centers are represented, such as those at Reims, Tours, St. Amand, Lorsch, Corvey, St. Bertin, Canterbury, St. Albans, Bury St. Edmunds, Salzburg, and Weingarten.

The majority of these books are of a religious nature, in keeping with the priorities of society. In addition to Bibles, there are all kinds of liturgical service books, such as Sacramentaries, Missals, Lectionaries, Graduals, Antiphonaries, Ordinals, Breviaries, Psalters, and most common of all, private devotional Books of Hours. In addition there are various theological works and commentaries, lives of the saints, and other forms of pietistic literature. Important works of

the classical authors are also represented, including ninth-century Carolingian copies as well as medieval literature and humanist manuscripts of the Renaissance. There are scientific treatises dealing with astrology, astronomy, medicine, plants, animals, and minerals; and works of a more practical nature telling how to take care of horses, how to hunt and fight, and when and how to plant. There are works relating to history, such as chronicles and biographies, as well as to law, exploration, and cartography.

Pierpont Morgan's first half-dozen manuscripts were acquired in June 1899, when he purchased James Toovey's collection of bindings and books in London. His first major medieval manuscript, however, and the real cornerstone of the collection, was recommended to him a month later by his young nephew Junius Spencer Morgan, who often advised him on purchases. Cabling him in code, Junius stated that he could obtain a ninth-century Gospels in a jeweled binding, a treasure unequaled in England or France. Morgan wisely took his nephew's advice and bought the manuscript now known as the Lindau Gospels.

The largest and most important of his five en bloc purchases was made in 1902, when he acquired the impressive collection of 110 illuminated manuscripts assembled by Richard Bennett of Manchester. Twenty-nine of these had belonged to William Morris, the Victorian author, artist, and printer. The last large purchase was concluded in 1911, when Morgan acquired fifty of the Coptic manuscripts that had been found a year earlier at Hamuli, in the Fayum, Egypt. These ninth- and tenth-century manuscripts, many of textual importance and sometimes decorated with frontispieces, form the oldest, largest, and most important group of Sahidic (a Coptic dialect) manuscripts with a single provenance, the Monastery of St. Michael near Hamuli.

An important turning point for the collection came in 1905, when Pierpont Morgan hired—also on the recommendation of Junius—Belle da Costa Greene as his librarian. Her role in shaping and developing the collection over some forty years cannot be overestimated. Through her recommendations and the active interest of J. P. Morgan, Jr., until his death in 1943, valuable additions continued to be made, based on their artistic merit or their scholarly or textual importance. Miss Greene's interests were not limited to the growth of the collection; she oversaw its cataloguing, arranged lectures, encouraged the research of serious students and scholars, supported publications, and inaugurated a number of memorable exhibitions. The Association of Fellows, established in 1948, has continued to make the acquisition of exceptional manuscripts possible. Increasingly, manuscripts and purchase funds have been given or bequeathed by other benefactors as well. One of the most notable gifts, the William S. Glazier Collection of seventy-four medieval and Renaissance manuscripts, came in 1984.

Today, through exhibitions, facsimiles, and other publications, the Library strives to make its collection—acknowledged as an important and fascinating window into medieval and Renaissance life—better known to both the public and scholarly community.

Als Pierpont Morgan im letzten Jahr des 19. Jahrhunderts seine ersten mittelalterlichen Handschriften erwarb, legte er damit den Grundstein für eine Sammlung, die seither wesentlich zur Erforschung und Wertschätzung von Manuskripten des Mittelalters und der Renaissance in den Vereinigten Staaten beigetragen hat. Zum Zeitpunkt seines Todes war sie mit rund 600 Bänden bereits die weltweit bedeutendste private Sammlung illuminierter Handschriften. Diese Schätze erbte sein Sohn, J. P. Morgan jr., der bis 1937 bereits etwa 200 weitere Manuskripte hinzugefügt hatte. Damals beschrieb der berühmte Bibliograph Seymour de Ricci die Sammlung als »die umfangreichste und schönste Auswahl von Handschriften auf dem amerikanischen Kontinent, … die in ihrer herausragenden Qualität allen übrigen – mit Ausnahme vielleicht von dreien oder vieren der größten Nationalbibliotheken der Alten Welt – überlegen ist«. Etwa zur gleichen Zeit konstatierte Charles Rufus Morey, der bedeutende Kenner mittelalterlicher Buchmalerei, daß »es kaum eine Epoche dieser Kunst gibt, … die gegenwärtig vollständig veranschaulicht und verstanden werden kann, ohne Manuskripte der Pierpont Morgan Library zu studieren. Die Bedeutung der Sammlung liegt nicht nur in ihrem Umfang, sondern auch in der herausragenden Qualität ihrer Einzelstücke.« Heute ist der Bestand mit mehr als 1300 Manuskripten – die bedeutenden ägyptischen, griechischen und koptischen Papyri nicht mitgezählt – noch reicher als vor über fünfzig Jahren, als de Ricci und Morey über sie urteilten.

Handschriften, oft prächtig bemalt oder illuminiert, sind unser bestes Bindeglied zum religiösen, intellektuellen und künstlerischen Leben Europas vor und noch einige Zeit nach der Erfindung des Buchdrucks. Mehr als tausend Jahre dienten sie als Hauptträger der Ideen und Bilder, die für die Entwicklung der westlichen Zivilisation bestimmend waren. Die kleine Auswahl, die hier gezeigt wird, besteht aus Glanzstücken der umfassenden Sammlung. Oft von Kirchenhäuptern und Staatsmännern in Auftrag gegeben, wurden diese Handschriften häufig aus seltenen und wertvollen Materialien angefertigt; der langwierige Herstellungsprozeß verband die Künste von Pergamentherstellern, Schreibern, Editoren, Illuminatoren und Buchbindern.

Unter den bildenden Künsten dieser Zeit – Skulptur, Architektur, Metallarbeit, Emailmalerei, Elfenbeinschnitzerei, Tafelmalerei und Tapisserien – sind die illuminierten Handschriften am zahlreichsten und meist am besten erhalten. Durch die Einbände geschützt und gewöhnlich verschlossen, blieben sie von Licht, Luft, Schmutz, von Veränderungen und der Hand der Restauratoren verschont. Oft erscheinen Zierwerk und Miniaturen in ihren lebendigen Farben und Vergoldungen über die Jahrhunderte kaum verändert. Viele leuchten noch genauso wie am Tag ihrer Fertigstellung. Die Sammlung der Pierpont Morgan Library ist nicht nur für den ausgezeichneten Erhaltungszustand ihrer Bestände bekannt, sondern auch für den großen Anteil an Büchern, die gänzlich (oder beinahe) unversehrt sind. Dadurch kann man vollständige Bilderfolgen und die zugehörigen Texte so studieren, wie ihre Schöpfer es beabsichtigten.

Abgesehen von den früheren Papyri, datieren die Bestände der Sammlung von spätantiken Codices des 5. Jahrhunderts bis zu reichillustrierten Büchern der Renaissance. Die Manuskripte geben Einblick in die Lebensgewohnheiten der Menschen, in das, was sie lasen und dachten, in die Art, wie sie Wissen einsetzten und vermehrten. Deutlich wird auch, und zwar oft an großartigen Exemplaren, wie unterschiedlich Bücher über diese Jahrhunderte geschrieben, ausgeschmückt, illustriert und gebunden wurden. Aus den früheren Epochen sind viele der bedeutendsten klösterlichen Zentren vertreten, so die von Reims, Tours, St. Amand, Lorsch, Corvey, St. Bertin, Canterbury, St. Albans, Bury St. Edmunds, Salzburg und Weingarten.

Die meisten der Bücher sind religiöse Schriften, gemäß der gesellschaftlichen Prioritäten. Neben Bibeln sind alle Arten liturgischer Meßbücher vertreten wie Sakramentare, Missale, Lektionare, Graduale, Antiphonare, Ordinale, Breviere, Psalter und die verbreiteten Stundenbücher für die private

Andacht. Hinzu kommen theologische Werke und Kommentare, Heiligenviten und andere devotionale Literatur. Vertreten sind auch Werke antiker Autoren, darunter karolingische Abschriften aus dem 9. Jahrhundert, mittelalterliche Literatur und humanistische Manuskripte der Renaissance. Die Sammlung umfaßt wissenschaftliche Abhandlungen zur Astrologie, Astronomie, Medizin, zu Pflanzen, Tieren und Mineralien sowie Werke zur Pferdehaltung, über das Jagen und Kämpfen oder über den Ackerbau. Sie enthält ebenfalls Werke zur Geschichte – so Chroniken und Biographien –, zum Rechtswesen, über Entdeckungsreisen und zur Kartographie.

Pierpont Morgans sechs erste Handschriften wurden im Juni 1899 gekauft, als er James Tooveys Sammlung von Einbänden und Büchern in London erwarb. Sein erstes bedeutendes mittelalterliches Manuskript allerdings, das den wirklichen Grundstein seiner Sammlung legte, wurde ihm einen Monat später von seinem jungen Neffen Junius Spencer Morgan empfohlen, der ihn bei Erwerbungen oft beriet. In einem verschlüsselten Telegramm berichtete ihm Junius von einem Evangeliar aus dem 9. Jahrhundert mit juwelenbesetztem Einband, einem Schatz, der in England oder Frankreich unübertroffen sei. Morgan folgte dem Rat seines Neffen und kaufte die Handschrift, die heute als Lindauer Evangeliar berühmt ist.

Die umfangreichste und bedeutendste unter den fünf Erwerbungen, die er »en bloc« tätigte, kam 1902 zustande, als Morgan die 110 illuminierten Handschriften der Sammlung Richard Bennett aus Manchester erwarb. Allein 29 von ihnen stammten aus dem Besitz von William Morris, dem viktorianischen Autor, Künstler und Drucker. Der letzte große Ankauf geschah 1911, als Morgan über 50 der koptischen Manuskripte erwarb, die im Jahr zuvor bei Hamuli im ägyptischen Fayum entdeckt worden waren. Diese Handschriften aus dem 9. und 10. Jahrhundert, viele mit historisch bedeutenden Texten und einige mit Frontispizen ausgestattet, bilden die älteste, größte und bedeutendste Gruppe sahidischer (ein koptischer Dialekt) Handschriften aus einheit-

licher Provenienz, dem Kloster von St. Michael nahe Hamuli.

Einen wichtigen Wendepunkt für die Sammlung markiert das Jahr 1905, als Pierpont Morgan – ebenfalls auf den Rat seines Neffen Junius hin – Belle da Costa Greene als Bibliothekarin engagierte. Ihre Rolle bei der Gestaltung und Weiterentwicklung der Sammlung über einen Zeitraum von vierzig Jahren kann nicht hoch genug geschätzt werden. Auf ihre Empfehlungen hin und aufgrund des aktiven Interesses von J. P. Morgan jr. bis zu seinem Tod im Jahr 1943 fanden weitere wertvolle Ankäufe statt, wobei die künstlerischen Vorzüge einer Handschrift beziehungsweise ihre wissenschaftliche oder textliche Bedeutung ausschlaggebend waren. Dabei blieb das Augenmerk von Miss Greene keineswegs auf die Vergrößerung der Sammlung beschränkt; sie leitete die Katalogisierung der Sammlungsbestände, organisierte Vortragsveranstaltungen, förderte die Forschungsarbeiten von Studenten und Wissenschaftlern, unterstützte Publikationen und begann eine Reihe bedeutender Ausstellungen. Eine der Aufgaben der 1948 gegründeten *Association of Fellows* ist es, auch heute den Erwerb hervorragender Handschriften zu ermöglichen. In zunehmendem Maße sind von anderen Stiftern Manuskripte vermacht und Ankaufsfonds eingerichtet worden. Eine der herausragendsten Schenkungen, die William S. Glazier Collection mit 74 Handschriften des Mittelalters und der Renaissance, wurde der Library im Jahre 1984 übergeben.

Heute ist die Pierpont Morgan Library darum bemüht, ihre Sammlung, die in faszinierender Weise den Blick auf das Leben im Mittelalter und in der Renaissance erlaubt, durch Ausstellungen, Faksimiles und andere Publikationen sowohl der Öffentlichkeit als auch der wissenschaftlichen Fachwelt immer besser bekannt zu machen.

VIRGO LACTANS

John Chrysostum, *Encomium on the Four Bodiless Beasts,* in Coptic, Sahidic dialect

Illuminated by Papa Isak

Egypt, Fayûm, Ptepouhar, dated 892–93, for Papostolos, as a gift to the monastery of St. Michael near present-day Hamuli

17 leaves, 335 x 260 mm; 1 full-page miniature and 1 historiated initial

Purchased by Pierpont Morgan, 1911; MS M.612 (fol. 1v)

VIRGO LACTANS

Johannes Chrysostomos, *Enkomion auf die vier körperlosen Tiere,* in koptisch, sahidischem Dialekt

Illuminiert vom Popen Isak

Ägypten, Fayum, Ptepouhar, auf 892–93 datiert, für Papostolos, als Geschenk für das Kloster St. Michael, nahe dem heutigen Hamuli

17 Blätter, 335 x 260 mm; 1 ganzseitige Miniatur und 1 figürlich ausgestaltete Initiale

Erworben 1911 von Pierpont Morgan; MS M.612 (fol. 1v)

When Morgan purchased this and fifty-three other Coptic manuscripts that had been found in 1910 in a cistern near Hamuli, he acquired the oldest, largest, and most important group of Sahidic manuscripts from a single provenance. The books made up almost the entire library of the monastery of St. Michael, which the monks evidently buried for safekeeping during the tenth century. Many have colophons ranging in date from 823 to 914, and nearly all were found in their original bindings. About twenty have decorative or pictorial frontispieces, usually a large ornamented cross with interlace patterns. Rarely, as in the present manuscript, the frontispiece consists of a full-page miniature. This image of the nursing Virgin *(Virgo Lactans),* one of the earliest surviving examples, recalls ancient Egyptian depictions of the goddess Isis nursing Horus, her savior son. Above the shoulders of the Virgin are the Greek abbreviations for the sacred names Holy Mary and Jesus Christ. But most astonishing is the inscription beneath the miniature, the earliest signed illumination in the Library: *By me, Isak, the most humble presbyter, I drew it.* W.M.V.

Provenance
Monastery of St. Michael, near Hamuli, Egypt; acquired by J. Kalebdian and sold through Arthur Sambon.

Selected bibliography and exhibitions
Werner 1972, pp. 8–10, fig. 10; Meyvaert 1989, pp. 16–17, figs. 12, 14–16; Depuydt 1991; Depuydt 1993, vol. 1, pp. 185–87, no. 96, vol. 2, pls. 12, 77, 327; Hamm 1996, p. 251, no. 267, repr. p. 250.

Mit dem Erwerb dieses Manuskriptes und weiterer 53 koptischer Schriften, die man 1910 in einer Zisterne nahe Hamuli gefunden hatte, gelangte Morgan in den Besitz der ältesten, umfangreichsten und wichtigsten Gruppe sahidischer Manuskripte aus einer einheitlichen Provenienz. Die Bücher bildeten nahezu den gesamten Bestand der Klosterbibliothek von St. Michael. Zum Schutz vor Vernichtung hatten die Mönche sie während des 10. Jahrhunderts vergraben. Viele enthalten Kolophone, die in ihrer Datierung von 823 bis 914 reichen, und nahezu alle Werke befanden sich noch in ihrem ursprünglichen Einband. Etwa 20 Bände besitzen dekorativ ausgestaltete oder mit Bildern versehene Frontispize; meist handelt es sich dabei um ein großes, ornamentiertes Kreuz mit Flechtmustern. Ganz selten, wie in der hier ausgestellten Handschrift, besteht das Frontispiz aus einer ganzseitigen Miniatur. Als eine der frühesten Darstellungen des Themas überhaupt erinnert dieses Bild der stillenden Jungfrau *(Virgo lactans)* an ägyptische Darstellungen der Göttin Isis, die ihrem Sohn Horus die Brust gibt. Auf Schulterhöhe finden sich die Namen der Jungfrau Maria und Jesu Christi in griechischen Kürzeln. Am erstaunlichsten ist jedoch die Beschriftung unterhalb der Miniatur: *Von mir, Isak, dem demütigsten Presbyter, ich zeichnete es.* Es handelt sich um die älteste signierte Buchmalerei, die sich im Besitz der Bibliothek befindet.

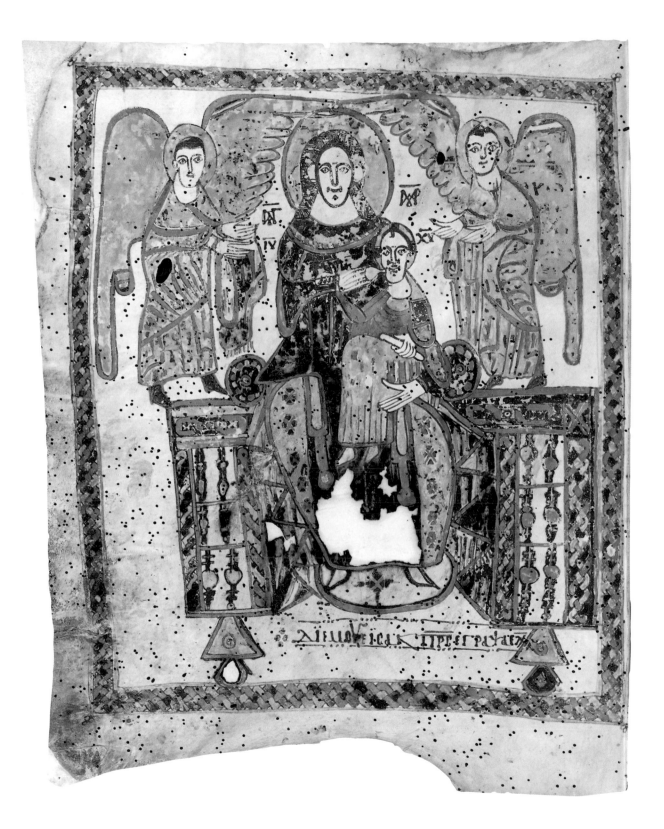

THE EVANGELIST MARK

Gospel Book, in Latin

Northern France, probably St. Amand, ca. 860

193 leaves, 240 x 190 mm; 4 full-page miniatures, 4 incipit pages, 6 framed text pages, and 12 canon tables

Purchased by the Library on the Belle da Costa Greene Fund, 1952; MS M.862 (fols. 57v–58)

DER EVANGELIST MARKUS

Evangeliar, lateinisch

Nordfrankreich, vermutlich Abtei St. Amand, circa 860

193 Blätter, 240 x 190 mm; 4 ganzseitige Miniaturen, 4 Incipitseiten, 6 gerahmte Textseiten und 12 Kanontafeln

Erworben 1952 von der Pierpont Morgan Library aus Mitteln des Belle da Costa Greene Fund; MS M.862 (fols. 57v–58)

This Gospel Book is the Library's masterful example of the so-called Franco-Saxon school of illumination. Manuscripts of this group were made in northeastern France, especially at the Benedictine monastery of St. Amand (where this codex is thought to have originated), from the mid-ninth (the late Carolingian period) to the tenth century. Franco-Saxon illumination is characterized by its emphasis on insular interlace, the ornamental patterns of which, however, are rigidly controlled and compartmentalized. Figures are used, but rarely, and when they are, a cool balance between the fanciful motifs derived from Viking art and the classical elements revived by the Carolingian Renaissance is maintained.

Dressed in an antique toga, the evangelist Mark is shown here writing his Gospel. Above him, and surrounded by inscriptions composed by the Spanish bishop Theodulph, scholar at the court of Charlemagne, is his symbol, a lion. The use of interlace on this and the other evangelist portraits in this Gospel Book is restricted to the sides of the pillars and the arch. R.S.W.

Provenance
Sir Thomas Phillipps (recorded twice, MS 2165 and MS 21787); Alfred Chester Beatty.

Selected bibliography and exhibitions
Millar 1927–30, vol. 1, pp. 44–47, no. 9, pls. 20–25; Faye and Bond 1962, p. 365; Guilmain 1967, pp. 231–35, figs. 1–12; Morgan Library 1974, no. 2, repr.

Dieses Evangeliar ist das Glanzstück der Bibliothek aus der Buchmalerei der sogenannten franko-sächsischen Schule. Die Handschriften dieser Gruppe wurden von der Mitte des 9. Jahrhunderts (der spätkarolingischen Zeit) an bis ins 10. Jahrhundert im Nordosten Frankreichs, vornehmlich im Benediktinerkloster von St. Amand (aus dem vermutlich auch dieser Kodex stammt), angefertigt. Typisch für die franko-sächsische Buchmalerei ist die Betonung insularer Flechtbänder, deren Ornamentstrukturen allerdings in strenger Regelmäßigkeit und Unterteilung verlaufen. Auch Figuren werden eingesetzt, allerdings sparsam, und es wird dabei eine kühle Ausgewogenheit zwischen den phantasievollen, aus der Kunst der Wikinger stammenden Motiven und den klassischen, von der karolingischen Renaissance wiederbelebten Elementen erreicht.

Der mit einer antiken Toga bekleidete Evangelist Markus wird hier bei der Niederschrift seiner Heilsbotschaft präsentiert. Über ihm befindet sich sein Symbol, der Löwe, eingefaßt von Inschriften, die der spanische Bischof Theodulf – ein Gelehrter am Hof Karls des Großen – verfaßt hat. Der Einsatz von Flechtbändern ist auf diesem wie auch auf den übrigen Evangelistenportraits des Evangeliars auf die Pfeiler und auf den Bogen beschränkt.

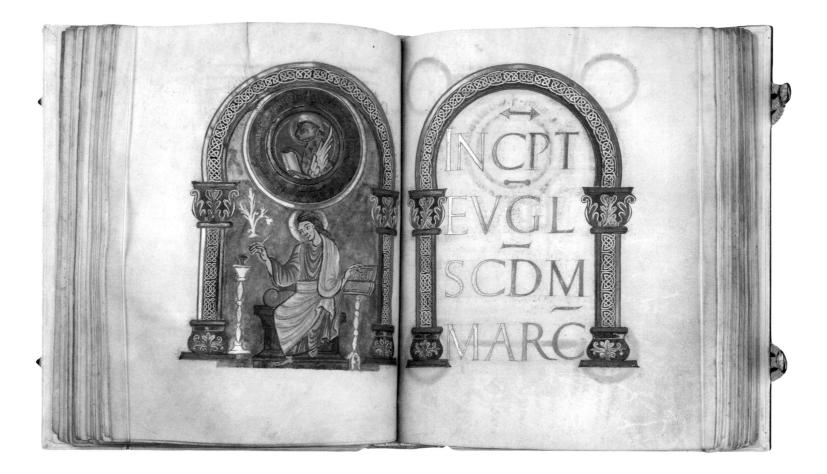

VISION OF THE LAMB

Beatus of Liébana, *Commentary on the Apocalypse*, in Latin

Illuminated by Maius (d. 968)

Spain, province of León, probably San Salvador de Tábara, ca. 950, for Abbot Victor of St. Michael of Escalada

301 leaves, 385 x 280 mm; 62 full-page and 48 smaller miniatures

Purchased by J. P. Morgan, Jr., 1919; MS M.644 (fol. 87)

DIE ERSCHEINUNG DES LAMMES

Beatus von Liébana, *Kommentar zur Apokalypse*, lateinisch

Illuminiert von Maius (gestorben 968 n. Chr.)

Spanien, Provinz León, vermutlich San Salvador de Tábara, circa 950 n. Chr., angefertigt für den Abt Viktor im Kloster St. Michael von Escalada

301 Blätter, 385 x 280 mm; 62 ganzseitige und 48 kleinere Miniaturen

Erworben 1919 von J. P. Morgan jr.; MS M.644 (fol. 87)

Although Beatus completed his twelve-book *Commentary on the Apocalypse* about 776, it is not clear that it was originally illustrated. Nevertheless the twenty-six surviving illustrated copies, produced between 950 and 1220, constitute the greatest achievement of medieval Spanish illumination. Of these, the Morgan Beatus is perhaps the most important, standing as it does at the beginning of the tradition. According to its colophon, Maius, the artist-scribe, painted the pictorial cycle "so that the wise may fear the coming of the future judgment of the world's end." While he based his copy on a now lost model, Maius also made important contributions of his own, such as the prefatory Evangelists' portraits, genealogical tables, and especially the frames and colored backgrounds.

The Vision of the Lamb (Apocalypse 5:6–14), while not one of the more terrifying images, is one of the most beautiful and original. At the cardinal points, surrounding the throne of the Lamb (symbolizing Christ), are the four living creatures, each with wings, a fiery wheel, and a book (interpreted as the symbols of the Evangelists: Matthew, angel; Mark, lion; Luke, ox; John, eagle); for St. Jerome the wheels indicated the rapid progress of the Evangelists throughout the world. Between the creatures are elders playing musical instruments. The throne, surrounded by a blue band with twenty-four stars, is supported by four angels. The radial, geometric scheme is unique to Spanish illumination. W. M.V.

Provenance
St. Michael's, Escalada; purchased by Guglielmo Libri in 1847; sold to Bertram, earl of Ashburnham (1797–1878) before 1852; sold by the next earl in May 1897 to Henry Yates Thompson (Ms. 97); his sale, London, Sotheby's, 3 June 1919, lot 21, to Quaritch, for J. P. Morgan, Jr.

Selected bibliography and exhibitions
Williams and Shailor 1991; Williams 1994, vol. 1 (introduction, references throughout), vol. 2, pp. 21–33, no. 2, repr. pp. 3–118.

Bis heute ist nicht erwiesen, ob die zwölf Bände des um 776 vollendeten *Kommentar zur Apokalypse* des Beatus ursprünglich illustriert waren. Dessenungeachtet bilden die 26 erhaltenen, zwischen 950 und 1220 angefertigten illustrierten Abschriften den Höhepunkt der mittelalterlichen spanischen Buchmalerei. Unter ihnen ist die der Pierpont Morgan Library möglicherweise die bedeutendste, da sie am Anfang der Tradition steht. Gemäß ihres Kolophons malte der Kopist Maius den Bilderzyklus so, »daß die Weisen das bevorstehende Strafgericht am Ende der Welt fürchten mögen«. Obgleich Maius' Kopie auf einer heute verlorenen Vorlage basiert, ist nachgewiesen, daß der Illuminator wichtige Elemente selbst eingefügt hat, so die vorangestellten Portraits der Evangelisten, die genealogischen Tafeln und vor allem die Rahmungen und kolorierten Hintergründe.

Die *Erscheinung des Lammes* aus der Offenbarung des Johannes (5,6–14) zählt zwar nicht zu den erschreckendsten, dafür jedoch zu den schönsten und originellsten Bildern dieser Apokalypse. An den Eckpunkten um den Thron des Lammes, das Christus symbolisiert, sind die vier lebenden Wesen plaziert, ein jedes mit Flügeln, einem Feuerrad und einem Buch. Sie werden als Symbole der Evangelisten interpretiert; Matthäus wird der Engel, Markus der Löwe, Lukas der Stier und Johannes der Adler zugeordnet. In der Deutung des heiligen Hieronymus versinnbildlichen die Räder das schnelle Fortschreiten der Evangelisten durch die Welt. Zwischen den Gestalten musizieren Presbyter auf ihren Instrumenten. Der von einem blauen Band mit 24 Sternen umgebene Thron wird von vier Engeln getragen. Das radiale, geometrische Schema findet sich nur in der spanischen Buchmalerei.

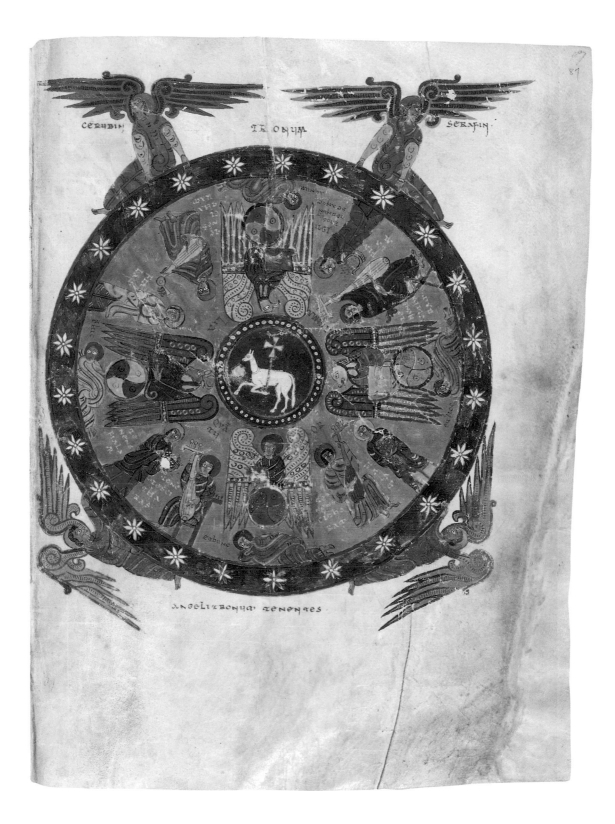

Nativity and Annunciation to the Shepherds

Lectionary of the Gospels, in Latin

Illuminated by Custos Perhtolt

Austria, Salzburg, monastery of
St. Peter, 1070s–80s

82 leaves, 245 x 182 mm; 16 full-page
and 3 smaller miniatures, 3 decorated
incipit pages

Purchased on the Lewis Cass Ledyard
Fund, 1933; MS M.780 (fol. 4)

Christi Geburt und Verkündigung an die Hirten

Lektionar zu den Evangelien,
lateinisch

Illuminiert von Custos Perhtolt

Österreich, Salzburg, Kloster von
St. Peter, zwischen 1070 und 1090

82 Blätter, 245 x 182 mm; 16 ganz-
seitige und 3 kleinere Miniaturen,
3 ausgeschmückte Incipitseiten

Erworben 1933 mit Mitteln des Lewis
Cass Ledyard Fund; MS M.780 (fol. 4)

According to its colophon this manuscript was made and dedicated by a certain Custos Perhtolt "to the bearer of the keys of heaven … as an expiation for all sins committed by him." To insure perpetual atonement he also added a curse: "May he who steals it suffer bodily pains." While this guardian Perhtolt has not been identified, though other manuscripts have been attributed to him (the closest is a Gospel in the monastery of Admont, Ms.511), there is little doubt that the "bearer of keys" refers to St. Peter, the patron of the abbey in Salzburg where the manuscript was produced. The Lectionary, which represents an advanced stage in the transition from the Ottonian to the Romanesque style, is also related to a Lectionary in Munich (Staatsbibliothek, Clm.15713), especially with regard to the form, selection, and arrangement of its cycle of miniatures.

Such is the case for these Lectionary Nativities, which include both the Annunciation to the Shepherds and the Midwife Washing the Christ Child. The necessity for the latter was much disputed by theologians, who argued that Christ's birth was as pure as his conception. Their contention that his pure and spotless body washed the waters, constituting a reference to baptism, may have suggested the baptismal character of the representation. The ox and ass fulfill the prophecy of Isaiah (1:3), who said that the ox would know its owner and the ass its master's crib. W. M. V.

Provenance
Salzburg, monastery of St. Peter (Codex A.VI.55); purchased from St. Peter's in 1933.

Selected bibliography and exhibitions
Swarzenski 1913, pp. 49–55; Harrsen 1958, pp. 19–20, no. 10, pls. 5, 25, 26, 83; Salzburg 1982, pp. 187, 360–61, no. 423, pls. on pp. 156, 157, 188; Benvin 1988, p. 4.

Nach Angaben des Kolophons wurde diese Handschrift von einem gewissen Custos Perhtolt angefertigt und »dem Träger der Himmelsschlüssel … als Buße für alle von ihm begangenen Sünden« gewidmet. Um immerwährende Sühne sicherzustellen, fügte er zusätzlich eine Verwünschung bei: »Möge derjenige, der es entwendet, größte körperliche Pein erleiden.« Obwohl man demselben Gardian Perhtolt auch andere Manuskripte (die größte Ähnlichkeit besitzt ein Evangeliar im Kloster Admont, Ms. 511) zuweist, konnte er bislang nicht näher identifiziert werden. Als nahezu sicher kann gelten, daß mit dem »Träger der Himmelsschlüssel« der heilige Petrus gemeint ist, der Patron der Abtei in Salzburg, in der diese Handschrift angefertigt wurde.

Das Lektionar, das ein fortgeschrittenes Stadium am Übergang vom ottonischen zum romanischen Stil aufweist, ist im Hinblick auf Form, Auswahl und Anordnung seines Miniaturenzyklus einem Lektionar in der Münchner Staatsbibliothek (Clm.15713) verwandt.

Das gleiche trifft auf die Lektionare zur Geburt Christi zu, die sowohl die Verkündigung an die Hirten als auch die Waschung des Christuskindes durch die Hebamme enthalten. Die Notwendigkeit dieser Waschung war bei den Theologen aufgrund der Auffassung heftig umstritten, die Geburt Christi sei wie die Empfängnis rein gewesen. Ihr Argument, daß sein makelloser Körper das Wasser selbst reinige und damit auf die Taufe verweise, könnte deren Einbezug in die Darstellung angeregt haben. Ochse und Esel erfüllen die Prophezeiung Jesajas (1,3), der verkündete, daß ein Ochse seinen Herrn und ein Esel die Krippe seines Herrn erkennen würden.

pax hominibus bone volun
tatis.

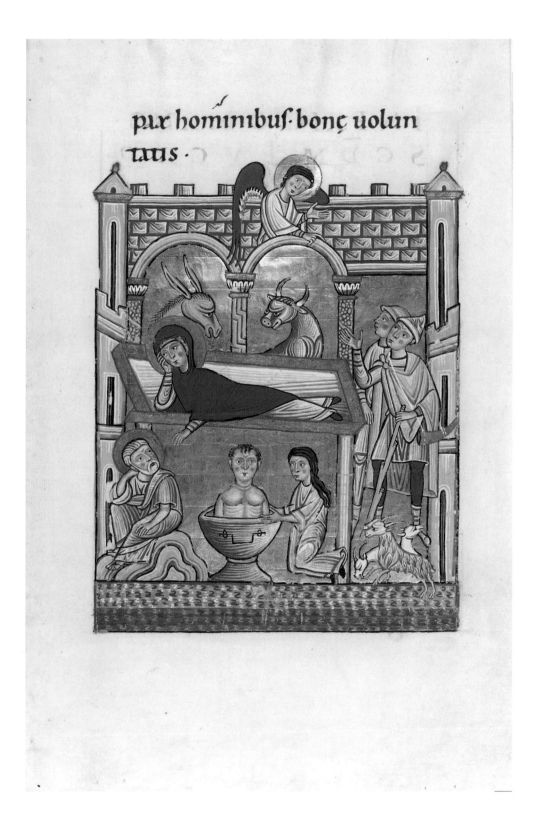

JEWELED BINDING WITH
CHRIST IN MAJESTY AND
CRUCIFIXION

Gospels, in Latin

England, between 1051 and 1065

86 leaves, 296 x 197 mm; 4 full-page
miniatures and 4 illuminated incipit
pages

Binding: England or Germany, last
third of the eleventh century

Purchased by J. P. Morgan, Jr., 1926;
MS M.708

JUWELENBESETZTER EINBAND
MIT CHRISTUS IN MAJESTAS
UND KREUZIGUNG

Evangeliar, lateinisch

England, zwischen 1051 und 1065

86 Blätter, 296 x 197 mm; 4 ganzseitige
Miniaturen und 4 illuminierte Incipit-
seiten

Einband: England oder Deutschland,
letztes Drittel des 11. Jahrhunderts

Erworben 1926 von J. P. Morgan jr.;
MS M.708

This luxury Gospels was made for Judith, countess of Flanders, between 1051 and 1065, when she was in England. The daughter of Count Baldwin IV of Flanders, she was born in or after 1031, and married, by 1051, Tostig, the son of Earl Godwin and brother of King Harold of England. In 1065 she was forced into exile in Flanders and in late 1070 or 1071 married Duke Welf IV of Bavaria. In 1094 she bequeathed this and other books to Weingarten Abbey (Welf I was the chief founder), where she was buried; it remained there until the secularization of 1802.

Although the Gospels clearly was made in England, the origin of its jeweled binding is less certain. Although formerly thought to have been made in England, it recently has been suggested that it was added after her second marriage. The silver-gilt binding is divided into two registers: At the top is a blessing Christ in Majesty flanked by angels with six wings (probably seraphim), while below the Crucifixion takes place on a living tree. The figures are individually cast. The titulus, *Jesus of Nazareth, The King of The Jews,* in gilt letters surrounded by translucent green enamel, is that ordered by Pilate (John 19:19). W. M. V.

Provenance
Judith of Flanders, who bequeathed it in 1094 to Weingarten Abbey; after the secularization of 1802 it became the property of Frederick Wilhelm of Orange-Nassau and was taken to his residence in Fulda; removed by the French town-major Niboyet; sold in 1818 by Delahante, a Parisian dealer, to Thomas Coke, first earl of Leicester, Holkam Hall MS 15; sold by the third earl of Leicester.

Selected bibliography and exhibitions
Temple 1976, pp. 109–11, no. 94, repr. 286; Needham 1979, pp. 33–35, no. 8, pl. 21; McGurk and Rosenthal 1995, pp. 251–308, pls. 5, 6; Clarkson 1996, pp. 212–13, n. 10.

Dieses kostbare Evangeliar wurde für Judith, Gräfin von Flandern, zwischen 1051 und 1065 angefertigt, als sie sich in England aufhielt. Die Tochter des Grafen Balduin IV. von Flandern wurde um 1031 geboren und heiratete 1051 Tostig, den Sohn Earl Godwins und Bruder des englischen Königs Harold. 1065 wurde sie gezwungen, ins Exil nach Flandern zu gehen, und heiratete Ende 1070 oder 1071 Herzog Welf IV. von Bayern. Im Jahr 1094 vermachte sie dieses und andere Bücher der Abtei von Weingarten, deren Hauptgründer Welf I. war; hier wurde sie auch zu Grabe getragen. Das Werk verblieb bis zur Säkularisation im Jahr 1802 in der Abtei.

Obgleich das Evangeliar offensichtlich aus England stammt, gibt es keinen gesicherten Nachweis über die Herkunft des juwelenbesetzten Einbandes. Neben die ursprüngliche Annahme, er stamme ebenfalls aus England, trat jüngst die Vermutung, daß der Einband erst nach der zweiten Eheschließung Judiths hinzugefügt worden sei. Der vergoldete Silbereinband ist in zwei Register unterteilt: Das obere zeigt den segnenden Christus in Majestas, flankiert von sechsflügeligen Engeln (vermutlich Seraphim), das untere die Kreuzigung an einem Baum. Die Figuren wurden einzeln gegossen. Der Titulus in vergoldeten Lettern, eingefaßt mit transluzidem grünem Email, entspricht im Wortlaut der Anweisung des Pilatus (Johannes 19,19): *Jesus von Nazareth, der König der Juden.*

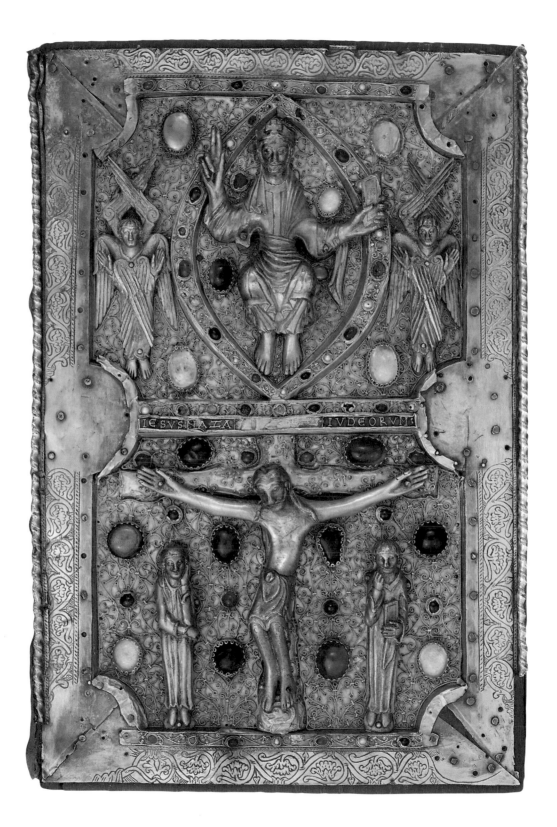

St. John the Evangelist Riding His Symbol

Gospels, in Latin

England, perhaps Gloucester, ca.1130

76 leaves, 264 x 172 mm; 4 full-page miniatures

Purchased on the Lewis Cass Ledyard Fund, 1932; MS M.777 (fol. 58v)

Johannes der Evangelist auf seinem Symboltier reitend

Evangeliar, lateinisch

England, vermutlich Gloucester, circa 1130

76 Blätter, 264 x 172 mm; vier ganzseitige Miniaturen

Erworben 1932 mit Mitteln des Lewis Cass Ledyard Fund; MS M.777 (fol. 58v)

Each of the Gospels in this manuscript is preceded by a full-page miniature representing an Evangelist seated upon his symbol, an iconographic feature apparently unique at this early date. The origin of this iconography is obscure, but at least two derivations have been suggested: Oriental planet representations in which the planet divinities ride or sit upon their zodiacal signs or Western representations of the four elements riding animal symbols. The latter requires equating the elements with the Evangelists, an association with both literary and artistic parallels.

Here St. John the Evangelist rides his eagle. The symbol was first linked with John by Hippolytus, a third-century Roman theologian, for whom the eagle represented the spirit that soars to the heavens with the "Word." Epiphanus of Salamis (ca. 360) added that John preaches that the Word, which became flesh, came from heaven, and would return there like an eagle after the Resurrection. (In Roman myth the eagle carried the soul of the emperor to heaven.) For Jerome, the strength of the eagle's flight was comparable to that of the written word. The miniature is archaic for the period, and its broadly interpreted Reims style may depend upon some Carolingian model.

W. M. V.

Provenance
Stephen Batman (d. 1584), who helped Matthew Parker, archbishop of Canterbury, assemble the great collection of manuscripts and books he bestowed upon Corpus Christi College in Cambridge; Sir Thomas Mostyn (d. 1758), no. 42: Mostyn Sale, London, Sotheby's, 13 July 1920, lot 40; Alfred Chester Beatty, MS 19; his sale, London, Sotheby's, 7 June 1932, lot 4.

Selected bibliography and exhibitions
Millar 1927–30, vol. 1, pp. 72–75, no. 19, pls. 57–59, frontispiece; Hinkle 1973, pp. 193–95, figs. 1–4; Kauffmann 1975, p. 65, no. 25, repr. 57, 58; Cahn 1996, vol. 2, pp. 31–32; van der Horst et al. 1996, pp. 144, 161, fig. 68.

Jedem der vier Evangelien dieser Handschrift ist eine ganzseitige Miniatur mit einem auf seinem Symboltier plazierten Evangelisten vorangestellt. Zu diesem frühen Zeitpunkt ist diese Ikonographie offensichtlich einzigartig; ihr Ursprung ist ungeklärt, doch sind zumindest zwei Quellen vorgeschlagen worden: orientalische Planetendarstellungen, auf denen die Planetengottheiten auf ihren Sternzeichen reiten oder sitzen, sowie abendländische Darstellungen der vier auf Tiersymbolen reitenden Elemente. Für die darin vorgenommene Gleichsetzung der Elemente mit den Evangelisten gibt es sowohl literarische als auch bildkünstlerische Parallelen.

In unserem Beispiel reitet der heilige Johannes auf seinem Adler. Dieses Symbol wurde erstmals von Hippolytus, einem römischen Theologen aus dem 3. Jahrhundert, mit Johannes in Verbindung gebracht; für ihn verkörperte der Adler den Geist, der mit dem »Wort« gen Himmel emporsteigt. Epiphanius von Salamis (circa 360) fügte hinzu, daß nach Johannes das Wort, das Fleisch wurde, vom Himmel kam und nach Christi Auferstehung wie ein Adler dorthin zurückkehren würde. (Im römischen Mythos trug der Adler die Seele des Kaisers gen Himmel.) Für den heiligen Hieronymus waren der kraftvolle Flug des Adlers und die Kraft des geschriebenen Wortes vergleichbar. Die Miniatur wirkt im Vergleich mit zeitgenössischen Werken in ihren Stilelementen altertümlich; ihr weitläufig mit Reims in Verbindung gebrachter Stil geht möglicherweise auf ein karolingisches Vorbild zurück.

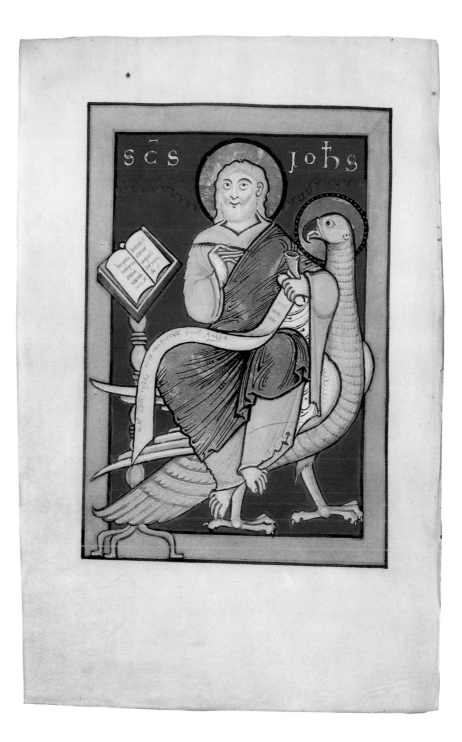

BOAZ OBSERVES RUTH
GLEANING IN HIS FIELD;
RUTH CONTINUES TO GLEAN;
RUTH EATING WITH BOAZ
AND THE REAPERS; BARLEY
STACK OF BOAZ

Old Testament Miniatures
(Maciejowski or Shah Abbas Bible),
in Latin, with Persian and Judeo-
Persian inscriptions

France, Paris, ca. 1250, probably for
Louis IX, king of France

43 leaves, 390 x 300 mm; 86 pages of
miniatures, each with two to four
scenes

Purchased by J. P. Morgan, Jr., from
the estate of Sir Thomas Phillipps,
1914, MS M.638 (fol. 17v)

BOAS BEOBACHTET RUTH BEIM
ÄHRENLESEN AUF SEINEM
FELD; RUTH FÄHRT FORT, DIE
ÄHREN ZUSAMMENZUTRAGEN;
RUTH BEI DER MAHLZEIT MIT
BOAS UND SEINEN SCHNIT-
TERN; BOAS' GERSTENGARBE

Alttestamentarische Miniaturen
(Maciejowski- oder Schah-Abbas-
Bibel), lateinisch mit persischen und
jüdisch-persischen Übersetzungen

Frankreich, Paris, circa 1250, vermut-
lich für Ludwig IX. (St. Louis), König
von Frankreich, angefertigt

43 Blätter, 390 x 300 mm; 86 Seiten mit
Miniaturen von jeweils 2 bis 4 Szenen

Erworben 1914 von J. P. Morgan jr.,
aus dem Besitz von Sir Thomas
Phillipps; MS M.638 (fol. 17v)

This volume of miniatures, unrivaled among early Gothic manuscripts for the breadth and perfection of its artistry, was the work of at least six painters. Since no other of their miniatures have been identified, they may have been mural painters, for some murals and stained glass in Ste-Chapelle have been connected with them. Ste-Chapelle was commissioned by Louis IX in the 1240s, and this picture book was probably made for him as well. Many miniatures emphasize battles fought by the Hebrews (dressed as French knights) for the Holy Land, suggesting a parallel with Louis's own attempt to reconquer it. The scale and elaboration of the Old Testament cycle are without parallel, and the battle scenes, with close attention given to armor, are among the most vivid of the Middle Ages.

The Latin inscriptions were added in Italy in the fourteenth century. In 1604 Cardinal Bernard Maciejowski, primate of Poland, gave the book to a papal mission to Shah Abbas the Great organized by Pope Clement VIII. The pope sought the Persian king's aid against the Turks and tolerance toward Christians in Persia. The shah, who finally received the manuscript in 1608, ordered the Persian translations. The Judeo-Persian transliterations were added later in the century. W. M. V.

Provenance
Probably Louis IX, king of France; Cardinal Bernard Maciejowski, bishop of Cracow; received in 1608 by Shah Abbas the Great; Giovanni Athanasi; his sale, London, Sotheby's, 15–16 March 1833, lot 201; to Sir Thomas Phillipps, Cheltenham (MS 8025 bis).

Selected bibliography and exhibitions
Cockerell et al. 1927; Cockerell and Plummer 1975; Stahl 1982, pp. 79–93, figs. 74, 76, 78, 80, 82; Weiss 1993, pp. 710–37, figs. 4, 6; Weiss and Voelkle 1997.

Dieser Band, einzigartig unter den frühen gotischen Handschriften in der Vielfalt und Vollkommenheit seiner künstlerischen Ausführung, ist das Werk von zumindest sechs Malern. Da ihnen keine anderen Miniaturen zugeordnet werden können, andererseits jedoch Wandmalereien und Glasfenster der Sainte-Chapelle in Paris mit ihnen in Verbindung gebracht werden, könnte es sich bei den Ausführenden um Künstler handeln, die auch Fresken erstellten. Ludwig IX. gab die Sainte-Chapelle um 1240 in Auftrag, und vermutlich wurde auch diese Bilderhandschrift für ihn angefertigt. In vielen ihrer Miniaturen ist besonderes Gewicht auf die Darstellung von Schlachten gelegt, welche die – wie französische Ritter gekleideten – Israeliten um das Heilige Land führten. Sie erinnern an Ludwigs eigenen Versuch, das Heilige Land zurückzuerobern. Der Umfang und die feine künstlerische Ausgestaltung des alttestamentarischen Zyklus sind ohne Vergleich. Die Kampfszenen, bei deren Ausarbeitung besonders den Rüstungen große Aufmerksamkeit geschenkt wurde, zählen zu den lebendigsten Darstellungen ihrer Art im Mittelalter.

Die lateinischen Inschriften wurden im 14. Jahrhundert in Italien hinzugefügt. 1604 schickte der Primas von Polen, Kardinal Bernard Maciejowski, das Buch auf einer von Papst Clemens VIII. befohlenen päpstlichen Mission an Schah Abbas den Großen. Der Papst ersuchte den persischen König um Hilfe gegen die Türken und bat um Toleranz gegenüber den Christen in Persien. Der Schah, der die Handschrift schließlich 1608 erhielt, veranlaßte eine Übersetzung ins Persische. Die jüdisch-persischen Übertragungen wurden gegen Ende des 17. Jahrhunderts ergänzt.

ualiter Ruth pmittente secru uadit ad colligendum spicas. et casu ingressa e agrum cuiusdā
cuiusdam nomine Booz. qui erat a finis noemi. Ille autem ueniens a ciuitate. cum uidiss Ruth
inter messores. audito unde esset et que esset jcepit messonbus utp omnia bene tractarent eam. sibi
etiam sapiens ne alio pgeret. ~

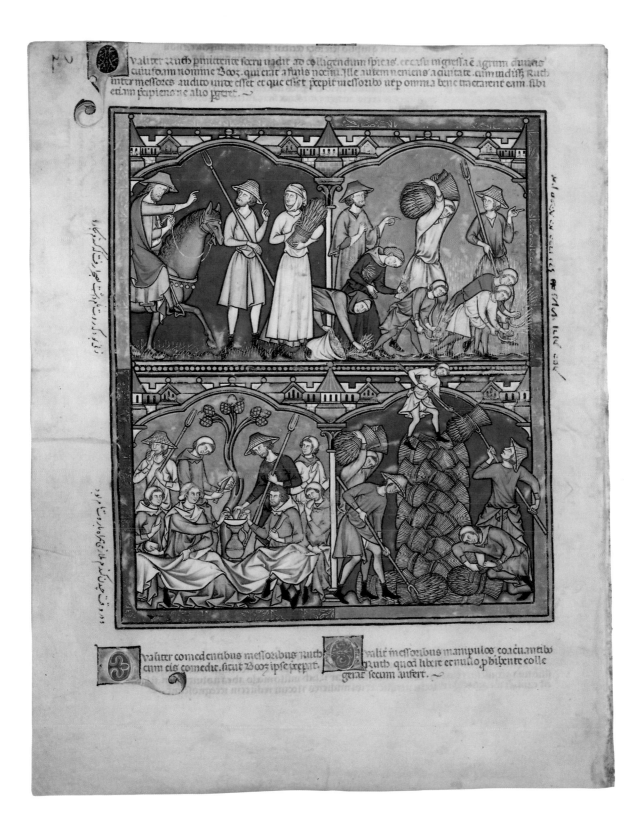

ualiter comedentibus messoribus Ruth ualiter messoribus manipulos coacuantibus
cum eis comedit. sicut Booz ipse jcepit. Ruth quod libret et nullo pbibente colle
 gerat secum aufert. ~

Saul Promises to Give His
Daughter Michal to David
if He Slays One Hundred
Philistines; David Slaugh-
ters Two Hundred Philis-
tines

Old Testament Miniatures
(Maciejowski or Shah Abbas Bible),
in Latin, with Persian and Judeo-
Persian inscriptions

France, Paris, ca. 1250, probably for
Louis IX, king of France

43 leaves, 390 x 300 mm; 86 pages of
miniatures, each with two to four
scenes

Purchased by J. P. Morgan, Jr., 1914;
MS M.638 (fol. 29v)

Provenance and selected bibliography and
exhibitions
See No. 118.

Saul verspricht David seine
Tochter Michal, wenn es
ihm gelingt, 100 Philister
zu erschlagen; David
erschlägt 200 Philister

Alttestamentarische Miniaturen
(Maciejowski- oder Schah-Abbas-
Bibel), lateinisch, mit persischen und
jüdisch-persischen Übersetzungen

Frankreich, Paris, circa 1250; vermut-
lich für Ludwig IX. (St. Louis), König
von Frankreich, angefertigt

43 Blätter, 390 x 300 mm; 86 Seiten mit
Miniaturen von jeweils 2 bis 4 Szenen

Erworben 1914 von J. P. Morgan jr.;
MS M.638 (fol. 29v)

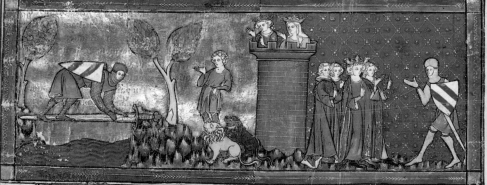

a vne ouec.

Sire fait cil qui descouurir ne se voldreit pas ne se su mie ci ueuuz. sy mos herbergier ace ste heure. Ja nus ma on sut encore dire que ie me doi a chlr combatre. se il est ci uainque diuant. car ml't de fu que ie men soie deliurez. Biau sire fait li rois ne uos hastez ia de la bataille. car uos nen auez nne mlt grt mestier. a cestui point dune uos seioiurnez. humiaus auec nos cu iesp our. et ie en uos uondrai sans bataille ce que uos estes uenu dire. plus ligeremet. Et ie le uoi droie bn le sachiez. car il nestoit li hons ou monde por cui ie seroie plus. Por mos biau sire sur lance

[...]

de p uos garantir non. car il naues pale poor contre celui qui se doit combatre auoc. Se ie le uoi priug encondure. et ie uos porrai deliure mais. et uos sera gaitiue contre tout homes fors dlui. z dui bataille quoi auerez. demain. car auis nel porez. uos auoir. auas monter. chr cest cheual. z al mlt bons ie uos douig mltot allez. Et ie le uoul al dir q ie uos amig iuec Iehu qui est ou monde. cals p la grt prouesce que en uos estait dist li rois Banc. qui est montez. Si dieu vout grt aleur en la cite sie fait li rois entrer en la plus belle chambre qui fust leans sina roine auec lui z toute gent que seul ie cremir qui sera ce que

[...]

prisoues. Et allez a dire ceste pri son.

Et d cestui los fait a elcagant ie uos cremirai. z bn point qui cuers uos est saluz. qui porta doure dun seul chlr vne comiez a kmr plait dont ie me houiue. De ce fait li rois ne seruetu ia houz. plus encor grouez pas. z honor. car tous li mo de durait au auerones quire ce que tu auerier. zqui pa prouesce. Et si serai grt prit z grt honors. Certes fait cel ie nen uoi point. aincos seront grt couarde si uoi bien que uos estes failhu cuer. ou uos doutez celuj ou uos me haez. qui crime ance. cause de mon hautt. sie la kec se cel lance

[...]

ne sage frai uos wrez tant. car ie ne sui ouquez de uous acourir ne uos z nuj. sie ie ne uoul onquez du ma ieu cudier. o ar quez que ie sue faites mos ma bataille auoir. our ie la uel sie onse pboure que ie uacendrie auoir. dlloing neuiug. iuau p pauig uir faire ans pbouures tant ioies tes eugereuu fous. Li rois cureut bn qnil te caute ur lui por par pauor detre qieuz. si bee de faire ouuretmeur qil qnil cudiera z bou li fume.

[...]

Une chretiene fan qnil z eare bn le sachiez. sie la en ma maudiz ne uoul sera niz torse de uos houtre. sie ie ne uoul bel hbgui

[...]

li gmandin. Et te gard il me uuet duuer leans. sice que descouuir nele uelt mie ne coureter sis pred est li rois uenuz allou sil. z li dit. Biau roy cual ueut mauui bel chlr. puis que tu soi armel porter cpas tu nu uez onquer mal aul si apertemet hardi ijue cu est qui a his pasier le pour. z p le grt har demeur que nos pauons ueu de loeruege que tu feuler tant que tu ieuuez houoi arone uos mais. Que me loez uos fait a eleagans. que iou enface. ie te duzai fait li rois. que ie te loerige. que tu tro diuier la roine ouuretmeur. car tu nai duit cuh cemir. sie en nul de

[...]

sie me erpoure. car iai allez zcu er z force dlui atendre. z d obac gtre lui. Et se uos lauez hibergue contre moi tant auermige pl grt hour. cuma droiture desfendre Et encell lui sage ahau na gauer on il auoit plus dad z d secor qnil nauria er. car cestu en la cort le Roy artu.

[...]

Comet fait li rois sectu que ce sur lance par la force que ie doi a qui mes siz iez. ie ne ci qu il est uel que tu faiz. car ie nel encore ueut ne arme non. Mais se ie sauoie d uoir que fait lance. Tu ne te obateroies a auuj. car tu ni porroie auoir duree. Ouiques

CHRIST IN MAJESTY

Single leaf from a Laudario, in Italian

Illuminated by Pacino di Bonaguida

Italy, Florence, ca. 1340

1 leaf, 454 x 335 mm; 1 large miniature, 5 medallions, and 2 border figures

Purchased by the Library, 1929; MS M.742

CHRISTUS IN DER MAJESTAS

Einzelblatt aus einem Laudario, italienisch

Illuminiert von Pacino di Bonaguida

Italien, Florenz, circa 1340

1 Blatt, 454 x 335 mm; 1 große Miniatur, 5 Medaillons und 2 Rahmenfiguren

Erworben 1929 durch die Pierpont Morgan Library; MS M.742

The large number of panel paintings—and even larger number of illuminated manuscripts—attributable to Pacino di Bonaguida attests to the important position he held throughout the first four decades of the fourteenth century. Although not as innovative as his contemporary Giotto, he is considered one of the fathers of the Renaissance in Florence.

This leaf is one of nearly two dozen, presently dispersed in European and American collections, from a Laudario (book of hymns in Italian) that was created for the Compagnia di Sant'Agnese. Affiliated with the church of Santa Maria del Carmine, this lay confraternity devoted to St. Agnes was composed of both men and women. The especially large miniatures of this Laudario make it the most elaborate Florentine book from the first half of the fourteenth century.

This leaf depicts a Christ in Majesty who raises his right hand in blessing and supports, with his left hand, a book inscribed with the Alpha and Omega. The Savior is surrounded by musical angels and, at his feet, lies the whole of creation. Below the miniature are the opening words of the hymn, "Alta Trinita beata . . . " (Highest blessed Trinity); indeed, different manifestations or representations of the Trinity are found at the four corners of the leaf. Within the bottom center medallion kneels a male member of the confraternity.

R.S.W.

Provenance
Made for the Compagnia di Sant'Agnese, Florence, ca. 1340; marquis de Talleyrand, Rome.

Selected bibliography and exhibitions
Harrsen and Boyce 1953, p. 14, no. 23, pl. 1; Kanter et al. 1994, p. 62, no. 16, pp. 73–76, no. 4i, repr.

Die große Anzahl an Tafelbildern – und die noch größere Zahl illuminierter Handschriften –, die Pacino di Bonaguida zugeschrieben werden können, belegen seine bedeutende Stellung im ersten Drittel des 14. Jahrhunderts. Zwar kann ihm nicht die Innovationskraft seines Zeitgenossen Giotto zugemessen werden, dennoch gilt er als einer der Wegbereiter der Kunst der Renaissance in Florenz.

Dieses Blatt ist eines von nahezu zwei Dutzend heute über europäische und amerikanische Sammlungen verstreuten Blättern aus einem Laudario (italienische Bezeichnung für Hymnenbuch), das für die Compagnia di Sant' Agnese geschaffen wurde. Diese der Kirche Santa Maria del Carmine zugehörige und der heiligen Agnes geweihte Laienbruderschaft setzte sich aus Männern und Frauen zusammen. Die ungewöhnliche Größe der ausgeführten Miniaturen macht das Laudario zum künstlerisch vollkommensten Florentiner Buch der ersten Hälfte des 14. Jahrhunderts.

Das Blatt stellt Christus in Majestas dar, seine rechte Hand zum Segen erhoben, während die linke ein mit Alpha und Omega beschriebenes Buch hält. Der Erlöser ist von musizierenden Engeln umringt, und zu seinen Füßen befindet sich, im Sinnbild der Halbkugel, die gesamte Schöpfung. Unter der Miniatur stehen die Eröffnungsworte des Hymnus »Alta Trinita beata …« (Hochheilige Trinität); tatsächlich finden sich in allen vier Ecken des Blattes verschiedene Manifestationen oder Repräsentationen der Dreifaltigkeit eingeschrieben. Im unteren Mittelmedaillon des Blattes kniet ein männliches Mitglied der Bruderschaft.

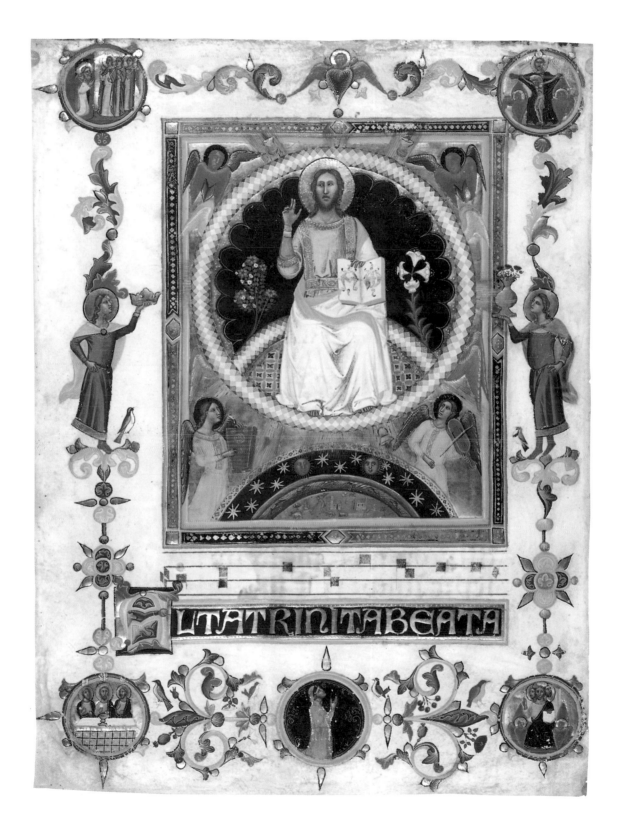

Last Supper, in an initial "C"

Single leaf from a Gradual, in Latin

Illuminated by Don Silvestro dei Gherarducci

Italy, Florence, Santa Maria degli Angeli, 1392–99

1 leaf, 590 x 400 mm; 1 large historiated initial

Purchased by Pierpont Morgan, 1909; MS M.653.4

Letztes Abendmahl, in einer »C«-Initiale

Einzelblatt aus einem Graduale, lateinisch

Illuminiert von Don Silvestro dei Gherarducci

Italien, Florenz, Santa Maria degli Angeli, 1392–99

1 Blatt, 590 x 400 mm; 1 große figürlich ausgestaltete Initiale

Erworben 1909 von Pierpont Morgan; MS M.653.4

The fame of illuminator Don Silvestro dei Gherarducci can be traced back as far as 1550 when Vasari praised him in the first edition of his *Lives of the Painters*. The famous father of art history tells us that Pope Leo X (see No. 125) was also an ardent admirer of Silvestro's creations. Indeed, the artist can be credited with the illumination of some of the most impressive of all Italian choir books. Active from the early 1370s until his death in 1399, Don Silvestro painted manuscripts for the use of his own monastery in Florence, Santa Maria degli Angeli, as well as another Camaldolese monastery near Venice, San Michele a Murano. This large Last Supper comes from the Venetian commission. It is but one of some fifty-one leaves or cuttings that survive from a monumental two-volume Gradual, the choir book used at Mass (the Library owns an additional four leaves and eighteen cuttings).

The large "C" introduces the Introit for the Feast of Corpus Christi. The Last Supper, at which Christ instituted the Eucharist, is the appropriate subject. The apostles react to Christ's announcement that one of them will betray him: Our attention is drawn to Judas, with his red money bag and black halo marked with scorpions. R.S.W.

Provenance
Made for the Camaldolese monastery of San Michele a Murano, near Venice, 1392–99; W. Bromley-Davenport, Capesthorne Hall (his sale, London, Sotheby's, 10 May 1907, lot 181).

Selected bibliography and exhibitions
Harrsen and Boyce 1953, pp. 16–17, no. 27, pl. 29; Boskovits 1975, pp. 115, 217 n. 91, 422, 424–25; Freuler 1992, vol. 2, pp. 480–85; Kanter et al. 1994, pp. 174–76, no. 17g, repr.; D'Ancona et al. 1995, passim.

Der Ruhm des Illuminators Don Silvestro dei Gherarducci läßt sich bis ins Jahr 1550 zurückverfolgen, als Vasari ihn in der Erstausgabe seines *Leben der berühmtesten Maler, Bildhauer und Architekten* voller Lob erwähnte. Der berühmte Begründer der Kunstgeschichte berichtet uns, daß auch Papst Leo X. (vgl. Kat.-Nr. 125) ein leidenschaftlicher Bewunderer von Silvestros Werken war. Tatsächlich ist der Künstler der Schöpfer einiger der eindrucksvollsten italienischen Chorbücher. Künstlerisch aktiv von den frühen 1370er Jahren an bis zu seinem Tod 1399, malte Don Silvestro Manuskripte für den Gebrauch in seinem eigenen Kloster Santa Maria degli Angeli in Florenz wie auch für ein weiteres Kamaldulenser-Kloster in der Nähe von Venedig, San Michele a Murano. Dieses großangelegte Abendmahl ist ein Auftragswerk für das venezianische Kloster. Es ist nur eines von etwa 51 Blättern oder Ausschnitten, die aus einem monumentalen zweibändigen Graduale, einem bei der Messe benutzten Chorbuch, erhalten sind. (Die Pierpont Morgan Library besitzt vier weitere Blätter und 18 Fragmente.)

Das große »C« eröffnet den Introitus (Eingangslied) zum Fronleichnamsfest. Das Letzte Abendmahl, bei dem Christus das Sakrament der Eucharistie einführt, ist das angemessene Thema. Die Apostel werden im Moment ihrer Reaktion auf Christi Ankündigung, daß er von einem der ihren verraten werde, festgehalten: Unsere Aufmerksamkeit wird auf Judas mit seinem roten Geldsack und seinen mit Skorpionen besetzten schwarzen Heiligenschein gelenkt.

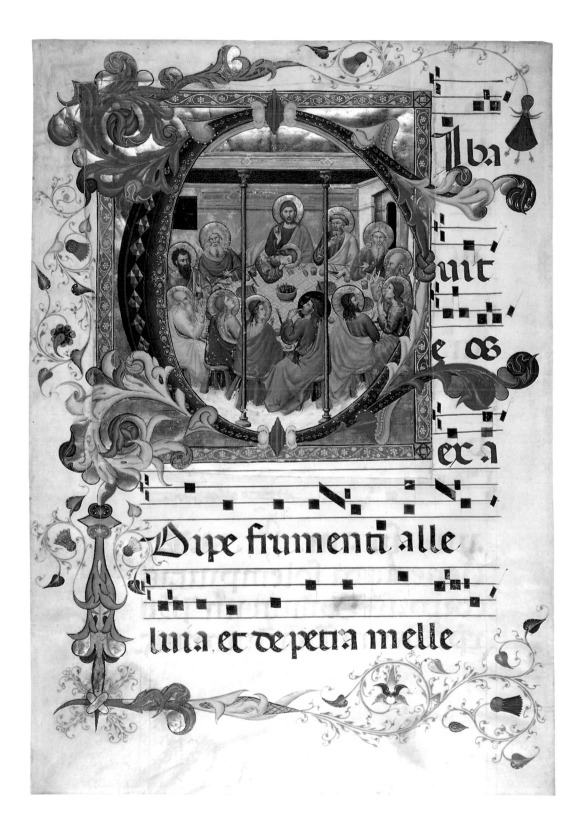

Iba

uit

es

et a

Dipe frumenti alle

luia, et de petra melle

DUKE WILHELM OF AUSTRIA RECITES THE OFFICE OF CORPUS CHRISTI

Thomas de Aquino, *Hystoria de corpore Christi,* in Latin

Illuminated by Nikolaus of Brünn

Austria, Vienna, ca. 1403–6, for Duke Wilhelm of Austria

43 leaves, 398 x 285 mm; 1 frontispiece, 1 historiated initial

Gift of Louis M. Rabinowitz, 1951; MS M.853 (fol. 1v)

HERZOG WILHELM VON ÖSTERREICH LIEST DIE FRONLEICHNAMSLITURGIE

Thomas von Aquin, *Hystoria de corpore Christi,* lateinisch

Illuminiert von Nikolaus von Brünn

Österreich, Wien, circa 1403–06, für Herzog Wilhelm von Österreich

43 Blätter, 398 x 285 mm; 1 Frontispiz, 1 figürlich ausgestaltete Initiale

Schenkung 1951 von Louis M. Rabinowitz; MS M.853 (fol. 1v)

The text, traditionally ascribed to Thomas Aquinas, comprises the full office for the feast of Corpus Christi (Body of Christ). Its frontispiece appropriately depicts Duke Wilhelm, "the Affable," contemplating an image of the body of Christ known as the Man of Sorrows, located within the initial *S* on the opposite page. The duke, kneeling on a homemade prie-dieu, holds a scroll with the words *Ave verum corpus Christi* (Hail, true body of Christ). The shield on the ground contains the colors of Austria; behind him is his armed squire. In the large panel below, the arms of the duke's wife, Johanna of Anjou, are flanked by the provinces over which he ruled: Carinthia and Carniola on the left and Styria and Tyrol on the right. Since the duke married Johanna in 1403 and died on 15 July 1406 as a result of a riding accident, the manuscript was probably executed between the two dates.

Nikolaus, in a German translation of the *Rationale divinorum officiorum* of Gulielmus Durandus (Vienna, Nationalbibliothek, MS 2765), depicted the duke a second time, along with his wife, kneeling before a Man of Sorrows triptych, a subject for which the duke apparently had a special veneration.

Gerhard Schmidt has attributed the border of the Morgan Man of Sorrows to the closely related Lyra Master, another of the hands found in the Durandus manuscript; Kurt Holter has attributed the initial and the frontispiece to him as well. W. M. V.

Provenance
Duke William of Habsburg (1370–1406); Emperor Charles VI (1685–1740); Prince Franz Joseph II von Liechtenstein, Vienna; sold 1951 through H. P. Kraus, New York.

Selected bibliography and exhibitions
Holter 1955, p. 221; Harrsen 1958, pp. 56–58, no. 42, pl. 62; Campbell 1961, pp. 294–301; Schmidt 1962, p. 12–13, no. 28, fig. 9, Baltimore 1962, pp. 68–69, no. 65, pl. 44; Fillitz 1995, p. 103, fig. 52; for the artist see Oettinger 1933, vol. 54, pp. 221–38.

Der üblicherweise Thomas von Aquin zugeschriebene Text enthält die gesamte Liturgie der Fronleichnamsfeierlichkeiten. Dem Anlaß entsprechend, zeigt das Frontispiz Herzog Wilhelm »den Gutmütigen« in Kontemplation über einer Darstellung Christi als Schmerzensmann, die innerhalb des Initials *S* auf der gegenüberliegenden Seite eingefügt ist. Der auf einem selbstgezimmerten Betschemel kniende Herzog hält eine Schriftrolle, auf der die Worte *Ave verum corpus Christi* (Gegrüßet seist du, wahrhaftiger Leib des Herrn) stehen. Der auf dem Boden liegende Schild trägt die Farben Österreichs; hinter dem Herzog steht sein bewaffneter Knappe. Auf dem darunterliegenden Bildfeld wird das Wappen von Johanna von Anjou, der Frau des Herzogs, von den Wappen der Provinzen flankiert, über die ihr Mann regiert: Kärnten und Krain auf der linken und Steiermark und Tirol auf der rechten Seite. Da der Herzog Johanna 1403 heiratete und am 15. Juli 1406 an den Folgen eines Reitunfalls verstarb, liegt die Vermutung nahe, daß das Manuskript in diesem Zeitraum ausgeführt wurde.

In einer deutschen Übersetzung des *Rationale divinorum officiorum* von Guillelmus Durandus (Wien, Nationalbibliothek, MS 27659) malte Nikolaus den Herzog ein zweites Mal – diesmal zusammen mit seiner Frau vor einem Triptychon mit der Darstellung des Schmerzensmannes kniend. Offensichtlich verehrte der Herzog dieses Thema in besonderem Maße.

Gerhard Schmidt hat die Bordüre des Schmerzensmannes der Pierpont Morgan Library dem nah verwandten Lyra-Meister zugeschrieben, einem weiteren Mitarbeiter am Durandus-Manuskript. Kurt Holter hat diesem auch die Initiale und das Frontispiz zugeschrieben.

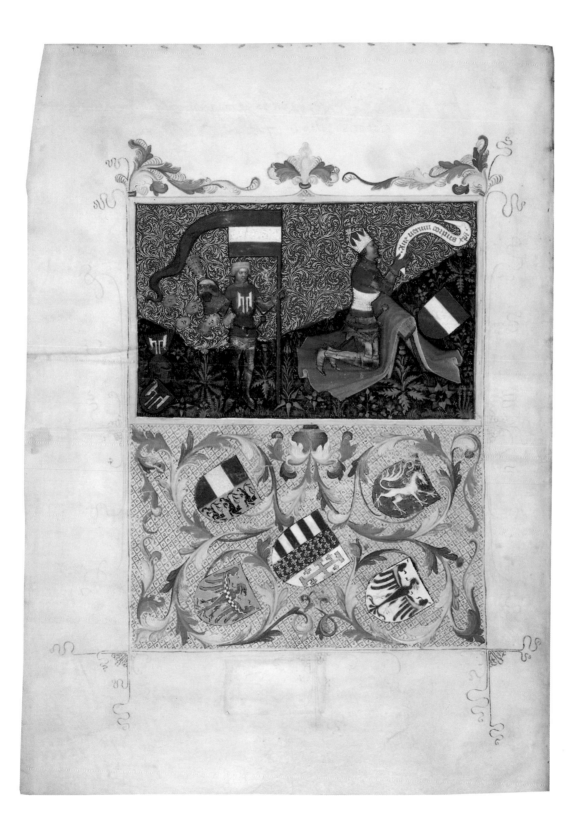

THREE TAROT CARDS FROM THE VISCONTI-SFORZA DECK

Italy, Milan, ca. 1450, probably for Bianca Maria Visconti and Francesco Sforza

Purchased by Pierpont Morgan, 1911; MS M.630, nos. 3, 10, 22

DREI TAROTKARTEN AUS DEM VISCONTI-SFORZA-KARTEN-SPIEL

Italien, Mailand, circa 1450, vermutlich angefertigt für Bianca Maria Visconti und Francesco Sforza

Erworben 1911 von Pierpont Morgan; MS M.630, Nr. 3, 10, 22

Fifteenth-century painted tarot cards are exceedingly rare, and neither the rules nor a complete deck survive. The thirty-five cards in the Library and thirty-nine in Bergamo form the most complete as well as one of the earliest and most important decks known. The pack of seventy-eight cards consisted of twenty-one trump (tarot) cards, a wild card (Fool), and fifty-six cards divided into four fourteen-card suits (cups, staves, coins, and swords). Each suit had ten number cards and four picture cards (page, knight, queen, and king). Invented as a card game for the nobility in Milan or Ferrara in the second quarter of the fifteenth century, apparently they were not used for fortune-telling before 1781, when Antoine Court de Gébelin erroneously identified them with the ancient Egyptian Book of Thoth.

The cards have been attributed to Bonifacio Bembo (active 1440–80) or Francesco Zavattari (active 1417–83), the slightly older painter in whose circle Bembo worked. The Morgan-Bergamo deck was probably made for Bianca Maria Visconti and Francesco Sforza, whose families' emblems are intermingled on some cards; they were betrothed in 1432 and married in 1441. The cards shown here are the Popess, the King of Swords (our modern suit of spades), and Time or the Hunchback. W.M.V.

Provenance
Visconti-Sforza family; Count Alessandro Colleoni (eighteenth century); passed down to another Count Alessandro Colleoni (1840–1924) of Bergamo, who sold it in 1911.

Selected bibliography and exhibitions
Moakley 1966; Kaplan 1975; Kaplan, 1978, pp. 65–86; Dummett 1980, 69ff.; Algeri 1981, 59ff., figs. 58, 62; Voelkle 1984, pp. 42–43, 35, repr. in color; Kaplan 1986, pp. 42–52.

Bemalte Tarotkarten aus dem 15. Jahrhundert sind äußerst selten. Weder die Spielregeln noch ein vollzähliger Kartensatz sind erhalten. Die 35 Karten der Pierpont Morgan Library und die 39 Karten in Bergamo bilden gemeinsam das vollständigste und zugleich eines der ältesten und bedeutendsten Kartenspiele überhaupt. Das Spiel aus 78 Karten bestand aus 21 Trümpfen (Tarotkarten), einer wilden Karte (dem Narr als Vorläufer des Joker) und 4 Farben (Becher, Speere, Münzen und Schwerter) mit jeweils 14 Karten. Jede Farbe umfaßte 10 Nummernkarten und 4 Bildkarten (Knappe, Ritter, Königin und König). Das ursprünglich im zweiten Viertel des 15. Jahrhunderts zur Unterhaltung der Aristokratie von Mailand oder Ferrara erdachte Kartenspiel wurde anscheinend nicht vor dem Jahr 1781 zur Weissagung der Zukunft benutzt, als Antoine Court de Gébelin es irrtümlich mit dem ägyptischen Buch Thot in Zusammenhang brachte.

Die Karten werden Bonifacio Bembo (tätig von 1440 bis 1480) oder dem etwas älteren Maler Francesco Zavattari (tätig von 1417 bis 1483) zugeschrieben, in dessen Kreis Bembo tätig war. Das Morgan-Bergamo-Kartenspiel wurde vermutlich für Bianca Maria Visconti und Francesco Sforza angefertigt, deren Familienembleme auf der Rückseite einiger Karten ineinander verflochten sind; die beiden wurden 1432 miteinander verlobt und heirateten im Jahr 1441.

Die hier abgebildeten Karten zeigen die Päpstin, den König der Schwerter (die heutige Farbe Pik) und die Zeit oder den Buckligen.

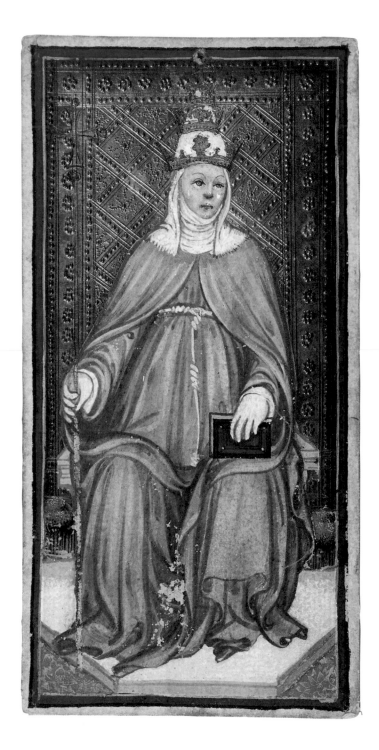

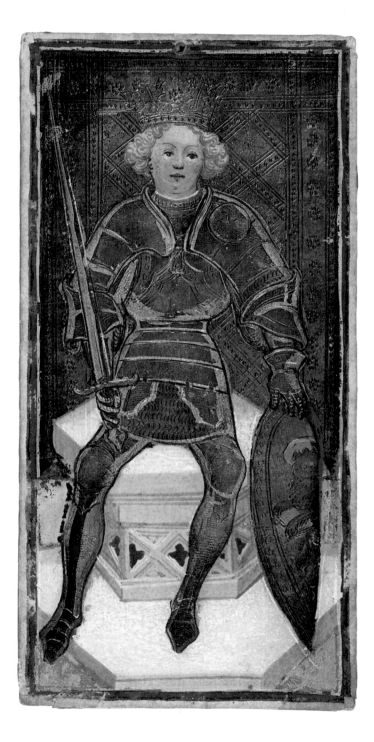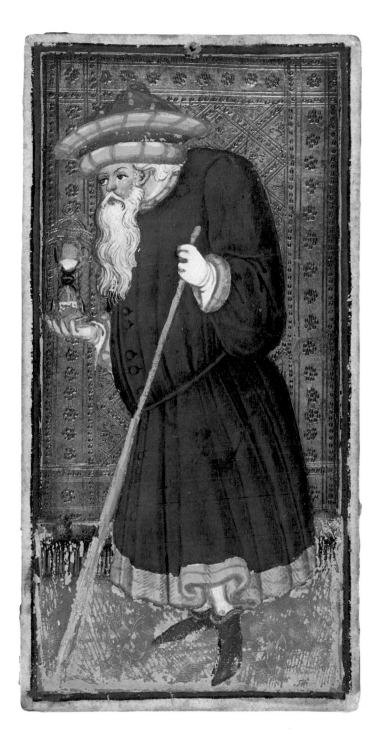

THE MEETING OF KING PRIAM
AND HELEN OF TROY

Jean de Courcy, *Chronique universelle,
dite de la Bouquechardière,* in French

Illuminated by the workshop of
Lieven van Lathem

Belgium, Bruges, ca. 1470

178 leaves, 430 x 310 mm; 3 large and
3 small miniatures

Purchased by Pierpont Morgan, 1902;
MS M.214 (fol. 84)

BEGEGNUNG ZWISCHEN
KÖNIG PRIAMUS UND DER
SCHÖNEN HELENA

Jean de Courcy, *Chronique universelle,
dite de la Bouquechardière,* französisch

Illuminiert in der Werkstatt des Lieven
van Lathem

Belgien, Brügge, circa 1470

178 Blätter, 430 x 310 mm; 3 große und
3 kleine Miniaturen

Erworben 1902 von Pierpont Morgan;
MS M.214 (fol. 84)

In 1416 the Norman knight Jean de Courcy
retired from his soldier's career to write this
military history, completed in 1422. As his
prologue relates, de Courcy extracted material
from earlier chronicles, adding his own moral-
izations. Volume I (this manuscript) contains
Books 1, the story of ancient Greece; 2, the
history of Troy (its miniature is reproduced
here); and 3, how royal descendants from
Troy establish cities throughout Europe. Vol-
ume II (M.224) contains Books 4, the history
of Assyria; 5, an account of Macedonia and
Alexander the Great; and 6, a record of the
wars of the Maccabees. Such grand historical
compilations, written in large, showy volumes
and illuminated with big pictures, were a fea-
ture of Burgundian court life and collector's
items for status-conscious courtiers.

The large miniatures introducing each of
the six books of the *Bouquechardière* (so called
because de Courcy was seigneur de Bourg-
Achard) are by the workshop of Lieven van
Lathem, a talented illuminator who worked
for the dukes of Burgundy. In the early
sixteenth century, when the manuscript was
owned by members of the French Estouteville/
Sainte-Maure and Baraton families, it was
"remodeled," and blue borders, coats of arms,
and small miniatures depicting Christ's Passion
were added to some of the leaves. R.S.W.

Provenance
François Baraton (d. 1519) and his wife, Antoinette de
Saint-Maure; duc de La Vallière (his sale, Paris, 1783,
no. 4601; bought by Dusaulchoix); count de Mac-
Carthy Reagh (his sale, Paris, 1817, no. 3945; bought
in by De Karny); Joseph Barrois (no. 38); sold in 1849
to Bertram, fourth earl of Ashburnham (his sale,
London, Sotheby's, 1 May 1899, lot 301; bought by
Quaritch, catalogue 211, 1902, no. 90).

Selected bibliography and exhibitions
de Bure 1783, vol. 3, pp. 58–61, no. 4601; *Catalogue
des livres rares et précieux* 1815, vol. 2, p. 15, no. 3946;
Catalogue of the Manuscripts at Ashburnham Place
[1901], no. 38; Detroit 1960, pp. 388–90, no. 205, repr.;
Delaissé et al. 1977, p. 244.

Im Jahr 1416 nahm der normannische Ritter
Jean de Courcy Abschied von seiner militä-
rischen Laufbahn, um diese 1422 vollendete
Geschichte des Kriegswesens zu verfassen. Wie
wir aus dem Prolog erfahren, sammelte de
Courcy sein Material in älteren Chroniken und
fügte seine eigenen moralischen Auslegungen
hinzu. Der erste Band (unser Ausstellungs-
stück) enthält Buch 1 zur Geschichte des alten
Griechenlands, Buch 2 zur Geschichte Trojas
(deren Miniatur hier zu sehen ist) sowie Buch 3
zur Gründung von Städten in ganz Europa
durch die königlichen Abkömmlinge Trojas.
Der zweite Band (M.224) enthält Buch 4 zur
Geschichte Assyriens, Buch 5 zur Geschichte
Mazedoniens und Alexanders des Großen so-
wie Buch 6 mit einer Darstellung der Kriege
der Makkabäer. Solche imposanten historischen
Sammlungen, verfaßt in großen, eindrucks-
vollen Bänden und mit großformatigen Bildern
illuminiert, waren Bestandteil des höfischen
Lebens in Burgund und Sammelgegenstände
statusbewußter Höflinge.

Die großen Miniaturen, die jedem einzel-
nen der sechs Bücher des *Bouquechardière* (so
genannt, weil de Courcy Seigneur de Bourg-
Achard war) vorangestellt sind, stammen aus
der Werkstatt von Lieven van Lathem, eines
talentierten Illuminators, der für die Herzöge
von Burgund arbeitete. Als sich das vorliegen-
de Buch im frühen 16. Jahrhundert im Besitz
von Mitgliedern der französischen Familien
Estouteville / Sainte-Maure und Baraton be-
fand, unterzog man es einer »Umgestaltung«.
Auf einigen Blättern wurden blaue Umrahmun-
gen, Familienwappen und kleine Miniaturen
mit Darstellungen aus der Passionsgeschichte
hinzugefügt.

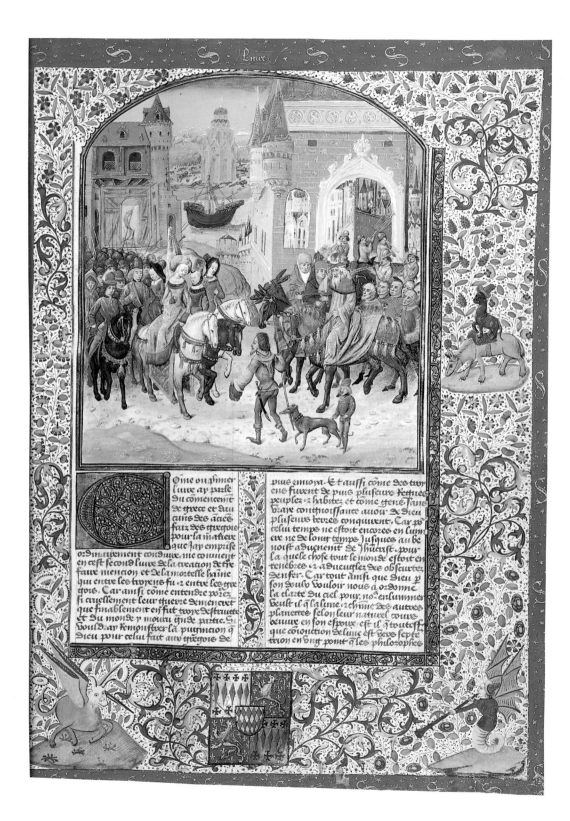

Pope Leo X Vesting for Mass

Preparatio ad Missam Pontificalem,
in Latin

Illuminated by Attavante degli
Attavanti

Italy, Rome, dated 1520, for Pope Leo X

19 leaves, 396 x 266 mm; 1 large
miniature, 29 historiated initials,
and 19 elaborate borders

Given to the Morgan Library by the
Heineman Foundation, 1977; MS H.6
(fol. 1v)

Papst Leo X. wird für die Messe gekleidet

Preparatio ad Missam Pontificalem,
lateinisch

Illuminiert von Attavante degli
Attavanti

Italien, Rom, datiert 1520, für Papst
Leo X

19 Blätter, 396 x 266 mm; 1 große
Miniatur, 29 figürlich ausgestaltete
Initialen und 19 kunstvolle Rand-
verzierungen

Erworben 1977 als Geschenk der
Heineman Foundation an die Pierpont
Morgan Library; MS H.6 (fol. 1v)

This *Preparatio ad missam* contains the prayers recited by the pope as he readies himself for the celebration of Mass. Among these are the prayers he recites while vesting himself with ecclesiastical garments, the first being his liturgical stockings and pontifical sandals. Appropriately, the manuscript's frontispiece depicts the seated pontiff, having just donned his stockings, presented with his liturgical shoes.

The manuscript was made for Pope Leo X; his name and the date 1520 are on the sides of the dais. Leo's arms appear in the bottom border, and the left border includes two of his impresas: a diamond ring accompanied by three feathers and a scroll inscribed *SEMPER* (always) and a yoke interlaced with a scroll inscribed *SUAVE* (sweet).

The illumination is by the Florentine artist Attavante degli Attavanti, who headed a prolific workshop in his native city. Dated 1520, this manuscript is among the artist's last works and, commissioned by the worldly but discerning Leo, is one of his finest. A Medici, Leo might have also enjoyed Attavante's work because of their common Florentine roots—the inscription on the dais refers to Florence as Leo's home.

This manuscript is listed in an eighteenth-century inventory of the papal sacristy; it was probably among the many manuscripts looted by Napoleon's troops in the Sistine Chapel in 1798. R.S.W.

Provenance
Made for Pope Leo X (r. 1513–21); Hamilton Palace
Library (their manuscript sale, London, Sotheby's,
1882, lot 531); Frédéric Spitzer; Edouard Kann
(his sale, Paris, Hôtel des Commissaires-Priseurs,
14 November 1930, lot 107); Dannie and Hettie
Heineman Collection.

Selected bibliography and exhibitions
Plummer and Strittmatter 1964, pp. 30–31, no. 35;
Wieck 1994, pp. 56–60, no. 4, repr.; Campbell 1996,
pp. 439, 441.

Dieses *Preparatio ad missam* enthält die Gebete, die der Papst während seiner Vorbereitung auf die Heilige Messe spricht. Darunter sind auch die Gebete, die er beim Anlegen seiner geistlichen Gewänder, beginnend mit den liturgischen Strümpfen und den päpstlichen Sandalen, vorträgt. Folgerichtig zeigt das Frontispiz des Manuskriptes den sitzenden Papst, der soeben seine Strümpfe angezogen hat und dem nunmehr seine liturgischen Schuhe gereicht werden.

Die Handschrift wurde für Papst Leo X. angefertigt; sein Name und die Jahreszahl 1520 stehen auf den Seiten des Podiums. Leos Wappen erscheint auf der unteren Rahmenverzierung; der linksseitige Rahmen beinhaltet zwei seiner Impresen: einen Diamantring mit drei Federn und einer Schriftrolle, auf der *SEMPER* (auf immer) geschrieben steht, sowie ein Joch, verbunden mit einer Schriftrolle, mit der Aufschrift *SUAVE* (süß).

Die Illumination stammt von dem Florentiner Künstler Attavante degli Attavanti, der in seiner Heimatstadt eine florierende Werkstatt leitete. Diese auf 1520 datierte Handschrift ist eine der letzten und – möglicherweise weil sie von dem weltlich gesinnten und zugleich sehr anspruchsvollen Papst Leo in Auftrag gegeben wurde – schönsten Arbeiten des Künstlers. Als Medici könnte Leo auch aufgrund der gemeinsamen Florentiner Abstammung Gefallen an Attavantes Arbeiten gefunden haben – auf Florenz, seine Heimatstadt, verweist die Inschrift auf dem Podium.

Diese Handschrift wird in einer Inventarliste der päpstlichen Sakristei aus dem 18. Jahrhundert aufgeführt; sie gehörte wahrscheinlich zu den zahlreichen Manuskripten, die von Napoleons Truppen 1798 bei der Plünderung der Sixtinischen Kapelle erbeutet wurden.

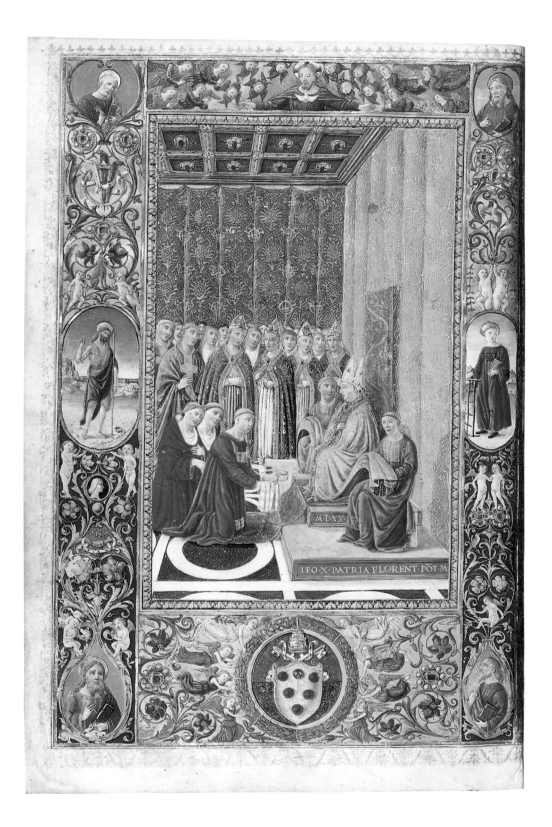

CRUCIFIXION WITH BISHOP
HUGO VON HOHENLANDEN-
BERG

Single leaf from a Missal, in Latin

Germany, Constance, ca. 1510

1 leaf, 407 x 289 mm; 1 full-page
miniature

Purchased as a gift of the Fellows, with
the special assistance of four trustees,
Mrs. Gordon S. Rentschler, and the
Arkville Erpf Fund, in honor of the
fiftieth anniversary of the Library,
1973; MS M.955, fol. 1v

KREUZIGUNGSSZENE MIT
BISCHOF HUGO VON HOHEN-
LANDENBERG

Einzelblatt aus einem Missale,
lateinisch

Deutschland, Konstanz, circa 1510

1 Blatt, 407 x 289 mm; 1 ganzseitige
Miniatur

Erworben 1973 als Geschenk der
Association of Fellows unter spezieller
Mitwirkung von vier Trustees,
Mrs. Gordon S. Rentschler und dem
Arkville Erpf Fund zu Ehren des
50jährigen Bestehens der Pierpont
Morgan Library; MS M.955, 1v

Before the discovery of this Crucifixion, all
that had been known of the first volume of the
Missal of Bishop Hugo von Hohenlandenberg,
from which this leaf comes, were eleven his-
toriated initials in a German private collection.
They had been attributed to Hans Springinklee,
a pupil of Albrecht Dürer. While this attribution
has been questioned, there is little doubt that
this Canon illustration, the artistic masterpiece
of the volume, was by an artist who was influ-
enced by Dürer. His paintings and watercolors
are recalled by the transparent and luminous
quality of the colors found in the drapery and
landscape. The portrait of Bishop Hugo is
similar to one now in Karlsruhe made by an
anonymous Bodensee artist, and the castle on
the hill may suggest Meersburg, a residence of
the bishops of Constance. The striking similar-
ity of the drapery and stance of St. John with
that of a St. John panel in Cologne (Wallraf-
Richartz-Museum) ascribed to Georg Pencz,
also a Dürer student, provides yet another
connection with Dürer's workshop. Since the
panel is dated about 1525–27, however,
either a dependency or a common prototype is
implied. Three remaining volumes, all intact,
are in the Erzbischöfliches Archiv in Freiburg
I. Br. (Da 42 2–4; the second volume is dated
1510). W.M.V.

Provenance
Hugo von Hohenlandenberg (1460–1532), bishop
of Constance (1496–1529, 1531–32), who commis-
sioned the four-volume Missal; in 1832 vol. 1 was
sold in Geneva and dismembered; Alfred Morrison
(1821–1897); Lord Margadale of Islay, F. D., who sold
it in London, Christie's, 20 March 1973, lot 115.

Selected bibliography and exhibitions
Morgan Library 1974, no. 49, pl. 49; Morgan Library
1976, pp. 26–28, 36–38, pl. 2; Konrad 1989, p. 85;
Konrad 1997, pp. 130, 332–24, repr. in color p. 131.

Vor der Entdeckung dieser Kreuzigungsszene
waren aus dem ersten Band des Meßbuches
von Bischof Hugo von Hohenlandenberg, aus
dem dieses Blatt stammt, lediglich elf mit Figu-
ren geschmückte Initialen aus einer deutschen
Privatsammlung bekannt. Diese hatte man
Hans Springinklee, einem Schüler Albrecht
Dürers, zugeordnet. Obwohl die Zuschrei-
bung nicht unstrittig ist, besteht kaum ein
Zweifel daran, daß diese Illustration des Meß-
kanons als Glanzstück des Bandes von einem
Künstler ausgeführt wurde, der unter dem
Einfluß Dürers stand. An dessen Gemälde und
Aquarelle erinnern die Transparenz und die
Leuchtkraft der Farben bei Faltenwurf und
Landschaft. Das Portrait von Bischof Hugo
ähnelt einem heute in Karlsruhe aufbewahrten
Gemälde, das von einem unbekannten Künst-
ler vom Bodensee stammt. Das Schloß auf dem
Hügel könnte Meersburg, die Residenz der
Bischöfe von Konstanz, wiedergeben. Die
auffällige Ähnlichkeit in der Darstellung des
Faltenwurfes und der Haltung des heiligen
Johannes mit einer Johannes-Tafel in Köln
(Wallraf-Richartz-Museum), die Georg Pencz,
einem anderen Dürerschüler, zugeschrieben
wird, bietet noch eine weitere mögliche Ver-
bindung mit Dürers Werkstatt. Da die Kölner
Tafel jedoch auf 1525 bis 1527 datiert wird,
könnte ihr entweder unsere Darstellung als
Vorlage gedient haben, oder beide gehen auf
ein gemeinsames Vorbild zurück. Die drei wei-
teren, vollständig erhaltenen Bände befinden
sich im Erzbischöflichen Archiv in Freiburg
im Breisgau (Da 42 2–4; der zweite Band da-
tiert von 1510).

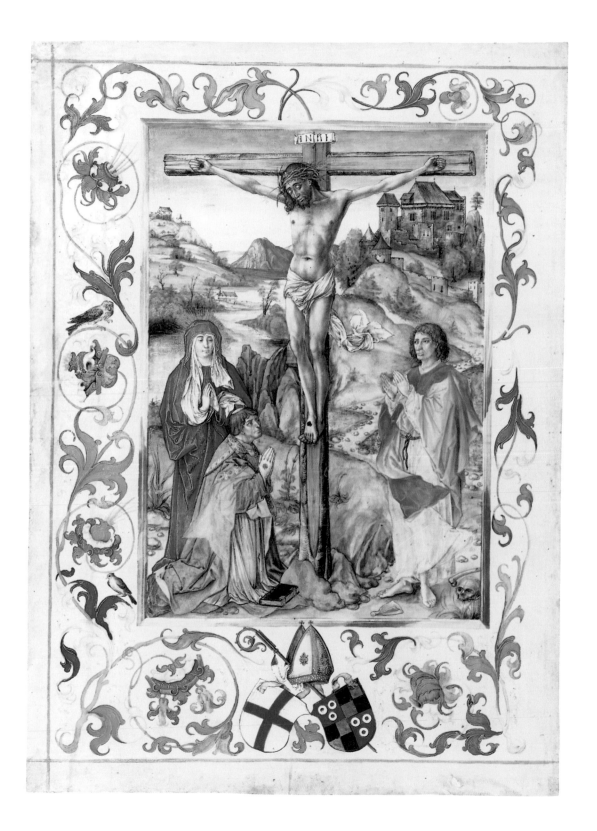

Works Cited in Abbreviated Form
Verzeichnis der abgekürzt zitierten Literatur

Algeri 1981
Giuliana Algeri, *Gli Zavattari: Una famiglia di pittori e la cultura tardogotica in Lombardia*, Rome, 1981.

Anderson 1961
Emily Anderson, ed., *The Letters of Beethoven*, vol. 1, London, 1961.

Anderson 1985
The Letters of Mozart and His Family, translated and edited by Emily Anderson, 3d ed., London, 1985.

Austen 1989
Jane Austen, *Lady Susan: A Facsimile of the Manuscript in The Pierpont Morgan Library and the 1925 Printed Edition*, preface by A. Walton Litz, New York, 1989.

Bagni 1984
Prisco Bagni, *Guercino a Cento: Le decorazioni di Casa Pannini*, Bologna, 1984.

Bagni 1985
Prisco Bagni, *Guercino e il suo falsario: I disegni di paesaggio*, Bologna, 1985.

Baltimore 1962
Walters Art Gallery, Baltimore, *The International Style: The Arts in Europe Around 1400*, 1962.

Barcham 1992
William Barcham, *Giambattista Tiepolo*, New York, 1992.

Bauer-Deutsch 1963
Mozart: Briefe und Aufzeichnungen, Gesamtausgabe, issued by the Internationale Stiftung Mozarteum, Salzburg, vol. 3, compiled and edited by Wilhelm H. Bauer and Otto Erich Deutsch, Kassel, 1963.

Bauer-Lechner 1923
Natalie Bauer-Lechner, *Erinnerungen an Gustav Mahler*, Leipzig, 1923.

Bean and Griswold 1990
Jacob Bean and William Griswold, *18th Century Italian Drawings in The Metropolitan Museum of Art*, New York, 1990.

Beethoven: Briefwechsel
Ludwig van Beethoven: Briefwechsel, Gesamtausgabe, vol. 2, edited by Sieghard Brandenburg, Munich, 1996.

Bellini 1943
Vincenzo Bellini, *Epistolario*, edited by Luisa Cambi, Verona, 1943.

Benesch 1947
Otto Benesch, *Venetian Drawings of the Eighteenth Century in America*, New York, 1947.

Benvin 1988
Anthony E. Benvin, an abstract of his paper, "New Growth on the Family Tree: A Reevaluation of Painting at St. Peter's Scriptorium (New York, The Pierpont Morgan Library, MSS M.780, M.781, Glazier 44; München, Bayerische Staatsbibliothek, Clm 15713)," *Manuscripta* 32, no. 1, 1988.

Berlioz, *Memoiren*
Hector Berlioz, *Memoiren: mit der Beschreibung seiner Reisen in Italien, Deutschland, Rußland und England*, translated by Elly Ellès, Wilhelmshaven, 1979.

Berlioz, *Memoirs*
The Memoirs of Hector Berlioz, Member of the French Institute, Including His Travels in Italy, Germany, Russia, and England, translated and edited by David Cairns, London, 1969.

Bindman 1977
David Bindman, *Blake as an Artist*, Oxford, 1977.

Bindman 1982
David Bindman, *William Blake: His Art and Times*, New Haven and Ontario, 1982.

Binyon 1922
Laurence Binyon, *The Drawings and Engravings of William Blake*, London, 1922.

Birmingham and Springfield 1978
Museum of Arts, Birmingham, and Museum of Fine Arts, Springfield, Massachusetts, *The Tiepolos: Painters to Princes and Prelates*, exhibition catalogue, 1978.

Blaukopf 1982
Herta Blaukopf, ed., *Gustav Mahler Briefe*, Vienna, 1982.

Bloomington and Stanford 1979
Indiana University Art Museum, Bloomington, and Stanford University Museum of Art, *Domenico Tiepolo's Punchinello Drawings*, exhibition catalogue by Marcia E. Vetrocq, 1979.

Blunt 1959
Anthony Blunt, *The Art of William Blake*, New York, 1959.

Bode 1912
Wilhelm Bode, *Die Tonkunst in Goethes Leben*, vol. 1, Berlin, 1912.

Bologna 1968
Palazzo dell'Archiginnasio, Bologna, *Il Guercino (Giovanni Francesco Barbieri, 1591–1666): Catalogo critico dei disegni*, exhibition catalogue by Denis Mahon, 1968 [1969].

Bologna 1991
Museo Civico Archeologico, Bologna, *Giovanni Francesco Barbieri, Il Guercino, 1591–1666: Disegni*, exhibition catalogue by Sir Denis Mahon, 1991 [1992].

Boskovits 1975
Miklós Boskovits, *Pittura fiorentina alla vigilia del Rinascimento, 1370–1400*, Florence, 1975.

Boston and Ottawa 1974
Museum of Fine Arts, Boston, and National Gallery of Canada, Ottawa, *The Changing Image: Prints by Francisco Goya*, exhibition catalogue by Eleanor A. Sayre, 1974.

Brahms Briefwechsel VI
Johannes Brahms Briefwechsel VI: Johannes Brahms im Briefwechsel mit Joseph Joachim, edited by Andreas Moser, 2d ed., Tutzing, 1974.

Brahms Briefwechsel IX
Johannes Brahms Briefwechsel IX: Johannes Brahms, Briefe an P. J. Simrock und Fritz Simrock, edited by Max Kalbeck, Tutzing, 1974.

de Bure 1783
Guillaume de Bure, *Catalogue des livres de la bibliothèque de feu M. le duc de La Vallière: Première partie*, vol. 3, Paris, 1783.

Busch 1978
Hans Busch, *Verdi's* Aida: *The History of an Opera in Letters and Documents*, Minneapolis, 1978.

Butlin 1981
Martin Butlin, *The Paintings and Drawings of William Blake*, New Haven and London, 1981.

Byam Shaw 1954
J. Byam Shaw, "Unpublished Guardi Drawings II," *Art Quarterly* 17, no. 8, 1954.

Byron 1986
Baron George Gordon Byron, *Manfred*, in *The Complete Poetical Works*, vol. 4, edited by Jerome J. McGann, Oxford, 1986.

Cahn 1996
Walter Cahn, *Romanesque Manuscripts: The Twelfth Century* (A Survey of Manuscripts Illuminated in France), 2 vols., London, 1996.

Cambridge 1970
Harvard University Art Museums, Cambridge, Massachusetts, *Tiepolo. A Bicentenary Exhibition, 1770–1970: Drawings, Mainly from American Collections, by Giambattista Tiepolo and the Members of His Circle*, exhibition catalogue by George Knox, 1970.

Cambridge and elsewhere 1991
Harvard University Art Museums, Cambridge, Massachusetts, National Gallery of Canada, Ottawa, and Cleveland Museum of Art, *Guercino, Master Draftsman: Works from North American Collections*, exhibition catalogue by David M. Stone, 1991.

Cambridge and New York 1996–97
Harvard University Art Museums, Cambridge, Massachusetts, and The Pierpont Morgan Library, New York, *Tiepolo and His Circle: Drawings in American Collections,* exhibition catalogue by Bernard Aikema, 1996–97.

Campbell 1961
Colin Campbell, "Heraldic Portrait of William, Duke of Austria," *The Coat of Arms* 6, no. 37, 1961.

Campbell 1996
Tom Campbell, "Pope Leo X's Consistorial 'letto de paramento' and the Boughton House Cartoons," *Burlington Magazine* 138, 1996.

Catalogue des livres rares et précieux 1815
Catalogue des livres rares et précieux de la bibliothèque de feu M. le comte de Mac-Carthy Reagh, Paris, vol. 2, 1815.

Catalogue of the Manuscripts at Ashburnham Place [1901]
Catalogue of the Manuscripts at Ashburnham Place: Part the Second, Comprising a Collection formed by Mons. J. Barrois, London, [1901].

Clarkson 1996
Christopher Clarkson, "Further Studies in Anglo-Saxon and Norman Bookbinding: Board Attachment Methods Re-examined," *Roger Powell: The Compleat Binder. Liber amicorum* (Bibliologia, 14), edited by John L. Sharpe, Turnhout, 1996.

Cockerell 1907
Sydney C. Cockerell, *A Descriptive Catalogue of Twenty Illuminated Manuscripts, nos. LXXV to XCIV (Replacing Twenty Discarded from the Original Hundred) in the Collection of Henry Yates Thompson* (Third Series), Cambridge, 1907.

Cockerell et al. 1927
Sydney C. Cockerell, Montague Rhodes James, and Charles Ffoulkes, *A Book of Old Testament Illustrations of the Middle of the Thirteenth Century . . . in The Pierpont Morgan Library at New York* (Roxburghe Club, no. 186), Cambridge, 1927.

Cockerell and Plummer 1975
Sydney C. Cockerell and John Plummer, *Old Testament Miniatures: A Medieval Picture Book with 283 Paintings from The Creation to The Story of David,* New York, 1975.

Cook and Wedderburn 1903–12
E. T. Cook and Alexander Wedderburn, *The Works of John Ruskin,* 39 vols., London and New York, 1903–12.

Crass 1957
Eduard Crass, *Johannes Brahms: Sein Leben in Bildern,* Leipzig, 1957.

D'Ancona et al. 1995
Mirella Levi D'Ancona et al., *I corali del monastero di Santa Maria degli Angeli e le loro miniature asportate,* Florence, 1995.

Degrada 1985
Francesco Degrada, "Prolegomena zur Lektüre der 'Sonnambula,'" translated by J. Hoffmann, *Musik-Konzepte* 46, November 1985.

Delaissé et al. 1977
L. M. J. Delaissé et al., *The James A. de Rothschild Collection at Waddesdon Manor: Illuminated Manuscripts,* Fribourg, 1977.

Del Mar 1969
Norman Del Mar, *Richard Strauss: A Critical Commentary on His Life and Works,* London, vol. 1, 1969.

Depuydt 1991
Leo Depuydt, ed., *Homiletica from The Pierpont Morgan Library: Seven Coptic Homilies Attributed to Basil the Great, John Chrysostum, and Euodius of Rome* (Corpus Scriptorum Christianorum Orientalium, DXXIV, DXXV: Scriptores Coptici, XLIII, XLIV), Louvain, 1991, transcription (XLIII, 27–46) and translation by Craig S. Wansink (XLIV, 27–47).

Depuydt 1993
Leo Depuydt, *Catalogue of Coptic Manuscripts in The Pierpont Morgan Library* (Corpus of Illuminated Manuscripts, 4, 5), 2 vols., Leuven, 1993.

Detroit 1960
Detroit Institute of Arts, *Flanders in the Fifteenth Century: Art and Civilization,* Detroit, 1960.

Deutsch 1946
Otto Erich Deutsch, ed., *Schubert: A Documentary Biography,* London, 1946.

Deutsch 1958
Otto Erich Deutsch, ed., *Schubert: Memoirs by His Friends,* New York, 1958.

Deutsch 1964
Otto Erich Deutsch, ed., *Schubert: Die Dokumente seines Lebens,* Kassel, 1964.

Deutsch 1966
Otto Erich Deutsch, ed., *Schubert: Die Erinnerungen seiner Freunde,* 2d ed. Leipzig, 1966.

Dreyer [1971]
Peter Dreyer, *Tizian und Sein Kreis, 50 Venezianische Holzschnittte aus dem Berliner Kupferstichkabinett,* Berlin, n.d. [1971].

Dummett 1980
Michael Dummett, with the assistance of Sylvia Mann, *The Game of Tarot from Ferrara to Salt Lake City,* London, 1980.

Eigeldinger 1979
Jean-Jacques Eigeldinger, *Chopin vu par ses élèves. Textes recueillis, traduits et commentés. Nouvelle édition entièrement remaniée,* Neuchâtel, 1979.

Eigeldinger 1986
Jean-Jacques Eigeldinger, *Chopin: Pianist and Teacher, as Seen by His Pupils,* translated by Naomi Shohet, Krysia Osostowicz, and Roy Howat, edited by Roy Howat, Cambridge, Massachusetts, 1986.

Erdman 1977
David V. Erdman, *Blake, Prophet Against Empire: A Poet's Interpretation of the History of His Own Times,* 3d ed., Princeton, 1977.

Fairfax Murray 1905–12
Charles Fairfax Murray, *Collection of J. Pierpont Morgan: Drawings by the Old Masters Formed by C. Fairfax Murray,* 4 vols., London, 1905–12.

Faye and Bond 1962
C. U. Faye and W. H. Bond, *Supplement to the Census of Medieval and Renaissance Manuscripts in the United States and Canada,* New York, 1962.

Fifield 1988
Christopher Fifield, *Max Bruch: His Life and Works,* New York, 1988.

Fillitz 1995
Hermann Fillitz, "Bemerkungen zur Tracht und zu den Insignien des Königs Charles VI und seiner Begleiter," in Reinhold Baumstark, ed., *Das Goldene Rössl, Ein Meisterwerk der Pariser Hofkunst um 1400,* Munich, 1995.

Fischer 1968
Manfred F. Fischer, "Die Umbaupläne des Giovanni Battista Piranesi für den Chor von S. Giovanni in Laterano," *Münchner Jahrbuch der bildenden Kunst* 19, 1968.

Focillon 1963
Henri Focillon, *Giovanni Battista Piranesi,* edited by Maurizio Calvesi and Augusta Monferini, Bologna, 1963.

Forte 1977
Allen Forte, "Ives and Atonality," in *An Ives Celebration: Papers and Panels of the Charles Ives Centennial Festival-Conference,* edited by H. Wiley Hitchcock and Vivian Perlis, Urbana, 1977.

Frankfurt am Main 1981
Städtische Galerie, Städelsches Kunstinstitut,
Frankfurt am Main, *Goya, Zeichnungen und
Druckgraphik,* exhibition catalogue by Margret
Stuffmann, 1981.

Freuler 1992
Gaudenz Freuler, "Oresenze artistiche toscane a
Venezia alla fine del Trecento: Lo scriptorium dei
Camaldolesi e dei Domenicani," in *La pittura nel
Veneto: Il Trecento,* Mauro Lucco, ed., vol. 2,
Milan, 1992.

Gassier 1973
Pierre Gassier, *Francisco Goya Drawings: The
Complete Albums,* New York and Washington,
1973.

Gassier 1981
Pierre Gassier, *The Life and Complete Works of
Francisco Goya,* 2d ed., New York, 1981.

Gassier and Wilson 1971
Pierre Gassier and Juliet Wilson, *Goya: His Life
and Work,* London, 1971.

Geelhaar 1993
Christian Geelhaar, *Picasso: Wegbereiter und
Förderer seines Aufstiegs 1899–1939,* Zürich,
1993.

Gilchrist 1863
Alexander Gilchrist, *Life of William Blake,*
2 vols., 1863; new and enlarged edition 1880.

Griswold 1991
William M. Griswold, "Guercino Drawings from
North American Collections" (Cambridge and
elsewhere 1991), review, *Burlington Magazine,*
September 1991.

Guilmain 1967
Jacques Guilmain, "On the Classicism of the
'Classic' Phase of Franco-Saxon Manuscript
Illumination," *Art Bulletin* 49, 1967.

Hague 1946
Robert Hague, "Odd Music from Caged Pianos;
Hilsberg Leads Philadelphians," *PM,* 12,
December 1946.

Hamm 1996
Gustav-Lübcke Museum, Hamm, *Ägypten
Schätze aus dem Wüstensand: Kunst und Kultur
der Christen am Nil,* Wiesbaden, 1996.

Harrsen 1958
Meta Harrsen, *Central European Manuscripts in
The Pierpont Morgan Library,* New York, 1958.

Harrsen and Boyce 1953
Meta Harrsen and George K. Boyce, *Italian
Manuscripts in The Pierpont Morgan Library,*
New York, 1953.

Hinkle 1973
William M. Hinkle, "A Mounted Evangelist in
a Twelfth-Century Gospel Book at Sées,"
Aachener Kunstblätter 44, 1973.

Histoire naturelle des Indes 1996
*Histoire naturelle des Indes: The Drake Manu-
script in The Pierpont Morgan Library,* foreword
by Patrick O'Brian, New York, 1996.

Holter 1955
Kurt Holter, "Die Wiener Buchmalerei," in
Richard Kurt Donin, *Geschichte der Bildenden
Kunst in Wien II Gotik,* Vienna, 1955.

van der Horst et al. 1996
Koert van der Horst, William Noel, and Wilhel-
mina C. M. Wüstefeld, eds., *The Utrecht Psalter
in Medieval Art: Picturing the Psalms of David,*
Utrecht, 1996.

Houston 1958
Museum of Fine Arts, Houston, *The Guardi
Family,* exhibition catalogue, 1958.

The Iliad
Homer, *The Iliad,* translated by A. T. Murray,
The Loeb Classical Library, Cambridge and
London, 1934.

Kalbeck 1912–21
Max Kalbeck, *Johannes Brahms,* rev. ed., Berlin,
1912–21; reprint Tutzing, 1976.

Kanter et al. 1994
Laurence B. Kanter et al., *Painting and Illumina-
tion in Early Renaissance Florence, 1300–1450,*
New York, 1994.

Kaplan 1975
Stuart Kaplan, *Visconti Sforza Tarocchi Deck*
(facsimile), New York, 1975.

Kaplan 1978
Stuart R. Kaplan, *The Encyclopedia of Tarot,*
vol. 1, New York, 1978.

Kaplan 1986
Stuart R. Kaplan, *The Encyclopedia of Tarot,*
vol. 2, New York, 1986.

Kauffmann 1975
C. M. Kauffmann, *Romanesque Manuscripts
1066–90* (A Survey of Manuscripts Illuminated
in the British Isles, vol. 3), London, 1975.

Klein et al. 1993
Albert Einstein, *The Collected Papers of Albert
Einstein,* vol. 5, *The Swiss Years: Correspondence,
1902–1914,* Martin J. Klein, A. J. Kox, and
Robert Schulmann, eds., Princeton, 1993.

Knox 1978
George Knox, "The Tasso Cycles of Giambat-
tista Tiepolo and Gianantonio Guardi," *Museum
Studies, The Art Institute of Chicago* 9, 1978.

Kobylańska 1983
Krystyna Kobylańska, ed., *Fryderyk Chopin:
Briefe.* Aus dem Polnischen und Französischen
übersetzt von Caesar Rymarowicz, Berlin, 1983.

Konrad 1989
Bernd Konrad, "Bemerkungen zum Missale des
Bischofs Hugo von Hohenlandenberg," *Glanz
der Kathedrale – 900 Jahre Konstanzer Münster,*
Konstanz, 1989.

Konrad 1997
Bernd Konrad, "Die Buchmalerei in Konstanz,
am westlichen und am nördlichen Bodensee von
1400 bis zum Ende des 16. Jahrhunderts," in
Eva Moser, ed., *Buchmalerei im Bodenseeraum
13. bis 16. Jahrhundert,* Friedrichshafen, 1997.

Lauth 1970
Wilhelm Lauth, "Entstehung und Geschichte des
ersten Violinkonzertes op. 26 von Max Bruch,"
in *Max Bruch-Studien. Zum 50. Todestag des
Komponisten,* edited by Dietrich Kämper,
Cologne, 1970.

Lesure 1993
François Lesure, ed., *Claude Debussy:
Correspondance 1884–1918,* Paris, 1993.

Lesure and Nichols 1987
François Lesure and Roger Nichols, eds.,
Debussy Letters, translated by Roger Nichols,
Cambridge, Massachusetts, 1987.

London 1978
Tate Gallery, London, *William Blake,* exhibition
catalogue by Martin Butlin, 1978.

London 1978a
Hayward Gallery (Arts Council of Great
Britain), London, *Piranesi,* exhibition catalogue
by John Wilton-Ely, 1978.

London 1991
The British Museum, London, *Drawings by
Guercino from British Collections,* exhibition
catalogue by Nicholas Turner and Carol
Plazzotta, 1991.

Loomis and Loomis 1938
Roger Sherman Loomis and Laura Hibbard
Loomis, *Arthurian Legends in Medieval Art,*
New York, 1938.

Los Angeles 1976
Los Angeles County Museum of Art, *Old
Master Drawings from American Collections,*
exhibition catalogue by Ebria Feinblatt, 1976.

Los Angeles and Minneapolis 1993–94
Los Angeles County Museum of Art and Min-
neapolis Institute of Arts, *Visions of Antiquity:
Neoclassical Figure Drawings,* exhibition
catalogue by Richard J. Campbell and Victor
Carlson, 1993–94.

Mabbott 1969
Edgar Allan Poe, *Collected Works of Edgar Allan Poe*, vol. 1, *Poems*, Thomas Ollive Mabbott, ed., Cambridge, Massachusetts, 1969.

Madrid and elsewhere 1988–89
Museo del Prado, Madrid, Museum of Fine Arts, Boston, and The Metropolitan Museum of Art, New York, *Goya and the Spirit of Enlightenment*, exhibition catalogue by Alfonso E. Pérez Sánchez, Eleanor A. Sayre, et al., 1988–89.

Magurn 1955
Peter Paul Rubens, *The Letters of Peter Paul Rubens*, translated and edited by Ruth Saunders Magurn, Cambridge, Massachusetts, 1955.

Mahler 1940
Alma Mahler, *Gustav Mahler: Erinnerungen und Briefe*, Amsterdam, 1940.

Mahler 1968
Alma Mahler, *Gustav Mahler: Memories and Letters*, edited by Donald Mitchell, translated by Basil Creighton, London, 1968.

Marchand 1976
Leslie A. Marchand, ed., *Byron's Letters and Journal*, vol. 5, Cambridge, 1976.

Marabottini 1966
Alessandro Marabottini, *Le arti di Bologna di Annibale Carracci*, Rome, 1966.

Martner 1979
Knud Martner, ed., *Selected Letters of Gustav Mahler*, translated by Eithne Wilkins, Ernst Kaiser, and Bill Hopkins, New York, 1979.

de Maupassant 1885
Guy de Maupassant, *Bel-ami*, Paris, 1885.

McEachern 1993
Jo-Ann E. McEachern, *Bibliography of the Writings of Jean Jacques Rosseau to 1800*, Oxford, 1993.

McGurk and Rosenthal 1995
Patrick McGurk and Jane Rosenthal, "The Anglo-Saxon Gospelbooks of Judith, Countess of Flanders: Their Text, Make-up, and Function," *Anglo-Saxon England* 24, 1995.

Meyvaert 1989
Paul Meyvaert, "The Book of Kells and Iona," *Art Bulletin* 71, 1989.

Millar 1927–30
Eric George Millar, *Catalogue of the Western Manuscripts in the Library of A. Chester Beatty*, 2 vols., Oxford, 1927–30.

Moakley 1966
Gertrude Moakley, *The Tarot Cards Painted by Bonifacio Bembo for the Visconti-Sforza Family, an Iconographic and Historical Study*, New York, 1966.

Montreal 1993–94
Canadian Centre for Architecture, Montreal, *Exploring Rome: Piranesi and His Contemporaries*, catalogue by Cara D. Denison, Myra Nan Rosenfeld, and Stephanie Wiles, 1993–94.

Morassi 1973
Antonio Morassi, *I Guardi: L'opera completa di Antonio e Francesco Guardi*, 2 vols., Venice, 1973.

Morassi 1975
Antonio Morassi, *Guardi: Tutti i disegni di Antonio, Francesco, e Giacomo Guardi*, Venice, 1975.

Morgan Library 1973
The Pierpont Morgan Library, *Sixteenth Report to the Fellows of The Pierpont Morgan Library, 1969–1971*, edited by Charles Ryskamp, New York, 1973.

Morgan Library 1974
The Pierpont Morgan Library, *Major Acquisitions, 1924–1974, Mediaeval and Renaissance Manuscripts*, New York, 1974.

Morgan Library 1976
The Pierpont Morgan Library, *Seventeenth Report to the Fellows of The Pierpont Morgan Library, 1972–1974*, edited by Charles Ryskamp, New York, 1976.

Morgan Library 1978
The Pierpont Morgan Library, *Eighteenth Report to the Fellows of The Pierpont Morgan Library, 1975–1977*, edited by Charles Ryskamp, New York, 1978.

Morgan Library 1981
The Pierpont Morgan Library, *Nineteenth Report to the Fellows of The Pierpont Morgan Library, 1978–1980*, edited by Charles Ryskamp, New York, 1981.

Morgan Library 1993
The Pierpont Morgan Library, *In August Company: The Collections of The Pierpont Morgan Library*, New York, 1993.

Mueller von Asow 1962
Hedwig and E. H. Mueller von Asow, eds., *The Collected Correspondence and Papers of Christoph Willibald Gluck*, translated by Stewart Thomson, New York, 1962.

Müller 1922–23
Erich H. Müller, "Zwei unveröffentlichte Briefe Glucks an Carl August," *Die Musik* 15, 1922–23.

Nectoux 1980
Jean-Michel Nectoux, ed., *Gabriel Fauré: Correspondance*, Paris, 1980.

Nectoux 1984
Jean-Michel Nectoux, ed., *Gabriel Fauré: His Life Through His Letters*, translated by J. A. Underwood, London and New York, 1984.

Needham 1979
Paul Needham, *Twelve Centuries of Bookbindings 400–1600*, New York, 1979.

Neue Zeitschrift 1835
Neue Zeitschrift für Musik 3, 1835.

The New Grove
Martin Cooper, "Duparc, Henri," *The New Grove Dictionary of Music and Musicians*, vol. 5, edited by Stanley Sadie, London, 1980.

New Haven 1979
Yale Center for British Art, New Haven, *The Fuseli Circle in Rome*, exhibition catalogue by Nancy Pressly, 1979.

New York 1967
The Pierpont Morgan Library, New York, *Drawings from New York Collections II: The Seventeenth Century in Italy*, exhibition catalogue by Felice Stampfle and Jacob Bean, 1967.

New York 1971
The Metropolitan Museum of Art, New York, *Drawings from New York Collections III: The Eighteenth Century in Italy*, exhibition catalogue by Felice Stampfle and Jacob Bean, 1971.

New York 1981
The Pierpont Morgan Library, New York, *European Drawings, 1375–1825*, exhibition catalogue by Cara D. Denison and Helen B. Mules, with the assistance of Jane V. Shoaf, 1981.

New York 1992
The Museum of Modern Art, New York, *Henri Matisse: A Retrospective*, exhibition catalogue by John Elderfield, 1992.

New York 1995–96
The Pierpont Morgan Library, New York, *Fantasy and Reality: Drawings from the Sunny Crawford von Bülow Collection*, exhibition catalogue by Cara Dufour Denison, 1995–96.

New York and Fort Worth 1991
The Pierpont Morgan Library, New York, and Kimbell Art Museum, Fort Worth, *The Drawings of Anthony Van Dyck*, exhibition catalogue by Christopher Brown, 1991.

Oettinger 1933
Karl Oettinger, "Der Illuminator Nikolaus," *Jahrbuch der preußischen Kunstsammlungen* 54, 1933.

One Hundred Manuscripts
Illustrations from One Hundred Manuscripts in the Library of Henry Yates Thompson, vol. 6, London, 1916.

Orenstein 1989
Arbie Orenstein, ed., *Maurice Ravel: Lettres, écrits, entretiens,* translated by Dennis Collins, 1989.

Ottawa 1982
National Gallery of Canada, Ottawa, *Bolognese Drawings in North American Collections, 1500–1800,* exhibition catalogue by Mimi Cazort and Catherine Johnston, 1982.

Paris 1998
Galeries Nationales du Grand Palais, Paris, *L'Art au temps des rois maudits Philippe le Bel et ses fils, 1285–1328,* Paris, 1998.

Paris and elsewhere 1979–80
Institut Néerlandais, Paris, Koninklijk Museum voor Schone Kunsten, Antwerp, The British Museum, London, and The Pierpont Morgan Library, New York, *Rubens and Rembrandt in Their Century: Flemish & Dutch Drawings of the 17th Century from The Pierpont Morgan Library,* exhibition catalogue by Felice Stampfle, 1979–80.

Parker 1956
K. T. Parker, *Catalogue of the Collection of Drawings in the Ashmolean Museum,* vol. 2, Oxford, 1956.

Perlis 1974
Vivian Perlis, *Charles Ives Remembered: An Oral History,* New Haven, 1974.

Peterson 1970
Merrill D. Peterson, *Thomas Jefferson and the New Nation: A Biography,* New York, 1970.

Petrucci 1953
Carlo Alberto Petrucci, *Catalogo generale delle stampe tratte dai rami incisi posseduti dalla Calcografia Nazionale,* Rome, 1953.

Pignatti 1974
Terisio Pignatti, *Tiepolo: Disegni scelti e annotati,* Florence, 1974.

Plantinga 1976
Leon B. Plantinga, *Schumann as Critic,* New York, 1976.

Plummer and Strittmatter 1964
John Plummer and Anselm Strittmatter, *Liturgical Manuscripts for the Mass and the Divine Office,* New York, 1964.

Poulenc 1947
Francis Poulenc, "Mes mélodies et leurs poètes," *Les Annales,* 1947.

Poulenc 1964
Francis Poulenc, *Journal de mes mélodies,* [Paris], 1964.

Reggio Emilia 1982
Basilica della B. V. della Ghiara, Reggio Emilia, *I dipinti "reggiani" del Bonone e del Guercino (pittura e documenti),* exhibition catalogue by Nerio Artioli and Elio Monducci, 1982.

Reich 1968
Willi Reich, *Arnold Schönberg oder der konservative Revolutionär,* Vienna, 1968.

Reich 1971
Willi Reich, *Schoenberg: A Critical Biography,* translated by Leo Black, New York, 1971.

Robison 1977
Andrew Robison, "Preliminary Drawings for Piranesi's Early Architectural Fantasies," *Master Drawings* 15, 1977.

Robison 1986
Andrew Robison, *Piranesi, Early Architectural Fantasies: A Catalogue Raisonné of the Etchings,* Washington, 1986.

Roethlisberger 1961
Marcel Roethlisberger, *Claude Lorrain: The Paintings,* 2 vols., New Haven, 1961.

Roethlisberger 1968
Marcel Roethlisberger, *Claude Lorrain: The Drawings,* 2 vols., Berkeley and Los Angeles, 1968.

Rogers 1778
Charles Rogers, *A Collection of Prints in Imitation of Drawings II,* London, 1778.

Roli 1972
Renato Roli, *Guercino: Collana disegnatori italiani,* Milan, 1972.

Rome 1992
American Academy in Rome, *Piranesi architetto,* exhibition catalogue by John Wilton-Ely, 1992.

Rossetti 1863
William Michael Rossetti, "Annotated Catalogue of Blake's Pictures and Drawings," in Gilchrist 1863, vol. 2; also published in new edition of Gilchrist 1880.

Salerno 1988
Luigi Salerno, *I dipinti del Guercino,* Rome, 1988.

Salzburg 1982
Dommuseum, Salzburg, *St. Peter in Salzburg, das älteste Kloster im deutschen Sprachraum,* exhibition catalogue, Salzburg, 1982.

Santa Barbara and elsewhere 1974
University of California, The Art Galleries, Santa Barbara, and elsewhere, *Drawings by Seventeenth-Century Italian Masters from the Collection of Janos Scholz,* exhibition catalogue edited by Alfred Moir, 1974.

Schiff 1973
Gert Schiff, *Johann Heinrich Füssli,* 2 vols., Zurich-Munich, 1973.

Schmalzriedt 1984
Siegfried Schmalzriedt, "Hugo Wolfs Vertonung von Mörikes Gedicht 'Karwoche': realistische Züge im spätromantischen Lied," *Archiv für Musikwissenschaft* 41, 1984.

Schmidt 1962
Gerhard Schmidt, "Ein St. Pöltener Missale aus dem frühen 15. Jahrhundert," *Österreichische Zeitschrift für Kunst und Denkmalpflege* 16, 1962.

Scholz 1976
Janos Scholz, *Italian Master Drawings, 1350–1800, from the Janos Scholz Collection,* New York, 1976.

Schuh 1976
Willi Schuh, *Richard Strauss: Jugend und frühe Meisterjahre: Lebenschronik 1864–1898,* Zurich, 1976.

Schuh 1982
Willi Schuh, *Richard Strauss: A Chronicle of the Early Years, 1864–1898,* translated by Mary Whittall, Cambridge, 1982.

South Hadley 1974
Mount Holyoke College Art Museum, South Hadley, Massachusetts, *Five Colleges Roman Baroque Festival,* exhibition catalogue, 1974.

Stahl 1982
Harvey Stahl, "Old Testament Illustration During the Reign of St. Louis: The Morgan Picture Book and the New Biblical Cycles," in Hans Belting, ed., *Il medio oriente e l'occidente nell'arte del XIII secolo* (Comité International d'Histoire de l'Art, Atti del XXIV Congresso Internazionale di Storia dell'Arte, 2), Bologna, 1982.

Stampfle 1978
Felice Stampfle, *Giovanni Battista Piranesi: Drawings in The Pierpont Morgan Library,* New York, 1978.

Stampfle 1991
Felice Stampfle, with the assistance of Ruth S. Kraemer and Jane Shoaf Turner, *Netherlandish Drawings of the Fifteenth and Sixteenth Centuries and Flemish Drawings of the Seventeenth and Eighteenth Centuries in The Pierpont Morgan Library,* New York, 1991.

Stones 1990
Alison Stones, "L'atelier artistique de la Vie de saint Benoîte d'Origny: nouvelle considérations," *Bulletin de la Société nationale des antiquaires de France,* 1990.

Stones 1996
Alison Stones, "Illustrating Lancelot and Guinevere," in *Lancelot and Guinevere: A Casebook,* Lori J. Walters, ed., New York, 1996.

Stravinsky and Craft 1960
Igor Stravinsky and Robert Craft, *Memories and Commentaries,* London, 1960.

Stricker 1996
Rémy Stricker, *Les Mélodies de Duparc: essai,* Arles, 1996.

Swarzenski 1913
Georg Swarzenski, *Die Salzburger Malerei von den ersten Anfängen bis zum Blütezeit des romanischen Stils,* Leipzig, 1913.

Taruskin 1996
Richard Taruskin, *Stravinsky and the Russian Traditions: A Biography of the Works Through Mavra,* vols. 1, 2, Berkeley, 1996.

Temple 1976
Elzbieta Temple, *Anglo-Saxon Manuscripts 900–1066* (A Survey of Manuscripts Illuminated in the British Isles, II), London, 1976.

Thaw I
The Pierpont Morgan Library, New York, Cleveland Museum of Art, Art Institute of Chicago, and the National Gallery of Canada, Ottawa, *Drawings from the Collection of Mr. & Mrs. Eugene V. Thaw,* exhibition catalogue by Felice Stampfle and Cara D. Denison with an introduction by Eugene V. Thaw, 1975.

Thaw II
The Pierpont Morgan Library, New York, and Virginia Museum of Fine Arts, Richmond, *Drawings from the Collection of Mr. & Mrs. Eugene Victor Thaw, Part II,* exhibition catalogue by Cara D. Denison, William W. Robinson, Julia Herd, and Stephanie Wiles, 1985.

Thaw III
The Pierpont Morgan Library, New York, *The Thaw Collection: Master Drawings and New Acquisitions,* exhibition catalogue by Cara D. Denison, Peter Dreyer, Evelyn J. Phimister, and Stephanie Wiles, 1994.

Thaw, Royal Academy
Royal Academy of Arts, London, *From Mantegna to Picasso: Drawings from the Thaw Collection at The Pierpont Morgan Library, New York,* exhibition catalogue by Cara Dufour Denison, Peter Dreyer, William M. Griswold, Evelyn J. Phimister, and Stephanie Wiles, 1996–97.

Thomas 1952–55
Hylton Thomas, "Piranesi and Pompeii," *Kunstmuseets Årsskrift,* 1952–55.

Tietze 1947
Hans Tietze, *European Master Drawings in the United States,* New York, 1947.

Trenner 1954
Franz Trenner, ed., *Richard Strauss: Dokumente seines Lebens und Schaffens,* Munich, 1954.

Udine and Bloomington 1996–97
Castello di Udine and Indiana University Art Museum, Bloomington, *Giandomenico Tiepolo: Maestria e Gioco, Disegni dal mondo,* catalogue by Adelheid M. Gealt and George Knox, 1996–97.

University Park 1975
The Pennsylvania State University Museum of Art, University Park, Pennsylvania, *Carlo Maratti and His Contemporaries: Figurative Drawings from the Roman Baroque,* exhibition catalogue by Jean K. Westin and Robert H. Westin, 1975.

Venice 1965
Palazzo Grassi, Venice, *Mostra dei Guardi,* exhibition catalogue by Pietro Zampetti, 1965.

Vigni 1972
Giorgio Vigni, *Disegni del Tiepolo,* Trieste, 1972.

Voelkle 1984
William Voelkle, "The Visconti-Sforza Tarots," *FMR* 8, 1984.

Walker 1968
Frank Walker, *Hugo Wolf: A Biography,* 2d ed., New York, 1968.

Washington 1978
National Gallery of Art, Washington, *Giovanni Battista Piranesi: The Early Architectural Fantasies,* exhibition catalogue by Andrew Robison, 1978.

Washington and Paris 1982–83
National Gallery of Art, Washington, and Grand Palais, Paris, *Claude Lorrain, 1600–1682,* exhibition catalogue by H. Diane Russell, 1982–83.

Weiss 1993
Daniel H. Weiss, "Biblical History and Medieval Historiography: Rationalizing Strategies in Crusader Art," *MLN* 108, 1993.

Weiss and Voelkle 1997
Daniel H. Weiss and William M. Voelkle, *Die Kreuzritterbibel: Die Bilderbibel Ludwigs des Heiligen,* Luzern, 1997.

Werner 1972
Martin Werner, "The Madonna and Child Miniature in the Book of Kells, Part 1," *Art Bulletin* 54, 1972.

Wieck 1994
Roger S. Wieck, "Preparatio ad missam pontificalem," *The Painted Page: Italian Renaissance Book Illumination, 1450–1550,* Jonathan J. G. Alexander, ed., Munich, 1994.

Williams 1994
John Williams, *The Illustrated Beatus: A Corpus of the Illustrations of the Commentary on the Apocalypse,* 2 vols. to date, London, 1994.

Williams and Shailor 1991
John Williams and Barbara A. Shailor, *A Spanish Apocalypse: The Morgan Beatus Manuscript,* New York, 1991 (A German edition was published under the title *Beatus-Apokalypse der Pierpont Morgan Library: ein Hauptwerk der spanischen Buchmalerei des 10. Jahrhunderts,* Stuttgart and Zürich, 1991).

Wilton-Ely 1978
John Wilton-Ely, *The Mind and Art of Giovanni Battista Piranesi,* London, 1978.

Wilton-Ely 1993
John Wilton-Ely, *Piranesi as Architect and Designer,* New York, New Haven, and London, 1993.

Worcester 1948
Fiftieth Anniversary Exhibition of the Art of Europe During the XIVth–XVIIth Centuries, Worcester Art Museum, exhibition catalogue, 1948.

Zola 1961
Emile Zola, *Nana,* in *Les Rougon-Macquart: Histoire naturelle et sociale d'une famille sous le Second Empire,* vol. 2, Paris, 1961.

Index of Artists, Authors, and Composers
Register der Künstler, Autoren und Komponisten

Project Staff
for The Pierpont Morgan Library

Karen Banks, Publications Manager
Patricia Emerson, Senior Editor
Deborah Winard, Publications Associate
Sandrine Harris, Assistant

Drawings and Prints
William M. Griswold, Charles W. Engelhard
Curator
Cara Dufour Denison, Curator
Stephanie Wiles, Curator
Ruth Kraemer, Research Assistant

Music Manuscripts and Books
J. Rigbie Turner, Mary Flagler Cary Curator

Literary and Historical Manuscripts
Robert Parks, Robert H. Taylor Curator
Christine Nelson, Curator

Medieval and Renaissance Manuscripts
William M. Voelkle, Curator
Roger S. Wieck, Curator

Photography and Rights
Marilyn Palmeri, Manager
Eugenia D. Coutavas, Associate

Patricia Reyes, Mellon Conservator
Reba F. Snyder, Conservator
Tom Fellner, Art Preparator
Lucy Eldridge, Registrar

The Library also wishes to thank
Gabriele Hoffmann, Rena Charnin Mueller, and
David W. Patterson.